W9-AGC-575

# Leonardo da Vinci and the Art of Sculpture

MONON TOWN & TOWNSHIP PUBLIC LIBRARY
427 N. MARKET ST., P.O. BOX 305
MONON, INDIANA 47959

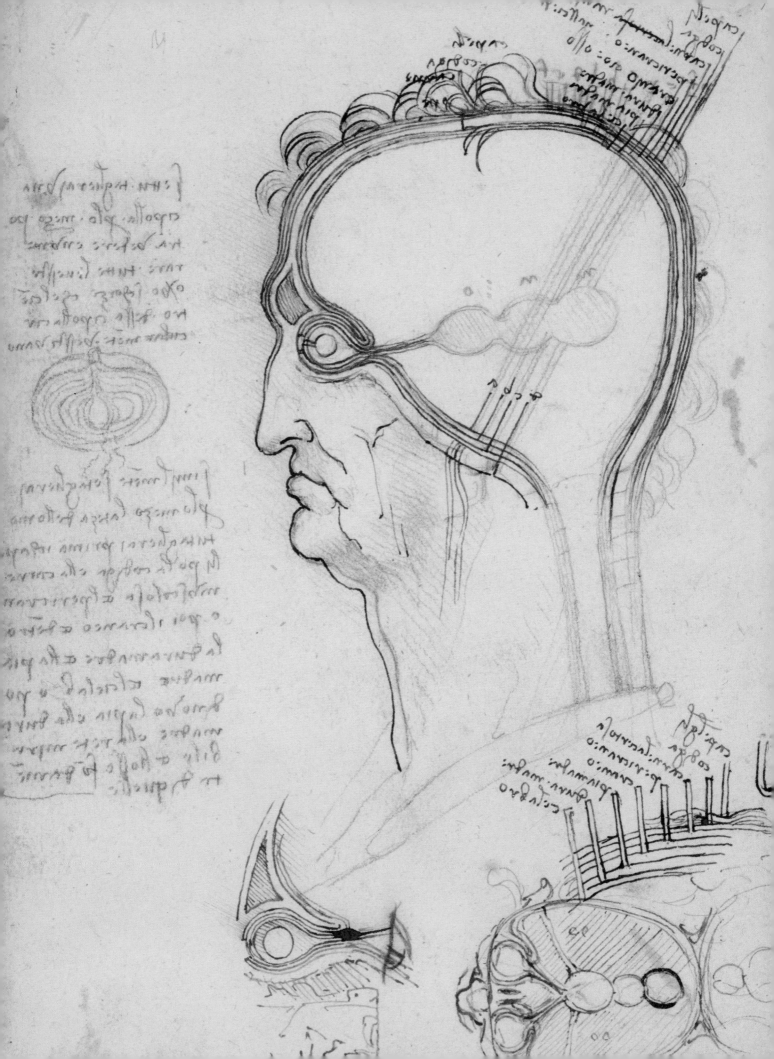

730.92
RAD

Gary M. Radke

*With contributions by*

Martin Kemp

Pietro C. Marani

Andrea Bernardoni

Darin J. Stine

Philippe Sénéchal

Tommaso Mozzati

# Leonardo da Vinci
## and the Art of Sculpture

High Museum of Art, Atlanta

The J. Paul Getty Museum, Los Angeles

Yale University Press, New Haven and London

MONON TOWN & TOWNSHIP PUBLIC LIBRARY
427 N. MARKET ST., P.O. BOX 305
MONON, INDIANA 47959

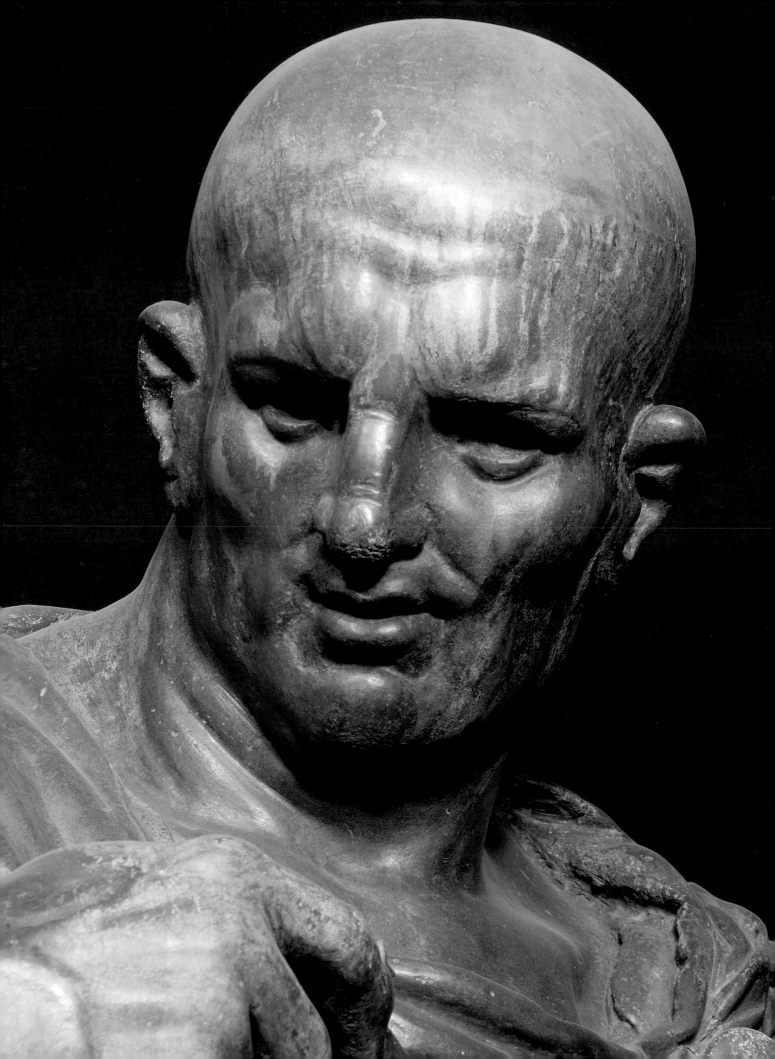

# Contents

The exhibition *Leonardo da Vinci: Hand of the Genius* is organized by the High Museum of Art in association with the J. Paul Getty Museum, Los Angeles, and in collaboration with the Opera di Santa Maria del Fiore and the Opificio delle Pietre Dure in Florence, Italy. The exhibition is generously supported by Lead Corporate Partner Delta Air Lines and sponsor Campanile Plaza. Support has also been provided by The Samuel H. Kress Foundation and Leonardo Society members Loraine P. Williams, Lanier-Goodman Foundation, Morgens West Foundation, and Mr. and Mrs. Gary W. Rollins, with additional support from Atlanta Foundation, Mrs. Robert Ferst, Olga Goizueta, and Turner Foundation. Cargo support of the Sforza horse is provided by UPS. The J. Paul Getty Museum is also grateful for the support of the Istituto Italiano di Cultura and the Italian Consulate General, Los Angeles.

This exhibition is supported by an indemnity from the Federal Council on the Arts and the Humanities.

This accompanying publication, *Leonardo da Vinci and the Art of Sculpture*, is supported by the Friends of Florence, a non-profit international foundation based in the United States.

Published on the occasion of the exhibition
*Leonardo da Vinci: Hand of the Genius*
**High Museum of Art**
Atlanta, Georgia
October 6, 2009–February 21, 2010

*Leonardo da Vinci and the Art of Sculpture: Inspiration and Invention*
**J. Paul Getty Museum**
Los Angeles, California
March 23–June 20, 2010

Published by the High Museum of Art, Atlanta,
in association with Yale University Press, New Haven and London
www.yalebooks.com

Library of Congress Cataloging-in-Publication Data
Radke, Gary M.
    Leonardo da Vinci and the art of sculpture / Gary M. Radke; Martin Kemp . . . [et al.]. —1st ed.
        p. cm.
    Published on the occasion of an exhibition held at the High Museum of Art Atlanta, Ga., Oct. 6, 2009–Feb. 21, 2010 and at the J. Paul Getty Museum, Los Angeles, Calif., Mar. 23–June 20, 2010.
    Includes bibliographical references.
    ISBN 978-0-300-15473-3 (trade cloth : hardcover)—
    ISBN 978-1-932543-32-2 (trade paper : pbk.)
    1. Leonardo, da Vinci, 1452–1519. 2. Leonardo, da Vinci, 1452–1519—Exhibitions. 3. Leonardo, da Vinci, 1452–1519—Criticism and interpretation. I. Leonardo, da Vinci, 1452–1519. II. Kemp, Martin. III. High Museum of Art. IV. J. Paul Getty Museum. V. Title.
    NB623.L6A4 2009
    730.92—dc22                                    2009028723

Text © 2009 by the authors
Compilation © 2009 High Museum of Art, Atlanta
All rights reserved. No part of this book may be reproduced without written permission from the publisher.

Andrea Bernardoni's essay is reprinted and translated from *Leonardo e il monumento equestre a Francesco Sforza: Storia di un'opera mai realizzata*, published in 2007 by Giunti Editori, by the permission of the author and the publisher.

Kelly Morris, Manager of Publications
Rachel Bohan, Assistant Editor
Nicole Smith, Exhibition Coordinator

Translations from Italian by Michelle Johnson, Sassari, Italy
Translations from French by Janice Abbott, Bry sur Marne, France

Designed by Jeff Wincapaw
Proofread by Michelle Piranio
Typeset by Maggie Lee
Color management by iocolor, Seattle
Produced by Marquand Books, Inc., Seattle
    www.marquand.com
Printed and bound by Mondadori, Verona, Italy

Details:
Front cover: Andrea del Verrocchio and Leonardo da Vinci, *Beheading of St. John the Baptist*, plate 21
Back cover: Giovan Francesco Rustici, the *Baptist*, from *John the Baptist Preaching to a Levite and a Pharisee*, plate 35
Page 2: Leonardo da Vinci, *The Head Sectioned to Show the Cerebral Ventricles and Layers of the Scalp*, plate 28
Page 4: Giovan Francesco Rustici, the *Levite*, from *John the Baptist Preaching to a Levite and a Pharisee*, plate 35
Page 10: Giovan Francesco Rustici, the *Pharisee*, from *John the Baptist Preaching to a Levite and a Pharisee*, plate 35
Page 14: Leonardo da Vinci, *Head of a Warrior*, fig. 17
Page 62: Leonardo da Vinci, *Studies of Horses*, plate 22
Page 82: Leonardo da Vinci, *Proportions of the Human Body according to Vitruvius*, fig. 51
Page 94: Leonardo da Vinci, *Studies for the Casting of the Sforza Monument*, plate 30
Page 136: Leonardo da Vinci, *Studies for the Trivulzio Monument*, plate 33
Page 160: Giovan Francesco Rustici, the *Baptist*, from *John the Baptist Preaching to a Levite and a Pharisee*, plate 35
Page 194: Leonardo da Vinci, *A Scene in an Arsenal*, fig. 117

# Directors' Foreword
# and Acknowledgments

*Leonardo da Vinci and the Art of Sculpture* is the important achievement of a satisfying partnership of the High Museum of Art in Atlanta and The J. Paul Getty Museum in Los Angeles. In 2007, we learned the exciting news that Giovan Francesco Rustici's impressive bronze statues of *John the Baptist Preaching to a Levite and a Pharisee*, which had stood over Ghiberti's North Doors on the Florentine Baptistery since 1511, were being cleaned and restored thanks to generous support from the Friends of Florence, an American cultural charity. We are delighted that this important work has allowed us to present such extraordinary works of Renaissance sculpture to the American public.

Colleagues at the Opera di Santa Maria del Fiore in Florence immediately embraced our proposal. President Anna Mitrano, the Administrative Council of the Opera, and Administrator Patrizio Osticrcsi all gave unusually generous support to the project, offering an unprecedented opportunity to include other recently restored works from their collections in this exhibition—including masterpieces by Donatello, Verrocchio, and perhaps Leonardo.

The Opera's loving stewardship of the cathedral complex in Florence ensures that art and religion enjoy an extremely fruitful centuries-long partnership in the center of the city. The restoration of the Rustici sculptural group was entrusted to Ludovica Nicolai and Nicola Salvioli under the supervision of Annamaria Giusti for the Opificio delle Pietre Dure in Florence. Restoration of the *Beheading of John the Baptist* panel from Verrocchio's silver altar

from the Baptistery was overseen by Clarice Innocenti and ably undertaken by Mari Yanagishita, Jennifer di Fina, Bruna Mariani, Raffaella Zurlo, and the scientific team at the Opificio delle Pietre Dure. Marcello del Colle and his colleagues at the Opera di Santa Maria del Fiore cleaned Donatello's *Bearded Prophet*.

Leonardo da Vinci was Giovan Francesco Rustici's mentor, and the sixteenth-century art historian and critic Giorgio Vasari went so far as to claim that Rustici's figures represented Leonardo's best sculpture. Gary Radke, the High Museum's consulting curator for Italian art, was charged with imagining an exhibition featuring the Rustici group within the broad context of Leonardo's interest in, projects for, and influence upon Renaissance sculpture. From the beginning, our goal has been to call attention both to the genius of Leonardo and to the sculptors who inspired him and to those he inspired. Leonardo, along with his teachers and models and the artists he mentored and influenced, all emerge in a clearer and more impressive light.

At an early phase in developing this project, Martin Kemp, a leading expert on Leonardo, generously advised and assisted us in proposing loan requests from the Royal Collection at Windsor Castle, the world's largest and finest repository of Leonardo's drawings associated with sculpture. The Honourable Lady Roberts, Martin Clayton, and Theresa-Mary Morton of the Royal Collection were instrumental in bringing these incomparable drawings to America. Beatrice Paolozzi Strozzi at the Museo Nazionale del Bargello in Florence

offered sage counsel regarding Rustici's position in our exhibition and catalogue.

The exhibition is supported in the United States by an indemnity from the Federal Council on the Arts and the Humanities. In addition, the High Museum wishes to thank its wonderful consortium of donors in Atlanta. The project's Lead Corporate Partner, Delta Air Lines, is always so generous in its support of the Museum and our mission to bring great art to Atlanta. Loraine P. Williams has played a dynamic role in her leadership and generous gift to the Leonardo Society. Corporate support also comes from Campanile Plaza, with foundation support provided by The Samuel H. Kress Foundation, the Lanier-Goodman Foundation, the Morgens West Foundation, and the Atlanta Foundation.

We wish to thank the Friends of Florence and its president Contessa Simonetta Brandolini d'Adda for their generous support of this publication and their production of a DVD on the restoration of the Rustici sculptural group.

The High Museum appreciates the counsel and participation of His Excellency Giovanni Castellaneta, Italian Ambassador to the United States, and Angela Della Costanza Turner, Honorary Consel General for Italy in Atlanta. The J. Paul Getty Museum is grateful for the support of the Istituto Italiano di Cultura and its director Francesca Valente and the Consul General for Italy in Los Angeles Nicola Faganello.

We would also like to acknowledge the many staff members at the High Museum of Art and The J. Paul Getty Museum. At the High Museum, the main players include Philip Verre, Chief Operating Officer; David Brenneman, Director of Collections and Exhibitions; Jody Cohen, Manager of Exhibitions; Jim Waters, Exhibition Designer; Angela Jaeger, Manager of Graphic Design; Julia Forbes, Head of Museum Interpretation; Nicole Smith, Exhibition Coordinator; Amy Simon, Associate Registrar; Kelly Morris, Manager of Publications; and Rachel Bohan, Assistant Editor. Gary Radke particularly acknowledges the research and administrative assistance of Darin J. Stine.

At the Getty Museum, above all we recognize the close collaboration of Julian Brooks, Associate Curator of Drawings, and Anne-Lise Desmas, Associate Curator of Sculpture and Decorative Arts; Eike Schmidt, former Associate Curator of Sculpture and Decorative Arts, was also a key contributor prior to his departure from the Getty. In addition, many other staff members of the Getty have assisted in a variety of ways, including David Bomford, Associate Director for Collections; Quincy Houghton, Assistant Director for Exhibitions and Public Programs; Amber Keller, Senior Exhibitions Coordinator; Lee Hendrix, Senior Curator of Drawings; Antonia Boström, Senior Curator of Sculpture and Decorative Arts; Brian Considine, Senior Conservator, and the staff of the Decorative Arts and Sculpture Conservation Department; Nancy Yocco, Senior Conservator, and the staff of the Paper Conservation Department; Toby Tannenbaum, Assistant Director for Education; Clare Kunny, Education Manager; Mary Beth Carosello, Education Project Specialist; Merritt Price, Design Manager; Robert Checchi, Senior Designer; Christina Webb, Designer; Catherine Comeau, Associate Editor; Paco Link, Senior Media Producer; Lien Nguyen, Media Producer; Betsy Severance, Exhibitions Registrar; and Bruce Metro and the staff of the Preparation Department.

The exhibition would not be possible without the generosity of its many lenders. We extend special thanks to the following: Her Majesty Queen Elizabeth II; the Honourable Lady Roberts, Martin Clayton, and Theresa-Mary Morton of the Royal Collection; Antonio Paolucci, Director, Vatican Museums; Anna Mitrano, Patrizio Osticresi, Lorenzo Fabbri, Paolo Bianchini, and Marcello del Colle at the Opera di Santa Maria del Fiore, Florence; Cristina Acidini Luchinat and Maria Matilde Simari, Istituti museali della Soprintendenza Speciale per il Polo Museale Fiorentino; Beatrice Paolozzi Strozzi, Maria Grazia Vaccari, and Dimitrios Zykos, Museo Nazionale del Bargello, Florence; Marzia Faietti, Galleria degli Uffizi, Florence; Fulvia Lo Schiavo and Carlotta Cianferoni, Museo

Archeologico, Florence; Pietro Giovanni Guzzo, Soprintendenza Speciale per i Beni Archeologici di Napoli e Pompei; Nicola Spinosa, Soprintendenza Speciale per il Patrimonio Storico, Artistico, Etnoantropologico e per il Polo Museale della Città Di Napoli; Mariella Utili, Museo Nazionale di Capodimonte, Naples; the Istituto Nazionale per la Grafica, Rome; Dr. Paolo Galluzzi, Director, Istituto e Museo di Storia della Scienza, Florence; Franco Ruggeri and Donata Vitali, Opera Laboratori Fiorentini, SpA, Florence; Annalisa Perissa, Gallerie dell'Accademia, Venice; Marc Bormand, Geneviève Bresc-Bautier, and Carel van Tuyll, Musée du Louvre, Paris; Antony Griffiths and Hugo Chapman, British Museum, London; Lázló Baán and Szilvia Bodnar, Szépművészeti Múzeum, Budapest; George Goldner and Carmen Bambach, the Metropolitan Museum of Art, New York; Alison Luchs and Shelley Sturman, National Gallery of Art, Washington D.C.; the Pierpont Morgan Library, New York; the American Numismatic Society, New York; and the J.B. Speed Art Museum, Louisville.

Michael E. Shapiro
*Nancy and Holcombe T. Green, Jr. Director*
High Museum of Art

Michael Brand
*Director*
The J. Paul Getty Museum

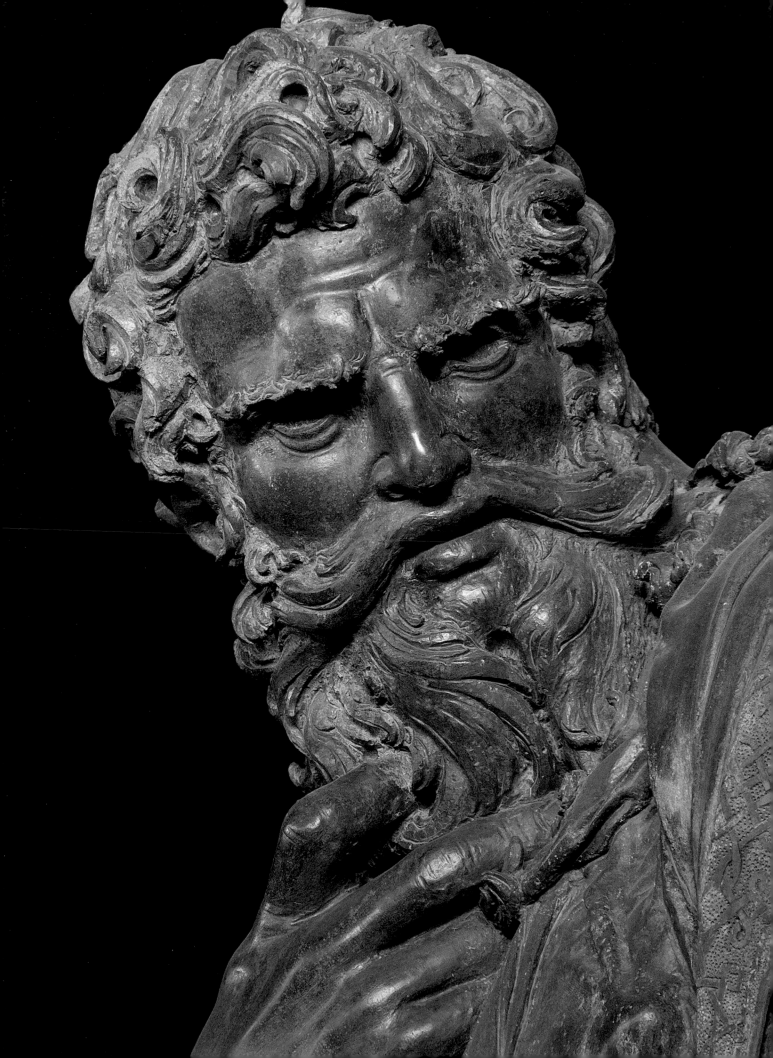

GARY M. RADKE

# Leonardo: The Mind of the Sculptor
*Introduction*

Getting into anyone's mind—let alone that of a genius like Leonardo —is hardly a simple matter. Our minds can express themselves in words, images, and creations that allow others to glimpse what we are thinking and dreaming, but a mind is so much more: the sum total of the cognitive and sentient activity of a human being. Our minds make us who we are. They are, as a famous publicity campaign poignantly observed, terrible things to waste.

No one would ever have accused Leonardo da Vinci of having failed to exploit his mind to its greatest potential, but there have been those who have wondered whether the outward expressions of his mind might have verged on wasteful: so many unfinished projects, so many incomplete visions, so many unrealized technical and artistic advances. Nowhere is this more true than in his thought and work as a sculptor. While the *Mona Lisa* and the luminous veil of what remains of the *Last Supper* testify physically to his accomplishments as a painter; while his anatomical drawings still stun us with their probing insights; and while his clever and useful mechanical devices seem to come alive in his notebooks, his sculptural ambitions—sometimes bigger than life, always pushing the limits of expression—largely remained objects of his imagination.

This exhibition, then, is doubly ambitious. On one hand it seeks to recuperate an aspect of Leonardo's creative activity—his thought and work as a sculptor—that has largely escaped notice and of which very little has survived except in his drawings and notebooks.[1] At the same time, it attempts the even more difficult task of entering his mind, seeking to read between the lines of the surviving visual and textual evidence to explore what Leonardo felt as well as thought about sculpture and three-dimensionality and how his thinking about sculpture intersected with his numerous other intellectual and creative pursuits. Our questions include: How did he respond to sculpture? What did he learn from it? What novel and traditional approaches did he bring to the sculptural enterprise? In what ways did his theoretical, technical, and artistic interests merge in his sculptural projects? What did

his encounters with the third dimension allow him to communicate to others? How, in turn, were the minds and works of other sculptors shaped and changed because of Leonardo's insights?

Fortunately, recent scholarship has devoted a good deal of energy to considering the broad dimensions of Leonardo's mind. In *The Mind of Leonardo: The Universal Genius at Work*, Paolo Galluzzi assembled an extraordinary interdisciplinary team to examine and bring together the numerous strands of Leonardo's intelligence and creative activity: artistic and scientific, technical and philosophical.[2] Instead of seeing Leonardo's creative and intellectual pursuits as a series of discrete activities juxtaposed with one another, Galluzzi and his colleagues demonstrated Leonardo's "fundamental unity of vision and method" and stressed how he assimilated "the universal laws that govern all the marvelous operations of man and nature, combining daring theoretical syntheses with ingenious experimentation."[3] Recognizing the importance of sculpture to this endeavor, Andrea Bernardoni, one of the contributors to our own catalogue, examined Leonardo's equestrian monument to Francesco Sforza,[4] Carlo Pedretti considered a terracotta bust attributed to Leonardo,[5] and Luca Garai reconstructed a piece of kinetic sculpture (Leonardo's project for a self-propelled lion).[6] Carlo Pedretti also brought together another team whose study of Leonardo's famous plans for the *Battle of Anghiari* included sculptural responses by Giovan Francesco Rustici and other artists.[7]

But there is still much more to explore and understand about Leonardo's relationship to sculpture, so this exhibition focuses more closely on the subject, all the while emphasizing that Leonardo never thought of sculpture and sculptural thinking as an isolated, self-sufficient field of inquiry and experimentation. Sculpture and what might be called "the mind of the sculptor" were immersed in the largely indivisible world of Leonardo's art and thought. Fortunately for us, examining even this single aspect of Leonardo's mind helps us to appreciate others as well.

Considering Leonardo's complex relationship with the art of sculpture and with his fellow sculptors also allows us to address popularly held but profoundly mistaken notions of Leonardo as a unique and unprecedented genius. Leonardo worked in a world that was intensely collaborative, where innovation often grew out of tradition, where ideas easily migrated from artist to artist and medium to medium, and where artistic exploration often involved technological and scientific studies as well as purely aesthetic ones. Repatriating Leonardo to this world means liberating him from the popular perception of the man always ahead of his time, who created nothing but "unprecedented" and unforeseen masterpieces and inventions. Leonardo was largely an autodidact, but that does not mean that he learned only from Mother Nature. His notebooks contain regular reminders to himself to consult a colleague about a problem or to borrow a particular book or manuscript. His responses to sculpture, his own plans for sculpture, and the influence of his work on younger generations of sculptors provide concrete evidence of how rooted he was in his own time and place—and how much better we can appreciate his work in that context.

## NOTES

1. There is no comprehensive modern study of this subject except for Valeri 1922, which is understandably out of date. For more recent contributions, see Brugnoli 1954, pp. 359–389; Pedretti "Leonardo as a Sculptor" 1989, pp. 131–147; and the studies cited in the essays in this catalogue.

2. *Mind of Leonardo* 2006. See also the cross-disciplinary approach of Martin Kemp in Kemp *The Marvelous Works* 2006 and *Leonardo da Vinci* 2006.

3. *Mind of Leonardo* 2006, p. 17.

4. Ibid., pp. 202–231.

5. Ibid., pp. 299–301. Thanks to Alexander Kader of Sotheby's London and the heirs of Luigi Gallandt, I had the privilege of examining this fascinating work in person in June 2008. See also Kemp 1991, pp. 171–176. I found the work intriguing but believe that an attribution to Leonardo is overly ambitious.

6. *Mind of Leonardo* 2006, pp. 276–279.

7. *La mente* 2006, which constituted the seventh section of Galluzzi's *Mind of Leonardo* exhibition. See especially the entries by S. Cremante, pp. 110–113.

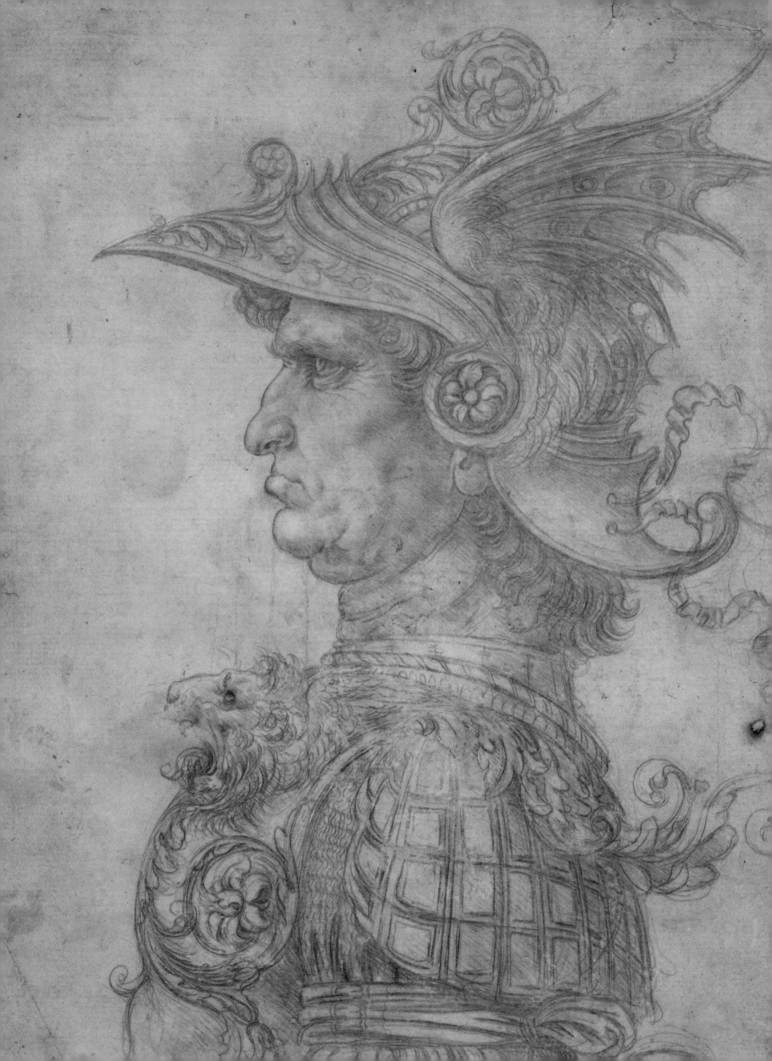

GARY M. RADKE

# Leonardo, Student of Sculpture

Leonardo was a perpetual student of sculpture. He studied ancient and Renaissance sculpture, created sculpture of his own, and incorporated sculptural ideas into all his creative practice. As Kathleen Weil-Garris Brandt has so elegantly demonstrated, sculptural precedents were as important for Leonardo's development as a painter as they were for his work as a sculptor.[1] For their part, Carlo Pedretti, Martin Kemp, and Pietro Marani have recovered the conceptual framework that characterized Leonardo's thinking about sculpture and three-dimensionality.[2] The goal of this essay is to consider Leonardo's origins as a sculptor—the modeler and maker of three-dimensional objects—and the lessons he drew from spending his formative years in a city populated by an extraordinary number of sculptures and sculptors. Conditioned in part by the constraints of organizing an exhibition that could not practically include many examples of Leonardo's painting—and the unique opportunities afforded by displaying recently restored works of sculpture that are not likely to travel again—I focus largely upon surviving objects that Leonardo is likely to have studied and created up until he left Florence for Milan in the early 1480s. It has long been recognized that during this period Leonardo took full advantage of an unusually extended relationship with his teacher Andrea del Verrocchio (1435–1488), but Leonardo also found numerous other opportunities for instruction and inspiration in sculpture-rich Florence.

## DRAPERY STUDIES

A famous series of drapery studies, two examples of which are in this exhibition (plates 1 and 3),[3] provide some of the earliest surviving evidence for Leonardo's sculptural interests and activities. While Leonardo does not seem to have been the earliest nor the only artist to have made such works—art historians have attributed their popularity to the Verrocchio workshop as well as to Domenico Ghirlandaio —Leonardo's visual essays on this subject stand out for their extraordinarily subtle and detailed observation of light, shade, and texture.[4]

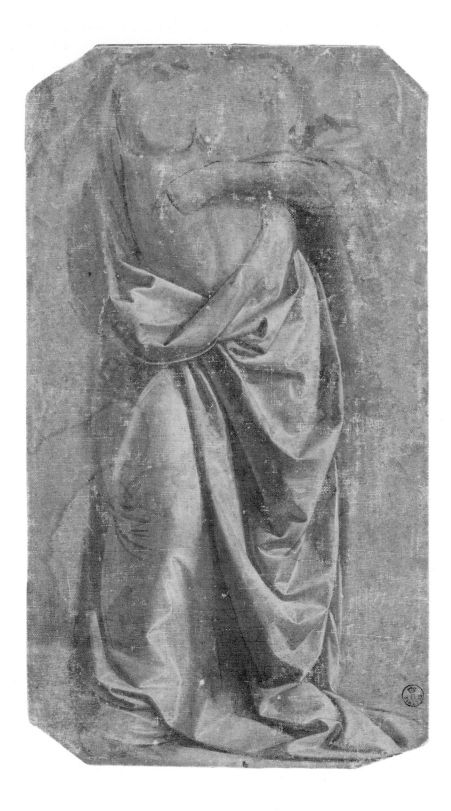

PLATE 1 **Leonardo da Vinci** (Italian, 1452–1519), *Draped Figure*, 1470s, silverpoint on white paper, 11⅛ × 6¼ inches. Istituti museali della Soprintendenza Speciale per il Polo Museale Fiorentino, Galleria degli Uffizi, Florence, inv. 433 E.

Leonardo recognizes that light enters even the deepest pockets of shade, and he senses folds within folds. Nearly all his brushstrokes are imperceptible, so shadows seem to bleed softly into the fabric that he is rendering on actual fabric, usually linen. Only his final white highlights stand out on the most salient edges of his arrangements. The three-dimensional seems to inhabit the two-dimensional surface on which he is drawing.

Leonardo's drapery drawings were not just an exercise in trompe l'oeil rendering but the product of an actual sculptural exercise. Vasari observed that Leonardo "carefully studied his craft by drawing from life, and sometimes by fashioning models or clay figures, which he covered with soft rags dipped in plaster and then patiently sketched them upon very thin canvases of Rheims linen or used linen, working in black and white with the tip of his brush—marvelous things indeed."[5] In other words, Leonardo arranged and physically modeled the drapery that he was going to render. His fingers and hands knew those folds and surfaces intimately. He arranged the drapery to reveal its softness and fullness.

It is clear that as Leonardo arranged the drapery he drew inspiration from the work of his master Verrocchio. Indeed, Uffizi 433E (plate 1) has often been attributed to Verrocchio because of its obvious relationship to Verrocchio's bronze figure of Christ for Orsanmichele (fig. 1),[6] which is documented to have been modeled from 1467 to 1470.[7] Leonardo, who would have been between fifteen and eighteen years old at the time, had probably just joined Verrocchio's shop. In the drawing, the arm quickly sketched across the nude chest recalls Verrocchio's Christ, as does the curving shelf of drapery at his waist, the multiplicity of folds, and their often sharp, light-catching edges.

It might seem, then, that Uffizi 433E is a preparatory drawing by Verrocchio himself that would have taught Leonardo how to think about drapery, but there are several reasons to retain the more widely held attribution to the younger artist. While Verrocchio's example is clearly evident in this extremely sculptural drawing, it reveals a pictorial sensibility as well, both in its rendering and in the physical arrangement of the fabric. As we shall see, the same attitudes toward light, shadow, and texture appear in a slightly later Louvre drapery study (plate 3), which is almost universally given to Leonardo. Second, while the curve of fabric at the figure's waist is superficially similar to the one on Verrocchio's Christ, the actual drapery from which the drawing was taken was arranged very differently, naturally swelling out and then spilling over itself rather than forming a suspended concave shelf as in Verrocchio's sculpture. What is more, the drapery that is observed in the drawing still seems soft and pliable, not starched and crisp. Most tellingly, the Uffizi drawing is worked from right to left, as we would expect from the left-handed Leonardo. The folds on the right are distinctly more finished

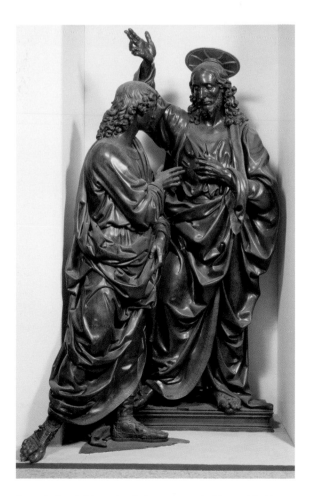

Fig. 1 Andrea del Verrocchio (Italian, 1435–1488), *Christ and St. Thomas*, commissioned 1466/67, Christ modeled by 1470, St. Thomas cast 1479, bronze, 90½ inches high, Museo di Orsanmichele, Florence.

than at the left, where Leonardo's underdrawing is still visible.

Leonardo's Uffizi drapery study also indicates that he was looking closely at Donatello's figures, both those with wet drapery like the so-called *Jeremiah* (Museo dell'Opera del Duomo, Florence) and *Judith and Holofernes* (Palazzo Vecchio, Florence) (fig. 2), which technical analysis has revealed was cast directly from a fabric-draped figure,[8] as well as the *Bearded Prophet* in this exhibition (plate 2), whose mantle curves and falls at his waist in the very manner depicted in the drawing. Donatello

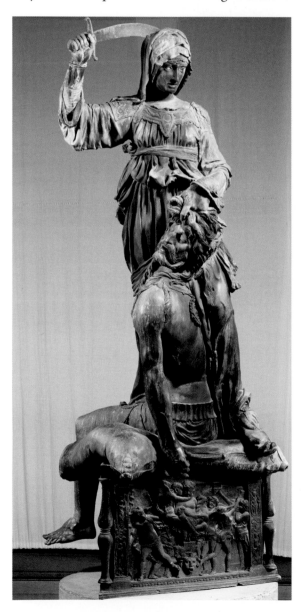

Fig. 2 Donatello (Italian, ca. 1386–1466), *Judith and Holofernes*, late 1450s, bronze, 92⅞ inches high, Palazzo Vecchio, Florence.

was the first Renaissance sculptor to study drapery as assiduously as Leonardo. Even when working in marble he constantly recalls the weight, texture, and fall of textiles.

As Leonardo continued to study painting and sculpture, his drapery studies became more complex, coherent, and stunningly luminous, as revealed in Louvre 2256 (plate 3), although the lowest portions were later retouched and slightly compromised with additional lines. Leonardo's drapery studies are best understood on their own as investigations of fabric tossed over the edge of a chair or simple support. In both drawings Leonardo indicates no anatomical structure underneath, even though the folds do suggest the positions of legs and feet. One gets the impression that Leonardo arranged and drew the drapery first and then decided what figural form it might evoke. These are exploratory studies, in which Leonardo first physically modeled and then depicted his forms. He tucked fabric into itself, "carving" deeply into every crevice while at the same time systematically observing the differences in density between a pocket of shadow that is relatively close to the surface and those that extend farther inward. The extraordinary range of grays and subtle transitions document and reveal Leonardo's fine touch as both a modeler and a draftsman, a man for whom the simplest and humblest of materials could reveal a world full of fascinating variety and detail. Verrocchio's explorations of complex drapery and light effects surely encouraged Leonardo in this pursuit, but he took his studies even further.

## MAKING MODELS

Equally at the heart of Leonardo's artistic training —both as a sculptor and as a painter—was model-making. We have already noted Vasari's report about Leonardo draping fabric on clay figures (though the two drapery drawings in this exhibition show him using a simple armature). In the early fifteenth century, Cennino Cennini recommended and gave instructions for making life casts,[9] and by mid-century Florentine painters were using

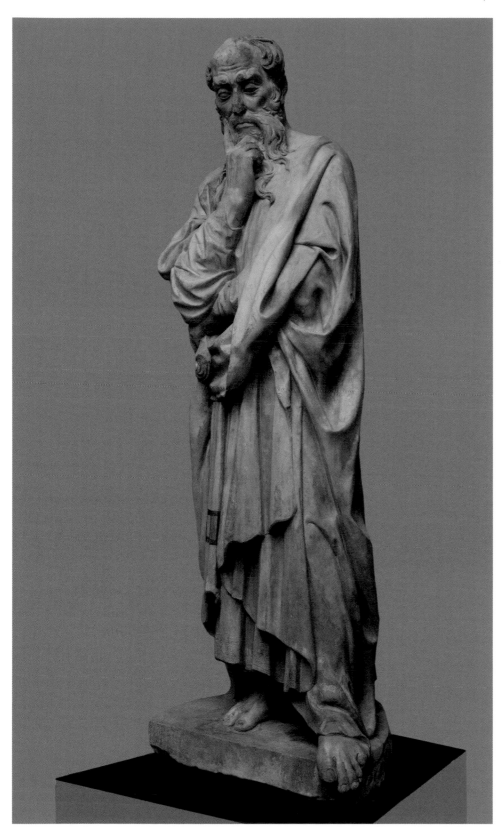

PLATE 2 **Donatello** (Italian, ca. 1386–1466), *Bearded Prophet*, for east side of Campanile, ca. 1418–1420, marble, 76 inches high. Museo dell'Opera del Duomo, Florence.

Unrestored statue.

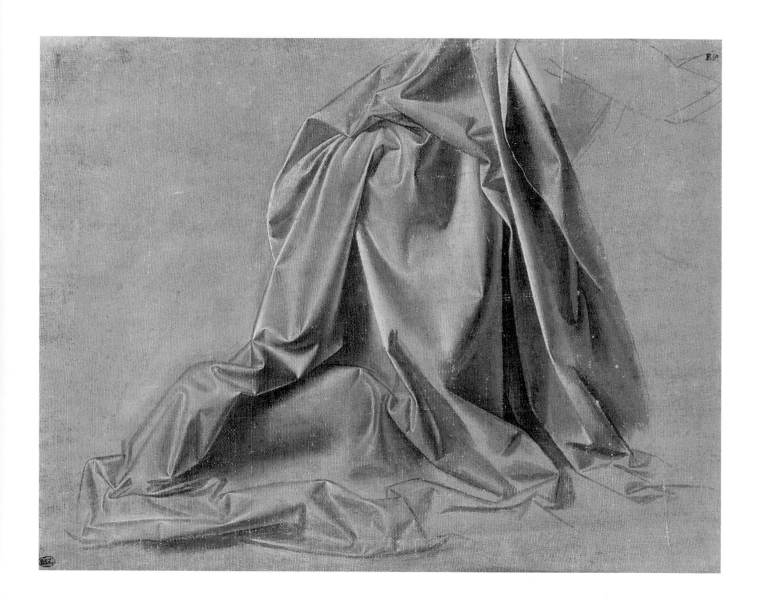

PLATE 3 **Leonardo da Vinci** (Italian, 1452–1519), *Drapery Study for a Kneeling Figure, seen in profile* (recto), 1470s, tempera and brush highlighted with white on gray prepared linen, 7⅛ × 9¼ inches. Musée du Louvre, Paris, Department of Graphic Arts, INV 2256.

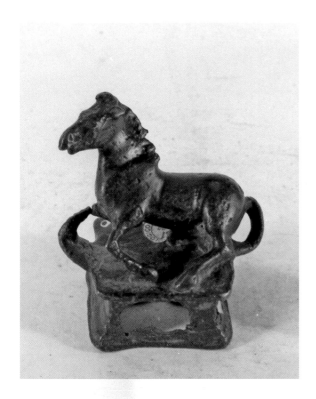

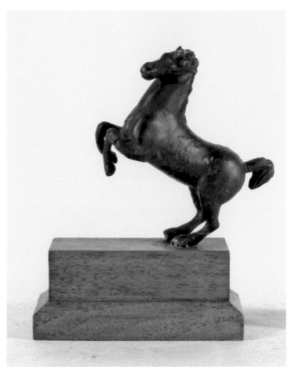

PLATE 4 **Unknown Hellenistic Artist**, *Miniature Falling Horse*, 3rd–1st century BCE, bronze, 3 × 5 inches. Museo Archeologico Nazionale, Florence, inv. 2250.

PLATE 5 **Unknown Hellenistic Artist**, *Miniature Rearing Horse*, 3rd–1st century BCE, bronze, 4 × 5 inches. Museo Archeologico Nazionale, Florence, inv. 2249.

three-dimensional models to produce what Laurie Fusco has called "pivotal representations"—that is, figures rotated and seen from different points of view.[10] Popularized in the Pollaiuolo workshop, three-dimensional models also played a central role in the Verrocchio workshop.[11]

In his 1584 *Treatise on Painting* Gian Paolo Lomazzo reports that Leonardo said that he delighted in clay modeling "as is shown by the various whole horses, legs, and heads I made and also human heads of our Lady, and Christ as a Child, both in full figure and in pieces, and a fair number of heads of old men."[12] Some of these may have been preparatory for sculpture, yet others for painting. Around 1527 Paolo Giovio claimed that Leonardo always "placed modeling as a means of rendering figures in relief on a flat surface before other processes done with the brush."[13] Cellini also cited Leonardo's practice of making small models, to which several Milanese writers of the seventeenth century made reference as well.[14]

On a theoretical level, Lomazzo further records that Leonardo agreed with the ancients that modeling was the sister of painting, and painting was the aunt of sculpture.[15] In other words, Leonardo saw painting and modeling as equals. Modeling enjoyed the high status of painting in Leonardo's artistic hierarchy because it was "closer to the imagination" than carving, which itself was nothing but "a fatiguing imitation of modeling."[16] These statements usefully distinguish the kinds of sculptural activity that Leonardo found praiseworthy—additive modeling in three dimensions and relief—from that which he found less so—noisy, dirty carving. He did not, then, disparage all sculpture, as is sometimes mistakenly thought to be the case upon a first reading of Lomazzo's *Treatise on Painting*;[17] rather, Leonardo's approach to sculpture distinctly favored that which he could literally shape with his hands.[18]

Explicit evidence for Leonardo's exploitation of models appears in a drawing for the *Battle of Anghiari* (plate 27 recto), where he accompanies a

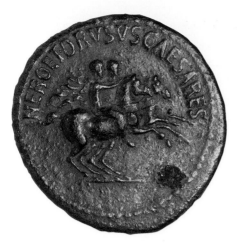

PLATE 6 **Unknown Artist**, *Caligula Dupondius*, ca. 40–41 CE, bronze, 1³⁄₁₆ inches in diameter. The American Numismatic Society, New York, Gift of George Hubbard Clapp, 1941.131.699.

PLATE 7 **Unknown Artist**, *Nero Sesterce*, ca. 64–66 CE, bronze, 1⅜ inches in diameter. The American Numismatic Society, New York, Bequest of Hoyt Miller, 1957.172.1544.

series of tiny sketches of horses and figures with a line instructing himself to "make a small one of this in wax, a finger long."[19] Given the position of the inscription, it is impossible to determine whether Leonardo was referring to the leaping figures above his words or the charging and rearing horses around them. Wax sketches would have allowed Leonardo to study the active and twisting movement of either subject from a variety of directions and so depict them more accurately in his painting. Fortuitously, the form of such tiny sketches is evident in two Hellenistic ancient bronzes, which Leonardo may have known in the Medici Collection and which could have encouraged him in this practice (plates 4 and 5).[20] The smaller of the two seems to be falling onto the open base, its right foreleg extending from it. The slightly larger horse rears on its haunches, its legs still spindly from their quick fashioning in wax. Once again the movement is momentary and complex, the horse dramatically and exaggeratedly twisting its head and tail.

## ANCIENT SCULPTURE

Other details on the verso of plate 27, as well as on the recto, indicate that Leonardo was studying ancient sculpture when he prepared these studies and thus was directly inspired by ancient precedents. A pair of rearing horses set next to a classicizing profile head clearly derive from ancient Roman coins like the *Caligula Dupondius*, ca. 40–41 CE, and the *Nero Sesterce*, ca. 64–66 CE (plates 6 and 7). As John Cunnally has shown, Leonardo sketched many numismatic portraits into his notebooks, and their recollections of ancient triumphal arches and public monuments, as well as horsemen rearing over fallen warriors, could have inspired his ambitious equestrian projects and the numerous galloping horses in his paintings.[21]

It has often been thought that Leonardo was uniquely uninterested in ancient sculpture, but that view has changed markedly as more and more of his thoroughly reworked motifs have been traced to their original sources.[22] He studied and derived poses, compositions, and details of naturalistic observation from coins, gems, ancient sarcophagi, and figural sculpture.[23] Leonardo himself wrote that "the imitation of ancient things is more praiseworthy than of modern ones,"[24] and he recorded around 1490 that the movement of the ancient equestrian statue in Pavia known as the *Regisole* was the most

admirable that could be seen.[25] He may also have conceived one of his most famous drawings, the *Vitruvian Man* (see fig. 51), as the frontispiece of a projected treatise on sculpture.[26] Characteristically, the *Vitruvian Man* drawing shows him both studying and contesting the accuracy of ancient theoretical assertions.

Martin Kemp has sensibly suggested that the rather stylized character of some horse heads and galloping horses on a drawing in this exhibition (fig. 3 and plate 22) depend upon Leonardo's direct study of ancient sculpture as he was developing ideas for his altarpiece of the *Adoration of the Magi* (fig. 100).[27] One of Leonardo's primary sources of inspiration was surely the collection of ancient sculpture that Lorenzo de' Medici gathered in the garden at San Marco where Michelangelo also famously studied.[28] Among the most impressive pieces Leonardo would have seen there was a life-size, bronze Hellenistic horse head (fig. 4).[29] The ancient protome itself inspired Donatello to create an even larger version (plate 8) as part of a never-completed equestrian monument to King Alfonso V of Aragon, who ruled Naples from 1442 to 1458. Leonardo would have known the work before Lorenzo de' Medici sent it as a diplomatic gift to Naples in 1471. Both the ancient original and the over-scaled Renaissance version surely inspired Leonardo to propose creating the Sforza horse on a colossal scale.[30] He emulated their breathtaking realism, too.

## LEONARDO AND BERTOLDO

Leonardo's mentor at the Medici Garden would have been the medalist and antiquarian Bertoldo di Giovanni (ca. 1420–1491).[31] His significance for Leonardo's artistic (and particularly sculptural) development cannot be overestimated. Bertoldo

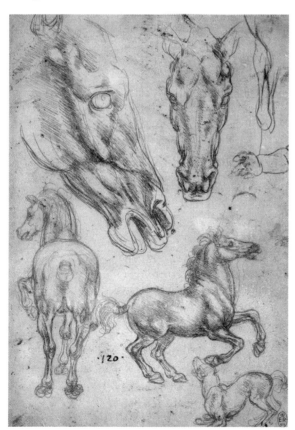

Fig. 3 Leonardo da Vinci, *Studies of Horses*, ca. 1480, metalpoint on pale buff prepared paper, 8½ × 5⅞ inches, Royal Library, Windsor Castle, RL 12285. This shows plate 22 under ultraviolet light.

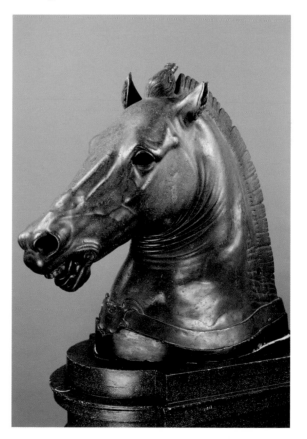

Fig. 4 Anonymous Artist, *Hellenistic Horse Head*, called "the Riccardi horse head," 3rd–1st century BCE, bronze, 32 inches high, Museo Archeologico Nazionale, Florence, inv. 1639.

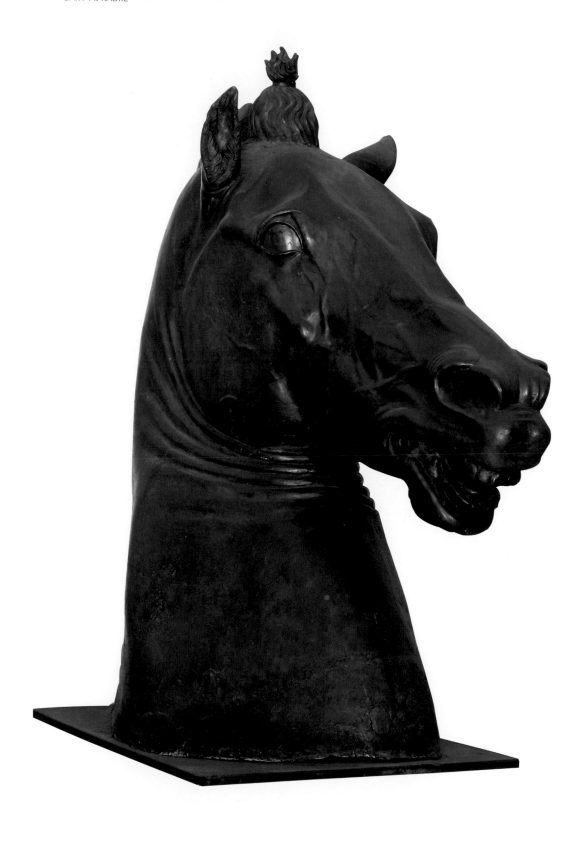

PLATE **8** **Donatello** (Italian, ca. 1386–1466), *Horse Head* (*Cavallo Carafa*), mid-fifteenth century, bronze, 68½ inches high. Museo Archeologico Nazionale, Naples, inv. 4887. Not in exhibition.

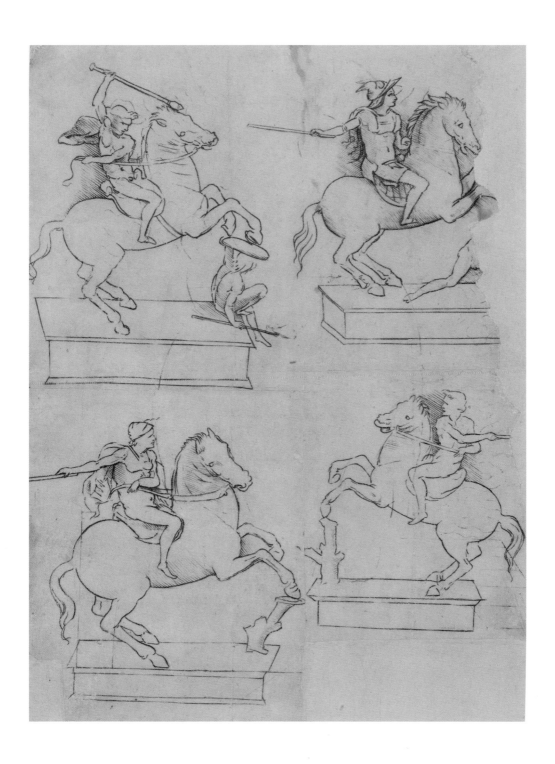

PLATE 9 **After Leonardo da Vinci** (Italian, 1452–1519), *Four Studies for an Equestrian Statue after Leonardo*, 1490–1510, engraving, 8½ × 6⁵⁄₁₆ inches. The British Museum, London, 1895,0617.182.

seems to have enjoyed unusually close relations with Lorenzo de' Medici and was entrusted with many of the family's private commissions, leaving more public projects like the family tombs to Verrocchio. Bertoldo enjoyed an easy relationship with the ancient world. Never the academic antiquarian like Pier Jacopo Alari Bonalcolsi (ca. 1460?–1528) at the court of Mantua, who appropriately became known as Antico ("the antique one"), Bertoldo taught Leonardo how to draw inspiration from and expand upon ancient models without being bound by them.

In his bronze *Battle Relief* (plate 48),[32] which was designed for a mantle above a fireplace in Lorenzo's private quarters and is likely to have been produced in the unsettled political climate of 1478–1479,[33] Bertoldo took on the creative challenge of reconstituting a much damaged sarcophagus in the Camposanto in Pisa that had lost most of its heads and had a gaping hole in its center. Bertoldo built up an orderly but exceedingly complex composition of largely nude foot soldiers and horsemen over and around the scaffolding of his ancient prototype. Where he was left free to invent new figures and interactions, he enriched the composition with layer upon layer of dramatic conflict. At the empty center of his prototype he posed a powerful helmeted warrior about to jump down from a

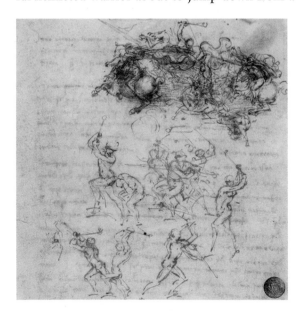

Fig. 5  Leonardo da Vinci, *Skirmish between Horsemen and Foot Soldiers; Foot Soldiers Wielding Long Weapons*, ca. 1503–1504, pen and brown ink over black chalk and traces of stylus on paper, 6⁷⁄₁₆ × 6¹⁄₁₆ inches, Gallerie dell'Accademia, Venice, 215.

full-chested, wildly rearing stallion to bludgeon a tumbling combatant. Slipping off his own horse, the unfortunate target of the first figure's club threatens to fall directly into the viewer's space. We find ourselves thrillingly in harm's way. At the far right a freshly imagined melee erupts in six overlapping layers: an upside-down figure collapsed on his left arm at the bottom edge of the relief, a warrior striding obliviously over him, a downed horse over which sprawls another upside-down figure about to be kicked by yet another rearing horse, whose legs cross over the shoulder of a final figure whose head snaps back defiantly.

This is the sort of drama and intricate observation and composition that Leonardo was initially to experiment with in the background of his *Adoration of the Magi* (fig. 100) and then put to even more superb use in his plans for the *Battle of Anghiari*[34] (fig. 5 and see plates 45 and 47). While Leonardo's horses were more lifelike than Bertoldo's and he conceived his composition fully in three dimensions—thanks in part to sculptural models that allowed Leonardo to move around them—Bertoldo's example remained crucial to his own imagining of the tangled and bitter confusion of battle. The lurching, hacking, and bludgeoning figures in the foreground of Leonardo's Accademia 215 each recall the individualized energy and liberated movement that Bertoldo gave to his own figures. Following Bertoldo's example, Leonardo continued to invent new poses and positions, each seeming to be a statuette of its own.[35]

Equally significant for Leonardo was Bertoldo's appreciation of the ancient Horse Tamers of the Quirinale in Rome. Bertoldo's bronze statuette *Bellerophon Taming Pegasus* probably dates to the early 1480s.[36] Bertoldo would have been at work on it just before Leonardo set off for Milan and began his earliest plans for the Sforza monument. Drawings and engravings associated with the equestrian monument (plate 9) show Leonardo recalling the tight relation of human figure, rearing winged horse, and base seen in Bertoldo's bronze as he explored how to support and pose his horse and rider. In a

great number of these graphic studies, Leonardo flings out his rider's arms and sets his chest parallel to the flank of the horse, as Bertoldo had imagined Bellerophon. Leonardo's horses also recall Pegasus, who twists in space, tail moving expressively. Leonardo was not long to be content with the relief-like arrangement of Bertoldo's group, which reads best and almost singularly from the right flank, but the vitality and energy of his mentor's group certainly appealed to him.

Leonardo might also have become familiar with the art of making medals through Bertoldo, who was a famous practitioner of the art, creating diplomatic gifts for the Medici and other dignitaries.[37] He specialized in works with rather fussy reverses, often based on ancient carved stones, gems, and coins, but to his credit Bertoldo's figures remained legible even on the tiniest scale. On the Pazzi Conspiracy medal (fig. 6), for example, Bertoldo communicated a vast amount of narrative and anecdotal information. Dozens of tiny assassins lay the groundwork for Leonardo's studies of hand combat in the *Battle of Anghiari*.

A few of Leonardo's drawings of emblems (plate 10 recto) suggest that he may have entertained the possibility of creating medals or plaquettes for his courtly patrons.[38] Two passages in the *Madrid Codices* (ca. 1490–1497) show him studying the technology necessary to produce such objects. Following earlier writers like Cennino Cennini, Leonardo described casting medals in plaster, though he added a layer of ash "in order to allow the wind confined between the medal and the form to pass this subtle veil of fine earth over the medal, it being a little moist, to fix the fine earth upon the medal."[39]

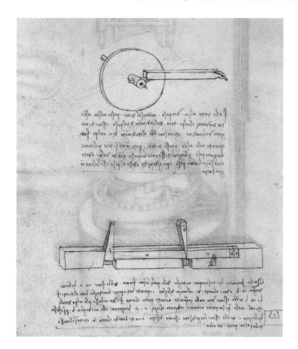

Fig. 7　Leonardo da Vinci, *Mechanism for Striking Medals*, *Codex Madrid*, 45r (detail), 1490s, pen and ink on paper, 8¼ × 6 inches, Biblioteca Nacional, Madrid.

He also drew a mechanism for striking medals (fig. 7), annotating it with the words

> This instrument is used for stamping medals. Its die is at A and the medal at B. Wedge D must be hit with a wooden hammer, and when you wish to remove the medal, strike wedge F. There must be a strong spring at H [that] will drive back the wooden blocks C and E as wedge F descends after it is struck. Medal B is in that way released by itself.
>
> Wooden [wedge] F must be wide beneath and narrow on top in order to avoid its being lifted on the opposite side when wedge D is struck.[40]

Leonardo's drawing pre-dates all other machines for striking medals, which only became popular in the mid-sixteenth century.[41]

## DONATELLO AND FOLLOWERS

Before moving on to discuss Leonardo's even more significant student/teacher relationship with Andrea del Verrocchio, it is worth pausing to consider Leonardo's self-directed visual education

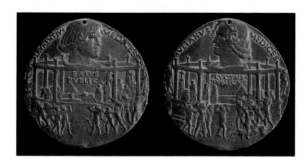

Fig. 6　Bertoldo di Giovanni (Italian, ca. 1420–1491), *Medal of the Pazzi Conspiracy*, obverse and reverse, 1478, bronze, 2⅝ inches in diameter, Museo Nazionale del Bargello, Florence.

PLATE 10 **Leonardo da Vinci** (Italian, 1452–1519), *Studies of emblems, architecture, the profile of a youth, and a decorative costume* (recto); *Studies of a clepsydra, optics, a decorative costume, and the oesophagus and stomach* (verso), ca. 1508, recto: pen, ink, and black chalk on paper; verso: pen and ink on paper, 14⅝ × 11⅛ inches. Royal Library, Windsor Castle, RL 12282 recto and verso.

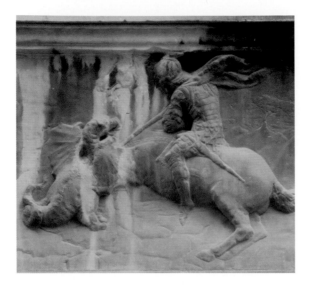

Fig. 8 Donatello (Italian, ca. 1386–1466), *St. George and the Dragon* (detail), ca. 1415–1417, marble, 14½ × 32 inches, Orsanmichele, Florence.

among the works of other distinguished fifteenth-century Florentine sculptors and their potential impact on his sculptural creations. Donatello (ca. 1386–1466) died just as Leonardo came to Florence, but his works and reputation illuminated the rest of the century, causing Vasari to wonder whether he truly belonged in the second "adolescent" section of *The Lives*, where his presence was chronologically appropriate, or whether he should be counted among the generation of Leonardo, Michelangelo, and Raphael because of his extraordinary achievements in human expression, form, and sheer inventiveness.[42] Leonardo's full debt to Donatello cannot be chronicled here, but his recollection of Donatello's *Bearded Prophet* (plate 2), newly freed of disfiguring discoloration and restored for this exhibition, may be paradigmatic. Donatello probably carved the figure around 1418–1420, as part of that distinguished series of life-size sculptures for the Florentine Campanile that included the *Zuccone* (see fig. 101) and *Jeremiah*.[43] Wrapped in and around his own thought, the *Bearded Prophet* rests one arm upon the other to bring his hand to bearded chin, where his index finger seems to consider a series of nascent ideas. His sturdy frame, erect and yet relaxed under his substantial robes, awaits the command of his mind and soul. What

better image to summon up when Leonardo himself searched for a thoughtful commentator for the far left reaches of his *Adoration of the Magi*, as recorded in the center of a sheet of studies now in the British Museum (plate 11).[44] The pointing foot and contrapposto pose allowed the figure the possibility of movement once he was to make sense of the miraculous scene playing out in front of him. In yet another sheet, now at the Ecole des Beaux-Arts in Paris, Leonardo stripped the figure of its clothes to explore that implicit movement.[45]

From Donatello, too, came the realization that relief sculpture might create effects of light, shade, and atmosphere. As Weil-Garris Brandt has demonstrated,[46] Donatello's relief of *St. George and the Dragon* (fig. 8) for Orsanmichele not only taught Leonardo about *sfumato* but set a crucial example for his lifelong interest in the treatment of flowing drapery, horses and dragons in motion, and the evocation of space and atmosphere. Leonardo's drawing of a horseman battling a dragon (plate 46) documents this relationship directly.[47] His composition mirrors the model he found in Donatello, and he uses ink wash strategically to evoke the marble relief's sculptural recession and salience.

No one was more adept at Donatello's *rilievo schiacciato* than Desiderio da Settignano,[48] who also produced some of the most alluring busts of children ever imagined (plate 12).[49] Often placed above doorways and on credenzas, such busts of children in marble, stucco, and terracotta must have populated many a Florentine palazzo, encouraging Leonardo to try his own hand at the type, as indicated by clay examples of "Christ as a Child, both in full figure and in pieces" recorded by Lomazzo and by Vasari's report that in his youth Leonardo made "heads of some women laughing, created through the craft of plaster-casting, as well as the heads of some children, which seem to have issued forth from the hand of a master."[50] Leonardo probably prepared for such works by initially drawing studies of children, peculiarly truncated at chest and upper arm (plate 13).[51] The flesh of our example is soft enough to have been drawn from life, but the stiff and formulaic pose suggests that he may

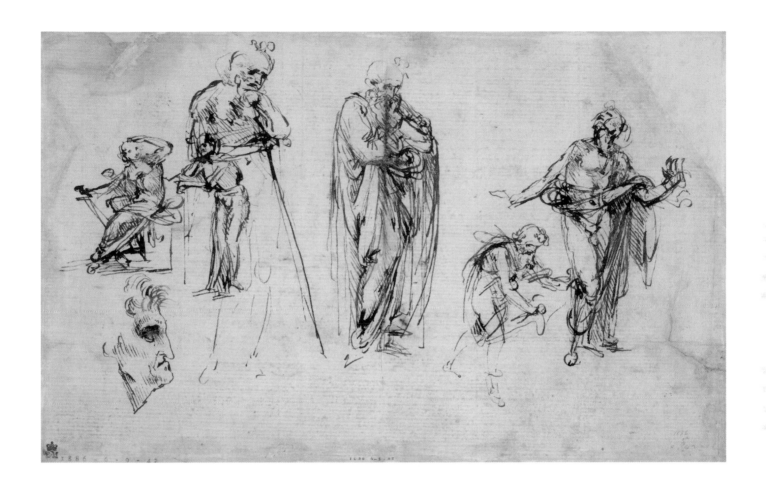

PLATE 11 **Leonardo da Vinci** (Italian, 1452–1519), *Studies of Six Figures including an Old Man Leaning on a Stick, and a Head in Profile*, 1480–1481, pen and brown ink on paper, 6½ × 20½ inches. The British Museum, London, 1886,0609.42.

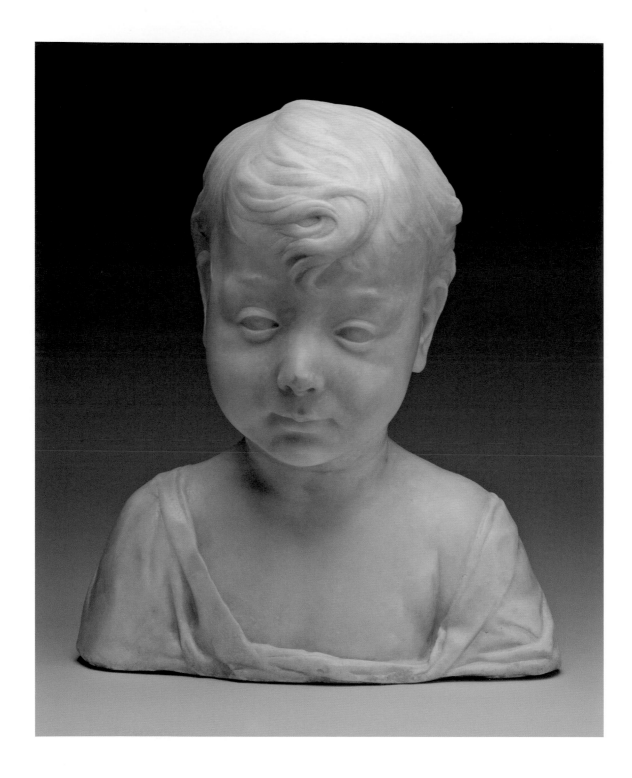

PLATE 12 **Desiderio da Settignano** (Italian, 1429–1464), *The Christ Child*, ca. 1455–1460, marble, 12 × 10⅜ × 6⅜ inches. National Gallery of Art, Washington, Samuel H. Kress Collection, 1943.4.94.

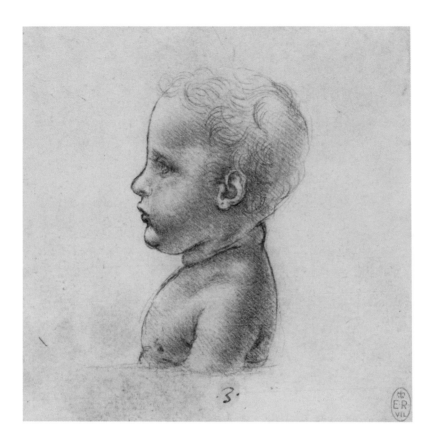

PLATE 13 **Leonardo da Vinci** (Italian, 1452–1519), *The Bust of a Child in Profile*, ca. 1495,
red chalk on paper, 4 × 4 inches. Royal Library, Windsor Castle, RL 12519.

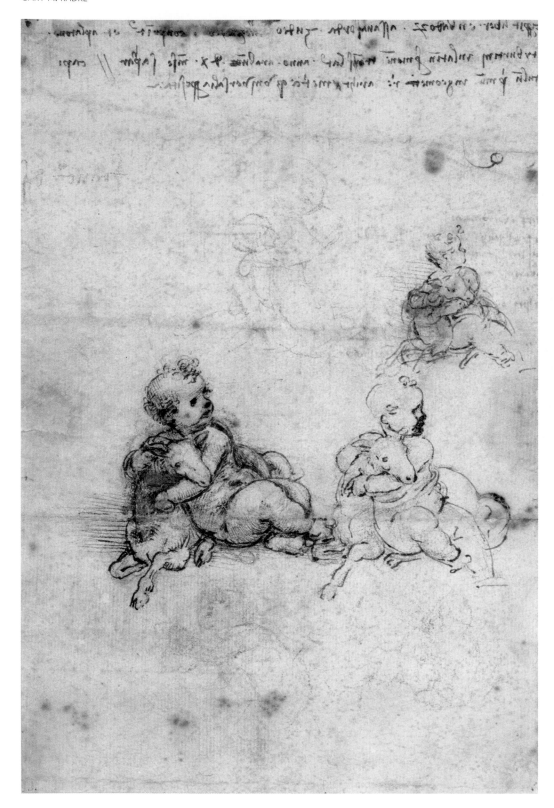

PLATE **14 Leonardo da Vinci** (Italian, 1452–1519), *Studies for the Christ Child with a Lamb*, ca. 1503–1506, pen, brown ink, and black chalk on paper, 8¼ × 5⁹⁄₁₆ inches. The J. Paul Getty Museum, Los Angeles, 86.GG.725.

actually have been working from a bust or a recollection of one. The shock of hair casually falling on the forehead of Desiderio's boy, the wisps at his temples, and the pudgy softness of his cheeks and lips all cried out to be rendered with the lightest touch of red chalk. Much more typical of Leonardo's approach of "stalking" his figures from all directions—as he did in equestrian studies (see plate 26)—is a charming sheet (plate 14) on which the Christ Child and a lamb shift in space with each reiteration of the composition.

## LEONARDO AND VERROCCHIO

When Leonardo entered Verrocchio's workshop around 1464 or 1465,[52] he joined Florence's most versatile and well-connected studio. Verrocchio's largely public commissions came repeatedly from the Medici family and, probably through them, the city's leading institutional patrons: the Mercanzia (chamber of commerce), the Signoria (heads of the civic government), and the Opera del Duomo (cathedral works).[53] No workshop could have been better suited to encourage and support Leonardo's multidisciplinary talents and interests. Verrocchio worked in silver, gold, terracotta, plaster, marble,

and bronze and painted on panel and fabric. He was well-read, played the lute, probably wrote poetry or at least extemporized, and had no wife or children to distract him from his creative pursuits. He seems to have been very devoted to his students— Leonardo, effectively abandoned by his father in his youth, lived with Verrocchio for at least a decade. Verrocchio's habits of mind, as perceptively summarized by Andrew Butterfield, anticipate Leonardo's own approach to the world: "his [Verrocchio's] knowledge of ancient sculpture, his analytic approach to artistic problems, his unusually broad culture, his acute powers of observation and description, and his potent narrative imagination," not to mention his "impulse to innovate and look forward," which included an "unprecedented concern for the incorporation of multiple viewpoints in sculpture."[54]

Any attempt to find evidence of Leonardo's participation in Verrocchio's workshop, then, must assiduously avoid the temptation to assume that the younger artist outclassed his master.[55] Neither should we take at face value Vasari's claim that Verrocchio "had a rather hard and crude style in both sculpture and painting, as if he had acquired it after endless study rather than because of any natural gift or aptitude."[56] Such disparagement was part of Vasari's rhetorical strategy to elevate Leonardo's

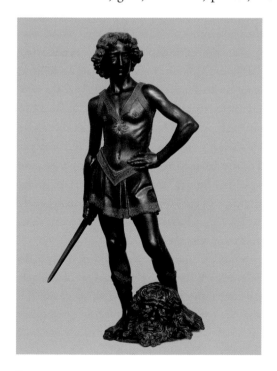

Fig. 9 Andrea del Verrocchio (Italian, 1435–1488), *David*, mid-1460s, bronze, 49³⁄₁₆ inches high, Museo Nazionale del Bargello, Florence.

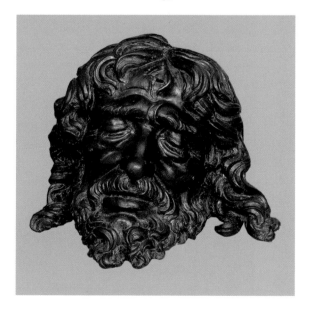

Fig. 10 Detail of the head of Goliath from Verrocchio's *David*, Museo Nazionale del Bargello, Florence.

status as a prodigy. Rather, it makes more sense to consider how Verrocchio's patient and intelligent mentoring drew out and encouraged Leonardo's abilities. Without Verrocchio there would have been no Leonardo.[57]

At least at the start, the differences between Leonardo and his teacher would have been more of degree than kind—and Verrocchio was certainly the more highly trained and experienced. When Leonardo entered the shop, Verrocchio was at work on his graceful and elegant bronze *David* (fig. 9), which can in some ways be considered a notional portrait, if not an actual one of the young artist at that age.[58] Verrocchio managed to take a subject that was extremely common in Florentine Renaissance art[59] and give it new freedom and life, combining anecdotal verism with pleasant and graceful idealism. At David's feet appears one of the most empathetic renderings of Goliath's severed head ever imagined (fig. 10). No caricatured villain, he seems to contemplate his fate with wrinkled brow and downcast eyes. All this Verrocchio accomplished with surprising efficiency: a few quick marks of the chisel accentuate Goliath's eyebrows and the furrow between them; a few veins enliven David's bony hands and arms; part of his rib cage pushes through his tight jerkin.

Verrocchio focuses on what is most essential and telling. From a distance the effect is stunningly realistic; up close, surprisingly fresh and at times even approximate. Verrocchio's lessons for Leonardo: observe and digest, liberate your forms, and charm your audience.

In 1468 Verrocchio took on a commission from the Signoria of the city of Florence for a bronze candlestick (fig. 11).[60] While it was less demanding artistically, the commission would have offered an opportunity for Leonardo to further his education in the art of bronze casting. Later drawings for lamps and fountains indicate that Leonardo paid close attention to its classical decorative vocabulary and composite construction. Verrocchio made his candelabrum from at least three but perhaps as many as six separately cast pieces. A small sketch by Leonardo for an oil lamp (fig. 12) closely mimics the form of Verrocchio's candelabrum, and Leonardo's designs for table fountains (plate 15) all show comparable ease in re-combining vases, columns, and other architectural forms.[61]

Verrocchio was also at work on a major sculptural commission in the later 1460s, the *Christ and St. Thomas* for the niche of the Mercanzia at Orsanmichele (see fig. 1).[62] Leonardo's master literally thought outside the box for this work, dispensing with the confined limits of a preexisting niche that had been designed by Donatello to hold just one figure and ingeniously adapting it for two. Hyper-attentive to narrative and drama, Verrocchio set Thomas stepping forward and across the niche to touch Christ's wound. Though he did not get around to modeling Thomas until nearly a decade after the Christ figure, Verrocchio must have imagined the two together from the start, Christ gently revealing his wound as he lifts his right arm in salutation and incipient blessing.

Verrocchio's commission provided Leonardo the opportunity to contemplate gesture and interpersonal communication, as well as to study the expressive and sculptural possibilities of drapery (see plate 1). As we have seen, Leonardo went back to basics and explored alternatives to his master's

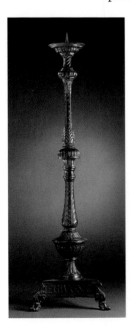
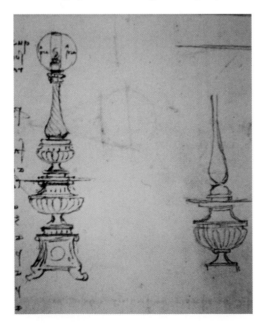

**Fig. 11** Andrea del Verrocchio (Italian, 1435–1488), *Candlestick*, 1468, bronze, 61⅜ inches high, Rijksmuseum, Amsterdam, BK16933.

**Fig. 12** Leonardo da Vinci, *Drawings of Lamps, Codex Atlanticus*, 217r (detail), 1478–1518, pen and ink on paper, Biblioteca Ambrosiana, Milan.

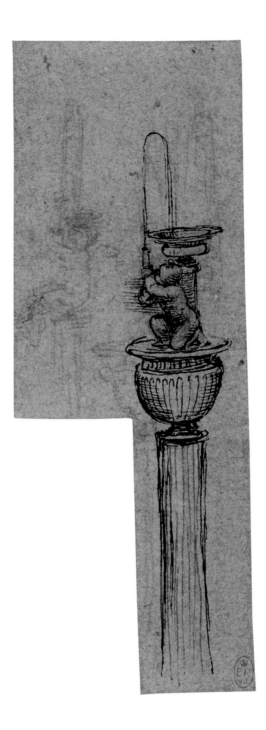

PLATE 15 **Leonardo da Vinci** (Italian, 1452–1519), *A Design for a "Heron's Fountain,"* ca. 1513, pen, ink, and red chalk on blue paper, 6¾ × 2½ inches. Royal Library, Windsor Castle, RL 12691.

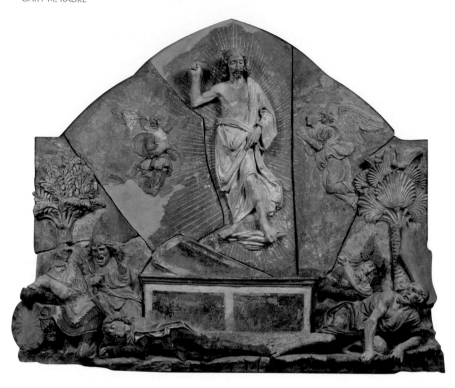

**Fig. 13** Andrea del Verrocchio (Italian, 1435–1488), *Resurrection*, ca. 1470?, painted terracotta, Villa Medici, Careggi, Museo Nazionale del Bargello, Florence.

manner in softer, swelling folds, which in turn may have contributed to Verrocchio's later creation of fuller and more naturally puckering drapery for his figure of St. Thomas.[63] Good teachers always take some lessons from their students.

By around 1470 Leonardo had been in the workshop long enough to provide increasingly important assistance to his master, though—and this point cannot be made strongly enough—Verrocchio's sculptural production had already reached such maturity and he exercised such evident control over his finished works that it is not clear whether or how Leonardo's sculptural practice may have diverged from his master's at this point. Like Ghiberti before him, who also greatly impressed Leonardo,[64] Verrocchio must have run a very tight shop. The homogeneity and consistency of both his and Ghiberti's works were especially favored by the fact that their major commissions were in bronze, where the wax models could be worked and reworked until the master had subsumed the contributions of his assistants. Clay could also easily be refashioned and corrected if Verrocchio assigned a first draft to an assistant.

Art historians have cautiously suggested that Leonardo's hand may be present in the naturalistic bronze fruit and foliage framing Verrocchio's tomb of Giovanni and Piero de' Medici (ca. 1470–1473),[65] or in two emotional figures in the painted terracotta relief of the *Resurrection* for the Medici villa at Careggi (fig. 13)—one screaming at the left, the other cowering at the lower right—but these works are more likely creations by Verrocchio.[66] Their example would have inspired and encouraged Leonardo to develop his interests in naturalism and high-pitched emotion.

Even in its current badly damaged state, the face of Verrocchio's screaming figure signals the origins of Leonardo's later warriors for the *Battle of Anghiari* (fig. 14).[67] As we shall see, screaming faces also appeared on other works by Verrocchio and seem to have been a hallmark of the shop. Leonardo also directly recalled the pose of Verrocchio's cowering figure in a sketch of *Phyllis and Aristotle*,[68] but as Butterfield astutely observed, the composition is

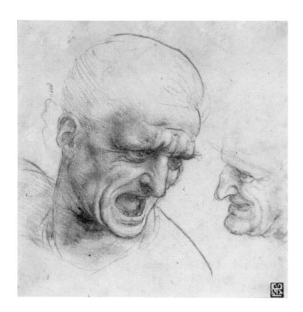

Fig. 14 Leonardo da Vinci, *Studies for the Head of Two Soldiers in the "Battle of Anghiari,"* ca. 1504–1505, charcoal or soft black chalk with traces of red chalk on paper, 7⁹⁄₁₆ × 7⁷⁄₁₆ inches, Szépművészeti Múzeum, Budapest, inv. 1775.

his figure was wearing, and he again projected facial emotion with impressive economy: gashes for the eyes, two lines for the knitted brow, lumps of clay for the characteristically high cheek bones, and a few quick but masterful curving forms for mouth and beard.

Leonardo would have been intrigued by his master's gift for succinct expression, but he eventually developed many of Verrocchio's themes in greater physical and psychological detail. Vasari, for example, was to praise Leonardo's now lost cartoon for a door curtain, saying, "it can truthfully be said that genius could not create anything in the divine realm equal in precision and naturalness. There is a fig tree, which besides the foreshortening of its leaves and the appearance of its branches, is drawn with such love that the mind is dazzled by the thought that a man could possess such patience."[70] Vasari was equally impressed by the *Last Supper*, where "every small detail in the work reflects incredible care and diligence. Even the fabric of the tablecloth is reproduced so well that Rheims linen itself would not appear more real."[71]

Verrocchio's example, then, provided the scaffolding for Leonardo's more detail-oriented and searching observation and rendering. This is evident if we compare Verrocchio's lovely and compelling

neither unique nor limited to Florentine artists.[69] Instead, the figure's boldly rendered, generalized musculature and his emotion-racked face continue a trajectory that Verrocchio initiated with his bronze *David* and head of Goliath (see figs. 9 and 10). In the case of the cowering figure, Verrocchio did not stop to worry about exactly what sort of clothing

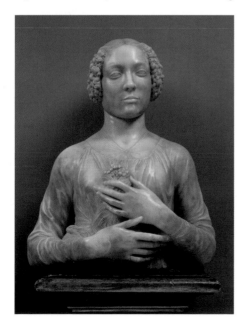

Fig. 15 Andrea del Verrocchio (Italian, 1435–1488), *Portrait of a Woman*, known as *Lady with Primroses*, 1475–1480, marble, 24 inches high, Museo Nazionale del Bargello, Florence.

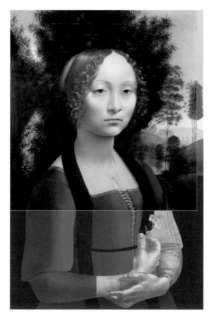

Fig. 16 Leonardo da Vinci, *Portrait of Ginevra de' Benci*, ca. 1475, oil on panel, National Gallery of Art, Washington, Ailsa Mellon Bruce Fund, 1967.6.1, 2001, digital construction based on existing panel painting and incorporating elements of a drawing of hands by Leonardo in the collection of Windsor Castle.

*Lady with Primroses* (fig. 15)[72] to Leonardo's *Portrait of Ginevra de' Benci* (fig. 16, as reconstructed by David Alan Brown).[73] The comparison underlines some of the differences that began to emerge between the two artists in the mid-1470s. Verrocchio's great leap forward was to include his young lady's arms and hands in the composition and tilt her head and shoulders so that a previously immobile sculptural type was transformed into the simulacrum of a living, breathing individual. Leonardo appreciated all this and more. He boldly and unprecedentedly set Ginevra across and into his space and explored tiny details and fleeting effects of light that were of distinctly less interest to Verrocchio. While Leonardo concealed his brushstrokes, Verrocchio had no qualms about letting his chisels and drill leave evocative but recognizable marks. The gathered fabric of the figure's bodice and the posies are carefully rendered, but Verrocchio greatly respects his medium, so that we never lose sight of the fact that they are carved from marble. Leonardo's approach was both more pictorial and more closely observant.

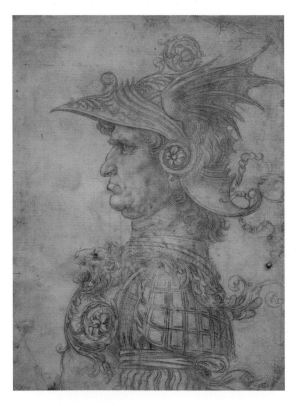

Fig. 17  Leonardo da Vinci, *Head of a Warrior*, ca. 1475–1480, silverpoint on prepared paper, 11⁵⁄₁₆ × 8⁵⁄₁₆ inches, The British Museum, London, 1895,0915.474.

Many of these characteristic differences are evident in a pair of terracotta angels now in the Louvre. With good reason, Passavant ascribed the angel on the left to Verrocchio, while the one on the right is sometimes associated with Leonardo (plates 16 and 17).[74] In each fragment, an angel kicks off from some clouds toward the edges of what was probably going to be a mandorla in the center of a larger composition. The left angel is palpably physical, a three-dimensional figure pressed into and projecting from the surface. The other can be credibly linked to Leonardo because it is so much more pictorial and detailed. Clouds are not flat objects on a surface, as they were for Verrocchio,[75] but shifting apparitions in the sky, drawn as much as modeled. And while wings, arms, and legs all had adhered to or run parallel to the horizontal plane in the left angel, the one on the right lifts its arms, pivots, and turns, even exaggeratedly. The creator of this relief observes hair and feathers down to the last curl and pinion and sends ribbons crossing one another and fluttering aloft. Drapery clings to the angel's knees and thighs, and folds appear deep within other folds, as Leonardo had observed in his long, patient hours of arranging and drawing drapery (see plate 3). There were still details to be worked out— the right angel seems to have turned its back too swiftly to allow its upper torso to be believably attached to its lower body and thighs, and the tiny ringlets of the angel's hair are a bit formulaic—but the general effect is mobile, graceful, and closely observed. If this is not a work by the young Leonardo, it still comes very close to his approach and may indicate that Leonardo was making an impression on other members of the shop.[76]

Leonardo moved on to explore the implications of such angel figures in numerous other studies, including a drawing of a winged figure, which appears on the top of a page otherwise filled with studies of *Fortune*, recognizable by her large shock of hair blowing forward (plate 18).[77] Completely in motion, *Victory* flies through a swirl of ink wash that effectively evokes a thick but traversable atmosphere. Her hair streams back and her left foot

kicks high, realizing the kinetics only implied by the terracotta.

A marble relief of *Alexander the Great* (plate 19), probably produced in Verrocchio's workshop in the early to mid-1480s, when Leonardo had left Verrocchio's employ, and a related drawing of a warrior by Leonardo (fig. 17 and page 12) both seem to reflect earlier bronze reliefs that Lorenzo de' Medici is said to have given to King Matthias Corvinus of Hungary.[78] Judging from the elaborately fussy and consciously antiquarian character of the workshop marble, however, Verrocchio's lost originals may actually have been produced for Piero de' Medici in the late 1460s. Several of its motifs recur in Leonardo's drawings, including a study of antique armor and dog-headed dragons (plate 20 recto and verso). Leonardo evidently delighted in hybrid, highly mobile creatures from early in his career. Vasari reports that he studied "reptiles, green lizards, crickets, snakes, butterflies, locusts, bats and other strange species of this kind" for a peasant's shield that he decorated for his father.[79]

In the *Alexander* relief we also find the high-cheeked screaming head type that Verrocchio put to such expressive use in his Careggi *Resurrection* (see fig. 13) and which Leonardo developed for the *Battle of Anghiari*. The *Darius*, which served as a pendant for the *Alexander*, is known through a few glazed terracotta reproductions (fig. 18). Verrocchio's depiction of the Persian general sported a similar dragon on his shoulder, wore a visored helmet topped by a stylized dolphin, and was protected by an open-mouthed lion's head on his chest.[80]

The similarities between Leonardo's drawing and Verrocchio's compositions are evident, but so is the distinct manner in which Leonardo reinterpreted his model. Taking into account that history has left us no option other than to compare an original by Leonardo with productions from Verrocchio's workshop, it is still obvious that Leonardo gave new life and energy to every motif for which he found inspiration in Verrocchio's work. Ribbons that follow an arbitrary course in Verrocchio's compositions blow believably in the wind in

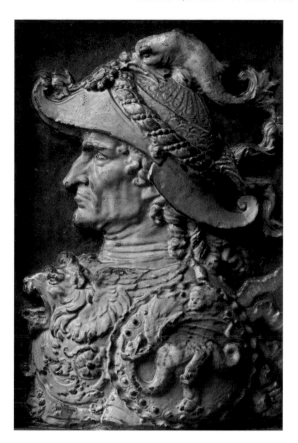

Fig. 18 Della Robbia workshop, *Darius*, 16th century, terracotta, 23¼ inches high, war loss.

Leonardo's, as does the warrior's hair, tendrils on his upper back, a ribbon above his forearm, and fringe on his sleeve. Leonardo also pays closer attention to the structural logic of the helmet, imagining a visor that could functionally pivot on the rosettes above his warrior's ear. Partly because he is drawing, but also because of his intense interest in the complexities of visual experience, Leonardo indicates that the wing above the rosette is translucent, and he distinguishes its softness from the glint of the metal visor and neck guard. He also takes pains to show how the twisting ribbon above the warrior's forearm slightly deforms the chain mail it encircles.

Leonardo also diverged from Verrocchio in selecting a distinctive facial type for his warrior. Recalling classical portraits of the Emperor Galba, Leonardo's warrior is neither smooth-faced like the Washington *Alexander*, whose physiognomy recalls Verrocchio's youthful St. Thomas (see fig. 1), nor

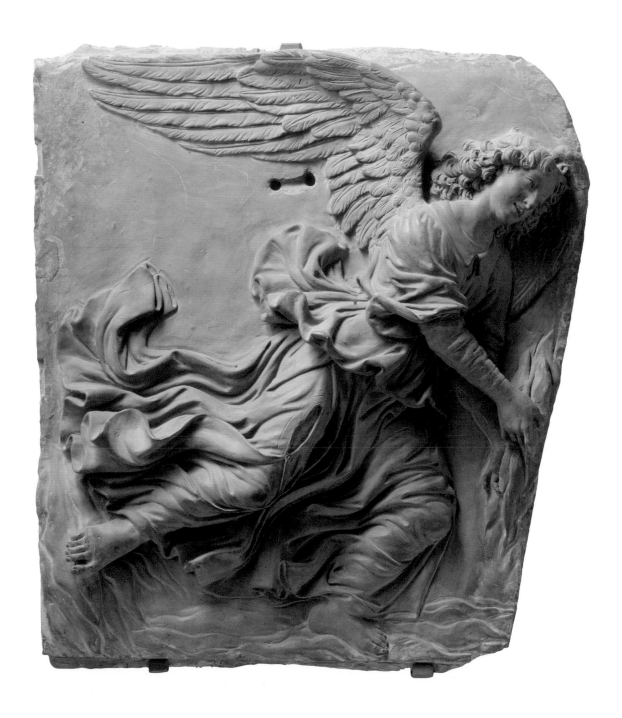

PLATE 16 **Workshop of Andrea del Verrocchio** (Italian, 1435–1488), *Flying Angel*, 1470s, terracotta relief, 14⅛ × 12⅝ inches. Musée du Louvre, Paris, Department of Sculptures, Madame Adolphe Thiers Bequest, TH 33.

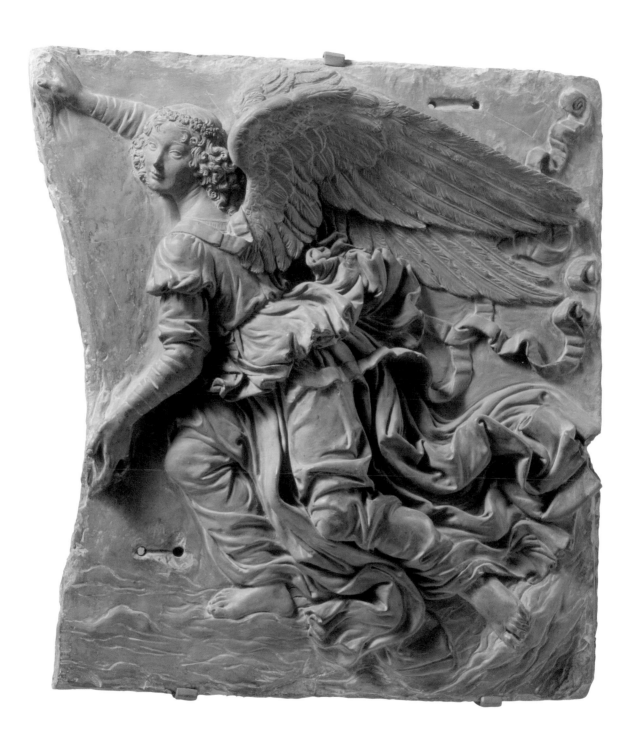

PLATE 17 **Workshop of Andrea del Verrocchio** (Italian, 1435–1488), **possibly Leonardo da Vinci?** (Italian, 1452–1519), *Flying Angel*, 1470s, terracotta relief, 14⅝ × 13⅞ inches. Musée du Louvre, Paris, Department of Sculptures, Madame Adolphe Thiers Bequest, TH 34.

PLATE **18 Leonardo da Vinci** (Italian, 1452–1519), *A Study for a Winged Figure, an Allegory with Fortune*, ca. 1481, pen, brown ink, and brown wash, with lines indented on paper, 9⅞ × 8 inches. The British Museum, London, 1895,0915.482.

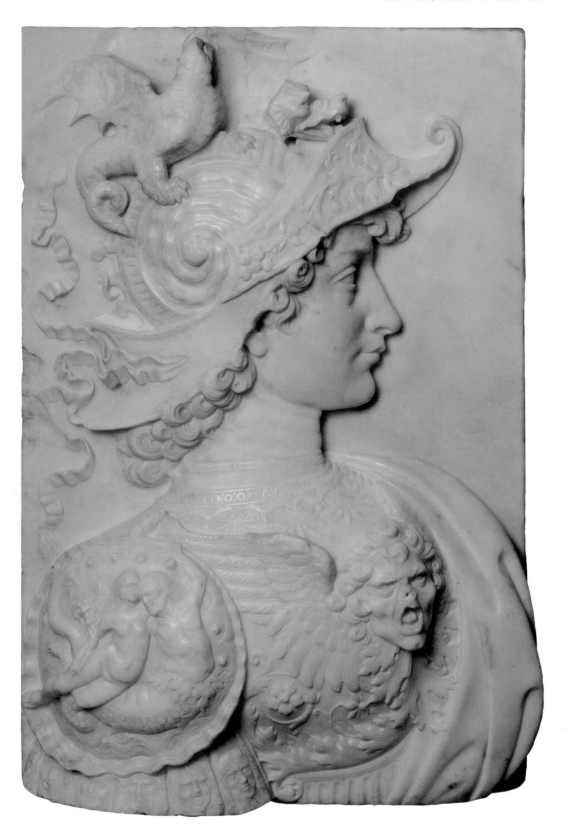

PLATE 19 **After Andrea del Verrocchio** (Italian, 1435–1488), *Alexander the Great*, ca. 1483–1485, marble, 21 × 14½ inches. National Gallery of Art, Washington, Gift of Therese K. Straus, 1956.2.1.

PLATE 20 **Leonardo da Vinci** (Italian, 1452–1519), *Sketches of Dragons* (recto); *Studies for Decorative Armour* (verso), ca. 1478–1480, recto: stylus, black chalk, pen, and ink on paper; verso: stylus, pen, and ink on paper, 6¼ × 9⅝ inches. Royal Library, Windsor Castle, RL 12370 recto and verso.

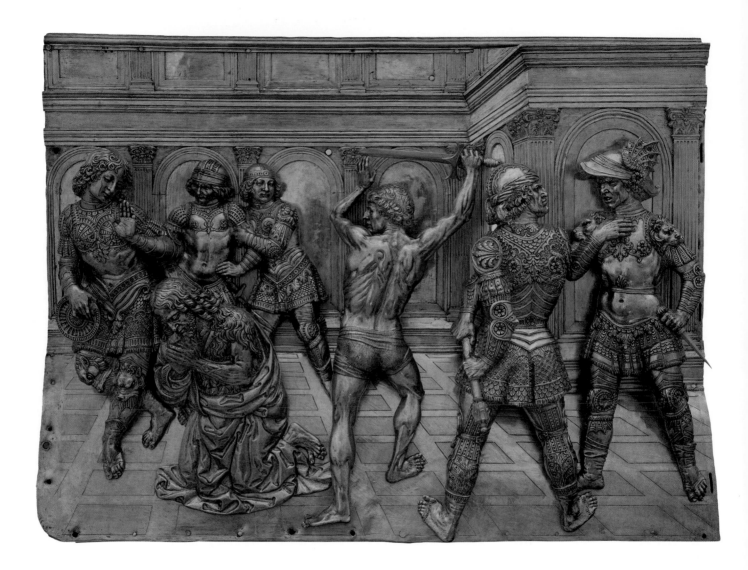

PLATE 21 **Andrea del Verrocchio** (Italian, 1435–1488) and **Leonardo da Vinci**
(Italian, 1452–1519), *Beheading of St. John the Baptist,* from the altar of the Baptistery
with scenes from the life of St. John the Baptist, 1477–1478 (payments until 1483),
silver, 12⅛ × 16½ inches. Museo dell'Opera del Duomo, Florence.

high-cheeked and emaciated like the *Darius* copies and so many of Verrocchio's other figures. Instead, Leonardo suggests lumps and sags of actual skin. His figure's furrowed brow, while deriving from the types of Verrocchio's Goliath (see fig. 10) and the cowering figure in the Careggi *Resurrection* (see fig. 13), is no longer marked by a few expressionistic slashes but fully modeled down to individualized eyebrow hairs. And in one final departure from Verrocchio, Leonardo eschews his master's characteristic corkscrew curls in favor of more softly wavy and natural locks.

## VERROCCHIO, LEONARDO, AND THE *BEHEADING OF THE BAPTIST*

Both Butterfield and Brown have called attention to the visual similarities between Leonardo's *Warrior* and a turbaned officer seen from the rear at the right of Verrocchio's relief of the *Beheading of St. John the Baptist* for the silver altar of the Baptistery in Florence.[81] Did Leonardo inspire Verrocchio? Verrocchio inspire Leonardo? Or, as I argue here, are the similarities due to the fact that both figures were in fact produced by Leonardo?

The recent cleaning of Verrocchio's *Beheading of St. John the Baptist* relief (plate 21) has allowed a detailed examination of its individual components.[82] Two stand out from the others: a youth with a salver at the far left (fig. 19) and the turbaned officer (fig. 20). Unlike the other figures, which are all posed parallel to the relief plane and chased with insistent linearity, the youth and officer are conceived and modeled much more expressively. The youth bends his right leg behind him; the officer reaches his right arm across his chest to his baton. The chasing on both is extraordinary, especially on the officer, whose obsessive detail distinctly recalls Leonardo's *Warrior* drawing. His turban seems to be tied out of actual fabric, his sleeve bends and turns in response to his actions, and his greaves are attached to his legs with perfectly detailed buckles. The youth is only slightly less precisely rendered, and he wears a similarly detailed skirt. His armor and its decoration are multilayered like the officer's.

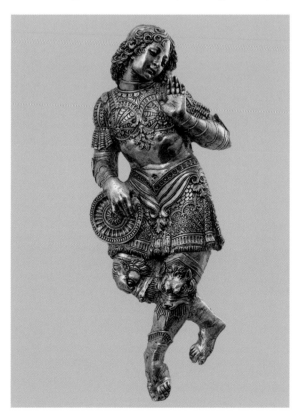

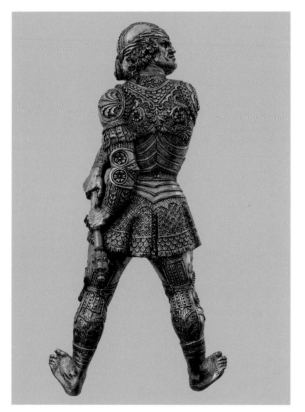

Fig. 19 Leonardo da Vinci, detail of the youth with a salver.

Fig. 20 Leonardo da Vinci, detail of turbaned officer.

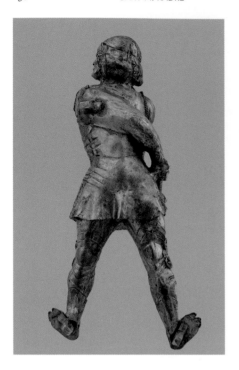  

Fig. 21  Detail of the turbaned officer from the rear.

Fig. 22  Detail of the youth from the rear.

Fig. 23  Detail of the helmeted soldier from the rear.

What is more, the sheets of silver that close off the back of each figure, predictably much more generalized than the front of each figure, bend evocatively to create forms that seem logically to continue from the front (figs. 21 and 22). Each seems to wear an actual garment, and their legs are fully tubular.

The features that these two figures have in common are markedly absent from the rest of the figures in the relief. The backs of the kneeling Baptist and the helmeted soldier at the far right of the relief, for example (fig. 23), are summarily closed off with unexpressive sheets of silver. While the turbaned officer's arm, torso, skirt, and legs remain highly expressive and coherent from the rear, the helmeted soldier is flattened and reduced to a schematic silhouette. A clear set of seams divides the front of the figure from its back, making it evident that the front was conceived in relief, not three dimensions. This is especially true on his head and torso (fig. 24). The head of the turbaned officer, on

the other hand (fig. 25), is fully modeled and more three-dimensional on the rear than the front— that is, on the right side of the figure as we see it in photographs.

The faces of the turbaned officer and the helmeted soldier are rendered differently as well. Consistent with the relief mode of the helmeted soldier, his features are incised and linear, more drawn than modeled. Lines crackle across his face, marking his lips, surrounding his upper lip and the corners of his nose, and etching crow's feet into his taut skin. His eyebrows pulsate in sharp lines. This is a masterful and compelling portrait that relates well to Verrocchio's economical manner of expressing features and emotions (see figs. 10 and 13), but one that is achieved principally through line and incision, not modeling. The face of the turbaned officer, on the other hand, is formed of liquid ropes of skin and muscle—an expressive topography whose pools and eddies catch and diffuse the light in a highly pictorial fashion. This is a face that is modeled, not just delineated.

In profile, seen from the point of view for which they were primarily intended (figs. 26 and 27), the two figures' hair and headdresses are equally

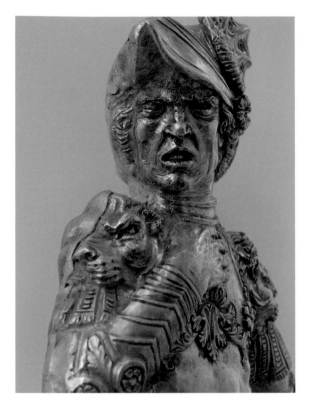

Fig. 24  Detail of the helmeted soldier's face from the side.

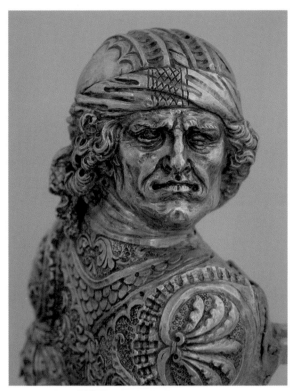

Fig. 25  Detail of the turbaned officer's face from the side.

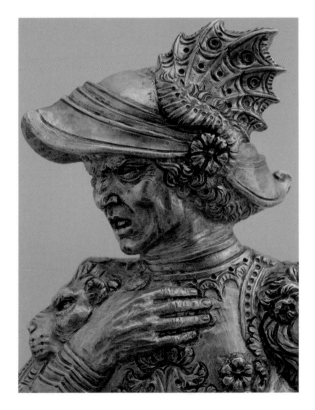

Fig. 26  Detail of the helmeted soldier in profile.

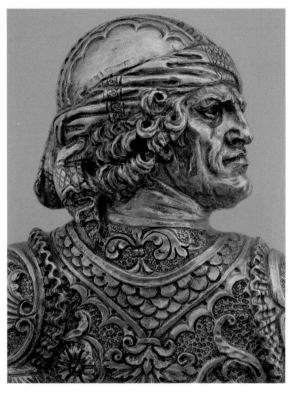

Fig. 27  Detail of the turbaned officer in profile.

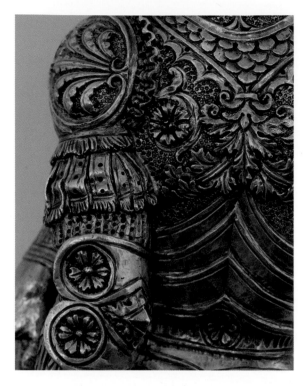

Fig. 28 Detail of the turbaned officer's sleeve.

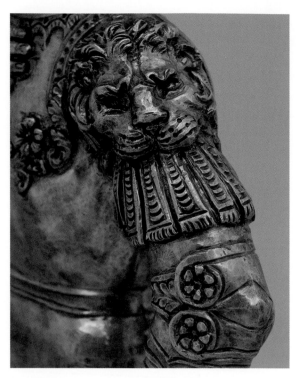

Fig. 29 Detail of the helmeted solider's sleeve.

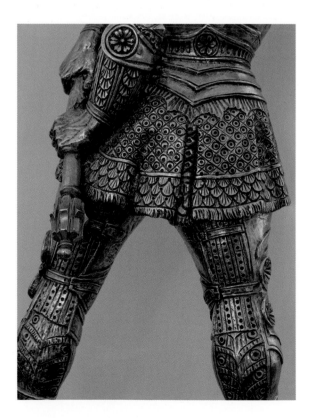

Fig. 30 Detail of the turbaned officer's leg and skirt.

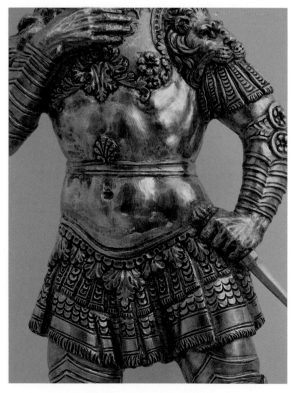

Fig. 31 Detail of the helmeted soldier's torso and skirt.

distinct. Bold lines define the helmeted figure's curly locks, visor, and winged plume, so very different from the manner in which Leonardo rendered similar items in his *Warrior* drawing (see fig. 17). Verrocchio wasted no time making the elements any more illusionistic than they needed to be. The turbaned figure's hair and head covering, on the other hand, betray intense, pictorially evocative observation. The head scarf rolls and bunches, tied into a most believable knot terminating in a fluttering cascade that is fully independent from the nape of the figure's neck, much like the forearm ribbon in Leonardo's *Warrior* drawing. Also, the turbaned figure's hair is slightly disheveled rather than arranged in Verrocchio's typical tight and repetitive curls. Worked thinly, it opens in a few dark holes, perhaps originally filled in but now creating evocative pockets of shadow.

The modeled character of the turbaned officer, on the one hand, and the incised, graphic character of the helmeted soldier, on the other, are equally evident when we examine the rendering of each figure's armor. The tendency toward excavated detail on the helmeted soldier's face reappears around the vegetal decoration that nestles into his breastplate and, much less believably, around his lined fingers, where the smooth surface of the armor is unnaturalistically depressed. On the turbaned figure, instead, vegetal and floral motifs either stand out from or are coterminous with the main plane of the armor. Only tiny round peening breaks the surface, just as it would on actual armor.

Not surprisingly, the maker of the turbaned officer also paid attention to many more naturalistic details than did the author of the helmeted soldier. Contrast the fringed tabs on his sleeve (fig. 28), for example, which bend and move on the turbaned figure like the fringe in Leonardo's drawing (fig. 17) but which are rendered schematically on the helmeted one (fig. 29). Note, too, how the overlapping scale motif at the bottom of the turbaned officer's skirt (fig. 30) runs both consistently and believably along the hem and is rendered with extraordinary— one might even say obsessive—detail for such a

small figure. On the helmeted figure's skirt the scale motif is sensibly more approximate (fig. 31). Until we look closely we hardly notice that the triple rows on the left morph into doubles before concluding in a quadruple row. The maker of the helmeted figure had little time or patience for the fully naturalistic detail seen on the turbaned officer, whose author obviously sat down with actual armor and studied how greaves are buckled onto leggings and how different materials interact with one another.

Significantly, the other figures of the relief are highly consistent with one another and with the helmeted officer and can be confidently assigned to Verrocchio. The kneeling figure of John the Baptist (fig. 32), for example, is conceived and rendered with the same insistent linearity as Verrocchio's Baptist in the Uffizi altarpiece (fig. 33). The arms of both figures seem primarily sinews, veins, and bones; in both, the collarbone and chest are rendered in tight lumps. Significantly, Gaurico later criticized Verrocchio's horse on the Colleoni monument for just these qualities, saying it was crudely realistic and seemingly flayed.[83] Also characteristic

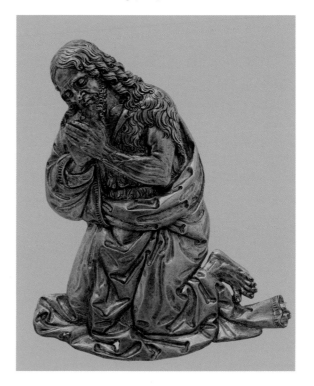

Fig. 32 Detail of the kneeling Baptist.

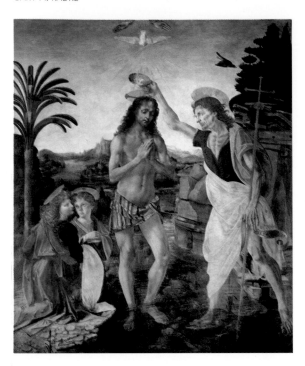

**Fig. 33** Andrea del Verrocchio (Italian, 1435–1488), *The Baptism of Christ*, 1472–1475, oil on wood, 70 × 59 inches, Galleria degli Uffizi, Florence.

of Verrocchio are the kneeling Baptist's high, prominent cheekbones, and the tightly wound strands of beard and long, parallel curls of hair that cascade down his neck, famously evident on the substantially larger figure of Christ at Orsanmichele (see fig. 1) and later on Verrocchio's Forteguerri monument. The silver altar Baptist's drapery also crumples into stylized folds, often hooked at their ends, as in Verrocchio's marbles.[84]

The ropey-muscled executioner at the center of the relief (plate 21) has regularly been praised as one of Verrocchio's masterpieces. Based in but not bound by anatomical observation, the figure was clearly inspired by his rival Antonio del Pollaiuolo's studies of nudes. Figures by both artists stretch the limits of believable anatomical representation. The muscles on the back of the executioner seem eroded out of some primeval corporeal geology. Expression counts more than accuracy. As with other figures by Verrocchio, the executioner's cheeks collapse to reveal high cheekbones, and sharp, quick lines define the wrinkles on his neck, around his mouth, and on his forehead.

The executioner is unique in being chased on both front and back (fig. 34), probably the artist's attempt to ensure the figure's credibility as he stands isolated before the largest amount of free, reflective surface in the entire relief. But the modeling differs from front to back, where the anatomy is nervously scratched into the surface. The executioner's undergarment and leg muscles are more fully defined than his torso, but his bent leg is flattened to fit flush against the background, just as was one of the legs of the helmeted soldier (see fig. 23).

All three figures I have been discussing—the kneeling Baptist, the executioner, and the helmeted soldier—also share a common compositional mode that is typical of many of Verrocchio's works. Even the executioner, whose right leg lunges back into the perspective setting, reads more as a silhouette than as a figure occupying space. Arms held aloft and head in strict profile, he, like the kneeling Baptist and the helmeted soldier, is basically posed across the picture plane rather than into it, much as Verrocchio arranged Christ and the Baptist in his Uffizi Baptism (fig. 33) and his Louvre angel (see plate 16). A similar conception dominates the pair of soldiers in the rear of the relief. They are so uncompromisingly arranged across the picture plane that the artist modeled only three arms, completely dispensing with the far figure's right arm. Once again insistent linearity dominates, perhaps accentuated by workshop execution.

Still, all these figures fit comfortably within Verrocchio's style and mental habits. As we have seen, he used broad surfaces, quickly drawn lines, and sharp incisions to create such remarkably empathetic figures as his head of Goliath. He showed little interest, however, in the kind of meticulous and relentless realism that we have seen on the youth with the salver and the turbaned officer. Verrocchio created the impression of reality much more approximately, often through just a few crucial details: the veins on David's arms, for example (fig. 35), or the quick chisel strokes around the scooped neckline of the *Lady with Primroses'* chemise (see fig. 15). He did not worry about completely describing every detail accurately, even

Fig. 34 Detail of the front of the executioner, from *Beheading of St. John the Baptist* (plate 21).

Fig. 35 Detail of the chasing around the fingers of Verrocchio's *David*, Museo Nazionale del Bargello, Florence.

allowing David's index finger (fig. 35) to submerge into the surface of his cuirass, producing the same sort of surrounding depression that we saw on the helmeted soldier.

In contrast, the youth with the salver and the turbaned officer are so highly and naturalistically rendered, as well as complicatedly posed, that they cannot be by Verrocchio—especially at their near miniature scale. On the other hand, the turbaned officer possesses the same self-awareness and psychological intensity as the warrior in Leonardo's drawing (see fig. 17 again), each manifesting an intelligence apparently gained by years of experience on the battlefield. In the face of the turbaned officer, age is no longer suggested by lines and gaunt sinews, as in Verrocchio's work, but by undulating currents of expressive flesh. Swelling forms over his eyes express concentration; eddies around his mouth mark determination.

This is an approach to human physiognomy that we see in many of Leonardo's studies, which began around this time.[85] Especially comparable to our

figure is the head of an older man (fig. 36), whose overhanging eyebrows and rivulets of jowly flesh describe a figure who is equally noble, expressive, and alert.[86] As is well known, time-ravaged and exaggerated faces were one of Leonardo's obsessions (see plates 38 and 40). Lomazzo reports that Leonardo spoke of having modeled "a fair number of heads of old men," and in an inventory Leonardo made before leaving for Milan around 1482 he recorded studies of many necks and heads of old people.[87] These studies focus on the malleability of human flesh and gave birth to such memorable figures as the screaming warrior for the *Battle of Anghiari* (see fig. 14). As with the turbaned officer on the silver altar, concentric ropes of skin surround his mouth, and his eyebrows swell and roll across his brow.

The youth with a salver (see fig. 20) also owes a clear debt to, but moves well beyond, the example of Verrocchio. His right hand, for example, recalls a stock model that appears frequently in Verrocchio's work. Verrocchio used it both for the hand of the angel holding the container of salve and for Tobias's right hand in his little painting of *Tobias and the Angel* (fig. 37). Neither is completely satisfying from a naturalistic point of view, especially

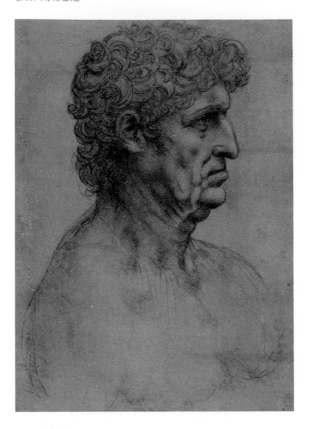

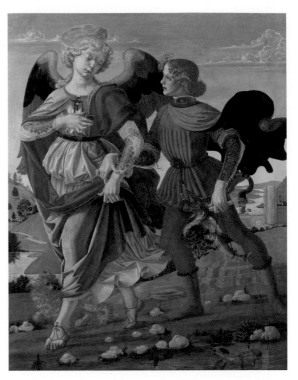

Fig. 36 Leonardo da Vinci, *Bust of a Man in Right Profile*, ca. 1510, red and black chalks on red prepared paper, 8¾ × 6¼ inches, Royal Library, Windsor Castle, RL 12556.

Fig. 37 Andrea del Verrocchio (Italian 1435–1488), *Tobias and the Angel*, 1470–1480, egg tempera on poplar, 33³⁄₁₆ × 20⅛ inches, National Gallery, London, NG781.

Tobias's hand, which hovers almost disembodied over the angel's wrist. The youth in the silver altar relief, on the other hand, holds his salver both elegantly and believably, thumb over the rim, three fingers in the depressed border, pinky steadying it to the side, the same logic that Leonardo applied to the Virgin's right hand thumbing through her book in the Uffizi *Annunciation* (fig. 38). Around 1480 Verrocchio attempted this gesture for the left hand of his figure of St. Thomas (see fig. 1), but fell short in positioning the thumb, which, were it actually holding onto drapery, should have been turned more in profile.

The youth's hair also derives from Verrocchio types, such as the angel in the Tobias panel, but it falls so much more naturalistically, in the manner of the head of Gabriel in Leonardo's Uffizi *Annunciation*. Soft, easy locks—freshly tousled—frame the face of each, while the youth's almond eyes, slightly open mouth, and dreamy look also anticipate the angel of Leonardo's *Virgin of the Rocks* (fig. 39), whose complex pose, tilted head, and preternatural grace inform the youth, too.

If the two silver figures are by Leonardo, then his association with Verrocchio was longer lived than sometimes thought and extended into sculptural as well as painted commissions and in a specific medium for which Verrocchio was well known but which until now has not been recognized among Leonardo's competencies. Given what we learn from surviving documentation, however, this might have been the two artists' last collaboration. Verrocchio participated in the competition for the silver altar reliefs in the summer of 1477, just before Leonardo embarked on an independent career. Preparations could have begun earlier that year. Judging from the speed with which artists usually responded to public competitions, it is likely that news reached the artistic community well in advance of public announcements. A clay model

was ready by 2 August 1477, and the commission for the *Beheading* was awarded to Verrocchio on 13 January 1478, with the unusual stipulation that the work be completed in just slightly over six months (by 20 July 1478). The looming deadline might have encouraged Verrocchio to keep Leonardo in his service, even though the younger artist had just received his first recorded professional commission three days earlier for an altarpiece for the chapel of San Bernardo in the Palazzo della Signoria, which he famously never completed. As it was, the silver relief was complete by December.

Verrocchio's preparatory terracotta model for the executioner survives,[88] and models for precisely the two figures that I have attributed to Leonardo were seen in the collection of the widow of Baron Adolphe de Rothschild in Paris in the early twentieth century.[89] Unfortunately, the two figures were never photographed, but leading scholars found the works so extraordinary that they posited the idea that Verrocchio had left the entire making of the relief to assistants.[90] Our detailed visual analysis rejects such a possibility. Instead, the high quality of the models probably reflected the special care with which Leonardo prepared his contribution to the ensemble—and alerts us to the possibility that

two other sculptures by Leonardo may be waiting to be rediscovered.

A plausible working scenario for the creation of the relief would entail Verrocchio working out preliminary sketches and then assigning two peripheral figures to his most mature and trusted student. Leonardo had, after all, reached his twenty-fifth birthday. Verrocchio would have assigned the rearmost figures—the weakest group—to another collaborator. Verrocchio kept the central figures of the Baptist, the executioner, and the helmeted soldier (which reprised his *Alexander* and *Darius* reliefs) for himself. The collaborating artists would have agreed upon the perspectival setting which gave them a uniform background and made it easier to subdivide the work.

Physical examination of the silver figures shows that they were all worked in repoussé and were not cast, so the clay models served as general guides, not as molds.[91] Later treatises, chief among them Benvenuto Cellini's,[92] suggest that the artists would have followed the general procedure for making a vase, first working a sheet of silver into the general shape of the front of their figures. They would then have filled their half figures with pitch to allow shaping, carving, and the adding of punch detail

**Fig. 38** Leonardo da Vinci, *Annunciation*, 1472–1475, oil on wood, 39⅜ × 85⅜ inches, Galleria degli Uffizi, Florence.

Fig. 39  Leonardo da Vinci, *Virgin of the Rocks*, 1483–1486, oil on panel, transferred onto canvas, 78⅜ × 48 inches, Musée du Louvre, Paris, Department of Paintings, INV 777.

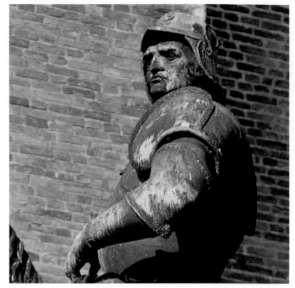

Fig. 40  Detail of the rider's face in Verrocchio's *Equestrian Monument to Bartolomeo Colleoni*, ca. 1483–1488, Campo dei Santi Giovanni e Paolo, Venice. See fig. 96.

to the surface.[93] For many of the figures, they then closed the backs with additional sheets of silver and added some cursory delineation.

The most obvious art historical consequence of assigning the turbaned officer to Leonardo would be to reopen the question of whether Leonardo participated in the creation of the Colleoni monument (see fig. 96).[94] The commission came in April 1480, before Leonardo left for Milan and began his own enormous equestrian project. A drawing by Leonardo of a male face in profile (plate 40) does bear a distinct resemblance to Verrocchio's Colleoni,[95] but here I think the proper interpretation is that both artists may have been sharing a model. Colleoni's face (fig. 40) marks a radical departure from Verrocchio's earlier, bonier, sinewy figures, but, like the

head of Goliath, its power derives from broad surfaces and expressionistic lines, gashes, and quickly rendered form, not the more detailed and fluid pictorial forms of Leonardo. Colleoni's helmet also has more in common with the *Alexander* and *Darius* reliefs and the figure at the far right in the Baptistery's silver altar relief than with Leonardo's *Warrior* drawing. Thus, while the turbaned officer and the helmeted soldier in the silver altar may add another example of a stare-off between Leonardo and Verrocchio,[96] we are left with a clear sense that both men were excellent students as well as fine teachers.

## ON TO MILAN

By the time Leonardo left Florence for Milan, he and Verrocchio had become colleagues, not just rivals. His emergence as an independent sculptor seems to have been rather slow, or at least kept in check by Verrocchio until Leonardo was well into his twenties. Remaining in Verrocchio's shop for a decade introduced him to a wide range of sculptural as well as other projects, and gave him a thorough grounding in their creation. He had experience with figural, relief, and decorative sculpture in bronze, clay, and silver, as well as marble. Besides

working on the projects we have already discussed in this essay, he must have been part of the team that helped Verrocchio to produce and place the enormous bronze orb on the lantern of Florence Cathedral (1468–1471), and he was still living with Verrocchio when his master won the commission for the marble Forteguerri monument in 1476 (though carving did not begin until 1481). If Vasari is correct, Verrocchio also made silver apostles for the altar of the Sistine Chapel and other silverwork, wooden crucifixes, works in terracotta, and "a head of St. Jerome, which is considered marvelous," not to mention a mechanical putto for the clock of the Mercato Nuovo. Verrocchio's brother's inventory of the shop also included reliefs, painted masks, and an ancient red stone *Marsyas*.[97] When Leonardo drafted a letter to Ludovico Sforza in 1481–1482 including the statement that he could "carry out sculpture in marble, bronze, or clay," he sounds as though he was being modest, but the rest of the sentence, which is too often associated only with his skills as a painter, came very close to the truth: "... and also I can do ... whatever may be done, as well as any other, be he whom he may."[98]

## NOTES

1. Weil-Garris Brandt 1989.

2. Pedretti "A Proem" 1989, pp. 11–39; Kemp 1999, pp. 237–262, which, unfortunately, does not contain illustrations; Marani and Fiorio 2007; and essays by Marani and Kemp in this catalogue.

3. Here and throughout this essay I follow and express my gratitude to Carmen Bambach for the extraordinarily careful catalogue entries in *Leonardo da Vinci* 2003, esp. pp. 110 and 283–284.

4. Christiansen 1990, p. 572, indicates that in Book 24 of his treatise, Filarete offers the first documented recommendation to draw from stiffened cloth, though the practice probably dates back to the 1420s. In general, see Viatte 2003, pp. 110–119. Cadogan 1983, pp. 27–62, offers a radically revised series of attributions, retaining Louvre 2256 as a work by Leonardo but attributing Uffizi 422E to Verrocchio.

5. Vasari 1991, p. 285. For the Italian text, see Vasari 1906, p. 20.

6. Prominent among the supporters of an attribution to Verrocchio are Passavant 1969, pp. 59–60 and 193; Cadogan 1983, pp. 40–42; Butterfield 1997, p. 76, who, however, does not provide a detailed rationale for accepting the attribution; and Christiansen 1990, p. 573.

7. See Butterfield 1997, pp. 209–212, for an exhaustive summary of the documentation.

8. See Bearzi 1950, pp. 119–123, and Dolcini 1988, pp. 64–66.

9. Cennini 1933, pp. 123–131.

10. Fusco 1982, pp. 175–194.

11. See the incisive observations in Weil-Garris Brandt 1989, pp. 21–26. Brown 1998, p. 50, sees the repetition of certain hand types as highly indicative of Verrocchio having casts or models of hands in the workshop that were studied and shared by him and his assistants.

12. English translation in Kwakkelstein 1999, p. 183. See Italian original in Pedretti 1957, pp. 62–67, esp. p. 63 "... della Plastica, della quale per che io sempre mi sono dilettato, & mi diletto, si come fanno fede diuersi miei cavalli intieri, & gambe, & teste, & ancora teste humane di Nostre Donne, & Christi fanciulli intieri, & in pezzi, & teste di vecchi in buon numero." See also Pedretti 1977, vol. 1, pp. 76–79, with English translation.

13. As cited in Kwakkelstein 1999, p. 183.

14. Kwakkelstein 1999, pp. 183–184

15. "... la pittura viene ad essere zia della scoltura, & sorella della Plastica," Lomazzo 1957, p. 159.

16. Lomazzo 1957, p. 159; Pedretti 1957, p. 63, "non è altro che vna imitatione faticosa della Plastica."

17. See the important corrective to this point of view in Martin Kemp's essay in this catalogue.

18. He may have taken some comfort, then, in Pomponio Gaurico's observation that the ancients distinguished between *sculptores*, marble carvers, and *sculptores*, those who worked in metal— that is, artists who first modeled in wax or clay and then realized those ideas in bronze. See Gaurico 1999, pp. 146–148.

19. RL 12328r, "fanne un picholo di cera lungho un dito."

20. Museo Archeologico, Florence, inv. 2249 and 2250.

21. Cunnally 1993, pp. 67–78.

22. See especially Clark 1969, pp. 1–34.

23. Allison 1974, pp. 375–384; Kemp and Smart 1980, pp. 182–193; and Marani 1995, pp. 207–225, and his essay in this catalogue. See also Pedretti 1991, pp. 214–244.

24. *Codex Altanticus*, 399r, "L'imitazione delle cose antiche è più laudabile che le moderne." Villata 1999, p. 70.

25. *Codex Atlanticus*, 399r, "di quell di Pavia si lalda più il movimento che nessun'altra cosa." Villata 1999, p. 70.

26. See Marani's essay in this catalogue.

27. Pedretti *I cavalli* 1984, p. 38, and Pedretti and Roberts 1977, pp. 396–409. The barking dog that is revealed under ultraviolet light can be associated directly with a similar figure in the background of the altarpiece.

28. Elam "Il Giardino" 1992, pp. 159–170, esp. p. 167, a condensed version of Elam "Lorenzo" 1992. See also Fusco and Corti 2006, p. 253, n. 53.

29. See Fusco and Corti 2006, p. 367, doc. 264.

30. Naples, Museo Nazionale Archeo-logico, inv. 4887. Regarding the casting of these works, see Borrelli 1992, pp. 67–82, and Formigli 1992, pp. 83–90. For the relationship to Leonardo, see *Leonardo e il leonardismo* 1983, pp. 136–137, and Caglioti 2003.

31. Draper 1992, p. 3, notes the difficulty of establishing his birthdate.

32. Draper 1992, pp. 133–145.

33. I follow Draper 1992, pp. 143–144.

34. Venice, Gallerie dell'Accademia 215. *Leonardo da Vinci* 2003, pp. 479–485.

35. Bambach in *Leonardo da Vinci* 2003, p. 552, has noted the similarities of the knife-wielding figure at the far left of Bertoldo's composition with some Herculean studies by Leonardo, especially Biblioteca Reale, Turin, 15577.

36. Draper 1992, pp. 176–185.

37. Draper 1992, pp. 79–106.

38. See also RL 12700r and v.

39. *Codex Madrid II*, fol. 141.

40. *Codex Madrid II*, 45v. I am grateful to Daniel Staylor for calling this text to my attention.

41. I am grateful to Alan Stahl for discussing these matters with me. See Stahl 2000.

42. Vasari 1991, p. 56: "Although Donatello lived in their period [the second], I could not decide whether or not to place him among the third group of artists, since his works are comparable to excellent ancient ones."

43. Janson 1963, pp. 33–41.

44. *Leonardo da Vinci* 2003, pp. 331–333.

45. Leonardo da Vinci, *Studies for the Adoration of the Magi* (recto), pen and brown ink over stylus, 7⅛ × 10⅜ inches, Bibliothèque de l'Ecole Nationale Supérieure des Beaux-Arts, Paris, 424.

46. Weil-Garris Brandt 1989, pp. 26–31.

47. *Leonardo da Vinci* 2003, pp. 336–338. The British Museum, London, 1952-10-11-2.

48. See Weil-Garris Brandt 1989, esp. pp. 20 and 29–30, for Leonardo's response to both Desiderio and Antonio Rossellino. Two scholars have even mistakenly attributed works that are by Desiderio to Leonardo. See Valentiner 1932, pp. 53–61, and Parronchi 1989, pp. 40–67, recently reprinted as a chapter in Parronchi 2005.

49. Luchs 2007, pp. 160–175, esp. pp. 168–171.

50. Vasari 1991, p. 285.

51. See also fig. 49 (Windsor 12567), showing a similar child from front and rear.

52. There is no firm documentation, but since his grandfather who had been taking responsibility for bringing him up in Vinci died in 1464, Leonardo is likely to have moved to Florence around that time.

53. For a useful overview of Verrocchio's principal commissions in this period and the character of his shop, see Butterfield 1997, pp. 1–7.

54. Butterfield 1997, p. 2.

55. Famously and incorrectly, Vasari claims that Verrocchio gave up painting after he saw Leonardo's angel in his *Baptism of Christ* (Vasari 1991, p. 287). In fact, Verrocchio's activity in this arena remained undiminished.

56. Vasari 1991, p. 232.

57. See the extensive study of their relationship in Windt 2003.

58. See Brown 2003, pp. 55–59.

59. Radke 2003, pp. 35–53.

60. The work is inscribed with the dates May and June 1468. See Butterfield 1997, pp. 81–82 and 212–213.

61. See also RL 12690r.

62. Butterfield 1997, pp. 56–80 and 209–212.

63. See Butterfield 1997, pp. 76–77, for an excellent analysis of the differences in the drapery styles without speculating upon the reasons for the change.

64. See Weil-Garris Brandt 1989, p. 28. Around 1495–1497 Leonardo expressed interest in creating a set of bronze doors for Piacenza Cathedral, telling the commissioners that their city, like Florence, was a place visited by many foreigners who would be impressed by beautiful works that should be made in bronze instead of wood. See *Codex Atlanticus*, 887r and v, in Villata 1999, p. 105.

65. Brown 1998, pp. 58–67. He also makes some intriguing comparisons with the problematic *lavamano* in San Lorenzo, which Butterfield 1997, pp. 9–12, more compellingly attributes largely to Antonio Rossellino, whose example would certainly have intrigued Leonardo.

66. See the summary of opinions in Butterfield 1997, p. 214. The suggested dating of the relief has vacillated greatly from the early 1460s through the late 1470s. I here follow Butterfield on stylistic grounds but call attention to Michael Rohlmann's appealing thesis that the relief originally capped Rogier van der Weyden's *Entombment* of the early 1460s in the Medici villa and therefore might date earlier. See Rohlmann 2008, pp. 94–97.

67. Budapest 1775. *Leonardo da Vinci* 2003, pp. 505–508.

68. Kunsthalle, Hamburg, inv. no. 21487, illustrated in Brown 1998, p. 96, fig. 84.

69. Butterfield 1997, p. 214.

70. Vasari 1991, p. 287.

71. Ibid., p. 290.

72. Butterfield 1997, pp. 90–103.

73. Brown 2003, pp. 101–121. See also Weil-Garris Brandt 1989, pp. 15–18, for a consideration of how Leonardo trumps the sculptor by portraying porphyry on the back of the portrait.

74. Passavant 1969, p. 31. See also Butterfield 1997, pp. 154 and 228–229, who believes that the right angel is too weak to be Leonardo's work. Gaborit, as cited in Boucher 2001, p. 130, suggested that Verrocchio himself might have been creating a deliberately contrasting pair and that therefore the two pieces are not by different hands, an opinion shared by Marc Bormond in Bresc 2006, p. 204.

75. See, for example, the clouds and curiously unforeshortened dove that he designed for the tabernacle of the Chapel of St. Luke in Santa Maria Nuova in 1477 (Butterfield 1997, fig. 160), and the little footstools of cloud under the angels' feet in his clay sketch for the Forteguerri monument (Butterfield 1997, fig. 182).

76. Boucher 2001, p. 130, suggests Lorenzo di Credi.

77. The British Museum 1895-9-15-482; *Leonardo da Vinci* 2003, pp. 338–341.

78. Brown 2003, pp. 68–73, and Butterfield 1997, pp. 156–157 and 230–232.

79. Vasari 1991, p. 288.

80. See a version from the Museu Nacional de Art Antiga, Lisbon (Brown 2003, fig. 61), and a lost variant from the Kaiser-Friedrich Museum, Berlin (Butterfield 1997, fig. 207).

81. Butterfield 1997, p. 157, and Brown 2003, p. 73.

82. For the most comprehensive examination prior to the restoration, see Butterfield 1997, pp. 104–125 and 218–220. See also the fundamental study by Günter Passavant in Passavant 1966, pp. 10–23.

83. Gaurico 1999, p. 224: "ille enim, ita ut aiunt, cruditer equum imitatus est, ut non aliud quam denudati equi facies videatur."

84. See the figure of the seated Christ, for example, in Butterfield 1997, fig. 198.

85. See, for example, RL 12276v, a page of comparative studies including an old man seen in profile. The most comprehensive study of this subject is Kwakkelstein 1994.

86. RL 12556. See also Leonardo's *Leonine Head*, RL 12502, and the *Head of a Hero*, Biblioteca Reale, Turin, 15575.

87. "Molte gole di vecchie. Molte teste di vecchi." Villata 1999, p. 15.

88. Radcliffe 1992, pp. 117–123, and Butterfield 1997, p. 220.

89. Butterfield 1997, p. 219.

90. Radcliffe 1992, pp. 122–123, continues to subscribe to this view.

91. Radcliffe 1992, pp. 118–120, reports that Foresi said that the models for the youth and turbaned figure were 17 centimeters tall, slightly smaller than the silver figures. The terracotta model for the executioner, on the other hand, is between three and five percent larger than the finished work.

92. Cellini 1967, esp. pp. 84–88.

93. Cellini 1967, pp. 91–95, also describes procedures for making life-size figures and larger in silver, one method requiring gesso molds and working from bronze matrices, the other traditional repoussé, which he favored. Pieces could be soldered together after fashioning.

94. Butterfield 1997, pp. 158–183 and 232–236.

95. Metropolitan Museum 1909.10.45.1. First noted by Bambach in *Leonardo da Vinci* 2003, pp. 418–419.

96. The most famous being the two angels at the left of Verrocchio's Uffizi *Baptism*.

97. Usefully summarized by Butterfield 1997, p. 6.

98. *Codex Atlanticus*, fol. 1082: "Item conducerò in sculptura di marmore, di bronzo e di terra . . . ciò che si possa fare ad paragone de omni altro, et sia chi vole," in Villata 1999, p. 17.

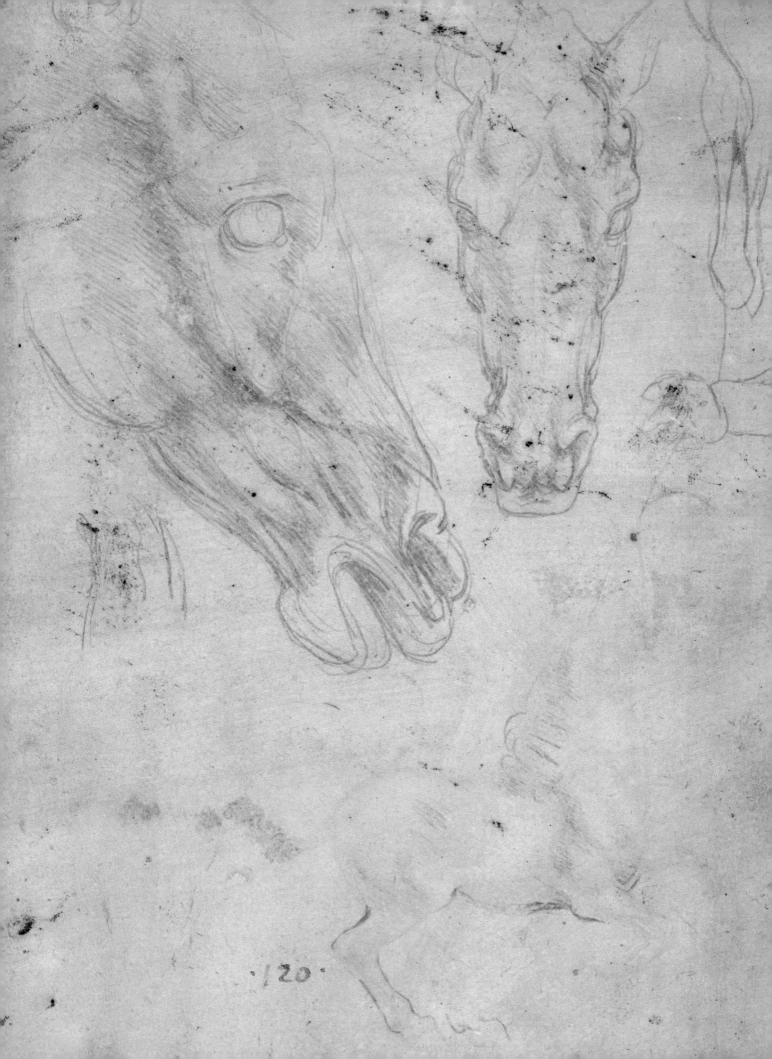

·120·

MARTIN KEMP

# What is Good about Sculpture?
## *Leonardo's* Paragone *Revisited*

Leonardo was one of the greatest visualizers of forms and space in three dimensions. He stands alongside Michelangelo and Bernini among sculptors, and with Kepler and Einstein among scientists. Like them, he could manipulate forms and space within his mind as a form of mental sculpture of the most fluid and plastic kind. Yet, in his *Paragone*, the comparison of the arts that opens the *Treatise on Painting* as assembled by his pupil Francesco Melzi, he is systematically dismissive of sculpture, the most plastic of arts.[1] Even poetry and music, the other main targets of Leonardo's verbal missiles, were not subject to such relentless bombardments. When we realize that he applied himself "to sculpture no less than painting, and practised both to the same degree," the paradox is compounded.[2]

In this essay I intend to resolve this paradox, insofar as it can be resolved. I will first justify the claim that Leonardo was a great plastic visualizer, and then look at the *Paragone* passages to see if we can extract what he thought was *good* about sculpture. Finally, we might be able to identify personal reasons why it might have been expedient for him to downgrade sculpture in his public pronouncements.

## FORMS IN SPACE AND TIME

Setting Leonardo beside the great astronomer Johannes Kepler is a good place to start, not least because Kepler's greatest visual creation, his image of the planetary system as a piece of geometrical engineering (fig. 41) is dependent upon a graphic, perspectival invention by Leonardo.

In striving to make the so-called Platonic solids and their derivatives tangible for readers of Luca Pacioli's *De divina proportione* (*On Divine Proportion*), Leonardo invented a novel method of portraying solid geometry. Produced in manuscript form in Milan in 1498 and printed in 1509, the Franciscan mathematician's treatise looked at the five regular polyhedra as the fundamental building blocks of the universe, following Plato in the *Timaeus*.[3] He also worked variations on the forms by truncating their corners or vertices, following

Archimedes, and built "prisms" or pyramids on their faces to provide stellated versions.

As presented in Euclid's *Elements*, the main source for Pacioli, the five basic forms are tricky to visualize for those without special skills and knowledge, and the variant forms devised by Archimedes are very difficult to grasp. The line diagrams of a standard kind that Pacioli had earlier used to illustrate three-dimensional geometry provided strictly limited help. Leonardo not only devised a way of showing them in perspective as sculptural bodies modeled in light and shade, probably using a drawing device, but also produced see-through versions—called *vacuus* in the Latin captions—in which each of the faces is "fenestrated," as if a framed window (fig. 42).[4] The skeletal versions allow us to see the full three-dimensional form of the body, so that we understand the configuration of the back as well as the front. It is clear from his sketches of such bodies that he could readily manipulate the forms in his mind, turning them, slicing off their corners, and building prisms on their faces. The drawings take part in a feedback loop with his mental images.

Fig. 42 *Truncated and Stellated Dodecahedron*, from Luca Pacioli, *De divina proportione*, Paganino di Paganini, Venice, 1509, p. xxxiiii, Victoria and Albert Museum, London.

We can grasp the nature of his skill by setting ourselves a task. If we take a cube (a hexahedron) and truncate its corners to the point at which the cut planes meet, what shape will remain? The answer is given in the endnote.[5]

This process of geometrical sculpting was closely related to the geometrical study of "transformation"—that is to say, the reshaping of a geometrical body of a given volume or mass into an alternative geometrical solid. It involved, as Leonardo said, the change of "one body into another without subtraction or addition of material."[6] On 12 July 1505, Leonardo signaled his own plan to write a treatise on the subject, partly in emulation of Giorgio Valla, whose two-volume mathematical compendium with the enigmatic title *De expetendis et fugiendis rebus* had been published in Venice in 1501. Valla died in the year that Leonardo visited Venice, but such was his reputation, not least as an expert on the ancient Roman architect Vitruvius, that Leonardo could hardly have failed to be aware of his achievements. Among the comprehensive range of mathematical procedures explicated by Valla, Leonardo was particularly drawn to a series of geometrical conundrums—*ludi mathematici*

Fig. 41 Johannes Kepler, *Folding Plate of the Geometrical Model of the Cosmos* from *Mysterium Cosmographicum*, Gruppenbach, Tubingen, 1596–1597.

(mathematical recreations), as he called them—which treated equivalences of areas and volumes. Indeed, the "games" came to be something of an obsession for him. They were locked into the ancient problem of squaring the circle—that is to say, finding a square precisely equivalent in area to a given circle—and the even more vexing question of finding a cube equal in volume to a sphere. Alongside Valla's encyclopedic book, Leonardo's library contained a treatise on "the squaring of the circle"[7] by an unlisted author. It is either Archimedes's *De mensura circuli* (*On the Measurement of the Circle*) or one of the many derivative treatises from the Middle Ages. Leonardo's three-dimensional transformations are richly represented in the *Codex Arundel* in the British Library and in the first of the *Forster Codices* in the Victoria and Albert Museum.[8]

Among the tasks Leonardo set himself was the systematic transformation of the four other regular bodies into a cube (fig. 43).[9] Looking at how he tackled such problems, they seem to be more about the manipulation of malleable materials than exercises in arcanely abstract mathematics. He says at one point that "geometry extends to the transmutation of metallic bodies which are materially suitable to be extended and shortened according to the needs of their manipulators."[10] There was always a physical reality to geometry for Leonardo, even at the conceptual stage when it existed his mind. This sense of the reality of geometry was not unique to Leonardo. The Archimedean issues of calculating volumes fed directly into the real world of mercantile mathematics. Judging the volume of a barrel of wine or a bale of wool was both a vernacular skill vital to trade and a mathematical problem. We should not be surprised to find Kepler publishing a treatise on the *New Stereometry of Wine Barrels* (*Nova stereometria doliorum vinariorum*) in 1615.

Leonardo's graphic techniques were widely adapted in representations of the polyhedra and their derivatives, whether they were illustrations for books on artistic perspective or figures in geometrical treatises. But no one put Leonardo's fenestrated technique to more spectacular use than

Kepler in the great folding plate in his *Mysterium cosmographicum* (*The Mystery of Cosmography*) of 1596–1597.[11] Kepler had discovered through a process of improvising geometrical diagrams that the ratios of the orbits of the planets in the heliocentric system of Copernicus could be modeled on the successive nesting of the Platonic solids inscribed in spheres. For a Platonist like Kepler, committed to the mathematical ideal behind natural design, this scheme represented a higher, divine reality than natural appearance. But it was also to be realized in material reality. His unrealized plan was to construct his Platonic cosmos as a giant clockwork machine—as a magnificent piece of cosmographical sculpture. As a great courtly device, it would have exceeded the ten-foot-high Ptolemaic armillary sphere made in 1588–1593 by Antonio Santucci for the Medici in Florence.[12] Such magnificent pieces of intellectual furniture stood alongside the products of the great sculptors, both physically and conceptually.

The spatial and sculptural vision that is expressed in its purest form in Leonardo's three-dimensional

Fig. 43 Leonardo da Vinci, *Sectioning and Cubing of a Dodecahedron*, *Codex Forster I*, 7r, 1487–1505, pen and ink on paper, 5¾ × 4½ inches, Victoria and Albert Museum, London.

Fig. 44  Leonardo da Vinci, *Design for a Centralized Temple in Plan and Solid Section*, pen and ink over silverpoint on blue prepared paper, 7⅞ × 11 inches, photographed with ultraviolet light, Royal Library, Windsor Castle, RL 12609 verso.

geometry found tangible expression in his ways of thinking about architecture. He saw buildings not as aggregates of plans and elevations, but as forms that stood sculpturally in space and plastically shaped the spaces within them. This is most apparent in the series of centralized "temples" that he planned around 1480 as an amazingly fertile series of permutations of a few basic geometrical figures. They are expressed not only in ground plans (with almost no orthodox elevations) but also as solid forms viewed as models that can be inspected from any angle. He also uses cut-through versions so that the "solid" form of the space that is modeled by the interior (fig. 44) can be seen.[13] The visual and conceptual effect of this interior "solid" is much like the sculptor's mold in which the outer shell is the negative of the form to be cast. The interior space in effect becomes a sculpture cast in air rather than bronze. Leonardo would have experienced just this sense of negative and positive shapes at an early age when a cast was opened in Verrocchio's workshop to disclose the bronze form within. Although we have no buildings by Leonardo himself in which

to feel the effect of this plastic vision, it exercised a profound impact on Donato Bramante. Anyone who has gloried in the mighty interplay of mass and space at the domed crossing of St. Peter's Basilica in Rome is a beneficiary of Leonardo's influence on his close colleague.

The same visual proclivities are at work when Leonardo comes to tackle the "dome" of the human cranium. A series of skull studies from 1489 uses a variety of sectioning techniques not only to reveal the inner structures of the house of the brain but also to clarify its geometrical proportions (fig. 45).[14] The central point of the skull is literally its nerve center, where the nerves transmitting the five senses all converge on the *sensus communis* (literally the "common sense"). In an innovative series of sectional and transparent demonstrations he envisioned the cerebral structures that contain all our mental faculties (see plate 28 recto). The skull is understood both as a complex plastic form that needs to be seen from a variety of angles, and as a shaped interior within which the highest functions of the human

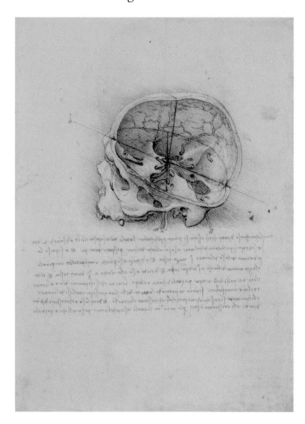

Fig. 45  Leonardo da Vinci, *Sectioned Skull*, 1489, pen and ink over traces of black chalk, 7½ × 5⅜ inches, Royal Library, Windsor Castle, RL 19058.

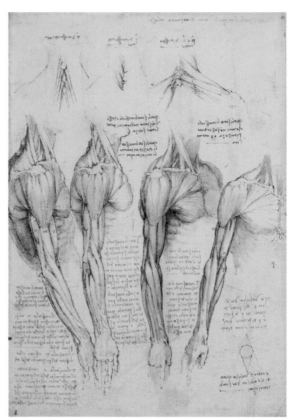

organism are performed in a protected and orderly manner.

Understanding the configuration of the human body is, not least, a sculptural task. How the exterior contours follow their concave and convex courses, how parts fit together, and how one thing lies above or below another all require a firm visual grip on forms interwoven in space. At various points in his work as an anatomist, Leonardo tried to reduce the viewpoints from which the body was surveyed to two or, at most, four—from the front and back, or from four views set at right angles to each other. He emphasized that a solid body could be reduced to "two half figures" and that a frontal and rear view would not leave any part unrepresented.[15] However, he repeatedly discovered that the complexities of organic form meant that intermediate views were needed, as well as views that were not all in the same plane. A certain feature emerged clearly from one angle and was largely lost from another, however skilled the draftsmanship. Looking at the foot and ankle, he allowed that at least six

Fig. 46 Leonardo da Vinci, *Muscles of the Arm in Rotated Views*, 1510–1511, pen and ink on white paper, 11⅜ × 11¾₆ inches, Royal Library, Windsor Castle, RL 19005v.

Fig. 47 Leonardo da Vinci, *Muscles of the Right Arm, Shoulder, and Chest*, ca. 1510–1511, pen and ink on paper, 11⅜ × 11¾₆ inches, Royal Library, Windsor Castle, RL 19008v.

views would be necessary to convey all the plastic information.[16]

Perhaps the most striking example of the multiplication of viewpoints for sculptural completeness is the series of no less than eight rotating shoulders on two sheets at Windsor (figs. 46–47). As the form turns, we watch as muscles swell and diminish, emerge and disappear, all fitting snugly together in a complex array of related shapes. The small star diagram in the lower right corner explains the principle at work. Schematizing the seen object as a sphere or cylinder, he outlines the method behind the successive viewpoints, showing the points of the "visual pyramids" from which the eye is looking. The diagram is a simplified version of an

earlier demonstration of visual pyramids based on a textbook of medieval optics by the British Franciscan John Pecham.[17] The principle is that light emanates everywhere in space in straight lines in all directions from an illuminated object. From any given position in relation to the object, the pupil is designed to gather the appropriate rays from a body to a point, actual or notional, within the eye. The angle that the rays subtend at the eye registers the relative size of the object. Thus, the farther away the eye moves from an object, the smaller the angle becomes and the more diminished in size the object appears.

The effect of the shoulders, drawn from the same close distance from the eight successive viewpoints, is what we might call a cinematographic sequence of views. As Leonardo explains, "If you wish to understand the parts of an anatomized man, you turn either him or your eye through all the various positions . . . turning him around and searching for the origins of each member."[18] This turning is, of course, a continuous process, not restricted to two, four, six, or even eight views. It is as if we have a small bronze statuette in our hands and are turning it to appreciate the nuanced modeling of the form and ever-changing contours, or as if we are walking around a fountain at the center of which is a sculpted figure designed to make a good effect from every angle. This was exactly the sculptural culture within which Leonardo grew to maturity as an artist. Verrocchio's bronze *Putto with a Dolphin*, sculpted for the garden of the Medici villa at Careggi (fig. 48), perfectly exemplifies the way in which Leonardo's master had pioneered the all-around view and what was later called the *figura serpentinata*—the serpentine or twisting figure that negates a single, frontal viewpoint.

Leonardo developed this vision of "serpentine" motion into a specific concept of space, what he called *quantità continua*. The argument came from the philosophy of mathematics. The basic elements of form, as Leon Battista Alberti had noted at the beginning of his *De pictura / Della pittura* (1435–1436), were point, line, plane (or surface), and

solid.[19] Only the solid had tangible existence, since the others all lacked the third dimension. Points, lines, and planes could be drawn on paper, but they only existed mathematically as concepts. A geometrical point has no dimensions at all. Since space could be viewed in terms of a series of points, there must therefore be an infinity of points in any given space. This means that a mobile body, whether moving relative to the space in which it is located or moving its parts, traverses an infinite number of positions, all of which are continuous and indivisible. This is the province of geometry, rather than arithmetic, which deals with discrete numbers, in his definition:

> Those sciences are termed mathematical which, passing through the senses, are certain to the highest degree, and these are only two in number. The first is arithmetic and the second geometry, one dealing with discontinuous quantity and the other with continuous quantity.[20]

He seems to have regarded numbers, with their discontinuous nature, as rather plodding, separate kinds of things, compared to the plastic continuities

Fig. 48  Andrea del Verrocchio (Italian, 1435–1488), *Putto with a Dolphin*, ca. 1479, bronze, 26⅜ inches high, Palazzo Vecchio, Florence.

WHAT IS GOOD ABOUT SCULPTURE?

of geometry. He was particularly taken with geometrical proportions that could not be expressed in numbers, such as the "divine" or "golden" section that lay at the heart of Pacioli's book. It is also characteristic that he should see mathematics as necessarily "passing through the senses" rather than being purely conceptual.

Thinking about the nature of point and line, Leonardo drew a nice analogy between space and time:

> A line is made by the movement of a point. A surface is made by the movement of a line that travels in straight lines. The point in time is to be compared with an instant, and the line represents time with its length.[21]

The implication, though he does not specifically draw it out, is that viewing a solid form is a temporal process of a continuous kind, since it involves successive transitions of viewpoints in space. Thus, the eight views of the shoulder constitute a drawn demonstration that embodies time in an utterly new way.

Leonardo realized that the painter who wishes to portray a form in motion must necessarily select some intermediate point from the infinite range of possibilities at which to "freeze" its dynamic transit. He would choose the point that provided the best effect for his purposes. The frenetic tangle of combatants in the *Battle of Anghiari* (see plate 47) in one sense presents itself as just such an arbitrary "frozen instant," but is actually an elaborate compound of poses selected to tell the story most effectively—the upraised swords, the biting and rearing horses, the grappling foot soldiers, and so on. We would not expect a snapshot to produce such telling visual conjunctions of perfect instants. As in the *Last Supper*, instants from time within the narrative are compressed into the field of the painting, to become visible, as he stressed, in an instantaneous glance, in what might be called a kind of synthetic instant.

Leonardo's special vision of the fluidity of forms in space with respect to the local motions of their parts, their overall locomotion, and the potentially infinite locations for the viewing eye is at once profoundly sculptural in its basic intuitions and deeply mathematical in its conceptual framework. No one had brought together these worlds of material plasticity and abstract concepts in the same way.

## THE *PARAGONE* AND THE QUALITIES OF SCULPTURE

What we now call Leonardo's *Paragone*—the comparison of the arts of painting, sculpture, poetry, and music—occupies the first section of the *Trattato della pittura* (*Treatise on Painting*), compiled by his most devoted pupil and assistant, Francesco Melzi, the son of a noble Lombard family. Many of the original manuscript passages are now lost, but it is clear from those that survive and other related notes that Leonardo embarked on the exercise while he was at the Sforza court in Milan between ca. 1492 and 1499, and that he continued to add supplementary arguments later in his career. He was consistently and exaggeratedly rude about the sculptor and his art. Yet it was at the court that he was most demandingly engaged in the practice of sculpture, namely, during the course of his creation of the great clay model for the Sforza horse, which was never cast and has long since been lost.

Leonardo's arguments against sculpture range from social to visual. The sculptor's work is laborious, fatiguing, sweaty, manual, dusty, and ungentlemanly. The fashionably dressed painter, by contrast, brandishes his fine brushes graciously in clean surroundings. The sculptor deals only with real, three-dimensional forms and avoids having to acquire a full mastery of natural effects, such as color, atmosphere, distance, transparency and translucency, light sources, and the varied effects of illumination and shadow. He concedes sculpture its own kind of reality: "Sculpture is nothing other than it appears to be, that is to say a modeled form surrounded by air and clothed in shaded and illuminated surfaces as are other natural objects; and this is produced by two masters, namely nature and man."[22] But it is a limited reality. Painting, by contrast, exhibits the

full range of optical effects, not least perspective, through which vast distances can be configured. The painter's art masters nature optically rather than requiring its collaboration.

However, embedded in the *Paragone* are what Leonardo puts forward as the positive claims that the sculptor might make in his defense. Although it subverts Leonardo's intentions, it is possible to isolate these claims to see what he considered to be the excellences of sculpture, even if these were invariably shared with painting. Unsurprisingly, in view of what we have said about his vision of form in space, he possessed a sharp sense of the need for the sculptor to master the intricacies of complex forms in the round:

> The sculptor in bringing his work to completion has to make each figure in the round with many contours so that the figure will look graceful from all viewpoints. These contours cannot be realized accurately without turning the form to see its profiles, namely the contours of the concave and convex parts seen against their abutment with the air that touches them.[23]

This is a perfect account of what Verrocchio had achieved. Leonardo specifically associates this quality with his notion of the continuous plasticity of geometry: "The sculptor . . . cannot make one figure without making an infinite number of contours possessed by any continuous quantity."[24] He also provides a marvelously vivid description of how the sculptor must proceed if he is to capture the nuances of contour in the human figure. We cannot doubt that this reflects his own experience in making sculpture in his studio:

> The sculptor, wishing to carve in such a way as to render the interval between the muscles and to permit the prominences of the muscles to stand out, cannot produce the required figure . . . if he does not move around it, stooping and rising in such a way as to see the true elevations of the muscles and the gaps between them. These features can be judged by the sculptor in this

situation, otherwise he would never capture the profiles or the true shapes of his sculpture.[25]

One of Leonardo's earlier drawings that can be directly related to sculpture, the studies of a horse's head from the side and front (plate 22), probably based on a sculptural prototype, instinctively reflects the need for a number of viewpoints over and above the two "half figures" that he insists are all that are theoretically necessary for the draftsman to render a form in its entirety. This mode of surveying a sculptural form from views at right angles to each other is also directly reflected in the *Codex Huygens* (plates 23–25). The study for the bust of a child (see plate 13), together with another sheet at Windsor in which the upper section of the child's torso is shown from the back and front (fig. 49), illustrates how at least three viewpoints are needed to make this particular form explicit. These studies are, as Gary Radke points out, intimately related to the Florentine sculptural tradition in which Leonardo was trained. Later, when he was faced with the complexities of equine form in the Sforza monument, he showed the upraised leg of the horse in four turning positions (plate 26, reading from right

**Fig. 49** Leonardo da Vinci, *Bust of a Child from Front and Back*, ca. 1495, red chalk on paper, 6½ × 5⁵⁄₁₆ inches, Royal Library, Windsor Castle, RL 12567.

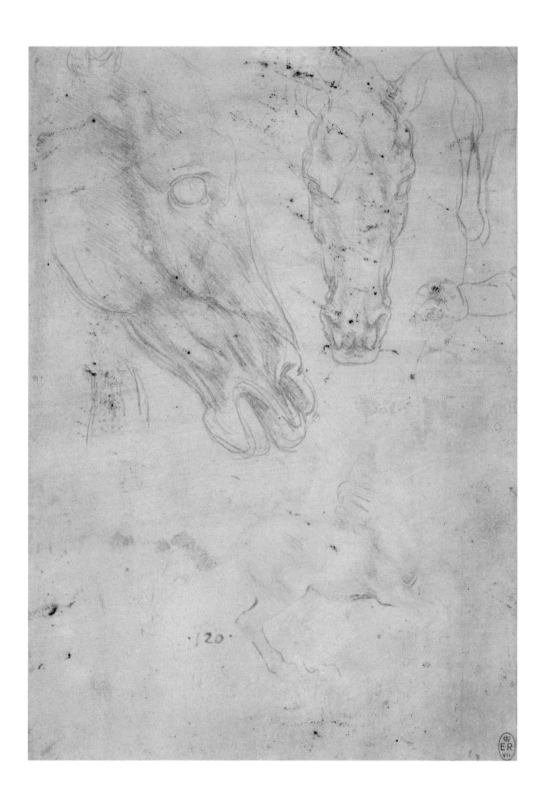

PLATE 22 **Leonardo da Vinci** (Italian, 1452–1519), *Studies of Horses*,
ca. 1478–1480, metalpoint on pale buff prepared paper, 8½ × 5⅞ inches.
Royal Library, Windsor Castle, RL 12285.

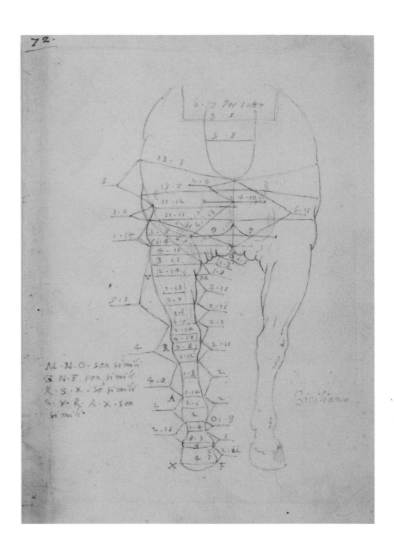

PLATE 23 **After Leonardo da Vinci** (Italian, 1452–1519), *Horse, Shown without Head, in Frontal Elevation*, fol. 72 of 128 folios from *Codex Huygens*, Carlo Urbini, 16th century, pen and brown ink on paper, 7 × 5⅟₁₆ inches. The Pierpont Morgan Library, New York, Purchase, 2006.14 (formerly MA 1139).

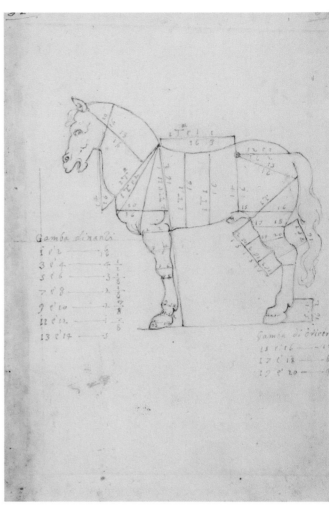

PLATE 24 **After Leonardo da Vinci** (Italian, 1452–1519), *Dimensioned Drawing of Horses' Heads*, fol. 75 of 128 folios from *Codex Huygens*, Carlo Urbini, 16th century, pen and brown ink on paper, 7¹⁄₁₆ × 5³⁄₁₆ inches. The Pierpont Morgan Library, New York, Purchase, 2006.14 (formerly MA 1139).

PLATE 25 **After Leonardo da Vinci** (Italian, 1452–1519), *Dimensions of a Horse*, fol. 82 of 128 folios from *Codex Huygens*, Carlo Urbini, 16th century, pen and brown ink on paper, 7 × 4¾ inches. The Pierpont Morgan Library, New York, Purchase, 2006.14 (formerly MA 1139).

to left), in partial anticipation of the later rotating shoulders. If pressed, Leonardo would have admitted how very demanding it was to handle complex forms mellifluously in sculpture.

This awareness of the infinity of potential viewpoints for sculpture also posed the question, faced implicitly or explicitly by all sculptors of the human figure, about the communication in space between the sculpted person and the spectator. We grant special priority to eye contact. Sometimes in a sculptural group, as with Verrocchio's marvelous *Christ and St. Thomas* of Orsanmichele (see fig. 1), the glances of the sculpted figures are locked within the group itself. Many traditional sculptures of single figures look blankly and undirectedly into some distant space. But increasingly in the Renaissance, led by Giovanni Pisano and Donatello, sculptors had turned the insistent glances of their sculpted characters toward the spectator. With such figures, there is a special moment in our examination of the sculpture at which it literally catches our eye. We suddenly realize that we are being looked at. During the early 1500s Leonardo explored and exploited this moment of direct eye communication in paintings, not only in the surviving works of the *Mona Lisa* and *St. John* but also in the project for the *Angel of the Annunciation*, as reflected in a pupil's drawing impetuously corrected by the master (plate 27). The archangel Gabriel remarkably announces the coming of Christ directly to us.

The translation of this mode of communication in sculpture was not directly achieved by Leonardo himself, but it is deeply infused in Rustici's magnificent group of *John the Baptist Preaching to a Levite and a Pharisee* from the Baptistery in Florence (plate 35). As we pass the north flank of the Baptistery, walking in an easterly direction past the column of San Zenobio and looking up at the three figures, we are first engaged by the Pharisee to the left, whose head we see more or less frontally. St. John and the Levite are seen mostly in profile at this stage. Directly in front of the group, we read the narrative. The saint is flanked by the two representatives of traditional Jewish sects who turn toward

him while he preaches to the implied assembly of listeners below. Finally, as we near the Cathedral we move into the Baptist's line of sight. It is a special moment. We could of course pass the sculpture in the other direction, and its meaning would unfold in a different sequence. Either way, the point is that the group involves a spatial unfolding that required the sculptor—or sculptors, if we assume that Leonardo was closely involved—to achieve total mastery of the qualities of spatial continuity that Leonardo demanded.

Leonardo was also happy to concede that the invention of sculpture involved the much-lauded mental faculty of *fantasia*. Residing in the same brain ventricle as intellect (plate 28), according to Leonardo's interpretation of medieval faculty psychology, the imaginative faculty lay at the heart of the representation of nature in works of art, just as it had lain at the core of Dante's poetic achievements. The great poet's *alta fantasia* might finally have been to no avail when he was faced with the ultimate, ineffable vision of transcendent divinity, but it had served to transport him on winged thought until the very last stage of his *Divina commedia*.

Leonardo saw the sculptor's *fantasia* as being fully exercised in the malleable media of small-scale modeling, clay or wax, just as the painter avails himself of rapid sketching on paper. He had played a key role in the releasing of *disegno* (draftsmanship) into a realm of improvisatory "brainstorming." He saw modeling as possessing comparable freedom. This is where sculpture and painting may be identified with each other:

> Modeling is the sister of painting, as was affirmed by the ancients. . . . Sculpture avails itself of clay models, which come closer to our imagination. These are then measured with compasses, and can thereby insinuate figures of men, horses and whatever you wish into marble.[26]

When, on the sheet with studies of horses and figures (plate 27), he reminds himself to "make a little one in wax a finger long" (either a horse or, less likely, a human figure), he is instinctively turning

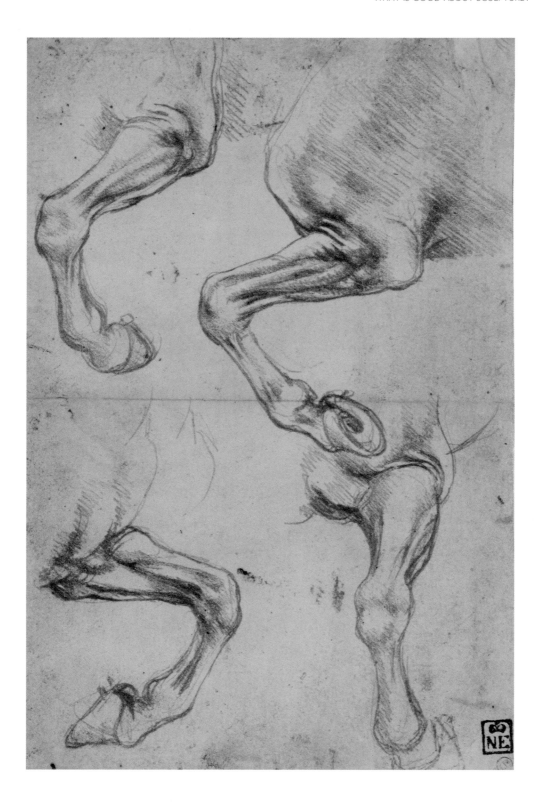

PLATE 26 **Leonardo da Vinci** (Italian, 1452–1519), *Studies of Horses' Legs*, ca. 1490,
black chalk on paper, 8½ × 5¾ inches. Szépművészeti Múzeum, Budapest, inv. 1776.

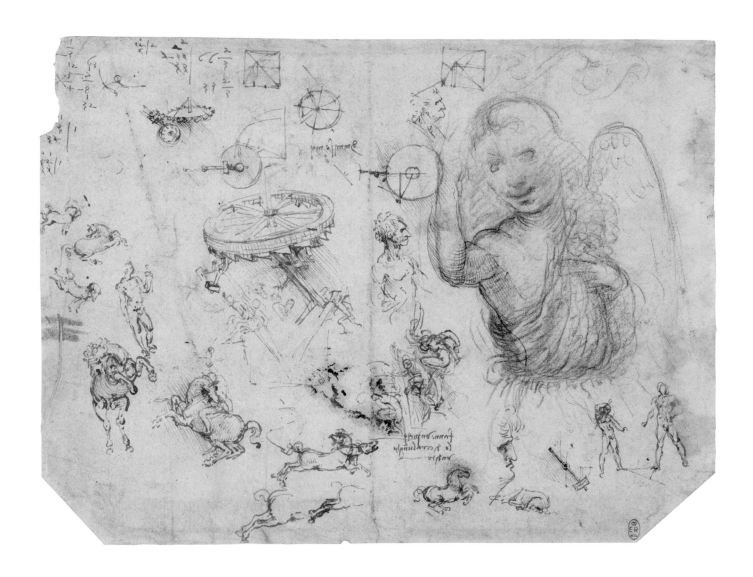

PLATE 27 **Leonardo da Vinci** (Italian, 1452–1519) **and Student**, *Sketches of Horses, Machinery, the Angel of the Annunciation, and Other Studies* (recto); *Sketches of Horses, a Profile of Nero, and Other Studies* (verso), ca. 1503–1504, recto: pen, ink, and black chalk on paper; verso: pen and ink on paper, 8¼ × 11⅛ inches. Royal Library, Windsor Castle, RL 12328 recto and verso.

PLATE 28 **Leonardo da Vinci** (Italian, 1452–1519), *The Head Sectioned to Show the Cerebral Ventricles and Layers of the Scalp* (recto); *Studies of the Head to Show the Optic and Aural Nerves, and Other Studies* (verso), ca. 1492, recto: pen, ink, and red chalk on paper; verso: pen and ink (with discolored white lead covering an earlier profile) on paper, 8 × 5⅞ inches. Royal Library, Windsor Castle, RL 12603 recto and verso.

to the medium in which he can sketch in three real dimensions.

If Leonardo's somewhat reluctant acknowledgment of the demands of the sculptor's art in the *Paragone* does not suffice to establish the qualities he saw sculpture as possessing, a glance at the drawings in this exhibition associated with sculptural projects will show the intensity with which he engaged the language of modeling in three dimensions. The drawings possess an extraordinary vitality and plasticity. The study of the horse from both the side and front in silverpoint on blue paper (see plate 31) is alone sufficient to make the point. It is a miracle of rhythmic contour and internal modeling as Leonardo caresses the form into subtle *rilievo* (relief), a property he identified as fundamental to both painting and sculpture. The alternative contours of the neck and the positions of the hind legs become less a matter of static definition than an instinctive quest to capture *quantità continua*—paradoxically—in a still image on paper.

Given Leonardo's indubitably positive sense of what sculpture could do, if not in word then in deed, how can we explain his negative pronouncements? In part, the answer lies in circumstances, often vexing ones, to which Leonardo was, like all of us, subject. Under pressure we tend to adopt exaggerated and inflexible stances. The first circumstance we must take into account is the context of the Sforza court. Court employment was a competitive business. Leonardo was jostling for attention and funds with authors of various kinds (including poets); musicians; and makers of expensive things like buildings, clothes, jewelry, and furniture, to say nothing of the military engineers and soldiers who in the final analysis were more vital to the duke's survival than were cultural adornments. The *Paragone* was a reflection of competition in the cultural sphere, albeit as a kind of verbal sport. Leonardo is known to have taken part in at least one actual event of *paragone* jousting in Ludovico's court. Part of the entertainment resided in the opposing parties taking extreme positions to goad their adversaries and to test how long they could hold their ground.

This does not mean that Leonardo was consciously parading arguments he did not believe, but it does explain their one-sided and dogmatic nature. We might imagine his sculptural adversary, perhaps Gian Cristoforo Romano, sharing jokes with him in private after a successful "performance."

The second circumstance is, to put it unkindly, Leonardo's own failure as a public sculptor. Whatever may have once existed of his small-scale works in clay or wax, no bronze sculpture ever came from his projects for at least two major equestrian monuments. His huge clay horse, exhibited at Sforza wedding celebrations in Milan, won short-term renown but was destroyed by invading French forces in 1499. Like his flying machine, the unprecedentedly massive bronze horse he planned as the memorial to the duke's father, Francesco, was integral to his quest for immortal fame, in emulation of the "ancients" such as Daedalus and Praxiteles. He could claim, reasonably enough, to have been unlucky. His first patron became embroiled in wars of dubious necessity and was overthrown by the French. Gian Giacomo Trivulzio, the commissioner of his later project for an equestrian memorial, also proved to be less of a fixture in Milan than either he or his artist hoped. Even Michelangelo, after all, failed to realize anything like his initial grand conception of the tomb of Pope Julius due to changing circumstances beyond his control.

But we can imagine that Leonardo felt vulnerable to accusations that he was a failed sculptor. He had sat on the committee to decide on the placement of Michelangelo's lofty *David*, sketching his rival's figure in Herculean form and transformed into a possible Neptune (see plate 37). He could only have grudgingly recognized that the young Michelangelo had achieved something truly astounding—and this in the face of Leonardo's own earlier interest in taking over the marble block that had lain "badly blocked out" in the Cathedral workshop for more than thirty years. Michelangelo was insistent on the supreme virtue of direct carving in marble, realizing the form that lay conceptually within, rather than prioritizing Leonardo's

preferred techniques of modeling in clay and wax. It is easy to believe that Leonardo dusted down his arguments against the marble sculptors when confronted with such competition.

To end on a negative note would be misleading, however. As in other fields of his diverse activity, Leonardo's inventiveness and originality were bright lights that irradiated the practice of many more pragmatically productive makers. His mastery of form in space, activated into interactive motion and communication, infused itself into the mainstream of later Renaissance sculpture through routes that are often difficult to reconstruct precisely. The task he set for sculpture, even though he needed to claim that it was a less demanding task than that he set for painting, would occupy leading sculptors for at least 400 years.

## NOTES

1. Leonardo da Vinci, in *Trattato della pittura, Codex Urbinas Latinus 1270,* (Vatican, 1817); *Libro di pittura* 1995; and Farago 1992.

2. Kemp *Leonardo on Painting* 1989, p. 38.

3. Pacioli 1509. The better of the two manuscripts, dedicated to Galeazzo Sanseverino, is in the Biblioteca Ambrosiana in Milan. The one dedicated to Duke Ludovico Sforza in the Bibliothèque Publique et Universitaire in Geneva is rather disorderly and may have been compiled later. For the solids more generally used in the Renaissance, see Kemp "Geometrical Bodies" 1989, pp. 237–241.

4. A suitable device, a perspective "window," is shown by Leonardo in *Codex Atlanticus* 5, where it is used to draw an armillary sphere; see Kemp 1992, p. 171.

5. The answer is a cuboctahedron, composed of six square faces at 45° angles to the original square faces, and eight faces of equilateral triangles resulting from the truncation of the original corners. Try drawing it!

6. Leonardo da Vinci, *Codex Forster I*, 3r.

7. Leonardo da Vinci, *Codex Madrid II,* fols. 2–3.

8. See *Leonardo da Vinci* 2006, pp. 111–113.

9. *Codex Forster I*, 7v.

10. *Codex Forster I*, 40v.

11. Kepler 1596–1597; see Field 1988.

12. Museo di Storia della Scienza, Florence.

13. Windsor 12069v, shown here in a photograph made with ultraviolet light, which brings out features no longer visible under normal illumination.

14. Clark 1968, no. 19058; Keele and Pedretti 1978–1980.

15. *Codex Urbinas*, 26v; Kemp *Leonardo on Painting* 1989, p. 39.

16. Windsor 19018r.

17. *Codex Ashburnham II*, 6v, Paris, Institut de France; see Kemp *Leonardo* 2006, pp. 112–114.

18. Windsor 19016r.

19. Alberti 1991, pp. 37–39.

20. *Codex Madrid II*, 67r.

21. *Codex Arundel*, 190v.

22. *Codex Urbinas*, 25v–26r; Kemp *Leonardo on Painting* 1989, p. 42.

23. *Codex Urbinas*, 20r–21r; Kemp *Leonardo on Painting* 1989, p. 39.

24. *Codex Urbinas*, 26v; Kemp *Leonardo on Painting* 1989, p. 39.

25. *Codex Urbinas*, 21r; Kemp *Leonardo on Painting* 1989, pp. 39–40.

26. Leonardo da Vinci, quoted in Lomazzo 1584, p. 159; Kemp *Leonardo on Painting* 1989, p. 45.

PIETRO C. MARANI

# *Leonardo,* The Vitruvian Man, *and the* De sstatua *Treatise*

Recently I tried to newly address the relationship between the study of the antique measured drawings of classical monuments and architecture and the study of the proportions of the human body.[1] I did this after having tried to fathom Leonardo's mental attitude in the late 1480s. At that time he was beginning to dissect the human body and verify the subtle relationships that harmoniously link the various limbs of the body. These studies led the artist to "survey" the human body as if it were an ancient statue, in search of the laws that govern its harmony.[2] It seems possible that Leonardo adopted a tool kit for measuring the human body that he took from architectural and antiquarian practice. This is supported by later testimony from Giorgio Vasari and the sculptor Giacomo Della Porta, who, citing the necessity of studying the antique, recounted the emblematic cases of Leonardo and Bramante, who journeyed to Rome to measure and draw ancient monuments, the foundation of "buona et regolata Architettura [good and ordered architecture]."[3] Leonardo's approach to "surveying" the human body—whether or not it was aimed at theorizing a proportional "canon" to include in his *Trattato della pittura* (*Treatise on Painting*) or, as I have intimated, into a possible "Trattato della scultura (Treatise on Sculpture),"[4]—can be read as a further confirmation by Leonardo of a method for measuring the human body and sculpture that Leon Battista Alberti provided with almost the same words and methods in his *De statua*, variously dated in a period ranging from 1435/36 to 1463.[5] Although it remained unpublished until the early 1500s, it must have been known in Florentine humanistic and artistic circles—especially considering the high reputation this author held in Leonardo's thought.[6]

Carlo Pedretti, in an incisive and dense contribution about twenty years ago, extensively answered critics' doubts regarding Leonardo's actual knowledge of Alberti's little treatise. Pedretti documented how Leonardo approached preparing a treatise on sculpture from a theoretical point of view (a subject to which we will return later). He singled out a drawing by Leonardo in the *Codex Atlanticus*

Fig. 50 Leonardo da Vinci, *Painting Mechanism for Sculpture*, *Codex Atlanticus*, 189v (detail), 1478–1518, pen and ink on paper, Biblioteca Ambrosiana, Milan.

(fig. 50) from ca. 1498 that shows the schematics of a method indicated by Alberti in *De statua* for creating a sculpture and another drawing by Leonardo in *Ms. A* (fol. 43 recto, ca. 1490–1492) accompanying a text entitled *De sstatua* [*sic*], which records the method proposed by Alberti for transferring, via a pointing mechanism, measurements from a clay model to a marble sculpture.[7] We can add some other congruences between Leonardo's and Alberti's methods and mental attitudes. These observations will prove useful for what I will later suggest about the intended destination of the famous *Vitruvian Man* drawing in the Gallerie dell' Accademia in Venice (fig. 51).

In *De statua*, Alberti's repeated references to the "taking of measurements [rilevamento delle misure]" (*de dimensione, dimensio quantitatum*),[8] seem to have made an impression on Leonardo's mind. They so impressed him that when in his notes on the *Paragone* (Comparison) between painting and sculpture Leonardo posed the question of how to define sculpture and how to compare it negatively to the more noble painting, he found no better definition than an art that relies on "simple measure-

ments of limbs" and the "nature of movements and poses,"[9] or even, an art whose practitioner does or does not have "power in measurements [in potestà le misure]" (*Ms. A*, ca. 1490–1492).[10] Defining the sculptor's limitations, Leonardo speaks of an artist who "only needs the length and size of the limbs of any body and their proportions, and this is your art."[11] Such statements (from a lost manuscript that Pedretti dates 1505–1510) almost seem written with Alberti's method for making measured drawings of the human body (or of a sculpture) in mind. We are especially reminded of Alberti's little treatise when we read in Leonardo's *Treatise on Painting*:

> In making a figure in the round, the sculptor makes only two forms, and not an infinite number for the infinite number of points of view from which it can be seen; one of these forms is seen from in front and the other from in back; this is proved to be so, for if you make a figure in bas-relief which is seen from in front, you will never say that you have put more of the work on display than a painter would do with a figure made from the same point of vantage and the same thing happens with a figure seen from the back. But bas-relief requires incomparably greater thought than that which is wholly in relief and somewhat approaches painting in concept, because it is indebted to perspective; work wholly in relief is not troubled at all about this problem, because it employs the simple measures that it finds in life. . . .[12]

Alberti himself recalls that (thanks to his measuring method) the sculptor could create his sculptures in two halves, one part showing the front and the other showing the back (or an upper part and a lower part): "You could . . . if you wished make one half of the statue in the Lunigiana and the other half on Paros."[13] What seems to characterize the painter's work, making "the science of painting" very difficult and "divine," is his ability to re-create space, air, atmosphere, places, animals, plants, and any other thing that the painter's mind can imagine. The sculptor's work, on the other hand, entails the

simple mechanical task of reproducing the real. The work of the painter is principally distinguished by the use of color and chiaroscuro and the mastery of the science of perspective, from which derives Leonardo's appreciation for bas-relief, whose successful effects depend increasingly on the sculptor's knowledge of perspective the more it approaches two-dimensional painting. From this definition emerges a sort of contrast between "drawing" (how the contour lines delimit the body's surface) and "chiaroscuro" (with which the painter tries to produce a three-dimensional effect on a flat surface). These categories appear to be adopted by Leonardo in his *Treatise on Painting* and particularly in the *Paragone* to indicate two differing visions—one of the sculptor and the other of the painter. A passage from the *Treatise on Painting*, to which Carlo Pedretti calls our attention, furnishes the theoretical basis upon which to establish the specific attributes of each field:

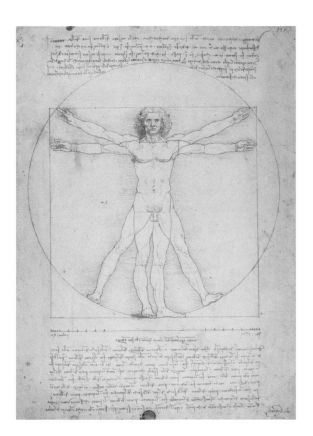

Fig. 51  Leonardo da Vinci, *Proportions of the Human Body according to Vitruvius*, called *The Vitruvian Man*, ca. 1492, pen and brown ink, brush and some brown wash over metalpoint on paper, 13⁹⁄₁₆ × 9⅝ inches, Gallerie dell'Accademia, Venice, 228.

But the divine science of painting considers the works human as well as divine, which are encompassed by surfaces (that is, the lines that are the boundaries of bodies), and with these she commands the sculptor to achieve the perfection of his statues. By means of her basic principle, that is, design, she teaches the architect to make his edifice so that it will be agreeable to the eye, and teaches the composers of variously shaped vases, as well as goldsmiths, weavers, and embroiderers. She has discovered the characters by which different languages are expressed, has given numerals to the arithmetician, has taught us how to represent the figures of geometry; she teaches masters of perspective and astronomy, machinists and engineers.[14] (Part 1, 42)

The passage, dating to 1490–1492, makes clear that for Leonardo drawing delimits the body's surface, which is the true subject of sculpture. As Pedretti again points out: "There is no doubt that whenever Leonardo discusses 'surface,' he has sculpture in the back of his mind, even when he writes about painting. In fact, his 'science of painting,' design, is what '*disegno*' was to be for Michelangelo, and so it is again sculpture that is taken to illustrate the second principle of painting, . . . where the effect of relief in painting is best exemplified by the process of modeling a surface."[15]

It is therefore no accident that Leonardo's drawing of the *Vitruvian Man* is a contour drawing in which the human body is portrayed only by outlines and without foreshortening. It is "without perspective." A "solid" but "projecting" and objectively measured body. Simply defined and extending in space, it is not intended as a body seen through the irregularities of air and space. Its boundaries or limits—that is, its outlines—do not make up the projection of a cumbersome physique on the two-dimensional surface of a "screen," as if it were the front plane of a block of material (or marble) on which appear "features" of an "internal" form to be reached and brought to light by excavating into the material itself. This portrayal appears to give visual

form to what Alberti suggested to do in the thirteenth and final chapter of *De statua*, where he confusingly tries to clarify drawing's role in the creation of sculpture. Marco Collareta brilliantly explicates Alberti's passage on how to extract the contours of a body from their sections:

> Here he essentially says that the ideal plane with which we cut the body can be identified with the real plane on which we apply the drawing and that the edges made visible by the ideal cut can in turn be identified with the contours of the drawn figure. In fact, the perspective view of a body coincides with the projection of the body's shadow if the pupil that receives the light is replaced by a source of light whose rays are intercepted by the body in question. The recollection of one-point perspective explains why Alberti interrupts his discourse on contours drawn from sections with an explicit reference to the art of the painter. Nevertheless, it will not disappear like the ancient idea of circumscribing the shadow projected by a body, arriving out of the necessity for one type of drawing which, while it no doubt has a privileged relationship with pictorial foreshortening, keeps itself within a tightly linear value that more or less evokes the graphic methods of architectural design.[16]

The silhouette Alberti describes here seems to correspond perfectly to the line drawing of the *Vitruvian Man*, whose real significance is therefore to be interrogated.

Recently studying Leonardo's drawings at the Louvre, focusing especially on the evolution of his drawing style and his continual change of media, I emphasized how Leonardo's every change of drawing instrument—from metalpoint to pen and ink, from black to red pencil—and each different mode of drawing—from the quick sketch to the fixed and dry drawing, from the sketchy drawing to the presentation drawing—reveal his precise intention to match his media with the different significance and functions of his drawings.[17] The *Vitruvian Man*, drawn with a fine-tipped pen and ink

on a metalpoint underdrawing, then worked with tiny touches of watercolor, was transferred onto this paper from another drawing using the *spolvero* technique, "proving that this drawing was destined for an important function."[18] It is evident that the drawing must have had a "demonstrative" function related to a specific project intended for publication and recognition. It portrays, along with two texts, a scheme of ideal proportions of the human body, drawn in two positions simultaneously, one with the man's arms open inside a square, the other with the man's arms open and legs parted inside a circle. The theme of the drawing is the correspondence of parts among themselves and the proportional relationship of the parts to the total height of the man. Vitruvius, cited directly by Leonardo in the upper text, is disputed: for Leonardo, the man's total height would be equal to ten times his face (not his head), whereas for Vitruvius, it would be eight heads. The discrepancy between these canons has been pointed out by scholars, but it is necessary to remember that for Leonardo, the methods and forms of measured drawing can change each time. Similarly, the aim of this drawing was not exclusively to furnish the ideal proportions of man.

But before entering into the possible meanings of the drawing, it is necessary to summarize briefly the cognitive process that led Leonardo to this formulation, which has become a symbol of the entire Renaissance (thanks to its anthropocentric conception), if not indeed a symbol of Western civilization. Leonardo's youthful proportional drawings[19] show that the artist was not very concerned about finding and fixing a priori rules for creating a theory or fixed and strictly observable "canon." Rather, he sought to draw general rules from the measurement of the various limbs of the human body, as well as from the similarities between one part and another, or from the possibility that a part of the body might correspond to another in length or be smaller or larger by a fraction of the part under consideration. For example, in Windsor 12607 (fig. 52), the length of the parts of the head are equivalent to the diagonal lines that connect the shoulders to the chest. All

**Fig. 52** Leonardo da Vinci, *Head and Shoulders of a Bald Old Man in Right Profile*, ca. 1487, pen and ink on white paper, 5¾ × 5¼ inches, Royal Library, Windsor Castle, RL 12607.

**Fig. 53** Leonardo da Vinci, *The Proportions of a Standing, Kneeling, and Sitting Man*, ca. 1490, pen and ink on paper, 6¼ × 8¼ inches, Royal Library, Windsor Castle, RL 19132v.

these lengths "between them have similar size."[20] In essence, it seems that Leonardo did not choose Vitruvius's length of the head as his predetermined "module" of measurement. Instead he chose to use the length of the face as a form of reference—at least in his initial studies (apart from a few exceptions, perhaps deriving from the variety of bodies he examined). This is shown by the drawing and text on Windsor 12304 recto,[21] where it reads: "The space from above the throat to the beginning of the lower part, qr, is half the face: it is the eighteenth part of man." It appears that for Leonardo, the total height of man corresponds, this time, to nine "faces," and not "heads." But in other situations he refers to a length in heads. On Windsor 19132 verso (fig. 53),[22] he relates the size of the head to the other parts of the body: "From one shoulder joint to the other is two heads. And similarly from the top of the chest to the navel. From that top to the beginning of the member is a head."

We have noted that the drawing of the *Vitruvian Man*, which is the point of arrival of a series of previous measured drawings, took the face and not the head as parameter: "From the roots of the hair to

below the chin is one-tenth of man's height." But he uses the foot as a point of reference for other parts: "The foot is the seventh part of a man." Leonardo, rather than constructing a theory of proportions, seems to limit himself to ascertaining relationships among various limbs. "They have similarities," "they are similar," and "it is the third part" are expressions that reveal his objective adherence to the object of his measurements. Even Leonardo's "scientific" prose does not venture far from the Latin terms adopted by Alberti in *De statua* for describing the parts of the human body: "Ad summas radices capillorum in fronte," "A mento ad summam verticem capitis," "A mento ad foramen auris," and so on, as listed in the *Tabulam dimensionum hominis*.[23] But Leonardo's aim is very different from Alberti's. Alberti, wanting to offer an instrument to sculptors for the exact proportioning of the body parts to mold into plastic form, felt it necessary to offer a proportional canon a priori, based on the length of the foot: six feet gives a man's total height, the result of measurements and measured drawings.

But both Alberti and Leonardo were aware of how much the measurement of limbs can change

according to how they flex or relax, or due to the position of the parts when a man is sitting or standing or lying down, or bent in a certain way.[24] It is as if Leonardo were retracing the study of the body already carried out by Alberti with an infinite number of new case studies on positions and random poses. With the same system of taking measurements that had allowed Alberti to create an efficient synthesis of practical use to sculptors, Leonardo instead left scattered concepts that Melzi later brought together in the *Treatise on Painting*. Though these notes were gathered with the painter and the effects he needed to represent in mind, many of the annotations could equally serve the sculptor, as frequently noted by Pedretti.

It is clear that many components came together in Leonardo's mind to form a similar approach for deciphering the human figure and its portrayal. In particular, I have pointed out many times that for him knowledge of antiquity was fundamental and ancient sculpture an ideal reference. As Leonardo proclaims in a renowned passage from the *Treatise on Painting*:

> Of the way to clothe figures. Observe decorum in clothing your figures according to their station and their age. And above all, see that draperies do not conceal movement; and that the limbs are not cut off by folds nor by the shadows of folds. As much as you can imitate the Greeks and the Latins in the manner of revealing limbs when the wind presses draperies against them, and make new folds; make many folds only for old men in positions of authority who are heavily clothed. (Part 4, 573)[25]

This passage—datable to 1510–1515 or even earlier, given that sketches of this concept are found on Windsor 19121, datable to ca. 1510—shows that Leonardo acquired a profound knowledge of ancient statuary and representational methods by having observed a specific ancient sculpture, probably seen in Florence, Rome, or even (given the date of the passage) in Milan, where he lived during those years. However, Leonardo's familiarity with antiquity must go back much further if around 1490, right in Milan, he could ask himself, "Which is better—to portray the natural or the ancient? Which is more tiring—profiles or shadows and light?"[26] and, in front of the statue of the *Regisole* in Pavia, he could declare, "One praises the movement of the one in Pavia, more than anything else. The imitation of ancient things is more praiseworthy than of modern ones."[27] His first contacts with ancient sculpture doubtless date back to the time he spent in the garden of San Marco, that is, the Orto de' Medici, where Lorenzo the Magnificent had collected a series of sculptures. Young Florentine artists (later, even Michelangelo) studied and copied there under the guidance of older masters like Verrocchio and Bertoldo.[28] The presence of Leonardo in this garden is recorded by the anonymous writer called the Anonimo Gaddiano, who asserted that Leonardo was "as a young man with the magnificent Lorenzo de' Medici, who gave him his own provisions and let him work in the garden in Piazza San Marco in Florence," where he was certainly able to admire the ancient works Lorenzo collected between 1475 and 1481.

Leonardo's move to Milan in 1482 did not interrupt his dialogue with antiquity, which he maintained through contacts with local sculptors who were steeped in humanistic culture and antiquity—men such as Amadeo, whose workshop, along with Mantegazza's, was responsible for a series of portraits of Roman emperors sculpted inside roundels

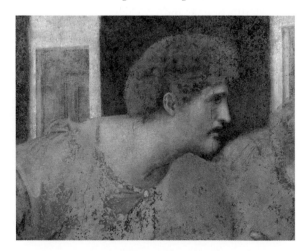

**Fig. 54** Leonardo da Vinci, Matthew from *The Last Supper* (detail), 1498, tempera on plaster, Convent of Santa Maria delle Grazie, Milan.

on the base of the façade of the Certosa in Pavia.[29] Some apostle heads—especially Matthew's (fig. 54) —in the *Last Supper*, painted by Leonardo in the Refectory of Santa Maria delle Grazie between 1494 and 1498, seem to reflect an awareness of the profiles of Roman emperors diffused on coins and medals, as well as reinterpretations by Lombard sculptors whose renewed sensibility for handling profiles and flat modeling, cut out on neutral backgrounds, was typical of Hellenistic gems and bas-reliefs.[30] The impulse to study antique statuary certainly came to Leonardo in this period from the commission of the equestrian monument to Francesco Sforza by Ludovico il Moro, from the sight of the horses of San Marco in Venice, from the *Marcus Aurelius* then in front of the Lateran in Rome, and from the *Regisole* in Pavia, not to mention more recent projects by Donatello in Padua (his equestrian monument to Gattamelata), and the monument to Colleoni that Verrocchio was preparing in Venice, cast only in 1493 by Alessandro Leopardi after the death of Verrocchio (see fig. 96).

In the monument to Francesco Sforza, Leonardo's contemporaries saw the rebirth of ancient monumental sculpture. In 1493 an effigy of Sforza on horseback, perhaps created from Leonardo's clay model, was shown under a triumphant arch in the Cathedral on the occasion of the marriage of Ludovico's niece Bianca Maria to Maximilian I. The court poet Baldassare Taccone spoke of it as "a grand colossus" and compared Leonardo to "Phidias, Myron, Scopas and Praxiteles."[31] Moreover, in 1498, when it was sensed that Leonardo's model would probably never be cast in bronze, Luca Pacioli states in his *De divina proportione* that "the admirable and stupendous equestrian statue" created by Leonardo "alienates with envy Phidias' and Praxiteles' works on Monte Cavallo," whereas in front of the *Last Supper* "Apelles, Myron, Polyclitus and the others had better give way," underlining that Leonardo had surpassed all of the ancient artists in sculpture as well as in painting.[32]

Recent studies call attention to how Leonardo's presence in Venice, perhaps already in his dealings with Cardinal Domenico Grimani's entourage, though limited to little more than one month (March–April 1500), could have been stimulating and determinative for Leonardo's subsequent stay in Tivoli and Rome.[33] He returned to Rome in 1505 and then stayed there continuously from 1513 to 1515, giving him the opportunity to study the ancient collections gathered in the Courtyard of the Statues at the Vatican Belevedere, including the *Sleeping Ariadne* (fig. 55), which Leonardo quickly sketched on a sheet of paper now in the *Codex Atlanticus*, fol. 770 verso (fig. 56).[34]

The previously mentioned passage in *Ms. A* ("Oh, which is more tiring: profiles or shadows and

Fig. 55 Anonymous Roman Artist, *Sleeping Ariadne*, 2nd century CE, copy after original by School of Pergamon (2nd century BCE), marble, Galleria delle Statue, Museo Pio-Clementino, Vatican Museums, Vatican City.

Fig. 56 Leonardo da Vinci, *Sketch of Sleeping Ariadne*, *Codex Atlanticus*, 770v (detail), 1478–1518, pen and ink on paper, Biblioteca Ambrosiana, Milan.

light?"), which refers directly to imitating "ancient things" as preferable to imitating "modern ones," again leads us back to Leonardo's tightly correlated conception of the difference between a sculptor's work (based on "profiles," that is, the boundary of simple surfaces) and a painter's work (whose task is to represent "shadows and light"). This invites us to look at Leonardo's *Vitruvian Man* in a new light. The drawing had been interpreted by Ludwig Heydenreich as a plate especially created by Leonardo to illustrate his *Treatise on Painting*.[35] According to Erwin Panofsky, it would have been one of the illustrations that belonged to the lost *Libro* on human movement, which Luca Pacioli tells us was completed by Leonardo by 1498 and which is echoed in copies from Leonardo's drawings in the *Codex Huygens* at the Pierpont Morgan Library in New York.[36] More recently, for Peter Meller the drawing would instead have been created as an illustration for a projected *Treatise on Architecture*, already hypothesized by Heydenreich in 1929,[37] whereas for Pedretti, who does not speculate on any specific destination, the drawing would have been born "as an illustration, and as such it presents itself with the precision of contour and clarity of detail that are requisites of a print reproduction."[38]

A wide discussion has also recently inserted the drawing into the context of Leonardo's proportion studies. For Giacomo Berra, "the technical analysis of the drawing should not obscure that which appears as the most important novelty in the different positions of the arts," which is that "the abstract study of proportional relationships has essentially been abandoned," so that the drawing "reiterates an aesthetic that identifies beauty with natural phenomenology."[39] On the other hand, Rolf Dragstra recently asserted that "The Drawing of the 'Vitruvian Man' . . . can be introduced as a key to define the elementary set of measurable proportions he needed in order to solve the problem of the perspective construction in the mural [of the *Last Supper*]."[40] An analysis in this direction encouraged Marco Bussagli and Rocco Sinisgalli to perceive in the drawing the application of the method

for constructing a geometrical figure based on the golden section.[41] Developing the ideas of Panofsky and Berra, Domenico Laurenza instead went into depth on the relationship between the drawing and Leonardo's anatomical, physiological, and pathological theories, reaching the conclusion that his *Vitruvian Man* describes the concept of "variety" in nature, associated with "mutation" and with the sense of movement (suggested by the superimposition of the two figures).[42] Pedretti radicalizes these concepts in a more precisely anatomical direction, asserting that "it is as if Leonardo, starting from the Vitruvian canon . . . were arriving at the conception of a proportional schema with which to explain the reciprocal relationships between the internal organs and vital functions."[43] Finally, we should not ignore a quick allusion, unfortunately not fully developed, by Giovanna Nepi Scirè. According to her, in this drawing Leonardo "wants to reach for ever-broadening knowledge and experiences in order to finally produce a painting or sculptural work (*plastica*) of perfect proportions."[44]

With this in mind, we must now carefully evaluate Carlo Pedretti's extremely intriguing proposal to see Leonardo's text that appears in the *Codex Atlanticus*, fol. 68 verso-a (see fig. 50) as draft of a "Proemio [theoretical introduction]" for a hypothetical *Treatise on Sculpture*.[45] We previously cited this note in regard to Leonardo's drawing, taken from Alberti's *De statua*, which appears at the bottom left. The lengthy passage—usually linked by scholars and particularly by Augusto Marinoni[46] to Leonardo's speculation on "the essence of nothing [essere del nulla]"—was considered by Pedretti instead as a text in which Leonardo faces the issue of bodily surfaces, endowed with materiality and themselves revealers of bodies ("Essendo la superfizie quella che mostra la figura de' corpi, essa superfizie ha in sé essere," in Pedretti's translation, "As the surface is that which shows the figure of the bodies, such surface is in itself a being"). Leonardo's text, then, functions as an introductory theoretical discourse ("A Proem") for writing a treatise on sculpture, which as a medium is based on the perception

of surfaces and consists of variously shaped sur-
faces. Pedretti admits that "were it not for the defi-
nition of surface as that 'which shows the figure
of the bodies,' it would be impossible to say that
Sculpture is what Leonardo has in mind as he drafts
these notes." He also observes that: "The introduc-
tory section to a book on the theory and practice of
sculpture would probably have included other such
observations, showing how '*disegno*' is the way to
record the 'boundaries' of the bodies."[47]

An almost spontaneous link can be made with
the *Vitruvian Man*. Its measurements and propor-
tions; its contour drawing, tracing, and transfer from
a *spolvero* sketch; and finally its paradigmatic value
in presenting an ideal shape only by means of lines
and surfaces or, better yet, by means of a projection
of the figure's contours (just as Alberti suggested in
the last paragraph of his *De statua*) strongly suggest
that the *Vitruvian Man* is an illustration Leonardo
prepared in anticipation of a printed version of his
*De sstatua* treatise. Evidently he came up with the
idea to compose it ca. 1490–1492, as testified by
the passage in *Ms. A*, fol. 43 recto, precisely titled
*De sstatua*. (Leonardo was thinking once again of
Alberti's text.) This was the exact moment when
he found himself in Milan, right in the middle
of his projects for the Sforza monument and his
most lively interest in ancient sculpture. This was
a moment, moreover, which saw him engaging in
an analogous theoretical treatise on painting and,
above all, sketching out the *Paragone* between
painting and sculpture. The chronological coher-
ence between the *Vitruvian Man* (which must be
assigned to around 1490) and many of the elements
we have noted within the work, as well as in Leo-
nardo's manuscripts and drawings outside it, are
connected to his interest in sculpture and support
the theory formulated here.

Benvenuto Cellini records that Leonardo dedi-
cated himself to simultaneously writing a treatise on
sculpture, painting, and architecture. (Here is not
the place to go through Leonardo's self-declarations
about being a sculptor, much less the sculptures that
we know about or that eventually have reached us,

about which others speak in this volume.) Even ear-
lier, Paolo Giovio recalled how Leonardo "placed
modeling as a means of rendering figures in relief
on a flat surface before other processes done with a
brush."[48] These last words almost seem to describe
the "model," the "archetype" of the *Vitruvian Man*.
It seems highly plausible that the *Vitruvian Man* was
prepared as an introductory illustration or frontis-
piece for Leonardo's never-completed *De sstatua*. It
could perhaps have been created to offer the exem-
plary model of a statue, not very different from the
one he drew without raised arms on Windsor 12722,
which is an exact study for a sculpture,[49] as well as
the paradigm of perfect and varied proportional
harmony.

## NOTES

1. See Marani "Leonardo, l'Antico" 2007, pp. 17–27.

2. Marani 1999, pp. 215ff.

3. Marani 1995, pp. 209ff.

4. See Marani "Leonardo, l'Antico" 2007. For Leonardo and his possible project *Trattato della scultura*, see Pedretti "A Proem" 1989, pp. 11–39.

5. Alberti *De statua* 1998, pp. 48–49.

6. For the point on Alberti's influence on Leonardo, see Marani 1994, pp. 358–367. See also Acidini 2006, pp. 19–25; for a broader context on the elements taken from the ancient, from Pisanello, regarding Alberti's theories, see Cavallaro 2005, pp. 328–338.

7. See Pedretti "A Proem" 1989, pp. 11–39, especially figs. 1–3 and 30. Doubts were expressed by Cecil Grayson about Leonardo's knowledge of Alberti's treatise, whereas Paola Barocchi accepted this possibility. See ibid., p. 12 and n. 4, for the discussion on earlier artistic literature regarding it.

8. For example, see Alberti *De statua* 1998, chaps. 5, 6, 8, and 12, and pp. 7–9, 12–13, 18–19, and passim. The importance of measurements is also recorded by Barocchi 1971, pp. 477ff. and n. 1 to p. 477.

9. *Trattato della pittura* 1995, cap. 35 ("Comincia della scultura, e s'ella è scienzia o no"), cited in vol. 1, p. 158.

10. Ibid., cap. 38, cited in vol. 1, p. 162.

11. Ibid., cap. 42, cited in vol. 1, p. 166.

12. "Lo scultore, nel fare una figura tonda fa solamente due figure, e none infinite per li infiniti aspetti donde essa po' essere veduta, e di queste due figure l'una è veduta dinanzi e l'altra di dietro; e questo si prova non essere altrimenti, perché se tu fai una figura in mezzo rilievo veduta dinanzi, tu non dirai mai avere fatto più opera in dimostrazione, che si faccia il pittore in una figura fatta nella medesima veduta; e 'l simile interviene a una figura volta indietro. Ma il basso rilevo è di più speculazione senza comparazione al tutto rilievo, e s'accosta in grandezza di speculazione alquanto alla pittura, perché è obligato alla prospettiva; e 'l tutto rilevo non s'impaccia niente in tal cognizione, perché lui adopera le semplici misure come l'ha trovate al vivo. . . ." (Part 1, 56). Translated by A. Philip McMahon in *Treatise on Painting* 1956. See *Trattato della pittura* 1995, cap. 37, vol. 1, p. 160.

13. Alberti *De statua* 1998, pp. 16–17, and Alberti 1991, p. 133.

14. "Ma la deità della scienzia della pittura considera l'opere così umane come divine, le quali sono terminate dalle loro superfizie, cioè linee de' termini de' corpi con le quali lui comanda allo scultore la perfezione delle sue statue. Questa, col suo principio, cioè il disegno, insegna allo architettore fare che il suo edificio si renda grato all'occhio, questa alli compositori di diversi vasi, questa alli orefici, tessitori, ricamatori, questa ha trovato li caratteri con li quali s'esprime li diversi linguaggi, questa ha dato le caratte alli arismetrici, questa ha insegnato la figurazione alla geometria, questa insegna alli prospettivi et astrologhi, et alli machinatori e ingegneri." Translated in *Treatise on Painting* 1956, pp. 30–31; here, however, Radke has changed the feminine articles to neuter and prefers the literal translation of "this" for "questa." See *Trattato della pittura* 1995, chap. 23, vol. 1, p. 148. See also Pedretti "A Proem" 1989, p. 16ff.

15. Pedretti "A Proem" 1989, p. 16.

16. Marco Collareta, in Alberti *De statua* 1998, p. 47.

17. See Marani *I disegni di Leonardo* 2008, pp. XXX–XXXII and passim, catalog card, pp. 7–84.

18. See Giovanna Nepi Scirè, in Nepi Scirè and Torrini 2003, pp. 99–102, n. 6.

19. For a review of Leonardo's drawing as a youth, see diagrams by Kenneth D. Keele in Pedretti "Studi di proporzioni" 1983, cats. 19–31, pp. 30–69, and Pedretti and Keele 1980–1984, vol. 3, pp. 820–821.

20. See Pedretti and Keele 1980–1984, vol. 2, p. 34, n. 21.

21. Pedretti and Keele 1980–1984, vol. 2, pp. 50–53, n. 28.

22. Alberti *De statua* 1998, pp. 18–20.

23. Ibid.

24. Ibid., pp. 8–9.

25. "Del modo del vestire le figure. Osserva il decoro con che tu vesti le figure secondo li loro gradi e le loro età e, sopra 'l tutto, che li panni non occupino il movimento, cioè le membra, e che le dette membra non sieno tagliate dalle pieghe, né dall'ombre de' panni. Et imita quanto puoi li Greci e Latini col modo del scoprire le membra, quando il vento appoggia sopra di loro li panni. E fa poche pieghe; sol ne fa assai nelli uomini vecchi togati e di autorità." Translated by A. Philip McMahon in *Treatise on Painting* 1956, p. 207. *Trattato della pittura* 1995, cap. 533, vol. 2, p. 355. The following remarks refer to Marani 2004, pp. 473–478.

26. Paris, Institut de France, *Ms. A*, 105v; see Brizio 1952, p. 219.

27. Milan, Biblioteca Ambrosiana, *Codex Atlanticus*, 339r: Sciolla 1996, pp. 14–17. The passage on the imitation of "ancient objects" is the only one quoted by Giovanni Agosti in his brief profile on Leonardo and the ancients in Settis, Farinella, and Agosti 1987, p. 533.

28. On St. Mark's Garden see Elam "Il Giardino" 1992, pp. 159–164. The garden already existed in 1475 and was described in 1478. Verrocchio restored the *Flayed Marsyas* in this garden for Lorenzo de' Medici. See also Marani 1999, pp. 113–121, and the bibliography cited there.

29. On this base, its sculptures, and the Lombard context, see Morscheck 1978; Agosti 1990, pp. 47–102; Schofield 1992, pp. 29–44; and Schofield and Burnett 1997, pp. 5–27.

30. The suggestion of an ancient model for Matthew's head in *The Last Supper* was made for the first time by this author in Brambilla Barcilon and Marani 2000, pp. 34–35 and passim.

31. Taccone 1493, 14r-v; Villata 1999, doc. 73, p. 78, for the documents connected to the commission for the Sforza monument. See also Brugnoli 1974, pp. 86–109, which illustrates the ancient and modern monuments cited above; Fusco and Corti 1992, pp. 11–32; and Ahl 1995, passim.

32. Villata 1999, doc. 124, pp. 107–108.

33. For these stays, see Marani 1995, pp. 207–225, with a wide bibliographic reference to the ancient sources and literature about the issue.

34. On this renowned sculpture and other works of ancient art in the Renaissance, see Bober and Rubinstein 1986, passim.

35. Heydenreich 1949, plate XVII.

36. Panofsky 1940, p. 44, figs. 28 and 75. Panofsky's point of view was essentially affirmed more recently by Zöllner 2003. See also Zöllner 1995, pp. 329–358.

37. See Meller 1983, pp. 117–133, fig. 1. The old proposal to look at the drawings in *Ms. B* of Paris as a treatise on architecture goes back to Heydenreich 1929, and further back to Geymueller in his anthological contribution to Richter 1883.

38. Pedretti 1992, pp. 5–39.

39. Berra 1993, pp. 202–205.

40 Dragstra 1997, pp. 83–84, fig. 4, and p. 98.

41. See Bussagli 2003, pp. 34–38; and Sinisgalli 2003, pp. 179–181.

42. See Laurenza 2001, p. 128 and passim. The author considers the drawing in Venice as showing Leonardo's becoming aware of the primary values of "variety" in works of nature. See also Laurenza 1997, pp. 237–239, fig. 1.

43. Pedretti 2003, p. 56.

44. Nepi Scirè, in Nepi Scirè and Torrini 2003, p. 101. The italics are mine. In this same volume, p. 181, Carlo Pedretti also briefly summarizes the latest critical positions on the drawing. It is peculiar that Nepi Scirè's intuition about the final *plastic* of the drawing was not caught and commented on by Pedretti in the same edition of Leonardo's drawings in Venice nor, to my knowledge, elsewhere after that.

45. See Pedretti "A Proem" 1989.

46. See Marinoni 1961, pp. 7–28.

47. Pedretti "A Proem" 1989, p. 23.

48. "Plasticem ante alia penicillo praeponebat, velut archetypum ad planas immagine exprimendas." For this and other sources that assert Leonardo's commitment to sculpture, see Pedretti "A Proem" 1989, pp. 11–13. On Giovio in particular, see Maffei 1999, pp. 234–246.

49. See Pedretti "A Proem" 1989, p. 20, and fig. 20.

ANDREA BERNARDONI

# Leonardo and the Equestrian Monument for Francesco Sforza
## The Story of an Unrealized Monumental Sculpture

## THE STORY OF A WORK NEVER COMPLETED

The casting project for the Sforza monument was one of the most ambitious challenges of the Renaissance period. No artist up to that time had conceived a bronze monument that reached 7.2 meters (almost twenty-four feet) in height and weighed almost seventy tons —to be executed in a single pouring.[1] Although the monument was never cast, studies for the preparation of the model, its casting mold, and construction site spanned almost two decades (1482–1499) and constitute one of the best documented set of plans in the history of art and technology, illustrating Leonardo's exemplary way of confronting a project of unprecedented complexity. He tried to address questions of aesthetics and calculations of statics with his organizational capabilities and a constant predisposition for technical innovation in solving new problems.

The saga of the so-called Sforza Horse has been noted by Leonardo scholars since the end of the nineteenth century. Though the originality of Leonardo's casting method was immediately pointed out, it was only with the rediscovery of the *Madrid Codices* in the winter of 1964–1965 that we were able to completely understand it.[2] Up until that time the technical aspects of this project were known only through some sheets of drawings in the Royal Collection at Windsor and from notes in *Ms. C*, from which we learned that the monument, originally conceived as life-size with the rider meant to dominate a rearing horse, was at some point subjected to a radical revision that tripled its size and changed the horse's position from rearing to striding. Leonardo's intention to cast the monument by an indirect technique was known, but some technical aspects of constructing the outer mold and the casting system were not fully understood, making the entire casting process unclear. Gaps in the sources suggest a similarity between Leonardo's method of constructing the casting mold and the modern-day piece-mold method,[3] but we are unable to specify some procedural nuances that cause us to put it in a phase before this method's final codification, of which we find the first full

95

description in *De la pirotechnia* by Vannoccio Biringuccio (1540), in the introduction of Giorgio Vasari's *Lives of the Painters* (1550), and in the *Treatise on Sculpture* by Benvenuto Cellini (1568). The casting technique developed by Leonardo still remains the oldest evidence in our possession of the reintroduction during the Renaissance of the indirect casting method, which after being discovered in ancient times had been forgotten in the medieval centuries.[4]

The political vicissitudes of the Milanese dukedom and the personal ones of the patron did not help Leonardo in proving the effectiveness of his casting method, but both the "clay colossus" created and displayed in his Corte Vecchia workshop in Milan for a long time and the casting equipment he developed were of notable importance among his contemporaries. Echoes can be found in some epigrams that glorify the huge model's grandeur and beauty,[5] as well as in works that record the history of metallurgical technology like Biringuccio's *De la pirotechnia*, which discussed the casting system, and Cellini's *Treatise on Sculpture*, where a method is illustrated for casting colossal sculptures that follows in Leonardo's footsteps and is referred to as "the most difficult and admirable thing of the past."[6]

A curious aspect of the entire project is the total lack of reference to the rider, which seems destined to remain an open issue. In fact, if we exclude two preparatory drawings where the rider is only sketched in order to study the dynamics of the monument with a rearing horse, no other evidence exists that makes it possible to reconstruct the sculpture in its entirety. This descriptive gap is difficult to explain, especially from the viewpoint of the patron, who undoubtedly saw the rider as the primary figure. Leonardo most likely preferred to concentrate on making the horse—the most technically problematic element of the project—and probably intended to do a detailed study of the rider that is now lost.

## A MONUMENT FOR THE DUKE: THE GENESIS OF THE PROJECT

The history of the equestrian monument to Francesco Sforza (fig. 57) seems to have begun many years before Leonardo's arrival in Milan (1482–1483) when, in a letter dating back to 1454 addressed to the magistrates of Cremona, Duke Francesco Sforza himself commented positively on their intention to erect two statues in his and his wife's memory to be placed over an arch in the square in front of the city's cathedral. There does not appear to have been a follow-up to the letter, and we are unable to say whether or not an equestrian statue was discussed. However, from a reference in a letter to "our engineer Maestro Antonio," we discover that the job of planning and supervising the realization of the two statues was given to Antonio Averlino (known as Il Filarete), who at the

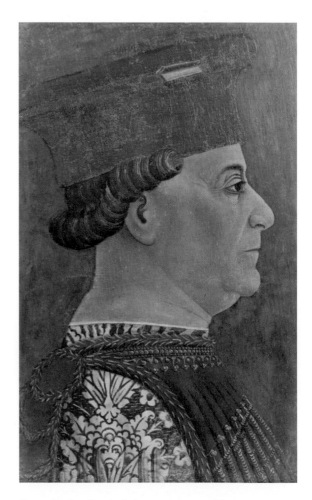

**Fig. 57** Bonifacio Bembo (Italian, active 1447–1478), *Portrait of Francesco Sforza*, ca. 1460, tempera on wood, 15¾ × 12³⁄₁₆ inches, Pinacoteca di Brera, Milan.

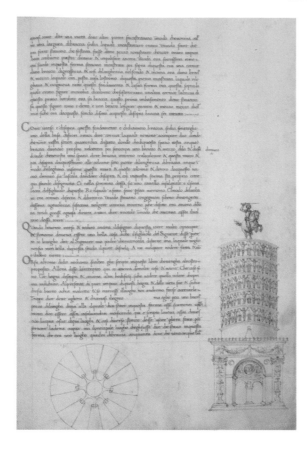

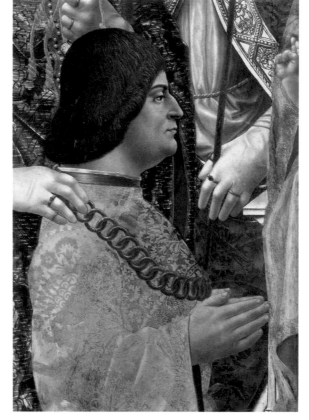

Fig. 58 Antonio Averlino, called Filarete (ca. 1400–ca. 1469), *Trattato di Architettura* (*Treatise on Architecture*), 15th century, II.l.140, MS It., cart., 200 cc., c. 172r, 15¾ × 11 inches, Biblioteca Nazionale Centrale, Florence.

Fig. 59 Maestro della Pala Sforzesca (Italian, end of the 15th century), *Portrait of Ludovico il Moro* (detail from *Pala Sforzesca*), ca. 1496–1497, tempera on panel, 90½ × 63 inches, Pinacoteca di Brera, Milan.

time worked for Sforza. The idea of the monument had found fertile ground, and Filarete developed it in his *Treatise on Architecture*, where in his illustration of the imaginary city Sforzinda, he focused on the need to erect an equestrian monument to King Zogalia (fig. 58).

Based on the drawing of an equestrian monument showing the characteristics of the first Sforza project,[7] we can credit Filarete with having adapted the rearing horse theme from a relief—found in various decorative themes in Lombardy and in coin production—to the complete rotundity of statuary.[8] If Filarete's design of the monument played a role in the conception of the rearing horse theme,

the reasons that first urged Galeazzo Maria Sforza and then Ludovico il Moro (fig. 59) to seek the realization of the monument in memory of their father are to be found in their desire to validate their political roles and promote their public image. The commemoration of the Sforza dynasty's founder would have emphasized the continuity between the Viscontis and Sforzas, thus presenting Duke Francesco not as a usurper but as someone who had reestablished order in Milan after a short Republican period following the death of Filippo Maria, the last Visconti. Francesco's marriage to Filippo's daughter Bianca Maria legitimized his power.[9]

The first evidence of Galeazzo Maria's interest in carrying out the equestrian monument in memory of his father goes back to 1473 when, in a letter to Bartolomeo Gadio da Cremona, Commissioner of Ducal Works, the latter was entrusted with finding the workers needed for executing "the likeness of the most illustrious Lord, our father of fond memory, on horseback in bronze."[10] At that

time Gadio managed construction at the Castello Sforzesco, where, according to the Duke's intentions, the statue was to have been placed; but his search among the artists and craftsmen who gravitated around the construction site of Milan's cathedral did not bring about any convincing solutions. The only proposals received were from the son of Maffeo da Clivate and the Mantegazza brothers, the first of whom proposed to build the statue in embossed and gilded copper and the others in brass.[11] Unable to find qualified artists in Lombardy or beyond, the project entered a stalled phase that was drawn out due to the sudden death of the duke in 1476.[12]

## LUDOVICO IL MORO: LEONARDO'S FIRST PROJECT

The search for artists who were also able founders began again with Ludovico il Moro's ascent to power. We do not exactly know when Il Moro put himself in charge of the project—a gap in documentation up until 1489 inhibits us from clearly reconstructing the event—but we have reason to believe that right from the first years of his regency, Ludovico would have given attention to reviving the project. Thanks to the testimony of Sabba da Castiglione, from whom we learn that the clay model was destroyed during the French invasion of 1499, we discover that at that time Leonardo had been working on the horse for about sixteen years.[13] Therefore, we can assume that he was involved in the Sforza monument project shortly after his arrival in Milan, between 1482 and 1483. In his famous letter of introduction to Il Moro, Leonardo seems to make reference to the same period, declaring that he is capable of "taking up work on the bronze horse, which will be to the immortal glory and eternal honor of the prince your father of happy memory, and of the illustrious house of Sforza."[14] From this evidence we learn that at the beginning of the 1480s Il Moro had already taken up his dead brother's project and had begun looking for an artist who could bring the project to completion. The way in which Leonardo found out

Fig. 60  Antonio del Pollaiuolo (Italian, 1431/1432–1498), *Study for an Equestrian Monument*, ca. 1482–1483, pen and brown ink with light and dark brown wash on paper, outlines of the horse and rider pricked for transfer, 11⅛ × 10 inches, The Metropolitan Museum of Art, New York, Robert Lehman Collection, 1975 (1975.I.410).

about Il Moro's intentions is unknown, but looking at events in Il Moro's life it may be that the news had already leaked out at the end of the 1470s, when Sforza was in exile in Pisa (1477–1479) and found a way to meet Lorenzo il Magnifico several times in Florence.

In support of the theory that Il Moro was already interested in his father's monument the year after his brother's death, there are drawings by Antonio del Pollaiuolo (fig. 60) that appear to show a rearing horse version of the Francesco Sforza monument.[15] However, based on recent studies in which new documentary evidence has emerged, we can assign a different date to Pollaiuolo's drawings. Thanks to references to two replies from Lorenzo il Magnifico to Il Moro found in the Medici archives, we learn that in April 1484 a request was made to send two sculptors to Milan.[16] Unfortunately, Lorenzo's letters are lost and therefore we do not know if there was an explicit reference to the Sforza monument or which sculptors were involved. The two major Florentine sculptors at the time, Andrea del

Verrocchio and Pollaiuolo, were busy; Verrocchio was in Venice for the Bartolomeo Colleoni monument, and Pollaiuolo was in Rome for the construction of the tomb for Pope Sixtus IV. If these lost letters referred to the Sforza monument, Leonardo's involvement could not have begun before April 1484.[17] This hypothetical timeline can be partially confirmed in the recent postdating of Leonardo's well-known presentation letter to around 1485.[18] The ways and times that brought about Leonardo's involvement in the project remain obscure, but from another letter by Il Moro to Lorenzo de' Medici we learn that on 22 July 1489, Leonardo was already involved in constructing the monument:

> The Lord Ludovico has in mind to make a suitable tomb for his father, and he has already ordered Leonardo da Vinci to make the model, that is, a huge bronze horse with the armed Duke Francesco on it. And because his Excellency would like to make a work of superlative quality, he has asked me to write to you on his behalf that he would like you to send him a master or two who are skilled in this kind of work. Although he has already commissioned this thing from Leonardo da Vinci, it doesn't seem to me that one can be confident that he knows how to do it. [missing words] Commending myself to you, Pavia, 22 July 1489.[19]

This is a very important document because it signifies the first evidence of Leonardo's involvement in the project and refers to the horse as "huge." We can see that at this date Galeazzo Maria's original project, which included a life-size realization of the monument, had already been subject to changes.

Even if this letter shines no light on how Leonardo was commissioned, it allows us to single out a period of crisis when Leonardo's abilities as a caster were called into question. For some scholars, this could coincide with his dismissal from the project.[20] In fact, if we put this document alongside a note from *Ms. C*, in which Leonardo points out that on 23 April 1490 he had again begun work on the horse,[21] a period of nine months is singled out

during which the project was subjected to a radical change that brought about a complete reconsideration of the work and a new assignment for Leonardo. Correspondence between Il Moro and Lorenzo de' Medici and between Lorenzo and Pollaiuolo leads us to believe that there was a serious attempt to involve the Florentine sculptor, who at this time (and not in the 1470s) would have sent the two sketches to Milan that portray the duke on a rearing horse.[22]

One of Leonardo's two drawings proposing the same theme as Pollaiuolo's appears to date back to this period (plate 29).[23] We can imagine that Il Moro, once he saw the two artists' proposals, also saw that it was impossible for Pollaiuolo to come to Milan and decided to abandon the idea of the rearing horse for a walking one, commissioning Leonardo to do the work. If we accept this likely scenario, we can point out the monument's statics as one of the reasons that the first project was abandoned. In fact, in the drawings one can see how both artists intended to adopt a solution defined as a *ponte*, or bridge, placing the horse's front hooves on a support hidden inside a scenographic prop that could be either a fallen soldier or a natural object such as a rock or tree trunk. Leonardo's solutions, however, were numerous, and from the only technical drawing that refers to the first project we cannot exclude the possibility that Il Moro decided to abandon the rearing horse theme because he considered it to be too audacious.

From details on Windsor 12349 recto and verso, attributable to the first version of the monument (plate 30), we learn that while the project was being reworked, Leonardo was leaning toward casting the horse using a multifurnace system with the mold upside down—a scheme that he would reuse in the second project. The most important element is a drawing of the vertical section of the horse where a beam is placed on the inside, suggesting an attempt to make the monument self-supporting, free of the support under the front hooves. Some of Leonardo's drawings back up this interpretation, showing that he was trying to balance the horse's

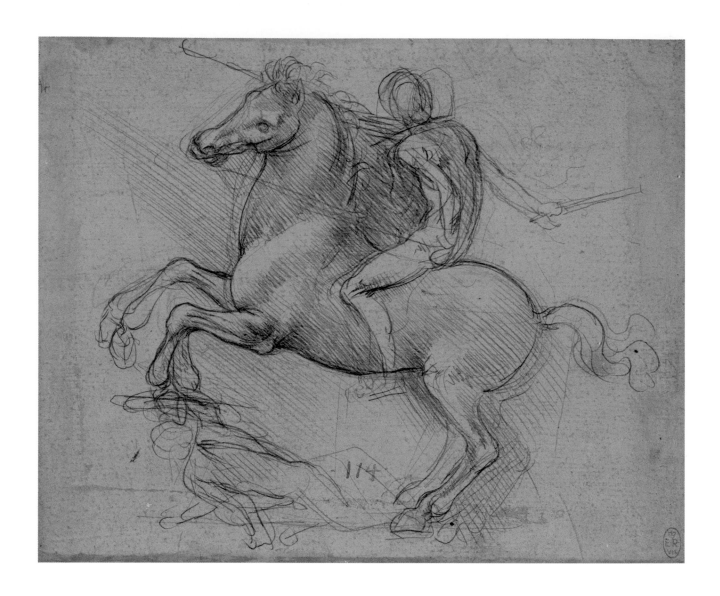

PLATE 29 **Leonardo da Vinci** (Italian, 1452–1519), *A Study for the Sforza Monument*, ca. 1488–1489, metalpoint on blue prepared paper, 5⅞ × 7¾ inches. Royal Library, Windsor Castle, RL 12358 recto.

unbalanced mass in front, lowering and moving the animal's center of gravity above the back hooves. We can especially see this effort in a drawing found today at the Bonnat Museum of Bayonne, in which the horse's joints are reduced to force lines as if the artist were trying to determine what geometric inclination to give the hooves in order to balance and support the animal's weight.[24] The same position of the hooves, with an even more drastic inclination, is also found in a bronze statuette clearly inspired by Leonardo at the Museum of Fine Arts in Budapest (plate 43). The mass's center here is also noticeably brought back and lowered; the back hooves are bent under the horse's weight and seem to form a triangle. This solution reminds us of the reticular structures that Leonardo developed in his architectural studies.[25] The flexed beam drawn in the vertical section of the horse found in the Windsor drawing can therefore be seen as a mechanical expedient for consolidating the monument's statics. Studies on the balance and relationship between the form and function of mechanical structures make up one of Leonardo's main interests in these years, and we can see the results in some of his drawings of bridges and throwing weapons[26] as well as in some of his observations on balance: the solution of the beam flexed under load shows notable analogies with the drawing of a rotating bridge that keeps its balance on only one pivot placed on the riverbank (fig. 61).[27]

Faced with the experimental nature of a solution of this kind, we should not be surprised by Il Moro's skepticism, since it concerned a life-sized monument for which well-understood and dependable techniques did not exist in the late 1400s. But if Il Moro was skeptical of Leonardo's capabilities, why did he express his faith in him? The reason can most likely be found in the fact that not many artists were capable of completing such a work; we can recall the difficulties Galeazzo Maria met in trying to track down skillful casters at the time of the project's conception. In 1489 Verrocchio had been dead for a year, while Pollaiuolo was in Rome working for the Pope. In spite of everything,

Leonardo, who was the heir of Verrocchio's art, was still considered the best choice.

## A HORSE OF COLOSSAL DIMENSIONS: THE SECOND PROJECT

It is difficult to determine if what prompted Il Moro to abandon the first project was only technical. Actually, the stylistic details of the new monument that emerge from documents in our possession make us also think of factors that we could define as sociopolitical as well as cultural. At twenty-four feet in height, the new horse was three times life-size, reflecting an ancient standard that used this size only for the portrayal of gods and emperors.[28] By accepting this solution, Il Moro's ambitions and the message he intended for Italy and Europe were clear. These went well beyond the commemoration of military virtue and the magnanimity of its leader, as in other Italian equestrian monuments created during the fifteenth century (Niccolò d'Este in Ferrara, Erasmo da Narni [Gattamelata] in Padua, Bartolomeo Colleoni in Venice), virtually elevating the founder of the Sforza dynasty to the status of an emperor or god.[29]

Fig. 61 Leonardo da Vinci, *Swing Bridge, Codex Atlanticus*, 855r, 1478–1518, pen and ink on paper, 24 × 17⅜ inches, Biblioteca Ambrosiana, Milan.

PLATE 30 **Leonardo da Vinci** (Italian, 1452–1519), *Studies for the Casting of the Sforza Monument,* ca. 1492–1493, pen, ink, and red chalk on paper, 11 × 7½ inches. Royal Library, Windsor Castle, RL 12349 recto and verso.

Johannes·antonius·dj·johannes·Ambrossius·de·bolate

Chi perde il Tempo e virtu non aquista
quanto piu pe penso Laximo piu satristo

Virtu non ha m poterebe auere chi lassa honore p aquistare hauere·

Non vale fortuna achi non safaticha · perfecto don no se senza gran pena
Coluy si fa felice cb virtu m despexa

Passano nostri triunfi nostre pompe

L agola e lsonno ellossose piume · Anno delmondo ogni virtu banata
tal cc ordel corso suo · quasi ssmarrita · Nostra natura e vinta daloostume

Ormai convien cosi cettarj spolio · Disse il maestro che ssegiendo inprima
infama nonsimen nessotto coltri · Saneb laqual custha virtu bonfuma
tal uesttigia in terra dsse lassa · Quel fumo in aria onnellacqua lassschiuma

Fig. 62 Andrea del Verrocchio (Italian, 1435–1488), *Measured Drawing of a Horse facing Left*, 1480–1488, pen and dark brown ink over traces of black chalk on paper, 9¹³⁄₁₆ × 11¹¹⁄₁₆ inches, The Metropolitan Museum of Art, New York, Frederick C. Hewitt Fund, 1917 (19.76.5).

Once the idea was conceived and the artist found who was considered capable of expressing this idea in a bronze statue, the technical aspects remained to be defined before moving on to the operative phase. On 23 April 1490, work on the second project began with Leonardo committing himself to transposing Il Moro's ambitions into a model for the new monument. Although it proposed a less audacious gait than the previous one, the monument presented unprecedented procedural difficulties because of its unusual size.

Excited by the new technological challenge that he was getting ready to face, Leonardo began a systematic study of the anatomy and proportions of the horse, which resulted in numerous life and measured drawings that, according to Vasari, were accompanied by an essay that is now lost.[30] Some of these studies, today visible in Leonardo originals found in the Royal Collection at Windsor and thanks to copies created by Carlo Urbino da Crema in the so-called *Codex Huygens* (see plates 23–25),[31] consist of measured drawings from life that portray

the anatomical proportions of the horse with linear measurements in terms of "heads" and "fractions of heads," based on a table made by Verrocchio that uses a Vitruvian measurement system (fig. 62).[32] We find a model that demonstrates Leonardo's sculptural aim in some studies of a horse in a drawing created on treated paper, today part of the Windsor collection (plate 31). A built-in scale reference is given as a "standard" that makes the conversion into life-size measurements possible.[33]

This technique for measuring the proportions can be traced back to Leonardo's Florentine training in Verrocchio's workshop. There, in 1481, Leonardo had surely helped in the studies and preparation of the model for the Colleoni monument. Some of his drawings date back to this period, likely preparatory studies for *The Adoration of the Magi*, in which a bronze horse's head, dating back to the third century BCE and then part of the Medici collection (see fig. 4), closely resembles Verrocchio's Colleoni (see fig. 96).[34] The same horse head is found in an anonymous engraving that was clearly inspired by Leonardo and possibly dates back to his first time in Milan; it could have been carried out by Leonardo's workshop in order to test the effectiveness of his relief etchings.[35] The drawings that portray the horse head (fig. 63) not only establish a connection with Verrocchio, but they also could have played a role in planning the Sforza monument. The same is true of the so-called Carafa horse head (plate 8), named for the owner to whom it was donated by Lorenzo de' Medici in 1471. It had been displayed in the San Marco garden along with the ancient horse

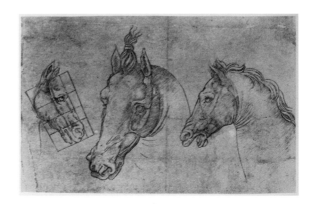

Fig. 63 Leonardo da Vinci, *Three Studies of the Head of a Horse*, 1490–1510, engraving, 4¹³⁄₁₆ × 6¹¹⁄₁₆ inches, The British Museum, London, 1874, 0711.1546.

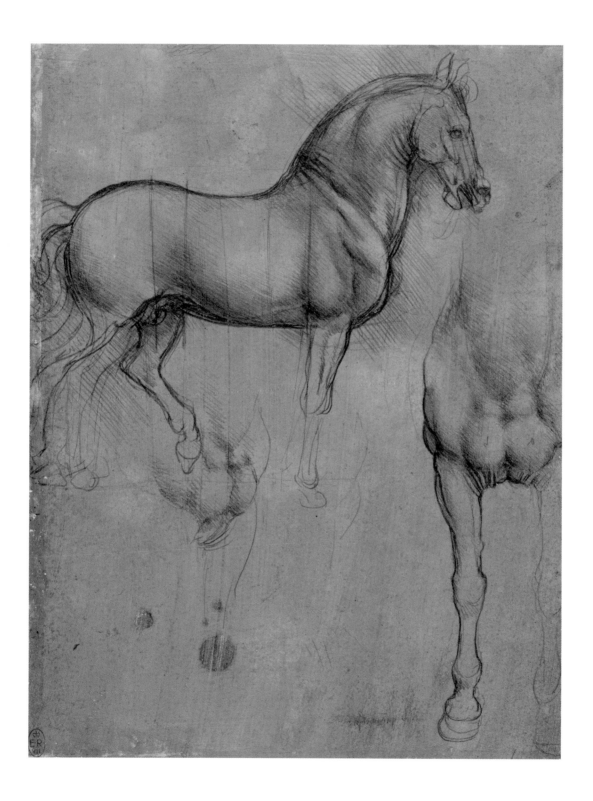

PLATE 31 **Leonardo da Vinci** (Italian, 1452–1519), *Studies of a Horse*, ca. 1490, metal-point on blue prepared paper, 8½ × 6⅜ inches. Royal Library, Windsor Castle, RL 12321.

Fig. 64  Leonardo da Vinci, *Study of the Proportions of a Horse's Head*, black chalk on pink prepared paper 10⅞ × 7¾ inches, Royal Library, Windsor Castle, RL 12286r.

Fig. 65  Leonardo da Vinci, *A Horse in Left Profile, with Measurements*, ca. 1490, metalpoint on blue prepared paper, 12¾ × 9⁵⁄₁₆ inches, Royal Library, Windsor Castle, RL 12319.

head.[36] The size of the Carafa head, most likely created in Florence in the Renaissance, reaches about two meters (6½ feet) in height, an order of magnitude very close to that of the Sforza monument.

Studies of the horse's proportions helped Leonardo make noticeable progress in creating two-dimensional portrayals that could be transposed into sculpture. In the oldest drawings, clearly inspired by Verrocchio, the horse is portrayed in frontal and profile views in which its outer morphological lines are shown (figs. 64–66).[37] Afterwards, perhaps as he was working on the clay model of the horse, Leonardo seems to have noticed that in order to transpose it from a natural to an artificial state, the measurements obtained from its frontal and lateral views were not sufficient, since they do not reproduce the model's volumetric variations

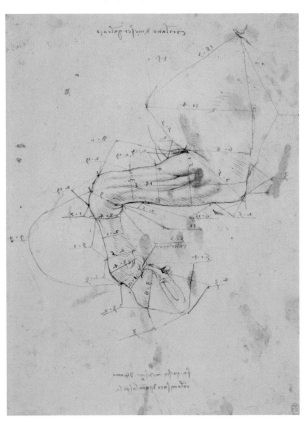

Fig. 66  Leonardo da Vinci, *A Horse's Left Foreleg, with Measurements*, ca. 1490–1492, pen and ink over charcoal, 9¹³⁄₁₆ × 7⅜ inches, Royal Library, Windsor Castle, RL 12294r.

with accuracy. In order to overcome this limitation, Leonardo developed a drawing technique (see plate 26), applied thereafter in his illustrations of human anatomy (see fig. 47), using the two-dimensional portrayal of the object in a sequence of various points of view, as if the observer rotated around it. In this way the drawings are no longer limited to reproducing only the model's outlines. In addition, the appropriate amount of chiaroscuro gives thickness to the body by highlighting anatomical details that, along with sequential drawings, give the sculptor numerous visual references for transferring the model from the drawing's two dimensions to the sculpture's three dimensions. An example of this technique can be found in a study of the front limb of a horse reproduced in a series of four different viewpoints that describe a 180° turn around the hoof (fig. 67).[38] By integrating the two-dimensional drawings along with the sequential depictions, the sculptor was provided with the necessary tools for mentally reconstructing the three-dimensional object and transferring the shapes onto the sculptural model.

The morphological study of the horse and its pose kept Leonardo busy for several months during which he studied horses in the Sforza stalls, as is made clear from surviving drawings.[39] An important moment that could have played a determining role in the model's conception seems to have been Leonardo's inspection with the Sienese engineer Fran-

cesco di Giorgio of the construction site at Pavia cathedral in June 1490. During Leonardo's stay in the city he was able to see the famous *Regisole* equestrian monument, a Roman statue dating back to the first century (and destroyed in the eighteenth century during the upheaval following the French Revolution). Among the folios of the Windsor collection, Carlo Pedretti came across a drawing of a horse on a piece of paper associated with the Pavian equestrian sculpture (fig. 68), torn from a sheet in the *Codex Atlanticus* on which Leonardo had written brief notes while thinking about the model he was working on at that time in Milan:[40]

Regarding that [horse] in Pavia, one praises its movement above everything else. The imitation of ancient things is more praiseworthy than that of modern ones. Can there not be beauty and utility as appears in fortresses and in men? The trot is nearly the attribute of the free horse. Where natural vivacity is lacking it is necessary to make an accidental [out of the ordinary] one."[41]

The rhetorical question of the relationship between beauty and usefulness, which apparently does not refer to the horse, can be traced to the twenty-second book of *The City of God* by Saint Augustine, likely one of Leonardo's sources,[42] where he reflects on the relationship between form and function in the anatomy of the human body.[43] Such a relationship is also at the foundation of

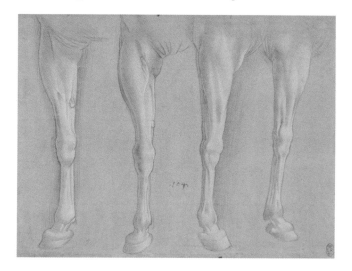

Fig. 67 Leonardo da Vinci, *Study of a Horse's Foreleg, Seen in Four Different Views*, silverpoint, heightened with white (some of which has been oxidized) on buff paper, 6¼ × 8⅛ inches, Royal Library, Windsor Castle, RL 12297r.

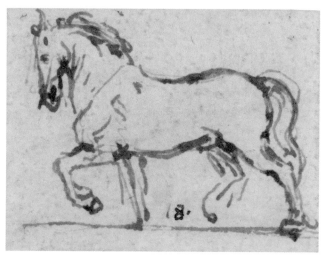

Fig. 68 Leonardo da Vinci, *Pacing Horse* (probably the first conception of the model for the Sforza monument), pen and ink on paper, 1⅛ × 1⁷⁄₁₆ inches, Royal Library, Windsor Castle, RL 12345r.

Fig. 69 Leonardo da Vinci, *Clay Model of the Sforza Monument inside the Armature for Transport*, *Codex Atlanticus*, 577v, 1478–1518, pen and ink on paper, 24 × 17⅜ inches, Biblioteca Ambrosiana, Milan.

Leonardo's own anatomical studies. Leonardo's clear reference to form and function in the Pavia monument underlines the problems that one faces in planning a statue where aesthetics and engineering solutions must be integrated. Leonardo had to consider gait, size, and other parameters on technical as well as political, social, and aesthetic levels.

In the final step Leonardo thought about how to give a monument animation. He stays on a general plane and perhaps wants to say that in order to convey liveliness in a statue one must intervene with secondary details that give a sense of movement, such as the kind of gait, the distribution of weight on the legs, and the wave of the mane.[44] Nevertheless, if we interpret the term "accidental" according to its meaning at the end of the fifteenth century, we have to refer to it not as "artificial" but as "out of the ordinary." Thus it is possible to read this step in a different manner, no longer as a general assertion, but as a direct reference to the *Regisole* and implicitly to the Sforza monument. The horse in the Pavia monument was pacing, a gait for parades that the animal acquired only through training, a walk that is out of the ordinary. If we look at the drawing of the horse related to this note, we notice that unlike the *Regisole*, it has a natural gait and therefore, as

Carlo Pedretti pointed out, it could be the first idea for the model of the Sforza monument.[45]

Once the horse's movement was defined and before creating the model, it was timely to study the monument's statics. Unfortunately, the lack of a final drawing keeps us from knowing exactly which solution Leonardo chose. In spite of the few references to this problem, we can advance some convincing theories. Initially, as it emerges from the only model drawing in our possession (fig. 69), Leonardo seems to have been thinking of using supports inserted inside props that were to be placed below the hooves of the two legs raised off the ground (an amphora and a tortoise), so as to transfer the weight of the horse onto four points of the base.[46] Subsequently, as seen from the drawings and notes in *Codex Madrid II*, he aimed at a more audacious solution that included the creation of a self-supporting monument free of an internal structure, only supported by the two legs in solid bronze. In this second case, which seems to have been the definitive solution, Leonardo planned to cast the monument directly with a bronze base in order to make a closed ring with the legs: an empirical solution that allowed him to compensate for the strain caused by the enormous weight the legs were subjected to.[47]

In May of 1491 Leonardo began to gather up his notes and thoughts regarding the casting process of the horse in a notebook now bound into *Codex Madrid II*. We can presume that the model was finished about a year after the trip to Pavia and that Leonardo was about to build the casting mold and prepare the foundry. As Martin Kemp revealed, the disordered series of notes that make up this notebook belong to a collection of mental experiments and offered the possibility of numerous interpretive hypotheses that could not be solved in the codification of a single production cycle.[48] Leonardo's doubts mainly concern controlling the molten metal during casting, whereas for building the casting mold it is clear that he intended to adopt an indirect casting technique based on the piece-mold method.

## ARTISTIC CASTING IN THE 1400S AND THE ORIGINS OF LEONARDO'S CASTING TECHNIQUE

The direct investment casting method is a very versatile technique that has serious limitations when artifacts of considerable size are to be cast. Modeling the wax over a clay core that was only sketched out does not make it possible to check the thickness of the bronze and consequently causes a substantial increase in weight and production cost. The variation in the thickness caused by manual wax modeling leads to nonuniform cooling of the bronze, creating superficial flaws and holes that force the artist to perform new partial castings and significant coldwork repairs in order to reach the desired quality of finish; the analysis of some of Lorenzo Ghiberti's statues made with this method show evidence of chiseled interventions more than one centimeter thick.[49]

The indirect lost-wax casting method based on the piece-mold technique requires the creation of a casting core derived from a negative outer mold. The outer mold is made by taking a piece-mold impression of the original model and then reassembling the pieces. A wax film is then applied to the outer mold equal to the thickness that the bronze should be. Once the wax solidifies, construction of the casting core is started by filling the empty space with a mixture of refractory clay suitable for resisting thermal and mechanical strains during casting.[50] In this way, after having removed the external negative outer mold, we obtain a core that is an exact copy of the model, reduced by the thickness taken up by the wax. For its part, the outer surface of the wax corresponds exactly to the outer surface of the original model. Bronze spacers are then inserted in suitable places into the wax surface to keep the core in place within the outer mold after the wax is melted out. Then the casting mold is built with foundry clay on the wax surface. Use of this indirect casting method makes it possible to save the original model, which can then be reused as a reference for finishing the casting or for performing other castings. Moreover, in this way it is possible

to obtain lighter, less expensive castings with fewer surface defects. These factors are essential when the intention is to perform one casting for a monument of colossal dimensions as Leonardo aimed to do.

Although the notes on casting the Sforza horse make up the earliest reference in our possession on the reintroduction of indirect casting, it is still difficult to establish whether Leonardo was actually the first craftsman to adopt this technique or if he limited himself to perfecting an evolved method of traditional Florentine sculptural production. Casting techniques had made considerable progress during the fifteenth century, thanks to craftsmen such as Ghiberti, Donatello, Brunelleschi, Pollaiuolo, and Verrocchio.

In order to understand the artistic fervor that animated cities like Florence, it is worth remembering the competition for making the East Doors (now the North Doors) of the Baptistery in Florence. It seems that one of the primary evaluation criteria used by the selection committee was casting technique. Ghiberti's prototype, created in a single casting with only seven kilos of bronze, won over Brunelleschi's, which was created with multiple castings and about twenty-five kilos of bronze.[51] We do not know if Ghiberti used an indirect casting method, but his propensity for obtaining ever-thinner casts makes it seem at least possible that he came close to this method.

The same thing can be said for the panels cast by Donatello for the old sacristy doors at San Lorenzo in Florence. Analysis has revealed that they were done in *lega campana*, or bell alloy, a bronze with a high tin content that is very hard and fragile when cold, and therefore not ideal for heavy mechanical finishing. However, from a metallurgical viewpoint, it is characterized by extreme fluidity in a liquid state, making it suitable for reproducing thin, very complex casts. We do not know the casting technique Donatello used, but the technical characteristics of the bell alloy suggest the indirect casting method and the panels offer evidence that already in the first half of the fifteenth century it was known that the cause of surface deformations in casts could

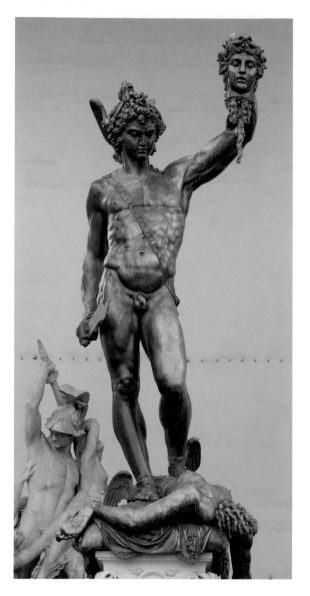

Fig. 70  Benvenuto Cellini (Italian, 1500–1571), *Perseus with the Head of Medusa*, 1545–1554, bronze, 18 feet high, Loggia dei Lanzi, Florence.

be attributed to uneven thickness, which affected the shrinking of material during solidification.[52]

Even more significant was the experience of Verrocchio, who in the years preceding Leonardo's departure for Milan performed a single casting of the *Christ* and then *St. Thomas* (see fig. 1). The casting technique is not documented here either, but as in the previous case it is possible to exclude the use of an indirect method from analyses performed on the work.[53] Even Vasari's testimony about Verrocchio ("having made models and forms, he cast

them; and they came out very strong, complete, and well made")[54] does not help us conclude that the *Christ* and *St. Thomas* were cast with the indirect casting technique, because the models could have been intended as preparatory studies or built-to-scale reproductions for remembering the original model that was lost in casting. Creating reduced-scale models was common practice, regardless of the casting technique used. In this respect we can think of Benvenuto Cellini, who created some wax and bronze models of his *Perseus* (fig. 70)[55] and, after initially thinking he would proceed with an indirect casting, changed his mind and opted for the traditional method because it was easier to carry out.[56]

With the affirmation in the Florentine competition of Ghiberti's casting technique over Brunelleschi's, casting in a single piece became the ideal, as is seen later in Verrocchio's *Christ and St. Thomas* and Cellini's *Perseus*.[57] Leonardo, then, chose to attempt a single cast for both intellectual and technical reasons. It is possible, in fact, that the reasons that led him to spend considerable time perfecting the casting method must be looked for not so much in the colossal size of the Sforza monument—which could have been cast in multiple parts with well-tested foundry equipment—but in Leonardo's obstinacy in wanting to make the horse *in un sol getto*, in a single casting. In the attempt to achieve this goal Leonardo developed a procedure that seems to be the result of integrating the traditional artillery casting method, which included the use of modular molds and partially permanent models,[58] with the modeling method recalled by Pliny and Pomponio Gaurico,[59] used in ancient times for reproducing statues and life portraits in plaster.[60]

If Gaurico can be cited as only a contextual source, since his *De sculptura* dates from the beginning of the 1500s, Pliny's case is different. His work could have played a determining role in encouraging Leonardo to experiment with an alternative to the direct casting technique. In fact, in the thirty-fifth book of his *Natural History*, where the technique of

plaster casting is explained, Pliny states that "Lysistratus of Sicione, brother of Lysippus, was the first to invent the casting technique for taking portraits from life. He also invented the technique for reproducing casts of statues and it was so successful that no bronze or marble statue was done without first making a clay model."[61] As we know, Leonardo owned a copy of the *Natural History*, translated into the vernacular by Cristoforo Landino,[62] from which he could have gotten the idea to transfer the plaster cast technique to bronze casting.[63] We can also presume that Leonardo had learned the plaster cast technique directly from Verrocchio, who, as Vasari tells us, specialized in producing models for drawings and sculptures, taking their form directly from "natural things."[64]

The uniqueness of Leonardo's casting method resides in its reuse of piece molds as matrices. Also, he does not use wax for the body. For this reason the outer mold had to be planned in two separate halves so that it could be reopened after the construction of the casting core. At first glance this operation might be understood as an attempt to lighten the mold and make it easier to move, as well as to facilitate the firing.[65] The idea of conceiving a mold in two halves can be traced to goldsmithing at the end of the fifteenth century, when it was apparently being used to produce objects with simple silhouettes, such as small bells. However, it is important to emphasize that Leonardo's molding technique shows more than one similarity to his thoughts on the transformation of forms in nature, particularly his explanations for the formation of fossils. They share the general principle of a mold understood as a universal outer mold that underlies their process of creation: after the decomposition of the mollusk, the shell is progressively filled with a "petrifying viscous humor," which, pushing air out through the porous sides of the shell, entirely fills it. Just as in bronze casting, the viscous humor solidifies and turns to stone, leaving the mollusk's impression.[66]

Leonardo's observations on fossil generation date from a period after the Sforza horse project

and it is therefore difficult to establish their relationship with his inventing the casting method. Still, it is important to point out a note in the *Codex Leicester* in which Leonardo remembers the multitude "of worm-eaten shells and corals hanging on rocks" that were brought to him by some peasants while he was working on the "Horse of Milan."[67] Although this reference does not provide sufficient proof, it does indicate Leonardo's interest in fossils in the period when he was working on the casting mold of the Sforza horse.

Lacking sources that clearly illustrate the steps leading to the renewal of casting methods, this documentary evidence helps shed light on the complex technical scenario at the end of the fifteenth century and underlines Leonardo's originality. Even if we cannot credit him with reintroducing this method, we must at least acknowledge that he described it for the first time. What seems certain is that his taste for a technological challenge, going where no one else had dared to push himself to that moment, stimulated Leonardo to develop new techniques and equipment for facing unprecedented technical problems. Casting a statue of colossal dimensions led Leonardo to reconsider the entire foundry system: the dimensions, the number and type of furnaces to use, the system for firing the molds, the bronze's gating network, the research and experimentation of new casting clay mixtures, and finally—the problem that troubled him most up until the moment he abandoned the project—the placement of the casting mold within the pit.

The notes and drawings found in the notebook bound into *Codex Madrid II* constitute a series of mostly separate annotations that do not allow the reconstruction of a single working plan. However, Leonardo does furnish enough information about the casting mold to allow a reconstruction of the phases of the entire casting process.

## BUILDING THE CASTING MOLD

After having created the horse model (reconstruction I), the first step for creating the casting mold is to take a piece mold, from which the casting core or "male," as Leonardo calls it, can be made. Leonardo says to first spread two layers of ash on the model, which are necessary for creating a cushion of friable material that favors the piece mold's subsequent detachment.[68] Then layers of clay are spread:

> First make the thickness [of the mold] that goes inside from the irons. And before placing the irons, cut up the mold in as many pieces as you please and prop up the parts that might fall down. But before starting work on the mold, mark the shape and alignment of the cutting with nails. And you shall let the nails stand out as far as you wish the thickness of the mold to be when ready for cutting.[69]

The nails provide references for later cutting the piece mold and for checking the uniformity of the applied clay's thickness (reconstruction II). During this phase, wax cones are also placed on the blanket of clay in order to create anchoring points for vents and sprues.[70]

The layers of clay applied to the model are made with a mix of different clays.[71] The first three are made of a fine granular blend of earth, coarse river sand, ashes, ground brick, egg white, and vinegar [terra, sabbion di fiume, cienere, maton pesto, chiara d'ovo e acieto],[72] in order to obtain the most compact and uniform surface possible for coming in contact with the bronze. The outside layers, instead, are designed to give body and strength to the piece mold. They are made up of mixtures that contain stronger binders and animal and vegetal fibers: "On the first third or fourth of the outside of the mold, you shall work with earth mingled with cow hair, and before finishing, take cow hair, hemp, and earth, and adding some glue, apply a layer of hemp on each layer of earth, once upright and once crosswise; finally, apply the sheets and the other irons."[73] It is not easy to discern the number and thickness of these layers, but from another entry

in *Codex Madrid II*, where Leonardo illustrates an experiment for testing the resistance to heat of the piece mold reinforced with iron bands, we learn that the overall thickness of the mold must be about one-third arm's length (about eight inches).[74] Before the last layers of clay are spread, pieces of bent iron are applied to the exterior. They are necessary for firmly assembling the piece mold.[75] The piece molds for the legs are made in the same way, with the only forethought being to make "a mold of three parts for each roundness of any of the limbs; it will be much easier to detach it from the earthen horse."[76]

After having marked and dismantled the piece mold (reconstruction III) the next step is the shaping of their edges. This process is necessary because the mold, besides being used to transfer the form from the model, will also be used for casting and therefore has to prevent bronze from penetrating the joints of the piece mold. In order to further guarantee adhesion, Leonardo dug joinery dovetails on the external border of the pieces, to be filled with plaster after the pieces are assembled.[77]

Once they are finished, the pieces of the mold are reassembled for building the outer mold, created in eight distinct sections: one for each leg, another for the horse's body divided into two halves, one for the head, and another for the tail.

Leonardo proceeds, ideally dividing the horse's mass into four parts, each presenting different constructional problems. The legs had to be made in solid bronze and did not need a core, so the mold could have been prepared directly for casting. The tail was shaped with a special core in order to lighten it greatly and allow it to be realized as a separate casting. For the body and head, Leonardo instead develops two distinct molding methods.

For the body, the outer mold is first built and divided into two halves[78] that will serve as negative space for creating the casting core. In order to reduce the volume within the outer mold and create a positive space to take the bronze, Leonardo does not use wax as in the traditional solution, but a fine-grained clay—*terra da boccali*, literally

Fig. 71 Leonardo da Vinci, *Entire Armature of the Casting Core, Codex Atlanticus*, 1104v–r, 1478–1518, pen and ink on paper, 24 × 17⅜ inches, Biblioteca Ambrosiana, Milan.

Fig. 72 Leonardo da Vinci, *Casting Mold of the Head and Neck, Codex Madrid II*, 157r, 1490s, pen and ink on paper, 8¼ × 6 inches, Biblioteca Nacional, Madrid.

"pitcher clay." Once the core is finished and the mold reopened, the clay is chipped away.[79] The reasons that led Leonardo to use clay can be found in the lower cost of this material and the ease in locating it.[80]

Once the clay is spread and dried inside the outer mold, ash or grease is scattered over it and the casting core is built. Some layers of fine foundry clay are spread over the two halves in order to obtain the most compact and uniform surface possible to be in contact with the melted bronze (reconstruction IV). A metal skeleton is mounted on one of the two halves (reconstruction V), and then they are closed in a vertical position (reconstruction VI–VII).[81]

Access to the internal core is possible through a specially formed opening left on the horse's back to allow continuous filling with brick powder, ash, or plaster (reconstruction VIII).[82] To facilitate movement and assembly of the core inside the mold, the core will be left empty in this phase to reduce its weight to the greatest extent possible.

The front part of the core will be molded so as to let two rings come out that will be connected to the internal metal structure, where the head will then be anchored at the time of assembly (fig. 71). Using chisels, wedges, and a machine designed to raise and rotate the halves,[83] the outer mold will be opened into two parting halves, freeing the perfectly molded casting core (reconstruction IX).

Leonardo developed a different molding technique for making the head (reconstruction X). Here the outside of the outer mold and the core (Leonardo's "male") are made simultaneously. Because the head mold will not be reopened, the space needed for the bronze will be done in wax. After the wax film is spread on the inside of the outer mold, the pieces are recomposed from the bottom up, filling the outer mold with clay in order to obtain a complete casting core. During the filling, the inside armature will be put in place, as will appropriate bronze spacers, which will be used to keep the core centered inside the mold once the wax is removed. The molding procedure for the head will conclude with the uppermost piece mold, a procedure for which Leonardo describes a special technique that consists in continuously checking the relationship between the outer piece mold and the core (fig. 72), using the uppermost piece mold as "a reference plug."[84]

I. Full-scale clay model of the horse.

II. Piece mold on the clay model.

III. Parts of the piece mold detached from the clay model.

IV. Foundry clay spread inside the mold to form the outside of the casting core.

V. Skeleton of metal bands inserted to reinforce the core.

VI. Closing of the two halves of the mold in preparation for creating the casting core within them.

VII. View of the two halves joined together with the metal reinforcement skeleton inside.

VIII. The interior of the joined halves thickened, leaving the center hollow.

IX. The piece mold opened and the core removed.

X. Parts of the exterior mold of the head and the metal reinforcement of the casting core within it.

XI. Smelting furnaces and casting pit.

XII. Hollow casting core positioned over half of the casting mold inside the casting pit.

XIII. Lowering the other half of the casting mold over the casting core.

XIV. Vertical section of the mold showing runners, explosive sensors, vents, and the core being filled.

XV. Complete mold in the casting pit with the head and legs attached.

XVI. Mold plastered and reinforced, with sprues and vents in place.

XVII. Casting pit partially filled.

XVIII. Cross-section of the foundry with the mold in the pit, ready for casting.

XIX. Position of furnaces and channels for directing molten bronze to the casting mold.

XX. Reverberatory furnace and two chambered manual bellows.

XXI. Explosion of firework sensors that signal the level at which the bronze has arrived inside the casting mold.

XXII. Bronze horse in the casting pit after the casting mold has been removed.

XXIII. Cast bronze horse in front of the foundry.

Before the final assembly on the inside of the casting pit, the mold sections must be fired. For this procedure Leonardo plans to specially heat the ground with buried furnaces:

> I see no other way than to lower the ground until the whole height of the furnace goes underground, after which, fill out and level the ground between the furnaces. You can handle your mold and burn it on this plane, and in this way, your furnaces will be erected into their permanent places. Once completed, remove the soil under the mold and lower it to its place, otherwise you might not be able to manage yourself because of the low ceiling. And I consider this the last and best course of action, and make rafters covered by earth over the furnaces in order to avoid deterioration.[85]

In another entry in his notebook, perhaps worried about the excess weight and fragility of the various sections of the mold not yet reinforced, he seems

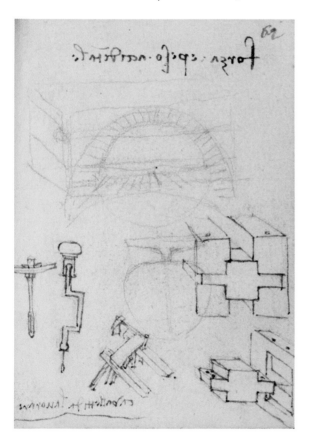

Fig. 73 Leonardo da Vinci, *Casting Furnace, Codex Forster III*, 31v, 1487–1505, pen and ink on paper, 3½ × 2⅜ inches, Victoria and Albert Museum, London.

to opt for firing them inside the casting pit during assembly.[86] Since the outer mold was also to be used as an outer covering, it had to be baked to keep the heat from damaging the organic components (hemp clippings) found on its exterior. Leonardo seems inclined to expose only the internal surface to the fire.[87] The core does not contain any organic material in its make-up and so it will be baked from the inside and outside.[88] We have no references for the head and legs but such a procedure for them should likely be executed above the heated ground to keep from exposing them to live fire, so as not to burn the hemp found in the outermost layers.

When Leonardo left Milan in 1499, he must have been ready to carry out the casting for some time. In a letter to Il Moro dated 1495, in which he complains about Il Moro's financial shortcomings, he says: "Of the horse I will say nothing because I know the times [del cavallo non dirò niente perché cognosco i tempi]."[89] Something had changed and the slowdown of the work was no longer due to practical difficulties but to outside obstacles. The previous year, in fact, with Charles VIII's descent on Italy, Il Moro's priorities had suddenly changed. Alarmed by the ease with which the French troops had crossed the peninsula, he decided to send the bronze collected for the monument to the Ferrara arsenal for making new cannons.[90] Deprived of materials, work on the horse stalled and never resumed.

We can presume that in 1494 the casting sections were finished and Leonardo was working on the preparation of the casting site (reconstruction XI). Two drawings of furnaces (figs. 73–74) appear to date to this period—one in the *Codex Forster III*[91] and the other in *Ms. H*[92]—that present strong similarities with the ones in *Codex Madrid II*. Also, Carlo Pedretti pointed out a drawing of a plan of the castle in Milan in *Ms. H* (fig. 75) which shows the ravelin that, according to Galeazzo Maria Sforza's original project, was to host the monument.[93] On the following page, half-covered by the drawing of a mechanical device, there is an equestrian sketch on a low pedestal that could portray the Sforza monument.[94]

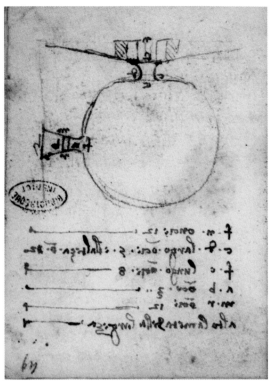

**Fig. 74**  Leonardo da Vinci, *Reverberating Furnace with Circular Casting Chamber*, *Ms. H*, 97r [45v]–96v [46r], Institut de France, Paris.

**Fig. 75**  Leonardo da Vinci, *Plan of the Sforza Castle in Milan*. Visible on the right, under the mechanical device, is an equestrian monument model whose base resembles the Sforza horse. *Ms. H*, 111r [32v]–110v [33r], Institut de France, Paris.

Fig. 76 Leonardo da Vinci, *Machine for Transporting and Turning Over the Casting Mold, Codex Madrid II*, 154r, 1490s, pen and ink on paper, 8¼ × 6 inches, Biblioteca Nacional, Madrid.

Fig. 77 Leonardo da Vinci, *Assembly of the Mold inside the Casting Pit*, ca. 1494, pen and ink with red chalk over silverpoint on white prepared paper, 5⅛ × 6 inches, Royal Library, Windsor Castle, RL 12348r.

## CASTING THE MONUMENT

As early as the time of the first project, Leonardo seemed inclined to perform a vertical casting but, perhaps when the casting pit was dug, he realized that the water-bearing stratum of the ground around Milan would not have permitted the complete burial of the mold and that being immersed in water would have risked the mold's integrity.[95] The impossibility of obtaining perfect water resistance led Leonardo to consider casting the mold horizontally.[96] Under those circumstances, the casting pit would have been only ten to thirteen feet deep, leaving sufficient space to make flooring out of refractory materials or sun-dried earth to preserve the mold.

Casting the mold in a horizontal or vertical position involves distributing the casting vents and sprues differently. With a gravity casting method—the bronze filling the mold from above—the vertical procedure would have offered a better guarantee for filling up the mold. This method made it easier to put reentry cones in the *materozze*, or casting cups.[97] The casting cups were needed because of solidification and to gather the gases generated by the molten metal and any residual dampness coming from the mold. The negative aspect of horizontal casting concerned the moment of pouring, during which the bronze ran level for long horizontal stretches. Sudden cooling would have kept the mold from filling correctly.[98] Moreover, the presence of undercuts due to the horse's shape made it difficult for the gas bubbles to rise and made it necessary to install a more complex venting network. If we try to imagine the horizontal casting mold, it is easy to identify some crucial points highlighted by Leonardo himself, such as the juncture of the legs with the body and base, where the difference in thickness would have produced a nonuniform solidification and different shrinking of the material, causing holes and surface defects.[99] Leonardo intended for the monument to be self-supporting and hold itself up on its solid bronze legs, so a casting defect would have compromised the statue's stability. Leonardo did not come to a final solution, and even after

20 December 1493, when he sealed his resolution "to cast the horse without tail and lying on its side [gittare il cavallo senza coda a diacere],"[100] he continued to develop both processes.

The problem that most conditioned Leonardo's choices was damp residue coming out of the casting mold, and we cannot rule this out as the reason that led him to the idea of an openable, two-part outer mold to facilitate drying the clay and to favor the firing. Water on the inside of the mold would generate vapor bubbles that could cause air holes in the bronze and cracks and fractures in the external outer mold, risking the final outcome of the casting.[101] To control the production of steam during casting, Leonardo designed a hollow casting core to form a condensation chamber attached to the outside through a chimney (reconstruction XII).[102]

The casting is the most delicate stage of the entire procedure. It is an irreversible act that cannot be interrupted without compromising the final result. Leonardo proceeded cautiously, planning experiments to test the behavior and resistance of the material placed under thermal mechanical strain: "First, make an earthen piece-like mold. And once burnt, treat it with resin or oil. Then allow it to stay 3 days underground. Afterwards, cast your bronze in it. You will also try with gypsum and have it treated with resin, as described above."[103] This brief note has never been given appropriate attention, but it is important in quantifying the amount of time Leonardo had in mind for the casting process: three days, in fact, could have been the maximum time expected for the entire process, including assembly, locking, and burying the mold. Leonardo also planned to create a miniature model of the system,[104] built to scale for the displacement and encumbrance of the site's machinery and perhaps to offer tangible proof of his project's validity to Il Moro.

Still thinking of how to render the casting mold waterproof, Leonardo decided to re-test Greek pitch and oil-based paints[105] and to see if the "fresh gypsum slaked with vinegar, wine, spirit of wine, or lye [gesso fresco stenperato con aceto, o vino, o acquavite, o lissciva]" resisted casting. In this way, he could have avoided firing,[106] which required strong reheating that could have altered the mold's integrity, especially at the points of contact with the iron armature.[107] Even if we are unable to say whether these tests were carried out, they show that Leonardo did not limit himself to technical solutions already worked out through experience, but boldly moved forward on his project and forced himself to look for innovative materials and equipment.

The documentation in our possession does not enable us to establish whether Leonardo had decided to cast the horse vertically or horizontally, but the fact that both in the notebook attached to *Codex Madrid II* and in the Windsor folios he only describes the mold's closure technique horizontally leads us to believe that he had decided on the second option and therefore considered the solution to the water infiltration problem to be horizontal pouring.

After baking the mold, he first positions the lower half, using a machine specially designed for transporting and turning over the halves inside the pit (fig. 76). The mold is set down on a brick support designed to give the workers free access to the underlying parts.[108] Subsequently, the casting core, which is equipped with special spacers for helping center it inside the mold, is lowered onto that half of the mold (fig. 77).[109] Finally, the mold is closed by lowering the other half into the pit (reconstruction XIII): "Once the mold is burnt, and you wish to put it together again, smear the joints with a paste made of either turpentine or linseed oil or egg

Fig. 78 Leonardo da Vinci, *Cross-section of the Casting Mold*, showing the cavity and the system for closing valves on the core, *Codex Madrid II*, 145r (detail), 1490s, pen and ink on paper, Biblioteca Nacional, Madrid.

Fig. 79  Leonardo da Vinci, *Casting Mold Section*, a schematic view of the cavity and the sprues for the bronze, ca. 1493–1494, pen and ink on stained white paper, 10¾ × 7⅝ inches, Royal Library, Windsor Castle, RL 12351v.

Fig. 80  Leonardo da Vinci, *Apparatus for Vertical Casting*, *Codex Madrid II*, 149r, 1490s, pen and ink on paper, 8¼ × 6 inches, Biblioteca Nacional, Madrid.

white compounded with brick powder. And once you have smeared the joints, close the mold forcefully, using your iron wedges."[110] Two concentric armatures, both made with three ribs, were planned for closing the two halves of the outer mold (fig. 78), one walled in on the inside of the core during its construction and the other inserted externally into the two halves in such a way that they could be united with the core by bolts, ensuring the rigidity of all the parts making up the mold.[111]

After closing the mold, filling of the casting core begins through the aperture on the horse's back (reconstruction XIV), with "ground brick or ashes, or if you prefer, gypsum or, better still, lime powder moistened a little with linseed oil in order to secure the compacting of the earth. Besides, you shall burn the core well, inside and out, and I wish to remind you that any trace of humidity would be the cause of a great error."[112] The head and leg

molds are attached at the same time (reconstruction XV), followed by the assembly of the sprues and vents (reconstruction XVI). Then the entire mold is sealed with plaster (fig. 79).[113] The pit is filled with sun-dried earth (reconstruction XVII) and is then packed down to give it greater resilience to the metallostatic push of the molten bronze.[114] Finally, once the ducts of refractory material that go from the furnace mouths to the pouring sprues are in place (reconstruction XVIII), we are ready to perform the casting.[115]

The choice between horizontal and vertical casting is reflected in the number, type, and placement of the furnaces. In the drawing where a vertical solution is illustrated, for example, it seems that Leonardo planned to build four furnaces to place on the edges of the casting pit (fig. 80). However, only one of these is fully detailed, leading us to think that this is not a final solution but a series

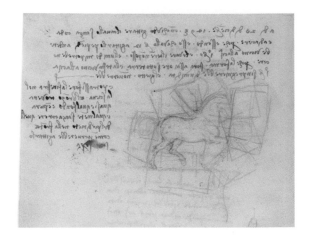

Fig. 81 Leonardo da Vinci, *Study on the Number and Placement of the Furnaces, with the mold placed horizontally in the casting pit, Codex Madrid II*, 151v (detail), 1490s, pen and ink on paper, Biblioteca Nacional, Madrid.

of sketches made to capture graphically what was taking shape in his mind. If the four sides were closed, as the drawing would lead us to believe, it would be impossible to work with the machine that transports and turns over the mold; one side needs to be free for entering the pit. Neither can we assume that the furnaces were built during or after burying the mold, because it would have required too much time, which—in a damp environment, particularly in vertical casting—would have risked the mold's integrity. An attempt to solve this problem can be seen in a note in *Codex Madrid II*, where Leonardo considers building a moving furnace on rails,[116] but this seems like a difficult solution to realize, since the furnaces were of considerable size and moving them during the procedure would have been extremely difficult. The hypothesis of three furnaces (reconstruction XI and XIX) is more logical and seems to be closer to Leonardo's approach: "Each furnace that delivers bronze to the body of the horse must hold the corresponding quantity of bronze. And the furnaces that fill the body and the legs shall have more. And the furnace that feeds the neck, head, chest, and legs, shall have still more, and this happens if you cast with the feet up."[117]

Although the number is not given here, we believe that the supposition of three furnaces is legitimate. In fact, if we integrate this step with the drawing of the machine for lowering the mold

Fig. 82 Leonardo da Vinci, *Study for Placing the Mold inside the Casting Pit*, ca. 1492, pen and ink on stained white paper, 11 × 7⅞ inches, Royal Library, Windsor Castle, RL 12350r.

into the pit, the placement of the furnaces is mandatory: one on the side, one at top for feeding the front part of the mold, and one at the back. In support of this theory, or at least as proof that Leonardo had considered this possibility, reference can be made to a note in the *Codex Trivulzianus* where he states that "one could make the large cast of one hundred thousand pounds with 5 ovens with XX thousand pounds for each or up to more than XXX thousand pounds."[118] In this entry he explicitly describes his intention of using five furnaces, but he implicitly alludes to the possibility of using three (each having a capacity of more than 30,000 pounds). The note takes on special importance if read as an attempt to solve the casting problem for the Sforza monument: five could have in fact been the number of furnaces planned for the horizontal casting and three for the vertical.

Two other indirect references to the three-furnace solution can be found in the works of Vanoccio Biringuccio[119] and Francesco de Marchi.[120]

Biringuccio's notes are particularly interesting because he could have learned the news straight from the artistic circles of Milan during his stay there in 1508,[121] or even in Siena at the beginning of 1503, during a visit from Leonardo.[122] De Marchi, however, seems to have borrowed his information from Biringuccio.[123]

The three-furnace solution seems preferable even in horizontal casting for the same logistical reasons. However, in this case, the system feeding the mold turns out to be more complicated. To this end Leonardo, worried by the excessive length of the sprues that were to take the bronze from the furnaces to the casting cups, also required Leonardo to take into consideration the possibility of using a larger number of smaller furnaces (fig. 81), so as to place them along the border of the casting pit dug out according to the outline of the horse's shape.[124]

Even if Leonardo does not seem to have arrived at a final solution, the amount of energy he uses in attempting to refine a system for feeding the mold is impressive, a question to which he returns in *Codex Madrid II* as well as in the folios of the Windsor collection; here, besides the various feeding schema using from one to six furnaces,[125] there are also two drawings that show how Leonardo had considered the idea of laying the mold of the horse down but placed diagonally across the casting pit (fig. 82).[126]

Leonardo had planned on using reverberatory furnaces for casting the bronze, heating devices in which burners are separated from the melting chamber and heat is transferred through radiation between the refractory material and the metal and by direct contact with the flame that enters the casting chamber through specially designed holes (reconstruction XX). Both the melting and alloy preparation were executed in the same furnaces since it was possible in this way to test its operation and holding capacity before casting, noticeably reducing production time.[127]

In order to avoid the bronze cooling down, the furnaces had to be preheated and the alloy preparation served this purpose. Leonardo affirms that the furnaces had to be heated for about "6 or 8 days."[128] This reference is important and it sheds light on the production time. Based on this data, besides the number of furnaces used, we know that they had to be built before transporting the mold into the casting pit, since the mold could not be left buried all that time, and the furnaces would have had to have been displaced to avoid leaving the mold unburied in the pit. The question of the number of furnaces not only concerns the way the mold is filled, but it introduces such metallurgical problems as how to check the uniformity of the alloy and the temperature. Leonardo is vague on the alloy preparation, not telling us anything about its composition and noting only some practical advice for handling the furnaces: "Smoke, that is, a fire that makes more smoke, will be less warm, and often is responsible for the solidification of the bronze."[129] He immediately makes reference to the problem of maintaining "the bronze in a liquid state [il bronzo in bagnio]," saying that "this is a little dangerous, when it is necessary that the melting is made in one try, in several ovens, that have to result in only one cast, that the quantity of bronze, and of the ovens, and of the fire be of the same quality; and similarly that the material that is melted be of the same alloy."[130]

The furnaces that Leonardo describes for casting the Sforza monument are made with semicircular or barrel-vaulted chambers (see figs. 73–74). A barrel-chambered furnace is drawn in the vertical casting system (see fig. 80),[131] but while this seems to clearly answer the need to distribute the bronze in the mold, it is certainly less efficient and more difficult to operate compared to one or even two smaller semicircular furnaces. The reasons for a choice like this can be found in the attempt to reduce the number of furnaces in order to guarantee more alloy uniformity. As it is illustrated in the drawing of the casting system, the furnace is placed on the side and, thanks to seven apertures, it distributes the alloy to different points of the mold along the median line that corresponds to the top of the horse's belly. The situation is obviously ideal since the length of the melting chamber and

**Fig. 83** Leonardo da Vinci, *Reverberation Furnace*, *Codex Atlanticus*, 1103r (detail), 1478–1518, pen and ink on paper, Biblioteca Ambrosiana, Milan.

burner (about twenty-six feet) makes it extremely difficult to maintain the entire furnace uniformly. Moreover, a furnace with multiple mouths, besides requiring subdivision—something Leonardo does not seem to do—makes it extremely difficult to plan the amount of bronze that has to come out of each one. An alternative to the barrel furnace is a semicircular chamber (fig. 83), but its use in large-scale casting is limited because it has only one exit mouth, strictly constraining the bronze's distribution system in the mold.

Leonardo designs the casting system in a way that includes filling the mold according to a predetermined logic. In fact, for the casting to be successful, it was fundamentally important to check the distribution of the bronze because if the bronze in the furnace that was supposed to fill the back part of the body reached the head "by moving transversely [per traversa via]," the filling logic would be compromised. A negative consequence would be the partial use of the furnace's contents or the premature emptying of one of the others. For this reason their opening sequence had to be studied carefully and a way had to be found to check the gradual increase of the bronze level on the inside of the mold so that the furnaces could be opened at the right moment. In order to remedy this problem, Leonardo designed special thermal gunpowder sensors that, if placed in the appropriate corresponding sprues at specific levels of the mold, would catch fire the moment molten bronze reached them, blowing the combustion residue out:

Remember, if you cast the horse upside down, to weigh the wax or earth that goes from the back, up to the top of the head, well. And place gunpowder near where the neck and back meet, in order to show, by the flash of the gunpowder, when the bronze has nearly filled the neck. And having this evidence, immediately open the outlets of the other furnaces. And I proceed this way in order to retain the bronze where it descends and avoid its running to lower places by traverse routes. And the furnaces shall fill up not only the neck but also all of the forepart, since the bronze from the other furnaces would be cold before having reached this part.[132] (reconstruction XXI)

## MACHINES FOR MOVING THE CASTING MOLD

As we have seen, the complexity of the molding process, including the construction of a casting mold that could be opened in two halves and composed of many assembled pieces, made it extremely tricky to handle the mold parts during the different phases of production: firing, building the core, and transporting it to the casting pit. For this reason it was advisable to custom-design lifting and transport systems. The machine presented on folio 154r of *Codex Madrid II* (see fig. 76) is a universal system that makes it possible to transport and turn over the mold:

This instrument is used to transport and to lower the form. And should you desire to lower it upside down, remove the cross-piece that is used for tying the instrument together and, reinforcing it on the side nearest the form, pull at the feet of the beams that support the half-form at points a and b. However, it would be preferable to detach the half form; pull it out; and fasten it to the entire instrument, carrying it to the place where it shall be lowered. And in this way, you shall fasten it in an upright, perpendicular position. Then, carry the instrument to the opposite part and, with the frame facing the instrument, secure the form. Once it is lowered with the aid of ropes, turn the form over, face

down. You shall proceed further, without any change in the instrument of the form.[133]

The operating versatility of this machine reflects Leonardo's indecision about the casting system and emphasizes how his planning oscillated between the horizontal and vertical solutions. Moreover, the design of this machine opens another interpretive scenario in which the final assembly of the mold is completed outside the casting pit: the machine seems to work on a closed mold but it is not clear if the drawing portrays only the outer mold or the complete mold with the core on the inside. Still, the presence of the armature for the "throat and body [gola e del corpo]" pushes us towards the second interpretation. If this is the case, this drawing would show how after 1491 (when it is permissible to think that the clay model of the horse had already been finished), Leonardo had not definitively codified the molding process and was still considering the possibility of assembling the mold outside the casting pit. However, as suggested by the note that accompanies the drawing, plans for the final assembly of the mold on the inside of the casting pit seem to have been gaining favor. The kinetics of this device are based on the action of a winch hanging from a horizontal beam by means of a fixed transmission pulley and connected with four ropes to the upper part of the mold. Using the winch, it is possible to gradually lower the mold onto its side, thanks to the transmission pulley's force de-multiplying action. To turn over the other half of the outer mold, a supporting cross is removed from the front of the machine, causing the rotation to stop at 180 degrees. The solution that Leonardo adopted for anchoring the winch ropes to the mold harness is interesting. They are not mounted directly on its frame but on a pulley, through which it is possible to distribute the traction force in two places using another rope.[134]

Folio 154v from the *Codex Madrid II* (fig. 84) presents another arrangement for supporting the two sections that make up the outer mold while opening and detaching the core. This is probably an initial sketch of the previous system in which Leo-

nardo develops a lever opening system. In fact, as we can see, the structure of this machine is composed of a base and a supporting frame for the outer mold halves that will be hinged to one another, forming an angle less than 90 degrees. The junction point then becomes the fulcrum of a lever where it is possible to place pressure for helping the halves detach from the horse. Once a half detaches, the machine rotates until it settles horizontally at the base.

In general, opening the outer mold in its two component halves is a very delicate operation, and in order to prevent the risk of fractures, two harnesses are made in wood and metal and anchored firmly to the iron strengthening rods of the two halves.[135] These protective structures will accompany the halves in every phase of the molding process and traction force will be exerted on them during the various operations.

On folio 154v Leonardo shows another way to invert the mold with a more complex kinetic structure in which a different system has been developed for anchoring the sections of the body mold. This drawing focuses on a circular support system for the sections. The rotation device is based on a winch and transmission pulley system. It is interesting to point out how Leonardo seems to have realized the inefficiency of this machine, which locked the mold section of the body inside itself during rotation. He quickly drew a bolt that makes it possible to move the fulcrum of rotation from one end of the base to the other. This then makes it possible to extract the body section simply by shifting the rotating point. However, even if in this way it is possible to turn the body section of the mold over without having to unhook it in a vertical position to reposition it on the opposite side, as was the case in the first machine we described, the moving frame that accompanied the mold section during the inversion remained blocked below it. If the supports for each mold section were not to be left in the pit, it became necessary to raise the mold section again to remove it. Therefore, we believe that this system's lack of versatility made Leonardo recognize that its use was limited to turning over the mold,[136] and caused him to abandon

Fig. 84 Leonardo da Vinci, *Study of the Wooden Framework with Casting Mold for the Sforza Horse, Codex Madrid II*, 154v, 1490s, pen and brown ink on paper, 8¼ × 6 inches, Biblioteca Nacional, Madrid.

this idea in favor of the solution developed in 154r (fig. 76). There he considered a sturdier harness instead of a mobile supporting wall for rotating and transporting the halves.

On folio 151v of *Codex Madrid II*, there is a barely legible drawing (fig. 85) of a lifting machine composed of a row of hoists mounted on the same rope, anchored to the floor and to a hoist on the ceiling. Hanging from the cord is a round shape that is most likely the casting core shown in section.

Concluding our excursus on the machines illustrated in *Codex Madrid II*, we feel we can affirm a thematic continuity that characterizes the folios between 157v and 154r, all dedicated to the problem of reinforcing the mold and the machines for moving it. In these folios, as we have seen, it is possible to follow the evolution of the machine for rotating the mold, which reached its final design in the model shown on folio 154r (fig. 76).

In the subsequent folios it is not possible to determine a systematic development, even if a certain sequence is traceable: on the folios written in pen from 153r to 145r, problems inherently dealing with the casting and pouring are prevalent, whereas problems related to the molding process predominate in 145r to 142r. Finally, on folios 141r and v, vertical and horizontal pouring is again discussed.

In order to complete the survey of all the machines designed by Leonardo for creating the Sforza monument, it is necessary to review the two moving lifters designed for the first project, noted in Windsor folio 12349r (see plate 30).[137] These lifters, similar in structure, illustrate a variety of devices for amplifying force. The one in the center of the folio is composed of a block with two frontal trains of five pulleys (mounted directly on the machine's frame) and four mobile ones. At the base of the right mounts, the machine is integrated with a powerful winch used along with a worm-drive mechanism. Below that on the same folio, there is a drawing of a similar machine made up of two pulley trains with eleven fixed transmission pulleys and ten mobile transmission pulleys, anchored into the frame by ropes. In this way the block pulley system could work even in an inclined position with respect to the ground without risking that the rope might leave the pulleys. Both of the models work on enormous blocks that remind us of the casting model in the first project, when the horse was supposed to be created life-size. A lifting system like this is basic equipment for a casting site and therefore we can presume it would also be used for the second project. In fact, in Windsor 12348r the core's placement is illustrated inside one of the halves of the outer mold of the horse's body, where it is suspended as if supported by such a lifting system (see fig. 77).

Leonardo was never able to test his casting process because of the French invasion. Between 9 and 10 September 1499, French troops led by Marshall Gian Giacomo Trivulzio burst into Milan and destroyed the clay colossus that may have been moved from the Corte Vecchia workshop to land owned by Leonardo near the S. Vittore al

Corpo Monastery, where the foundry was presumably installed. We have only Sabba da Castiglione's indirect testimony about the event, but from chronicles by Giovanni Andrea Prato it is possible to reconstruct one important event after another on that day and to imagine the moment when the clay model of the horse was destroyed. Once the city had been taken over, the soldiers set up camp at S. Vittore al Corpo for the remainder of the day "doing every evil thing [ facendo ogni male]" and, in spite of the officers' intervention, in the turbulence of the events the clay colossus was used as a target by the *balestrieri guasconi* (Gascon crossbowmen).[138] Even though the molds were saved and casting was still possible, Leonardo and Ludovico il Moro's project of casting in a single pour the biggest equestrian monument ever known was definitively abandoned.

We do not know Leonardo's reaction to the model's destruction, but his remorse about the entire event is well expressed in a short note in *Ms. L*: "the Duke lost the State and [his] thing[s] and [his] liberty and none of his works were finished by him [il duca perso lo stato ella roba ellibertà e nessuna sua opera si finì per lui],"[139] and from an epitaph that concludes his notebook on the casting: "If I have not been able, if I . . . [Se io non ho potuto fare Se io . . .]."[140]

In 1501 the last act of the entire Sforza monument project took place when Ercole I d'Este, perhaps encouraged by Leonardo himself (still hoping his work could be saved), asked the French governor of Milan, Georges d'Amboise, through his ambassador Giovanni Valla, for the clay molds (the matrices) of the horse for casting a monument in his honor. But as far as we know, his request was not fulfilled.[141]

## CONCLUSIONS

Approaching the end of our study of the sources concerning the attempt to cast the Sforza monument, we are inclined to regard this long chapter of Leonardo's life as an adventure that—in spite of its ending—left its mark on the history of casting techniques. Although nothing came of his work, in his notes and drawings in *Codex Madrid II* and the

Fig. 85 Leonardo da Vinci, *Multiple Blocks for Lifting the Casting Core, Codex Madrid II*, 151v (detail), 1490s, pen and ink on paper, Biblioteca Nacional, Madrid.

Windsor miscellany, we find the first written references to the indirect casting method. However, we must be wary of attributing to Leonardo the birth of this method, and we should be even more careful not to give it too modern an interpretation. On the casting process adopted by him, or only imagined by him, we can only speculate. The sense that emerges from reading his notes is not of the codification of a working method but of a process in development in which the only certainty is his intention to use an indirect casting technique. The steps leading to the moment of the bronze pour are anything but clear and are open to diverse interpretations.

If we can accept the casting process we have reconstructed, an image emerges—which we believe is closest to the truth—of Leonardo trying to apply to statuary a well-established method from military casting. In that method, the mold's construction was made taking a cast from a partially permanent model: the cannon barrel was made in clay or wood, whereas the projecting, finishing touches were in wax and destined to be lost during casting. The method of casting artillery did not work for statuary, so a new way had to be found in plaster casting techniques. Therefore, we strongly believe that the method for artillery casting and the plaster casting method conditioned Leonardo's choices. Nevertheless, if we want to see here what led Leonardo to this turning point in casting

technique, we have to acknowledge that these two techniques represent the limit of his solutions. Though preserving the model and involving some clever solutions—such as the thermal sensors for checking the "rising of the bronze" or the mobile furnaces that made it possible to transport and assemble the mold while simultaneously alloying the bronze—Leonardo's casting mold constituted a fragile element that most likely would have compromised the success of the pouring. This method is anything but modern, and upon closer examination we see that Leonardo does nothing but act on analogy, a *forma mentis* straight from the artisans, integrating two notable methods, modular molding and plaster casting, to solve an unprecedented problem: making a colossal monument in a single pouring. In doing this, Leonardo reconstructed as a sort of puzzle the shape that was imprinted on the interior of the piece mold, and without losing the shape he found the way to reduce its volume to transfer it onto the casting core. In this way he obtained that perfect reduction in scale that allowed him to calculate exactly the amount of bronze necessary for the pour: the turning point had been reached.

Nonetheless, the audacious Sforza project and its subsequent "failure" immediately aroused great consternation, as well as admiration, that was translated into humorous episodes. Witness a passage of a biography by a Leonardo scholar written in the 1540s, where it is written that Michelangelo, ironically consulted by Leonardo regarding a Dante citation, replied: "It is said that you also made a design of a horse to cast in bronze and were not able to cast it and for shame you let it be . . . and you were believed by those Milanese idiots [literally, 'capons']."[142] Regarding the Sforza Horse, the same anonymous biographer concluded that "it was universally judged to be impossible to cast, above all because he said that he wanted to cast it in a single piece."[143]

Two centuries later in France, the Swiss caster Jean Baltazar Keller cast an equestrian monument for Louis XIV (based on a model by François Girardon) approximately seven meters (twenty-three feet) tall, using a casting method very similar to Leonardo's (fig. 86). The symmetries between some of the drawings found in the *Codex Madrid II* and the prints that describe Keller's method[144] lead us to believe that some copies of Leonardo's manuscript existed, a theory that finds support in remarks by Benvenuto Cellini, who in his *Treatise on Architecture* states that he bought in France "a book written in pen copied from one by the great Leonardo da Vinci [libro scritto a penna copiato da uno del gran Lionardo da Vinci]."[145] Regardless of the strong similarities, a comparison of Keller's method to Leonardo's would be forced, since the

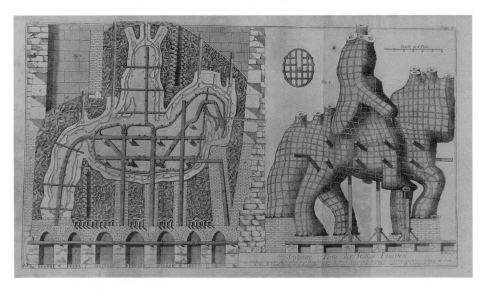

Fig. 86 *Casting pit, seen in sections, and the complete iron mold of the equestrian monument for Louis XIV,* 1775, *Encyclopédie Planches,* vol. 8, *Sculpture,* "Fonte des Statues Equestres," Planche V.

PLATE 32 **After Leonardo da Vinci** (Italian, 1452–1519), *Re-creation of the Sforza Horse,* 2007, fiberglass and steel with resin coating, 30 feet high. Opera Laboratori Fiorentini SpA.

technical context in which Keller worked was different from the one at the end of the fifteenth century. By the time he was working in 1699, Keller could count on a casting method that was rigidly standardized.

Like other of Leonardo's projects and technical dreams, the Sforza monument has aroused the interest of scholars and patrons passionate about Leonardo, some of whom have recently devoted themselves to the re-creation of the unfinished work. Three attempts, assembled from separate pieces, can be cited. The first, made with fiber-reinforced plastic under the supervision of Hidemichi Tanaka, was unveiled in Nagoya City in Japan in 1989. The second was cast in bronze in 1999 on the initiative of American ex-pilot Charles Dent, examples of which are on display in Grand Rapids, Michigan, and in front of the San Siro racetrack in Milan.[146] The third was made in polystyrene resin by the Opera Laboratori Fiorentini in Florence and is on view in

Atlanta as part of this exhibition (plate 32).[147] All these re-creations focused on reproducing Leonardo's model, trying to imagine the gait and shape of the horse based on information available from various sources. In none of these cases was an approach to the monument developed in the light of Leonardo's casting techniques. Engineering studies undertaken in the Japanese and American efforts suggested that Leonardo's casting method inadequately addressed metallurgical problems related to the speed of filling the mold and statics— the legs, even with support under the lifted rear foot, would not have supported the statue, which would have imploded under its own weight.[148]

New virtual casting studies offer a more positive assessment of Leonardo's ideas. I have coordinated joint efforts between the Istituto e Museo di Storia della Scienza in Florence and XC Engineering of Cantú (Como) that use FLOW-3D® simulation software for understanding dynamic fluid processes.

Simulations of vertical casting were conducted, following Leonardo's explicit drawings (see fig. 80). For the horizontal casting, we assumed a feeding mechanism of three major channels flowing from a single furnace. In both cases, we projected an average thickness of about two inches (five centimeters) and considered that the two supporting legs would be solid bronze, the lifted legs hollow. Intriguingly, both the vertical and the horizontal casting schemes proved possible. Contrary to what Leonardo imagined, it was the vertical scheme that showed greater filling problems, resulting in a major casting flaw, due largely to uneven cooling of the bronze. Effects of humidity, which so preoccupied Leonardo's thinking about the vertical scheme, actually had little negative effect. He was right to have chosen the horizontal scheme, however, for it proved to distribute the bronze more evenly throughout the mold. This does not prove that Leonardo could have actually cast his horse successfully, but modern technology does confirm that he was headed in the right direction.

## NOTES

I would first like to thank Professor Paolo Galluzzi for starting me out on Leonardo studies and the in-depth studies of techno-scientific themes, encouraging me to study the Sforza monument project. Thanks to Riccardo Braga for his skill and professionalism in transcribing my verbal reconstruction of Leonardo's casting process into a graphic-digital language, and to Angela Manetti and Massimo Zanoccoli for their advice in writing this essay and proofreading the draft. Finally, thanks to the multimedia laboratory and photography archives at the Istituto della Storia della Scienza, especially Franca Principe, Sabina Bernacchini, and Paola Scortecci for their precious help in obtaining the images.

1. The size of the clay model made by Leonardo is given to us by Luca Pacioli in the preface of *De divina proportione*: "Essendo, excelso duca, a dì di VIII de febrarode nostra salute gli anni 1498 correndo in compagnia de li perspicacissimi architettie ingenieri e di cose nove assidui inventori, Leonardo da Vinci compatriota nostro fiorentino, qual de sculptura getto e pictura con ciascuno el cognome verifica. Commo l'admiranda e stpenda equestre statua, la cui altezza da la cervice a piana terra sono bracia 12 cioè 36 tanti de la qui presente linea a b e tutta la sua unea massa a libre circa 200000 ascende, che di ciascuna l'oncia comuna sia il duodecimo...." Its height is also confirmed in *Codex Madrid II*, 151v.

2. The disappearance of Leonardo's two manuscripts marked as 8936 and 8937, today known as *Codex Madrid*, was caused by their erroneous cataloguing, probably at the time many manuscripts were transferred from the collections at Palazzo Reale at the Biblioteca Reale di Spagna, today known as Biblioteca Nacional (The National Library). The manuscripts show the mark Aa. 119, 120 and were recorded in the library's inventory as Aa. 19, 20. The error was put in the library's catalogs thereafter until, on the initiative of biographer Tamaro Marinis in 1906, a search began (involving several scholars) for the lost manuscripts that extended to the winter of 1964–1965, when the person in charge of manuscripts, Don Ramon Paz, found the two da Vinci codices in the place of their original marking. In 1967 the facsimile publication of the two manuscripts was authorized. For the story of the two Madrid manuscripts, see Reti 1974, pp. 11–22.

3. Bovi 1959, pp. 24–25.

4. Thanks to the modern techniques of radiographic and tomographic analysis performed on some of the antique bronzes, it was possible to show how the indirect casting method was already in use starting from the 5th century BCE. (Heilmeyer 1999, pp. 239–254; Formigli "Le antiche terre" 1999, pp. 67–71). An important description of the indirect casting technique in ancient times comes from the so-called *Kylix del pittore della fonderia*, dating back to the 5th century BCE. On the cup can be found depictions of the casting stages of a large bronze monument and the most important steps are pointed out, like the one for assembling the pieces melted separately and the one for mechanically finishing the surface. In this scene there is a reproduction of two statue feet attached to a wall that were interpreted as sectioned parts of an initial clay model from which the molds would have been extracted for the indirect technique (Zimmer 1999, p. 25).

5. Fusco and Corti 1992, pp. 27–32.

6. Cellini 1987, p. 553.

7. Filarete 1972, 172r.

8. Spencer 1973, p. 34.

9. Spencer 1973, p. 25; Bush 1995, pp. 79–80.

10. "la imagine del Illustrissimo Signore nostro pater de bona memoria de bronzo a cavallo" (Milan, State Archives, Rg. Miss. 112, 355v–356r [Spencer 1973, p. 25; Lopez 1982, p. 112]).

11. Bartolomeo Gadio da Cremona's letter to Galeazzo Maria Sforza on 29 November 1473 (Milan, State Archives, Potenze Sovrane, file 1458. See also Fusco and Corti 1992, pp. 12–13).

12. Bush 1978, p. 48.

13. "... et oltra ciò si occupò nella forma del cavallo di Milano, oue sedeci anni continui consumò: et certo che la dignità dell'opera era tale, che non si poteua dire havere perduto il tempo et la fatica. Ma la ignorantia et trascuragine di alcuni, li quali siccome non cognoscono la virtù, così nulla la estimano, la lasciò poi vituperosamente roinare et io vi ricordo et non senza dolore et dispiacere il dico, una così nobile et ingegnosa opera fatta bersaglio a' balestrieri guasconi...." Castiglione 1560, Ricordo CIX, 115v; see also Beltrami 1919, p. 182.

14. "dare opera al cavallo di bronzo, che sarà gloria immortale et aeterno honore de la felice Memoria del Signor vostro patre et dela inclyta casa Sforzesca." *Codex Atlanticus*, 1082r.

15. Pedretti "I cavalli" 1984, p. 47; Meller 1934, pp. 5–6.

16. "Al signor Ludovico, che ogni volta che vuole, gli scultori sono a sua posta"; "Al signor Ludovico. Risposta alla sua circa gli scultori" (Del Piazzo 1956, pp. 285–286; see also Fusco and Corti 1992, p. 14).

17. Fusco and Corti 1992, pp. 14–15.

18. Pedretti 1988, pp. 76–81; Schofield 1991, p. 115, n. 13.

19. "[omission (redacted?)] El Signor Ludovico è in animo di fare una degnia sepultura al padre, et di già ha ordinato che Leonardo da Vinci ne facci il modello, cioè uno grandissimo cavallo di bronzo, suvi il Duca Francesco armato. Et perché Sua excellentia vorrebbe fare una cosa in superlativo grado, m'à decto che per sua parte vi scriva che desiderrebbe voi gli mandassi uno maestro o dua, apti a tale opera; et per benché gli habbi comesso questa cosa in Leonardo da Vinci, non mi pare si consuli molto la sappi condurre. [omissis] Raccomandomivi. Papie, XXIIa Iulii 1489" (Florence, State Archives, Mediceo avanti il Principato 50, 155. Published in Beltrami 1919, doc. 36).

20. Fusco and Corti 1992, p. 16; Kemp 2006, pp. 18–19.

21. *Ms. C*, 15v.

22. Fusco and Corti 1992, p. 18.

23. Based on the event of 1489 that would have involved Leonardo and Pollaiuolo, Laurie Fusco and Gino Corti proposed different dating even for Leonardo's drawings that portray the monument in the version with the rearing horse (RL 12357, P 105r, and RL 12358, P 106r). The first was made after April 1484 and put with the letter of presentation to Il Moro, while the second possibly dates back to 1489, based on the graphic style of the drawing (Fusco and Corti 1992, p. 16).

24. Bayonne, Musée Bonnat (no. 1327).

25. Attempts at reticulation can be seen in some bridge models (*Ms. B*, 23r, *Codex Atlanticus*, 855r) as well as in the structures for theatrical scene installations like the one created for the production of *Orfeo* by Poliziano,

whose drawing shows the lines of force that portray the loading apparatus of the "theatrical machine" (*Codex Atlanticus*, 131v-a). Bush 1978, p. 51.

26. *Codex Atlanticus*, 140r.

27. *Codex Atlanticus*, 855r.

28. Pliny 1988, pp. 155–161; Gaurico 1999, pp. 162–163.

29. Bush 1978, p. 57.

30. Vasari 1973–1981, vol. 4, p. 34.

31. Panofsky 1996, p. 5.

32. Kemp *Leonardo* 2006, p. 324; Panofsky 1996, pp. 38–39. The same measuring system was taken up by Alberti who, in *De statua*, takes the foot as the unit of importance for the proportions of the human body (Alberti *De statua* 1998, pp. 8–10).

33. RL 12321r (P 92r).

34. Calcani 1983–1984, pp. 58–61; Pedretti "Il linguaggio delle mani" 1984, p. 38; Kemp *Leonardo* 2004, pp. 325–326.

35. On paper 119r of *Codex Madrid II* an engraving technique is described for making matrices of prints through the etching technique (Kemp *Leonardo* 2004, p. 325).

36. Calcani 1983–1984, p. 58.

37. For the drawings on the proportion of Verrocchio's horse, see Metropolitan Museum of Art, New York, 1917, n. 19.76.5 e GNDS, Galleria Corsini, Rome, F.C.12761, 5r–v. For Leonardo cf. RL 12318r (P 88r), 12319r (P 89r), 12294r (P 94r), and 12286r (P 124v). Cf. also Kemp *Leonardo* 2004, p. 325.

38. RL 12297r (P 101r).

39. RL 12321r (P 92r), 12294r (P 94r).

40. Pedretti "I cavalli" 1984, pp. 51–52.

41. "Di quel di Pavia si lada più il movimento di qualsiasi altra cosa. L'imitazione delle cose antiche è più laudabile di quella delle moderne. Non può essere bellezza e utilità come appare nelle fortezze e nelli omini?42. Il trotto è quasi qualità di cavallo libero. Dove manca una vivacità naturale bisogna farne una accidentale." According to Pietro C. Marani and Martin Kemp this phrase is interrogative, whereas for Pedretti it is affirmative (Marani 1984, p. 291, n. 18; Kemp *Leonardo* 2004, p. 329; Pedretti 1978, p. 156). See *Codex Atlanticus*, 147v.

42. An edition of *De Civitate Dei* by Saint Augustine is cited in the list of Leonardo's books in *Codex Madrid II* (*Codex Madrid II*, 2v; see also Pedretti 1977, vol. II, p. 357; Kemp *Leonardo* 2004, p. 330).

43. Augustine 1973, pp. 1413–1414.

44. Kemp *Leonardo* 2004, p. 331.

45. Pedretti "Il linguaggio delle mani" 1984, pp. 51–52.

46. See *Codex Atlanticus*, 577v. The same solution was also presented in some drawings of the project for the Trivulzio monument (RL 12356r, P 135r; 12360r, P 139r).

47. Casting references for the solid base with the monument are in *Codex Madrid II*, 146v and 147r, and are graphically confirmed in the drawing of the casting mold seen in sections in RL 12351v (P 110r) [fig. 45].

48. Kemp *Leonardo* 2004, p. 336.

49. Bearzi 1968, p. 100.

50. The substantial difference between the direct and indirect casting processes consists in reversing the building stages: in the first case, the casting core is the first thing created, then the external form is built on it through applying layers of clay. In the second case, however, the core is built through repeated fillings of a pit matrix (Formigli "Le antiche terre"1999, pp. 67–71).

51. Lein 1999, p. 387.

52. Bearzi 1968, p. 102.

53. The extreme irregularity of the back of the statue and the noticeable thickness of the bronze leave no doubts about it. Massimo Leoni has a different opinion; he is said to be certain of the use of the indirect casting technique (Leoni 1992, p. 97).

54. "fattone i modelli e le forme, le gettò; e vennero tanto salde, intere e ben fatte." Vasari 1973–1981, vol. 3, p. 362.

55. The to-scale models of Perseus, in wax and bronze, are today housed at the Museo Nazionale del Bargello in Florence.

56. ". . . io lavoravo in una camera terrena nella quale io facevo il Perseo di Gesso, della grandezza che gli aveva da essere, col pensiero di formarlo da quel di gesso. Quando io viddi che il farlo per questa via mi riusciva un po' lungo, presi un altro espediente . . ." (Cellini 1987, p. 324).

MONON TOWN & TOWNSHIP PUBLIC LIBRARY
427 N. MARKET ST., P.O. BOX 305
MONON, INDIANA 47959

57. Lein 1999, pp. 387–390.

58. Biringuccio 1977, 83r–88r. See also Kirwin and Rush 1995, pp. 87–102.

59. Gaurico 1504, p. 234.

60. In the sixth book of *De sculptura* dedicated to "Chemiké" (*la fusione*), Gaurico gives a confusing description of a molding method for producing wax pits starting from models made in plaster and clay that make us think of the indirect casting method. Nonetheless, the discussion remains suspended without offering further elements that could help us in understanding the method, dwelling only on the description of the direct method (Gaurico 1999, pp. 226–241).

61. Pliny 1982–1988, XXXV. 153. 44.

62. Favaro 1918.

63. The step where reference is made to the transfer of molding techniques in bronze casting is also present in the translation of *Naturalis Historia* by Cristoforo Landino (Pliny 1534, XXXV. XII. 90–100).

64. Vasari 1973–1981, vol. 3, pp. 372–373.

65. Starting with 7.2 meters in height of the clay model, an approximate estimate can be made of the volume of the entire casting mold that should reach around 30 cubic meters. This means that the clay casting used in the construction would have reached more than 50 tons (a cubic meter of clay can weigh from 1,700 to 2,000 kg). If we also consider that the casting mold had to be reinforced with a steel rectangular armature, the total weight would increase considerably. Therefore the tremendous weight and volume made it easier to make a mold in sections to assemble on the inside of the pit.

66. *Ms. F*, 79v.

67. *Codex Leicester*, 9v.

68. *Codex Madrid II*, 148v.

69. "Conponila [la forma] prima tutta di quella grossezza che va da' ferri in dentro. E innanzi che metti i ferri, la taglierai di quanti pezzi ti piacerà e puntellerai le parti atte a cadere, ma innanzi che cominci la forma, segna coi chiodi la natura over l'andare de' tagli, e tanto lascia fori essi chiodi quanto tu vuoi che essa forma sia grossa quando sia da tagliare" (*Codex Madrid II*, 142v).

70. "Le boche da gittare sieno fatte di ciera o d'aste sopra il cavallo inanzi cominci la forma" (*Codex Madrid II*, 144r).

71. The composition of the "lute" was one of the primary problems a caster had to deal with since the clay, besides being plastic, had to be compact and resistant to cracking, and have a high refractory degree—all elements on which the casting mold's intactness depended. For understanding how accurate this mix had to be, there is a chapter dedicated to it in Biringuccio's *De la pirotechnia* (Biringuccio 1540, 77r).

72. *Codex Madrid II*, 144r.

73. "Farai dala terza parte di fori della forma, overo la quarta prima con terra mista con pelo di bo, e cquando se' all'ultimo tolli pelo di bo e canapa e tterra con alquanta colla, e dà a ogni solo di tera un sol di canava, quando pe rittò e quando per traverso, e poi dà le tole e altri ferri" (*Codex Madrid II*, 142r).

74. "Torai tanta grossezza di terra quanto tu vuoi che sia la grossezza della tua forma, cioè ⅓ di braccio e cquella ricuoci e vedi quanto sia profonda in dentro. E dove tu vedi che la cimatura si difende dal foco, a cquella distantia potrai mettere i tua ferri nella forma. E ssappi che cque' ferri che sieno infra tterra ricotta, siano più per danno che per utile, che se vogliano stare fra lla tera e cimatura" (*Codex Madrid II*, 142r).

75. *Codex Madrid II*, 157r.

76. "a cciascuna retondità di qualunque menbro la forma di tre pezi; con molta più facilità la spiccherai dal cavalo di terra" (*Codex Madrid II*, 148r).

77. "Acciò che 'l bronzo ch'entrassi per le commessure non isspiccassi il giesso col quale voglio stopare di fori le commessure dela forma, ho deliberato fare nella parte di fori d'essa commessura uno cavo, che di profondità e grandezza sia 3 dita. A coda di rondine, e cquello riempire di fresco giesso e poi serra di fori con la tolla" (*Codex Madrid II*, 148r).

78. *Codex Madrid II*, 154r, 155v.

79. For facilitating the clay's detachment from the mold it is likely that Leonardo planned to interject a layer of ash, as in the case of the mold model, or cover the surface with grease (*Codex Madrid II*, 143r).

80. Regarding Leonardo's consideration of the possibility of using wax (RL 12350r, P 111r; 12347r, P 130v; *Codex Madrid II*, 150v), in a note in *Codex Madrid II* he seems to decide on the use of clay: "questa farai di tera da bocali, salvo le gambe che sien di tera rozza" (*Codex Madrid II*, 144r), repeating the same concept expressed in a Windsor paper: "quando tu arai facto la forma sopra il cavallo, e tu farai la grossezza del metallo di terra" (RL 12350r, P 111).

81. Leonardo makes reference to the building steps for the casting core on a sheet from the Windsor collection that refers to the studies for the monument

to Gian Giacomo Trivulzio (Cf. Pedretti "I cavalli" 1984, pp. 67–81): "Oltre a di questo chava la forma e poi fa'lla grossezza e poi riempi la forma a mezza a mezza, e cquella integra poi co' sua ferri, cerchiala e ccignila e lla richuoci di dentro, dove à ttoccare il bronzo" (RL 12347r, P 130r). Even if it is not possible to establish with certainty whether Leonardo had recovered the method used for building the core for the Sforza horse, the notable symmetries with the technique described in the paper about the Trivulzio monument shed further light on the dynamics of this process. From Leonardo's illustration of building a casting core (*Codex Madrid II*, 155v; RL 12348r, P 108r) it seems that the two halves that made up the mold also included the leg mold. However, their assembly in this stage of the procedure is superfluous and only contributes to complicating the transport and assembly steps.

82. "Il maschio vole essere ripieno di polvere di quadrello, o di cenere, o voi di giesso, o meglio polvere di calcina, inumidito alquanto con olio di lino, acciò che'l pilare resti con la terra calcata. Oltra di questo, il masschio ricocerai bene di fori e di dentro, ch'io ti ricordo che ogni poca d'umidità sarebbe cagion di grande errore" (*Codex Madrid II*, 144v).

83. *Codex Madrid II*, 155v.

84. "Il pezo della fronte, cioè della sua capa, colla groseza dentro della ciera, sia l'ultima cosa ad essere chiavato, aciò che per essa finestra si possi fare il masschio interamente pieno, che va dentro la testa e orechi e gola e che circunda il legnio e sseri sua armatura. E poi tignerai il pezzo della fronte di dentro e ttanto quanto nel serare é tigne del maschio, tanto ne leva di mano i'mano sempre ritignendo, in modo tochi col

pezo della fronte rimesso" (*Codex Madrid II*, 157r).

85. "Altra via non ci vego se non che s'abbassi il tereno tanto, ch'e forni colla loro alteza vadino sotto tera e poi infra fornelli rienpi e ripiana. E sopra esso piano manegia e ricuoci la tua forma e in questo mezo i tua fornelli saranno fatti ai loro stabili lochi. E cquando la forma è in punto, tra' le il teren di sotto e al suo loco l'abassa, altrimenti tu non ti potressti manegiare per la bassezza del solaro. E questo piglio per ultimo e migliore partito, facendo travate sopra i fornelli, coperte di tera acciò non si guastino" (*Codex Madrid II*, 147v).

86. ". . . perché la forma sia di meraviglioso peso, ricocila nella fossa" (*Codex Madrid II*, 141v).

87. In a paper in *Codex Trivulzianus* there is an indirect confirmation of the technique for refiring the casting mold only on the surface that comes in contact with the molten metal. In this paper Leonardo compares this process to artillery casting, where he explicitly states that the "cappa va solamente ricotta di dentro" (*Codex Trivulzianus*, 16r).

88. *Codex Madrid II*, 144v.

89. *Codex Atlanticus*, 914ar.

90. News reported by Marin Sanudo stating that on 17 November 1494 Duke Ferrara Ercole I d'Este had as a donation from Il Moro "100 miera di metallo, el qual era sta comprà per construir el cavallo in memoria dil duca Francesco" (Sanudo 1883, pp. 118–119; see also Fusco and Corti 1992, p. 22). Recent studies suggest that the amount of bronze given to Ercole I was really a sort of partial repayment for a debt that Ludovico negotiated with his brother-in-law (Lopez 1982, pp. 128–129).

91. *Codex Forster III*, 31v.

92. *Ms. H*, 96v [46r].

93. Cf. Pedretti 1995, p. 37.

94. *Ms. H*, 111r [32v]–110v [33r].

95. The humidity reduces the cohesion of the clay; during casting, vapor develops and can crack the mold or make bubbles in the bronze.

96. *Codex Madrid II*, 144v.

97. The gate is a receptacle placed at the mouth of the casting sprues and fills up when there is excess in order to compensate for the decrease in volume of the bronze during solidification. The liquid-to-solid phase of the bronze goes from bottom to top and from the outside to the inside, generating a withdrawal cone, a lacuna characteristic of casting processes due to the decrease in the bronze level compensating for the reduction in volume.

98. "Perché il bronzo che ssi truova cadere nel taglio della tavola del cavallo, stando il cavallo a diacere, è molto più basso che lle ganbe e corpo del cavallo, onde acaderebbe che il bronzo che piove fori d'esso taglio di tavola overo basa, tutto correrebbe a esso taglio di tavola più di sé basso, e corendo a esso loco non si fermerebbe dove cade, com'è il mio desiderio, e movendosi per via traversa e ppiana, il moto sarebe tardo e ssendo tardo si potrebbe fermare e sstoppare il transito all'alto che viene" (*Codex Madrid II*, 146v).

99. *Codex Madrid II*, 141v and 148v.

100. *Codex Madrid II*, 151v. The junction point of the tail and the body was a very difficult passage that could have caused surface deformations or only partial filling of the tail.

101. In the Renaissance the production of these vapors was explained with

an Aristotelian theory of elements and primary qualities: a gaseous body (aeriform) had a natural place beyond the solid (earthy) and liquid (watery) bodies. For this reason during the pouring, when the molten metal poured from above had to take the place of air in the casting pit, turbulence and gurgling were generated by the air coming up through the molten bronze. Though this phenomenon could be contained by installing an appropriate network of vents, it was more difficult to check on the vapors produced by residual humidity in the mold. This vapor could create air pockets that would push toward the outside, producing alterations in the mold that, in the worst cases, could explode under the pressure of the molten bronze.

102. "Ricordati di lasciare in el maschio uno esalatorio per lo quale possa esalare l'aria o l'umidità rinchiusa, acciò che quando il bronzo ha circondato il maschio, che la umidità fumando e moltiplicando non avessi a passare per lo bronzo, e farlo ribollire e saltare via" (*Codex Madrid II*, 149r).

103. "Farai in prima uno pezo di terra a uso d'una forma. E cquello ricotto impecerai con greca pece o voi olio. Di poi fai stare 3 dì sotto terra. Di poi vi gitta dentro il tuo bronzo. Ancora proverai con giesso, e quello impecia come di sopra dissi (*Codex Madrid II*, 145r).

104. RL 12350, P 111r.

105. *Codex Madrid II*, 145v.

106. *Codex Madrid II*, 148v.

107. The heated iron and clay have different thermal expansion rates that can cause cracks and fractures in the casting mold.

108. "Farai la fossa tanto più profonda, che un omo possa stare a sedere sotto essa forma, avendo prima fatto tre muri, uno in mezzo e 2 dalli stremi coperti d'asse" (*Codex Madrid II*, 144v).

109. *Codex Madrid II*, 156r.

110. "Quando la forma sia ricotta e ttu la vogli insieme ricommettere, ungi le comessuredi polta, fatto con trementina, o olio di lino, o chiara d'ova, mista con polvere di quadrello. Einfangato che hai dette commessure, sera la forma per forza co' tua coni di ferro" (*Codex Madrid II*, 142r and 145r).

111. *Codex Madrid II*, 157v.

112. ". . . polvere di quadrello, o di cienere, o voi di giesso, o meglio polvere di calcina, inumidito al quanto con olio di lino, acciò che'l pilare resti colla tera calcata. Oltre a di questo il maschio ricocerai bene di fori e di dentro ch'io ti ricordo che ogni poco d'umidità sarebbe cagion di grande errore" (*Codex Madrid II*, 144v).

113. *Codex Madrid II*, 141v. The same system for sealing the mold was planned for the Trivulzio monument, for which a half shipload of plaster was to be used (RL 12347r, P 130r).

114. *Codex Madrid II*, 144v and 145v.

115. The closing and burying process of the vertically positioned mold is planned using the same stages as the horizontal one, with the difference that sprue and vent systems are considerably simplified, since, as Leonardo himself states, in this way "si può fare tutte le bocche del corpo essere senza isfiatatoi, salvo che nel più alto loco d'esso corpo. E lle ganbe sieno comune esalatione della rinchiusa aria oltre al bronzo che l'enpie" (*Codex Madrid II*, 149r).

116. "Pruova nello allegare a ffare un fornello su travata, da poterlo sopra curri manegiare e ttirare a' tua propositi" (*Codex Madrid II*, 148r).

117. "Ciascun fornello che porge al corpo del cavallo arà la sua quantità di bronzo. E tanto più erano quelli a empire il corpo e le gambe e tanto più quello che empie il collo la testa, petto e gambe e questo accade nel gittare coi piedi in su" (*Codex Madrid II*, 148v).

118. "se avessi a fare lo gran gitto di cento mila libbre fallo con 5 fornelli con XX mila libre per ciascuno o insino a XXX mila libre in più" (*Codex Trivulzianus*, 17r).

119. "Pur esser potrebbe che tanta fusse [la materia da fondere] che ad una fornace sola non sarebbe forse bene di fidarsi, ma far come haveva pensata Leonardo da Vinci Scultore eccellente, quale un gran colosso d'un cavallo che hauiua fatto per il Duca di Milano volendolo gittar con la fusione di tre fornaci a un tempo far el voleua . . ." (Biringuccio 1977, 103r).

120. "Dicono ancora che Leonardo di Vinzo Toscano valente scultore volendo fare un cavallo di metallo al Duca di Milano non si fidò d'una fornace sola, ma ne volse tre, le quali potessero disfare il metallo che in esso cavallo vi andava" (De Marchi 1599, book 4, pp. 20–21).

121. Cf. Tucci 1968, p. 625.

122. *Significativa a questo proposito è l'annotazione del nome Pagolo di Vannoccio sul retro della copertina del Ms. L che Renzo Cianchi ha identificato con il padre di Biringuccio, alimentando così l'ipotesi di un loro probabile incontro* (Cianchi 1964, pp. 277–297; cf. also Pedretti 1991, pp. 121–135).

123. Cf. Cianchi 1967, p. 290.

124. *Codex Madrid II*, 151v.

125. *Codex Madrid II*, 147r, 149r, and 151v, and RL 12350r, P 111r; RL 12349r and v, P 112r and v.

126. RL 12350r, P 111r; RL 12347, P 130r.

127. "Quando il fornello dell'allegatione del metallo farà buona pruova, e ttu componi quel numero de fornelli che nel giecto a tte s'appartiene, in quella medesima forma e in ciasscuno fa allegare del metallo. E questo fo primariamente perché il tempo s'abbrievi dello allegare, che molto più presto s'allegherà con 5 o 6 fornace a un tracto, che una per volta. L'altra si è che ss'io allegassi sempre con una sola fornace, ella 'i si frussterebbe e sarebbe pericolosa nell'ultimo. Ancora le fornaci sono migliori ne la seconda e terza fusione che nella prima, onde essendo tutte le fornace use più volte alla fusione, faranno nel fine più utile e più sicura pruova, cioè el giecto del cavallo" (*Codex Madrid II*, 142r).

128. *Codex Madrid II*, 149v.

129. ". . . il fumo, cioè il foco che ffarà più fumo, sarà men caldo e sspesso è cagione che 'l bronzo fonduto si congiela" (*Codex Madrid II*, 151r).

130. ". . . questo è un poco pericoloso, onde è neciessario che 'l fondere fatto a un tratto, in più fornelli, che abbia a conferire 'n un solo gietto, che lle quantità del bronzo, e de' fornelli, e del foco sia di pari qualità; e similmente la materia che ssi fonde sia di pari legatione" (*Codex Madrid II*, 148r). Translation by Gary Radke.

131. *Codex Madrid II*, 149r.

132. "Io ti ricordo che se ttu gitti il cavallo sottosopra, che ttu ben pesi la cera o ttera che va dalla schiena alla somità del capo, e che ttu metti polvere da bombarde vicino al loco dove il collo s'appicca colla sschiena, acciò che quando il fonduto bronzo ha presso che pieno il collo, che 'l vampo d'essa polvere lo dimosstri. E fatto tal dimosstratione, subito fa distoppare li altri

fornelli. E cquesto fa perché il cadente bronzo si fermi dove cade e non n'abi per traversa via a correre ne' lochi più bassi del suo colpire. E ffa ch'e forni dinanzi oltre allo empiere del collo, che ancora e' possino enpire tutta la parte dinanzi, perché il bronzo delli altri forni prima sarebbe freddo che li avessi soccorso" (*Codex Madrid II*, 148r).

133. "Questo strumento serve a portare e calare la cappa. E sse lla vorrai calare in modo che resti roverscia, leva la crociera che fa sbarra e armadura allo sstrumento di ver la cappa e ttira i piè de' ritti legni che sostengono la mezza cappa in e lochi a b. Ma il meglio sia a sspiccare la mezza cappa e ttirala e ffermarla allo intero strumento e tirarlla per infino al loco dove debbe essere calata. E così, in piè, perpendicularmente la fermerai. Poi le porta lo strumento dall'oposita parte, e fferma la capa col connesso di verso lo sstrumento e calala colle corde roverscia. Del calarla boconi farai poi senza altremanti mutare lo strumento alla cappa" (*Codex Madrid II*, 154r).

134. *Codex Madrid II*, 154r.

135. *Codex Madrid II*, 154r, 155v; *Codex Atlanticus*, 577v.

136. "Questo telaro e sstrumento dell'argano sia separato dall'armadura del legname della forma, e ssol s'adopera ad alzare e abassare essa forma" (*Codex Madrid II*, 154v).

137. RL 12349r (P 112r).

138. Cf. Pedretti 1995, pp. 27–32.

139. *Ms. L*, 1r.

140. *Codex Madrid II*, 141r.

141. Cf. Fusco and Corti 1992, pp. 24–25.

142. ". . . dichiaralo pur tu che facesti uno disegno d'uno cavallo per gittarlo in bronzo e non lo potesti gittare e per

la vergogna lo lasciasti stare . . . et che t'era creduto da quei caponi de' Milanesi" (Anonimo Gaddiano, BNCF, Cod. Magliab. XVII, 1540?, 17. Published in Beltrami 1919, p. 163).

143. "universalmente fu giudicato essere impossibile da fondere maximamente perché si diceva volerlo gittare di un pezzo" (Anonimo Gaddiano, BNCF, Cod. Magliab. XVII, 1540?, 17). Published in Beltrami 1919, p. 162.

144. Boffrand 1743, p. 29 sgg.

145. Cellini 1987, pp. 568–569.

146. A complete illustration of Charles Dent's project can be found at www.leonardoshorse.org.

147. The model of the horse was produced for the exhibition *The Mind of Leonardo, The Universal Genius at Work*, according to the present author's instructions.

148. Cf. Tanaka 1995, p. 133; Polich 1995, pp. 136–141.

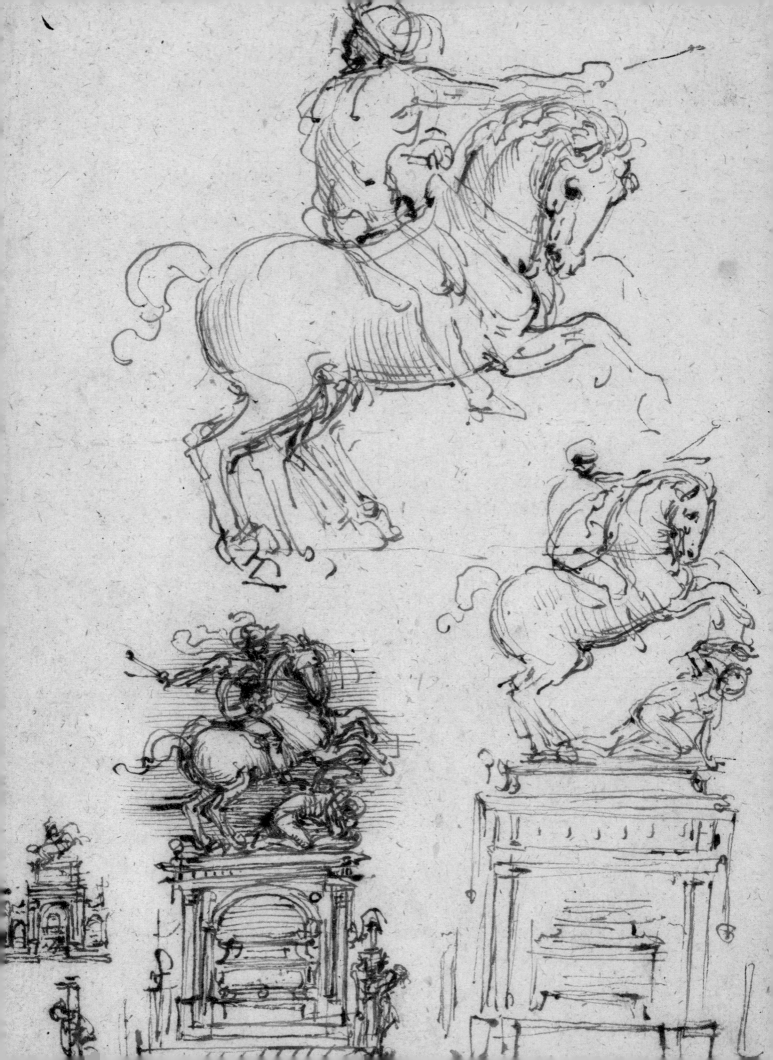

GARY M. RADKE AND DARIN J. STINE

# *An Abiding Obsession*

## *Leonardo's Equestrian Projects, 1507–1519*

Chastened but undaunted by his failure to cast an over-life-size bronze equestrian monument to Francesco Sforza, Leonardo proposed at least two other equestrian projects: one in Milan to crown the funerary monument of General Gian Giacomo Trivulzio and the other in France, probably for King Francis I.[1] Once again, neither project came to fruition. But a cache of surviving drawings, along with a cost estimate for the Trivulzio monument written in Leonardo's own hand, allows us to document his continuing fascination with equestrian sculpture throughout the first two decades of the sixteenth century and so gain a more precise understanding of how Leonardo planned his sculptural projects. He actively stalked his subject, revisiting some ambitious ideas numerous times and entertaining fanciful new possibilities, too, before arriving at proposals for monuments that were to feature life-size horses and riders—only to have shifting economic, personal, and political fortunes conspire against him yet again.

In this essay we will review the history of the Trivulzio and Francis I projects, offer a new reconstruction of Leonardo's plans for the Trivulzio monument, highlight his dynamic creative process in conceiving both projects, and evaluate how he built upon tradition to offer novel equestrian possibilities to his patrons.

## LEONARDO AFTER THE FALL OF LUDOVICO IL MORO

With the demise of the Sforza regime in 1499, Leonardo temporarily suspended his sculptural activity. He worked for awhile as a military engineer for Cesare Borgia, whose ego and military ambitions might have encouraged Leonardo to propose an equestrian monument had they been collaborating in more settled times. Borgia, however, was an unreliable and widely detested employer, and Leonardo found his way back to Florence in 1503, fully knowing that sculpted equestrian monuments and their celebration of individual political and military accomplishments were frowned upon by the republican government.[2] Still, Niccolò Machiavelli and Piero Soderini recognized Leonardo's multiple talents and, besides encouraging the artist to realize his

dream of diverting the Arno River from Pisa, set Leonardo to redeem himself artistically with a somewhat ironic commission in the Palazzo della Signoria depicting a key victory of the Florentine military at the Battle of Anghiari over the Milanese, his former employers. Leonardo's own sketches and surviving copies of portions of the work that he did complete (plates 45 and 47, for example) indicate that much of the composition was to center around skirmishing horsemen, a subject Leonardo had earlier considered in his studies for the *Adoration of the Magi* (see fig. 100) and the Sforza monument (plate 29, for example). Leonardo did not complete the painting, but its preparation did give the artist ideas for a newly energized equestrian type that he would soon use as the departure point for the Trivulzio monument in Milan. In Florence, Leonardo's sculptural models and sketches for the *Battle of Anghiari* inspired Giovan Francesco Rustici and other sculptors to create small but dynamic, multi-figural equestrian sculptures of their own (see plates 41 and 42).

In the fall of 1506, the Florentine republic reluctantly but wisely released Leonardo to work for the militarily superior French regime in Milan. Back at an autocratic court, Leonardo either met or became reacquainted with Gian Giacomo Trivulzio (1436–1518), who eventually commissioned a funerary monument that Leonardo proposed to top with a bronze equestrian statue. Trivulzio was well connected in the military world.[3] He was related by his first marriage to the renowned Colleoni clan of Bergamo[4] and intimately connected to the Neapolitan court through his second wife,[5] whom he met while he was in exile serving the kings of Naples. He also forged an alliance with the Gonzaga in 1501 through the marriage of his son Gian Nicolò (1479–1512) to Paola Gonzaga di Castiglione (1489–1519).

It was evidently unproblematic for the largely apolitical Leonardo that Trivulzio was an arch enemy of the Sforza regime. Ludovico il Moro disparagingly called Trivulzio "Il Grammaticuccio" (the big fat grammarian) and banished him from Milan in 1483, soon after Leonardo had arrived for his earlier seventeen-year stint in that city. In 1499 Trivulzio led the French troops who toppled the Sforza regime[6]—an event which he commemorated with a portrait medal—and in September of that year Trivulzio secured Milan for King Louis XII of France, who awarded him the titles of Marchese of nearby Vigevano and Marshal of France. Trivulzio played a particularly prominent role in Louis XII's triumphal entry into Milan with 1,020 horsemen on 6 October 1499. Brandishing a gilded baton, he immediately preceded the king.[7]

Once in power, Trivulzio and his French overlords co-opted much of the classical vocabulary and artistic ambitions of the Sforzas. Charles Robertson has masterfully outlined and analyzed Trivulzio's cultural ambitions and projects,[8] which early on included hiring Bramante to rebuild an imposing (if somewhat severe) family palace on the Via Rugabella in Milan (ca. 1485).[9] Trivulzio also formed and then refurbished a sizable classical manuscript library before and after a fire in 1500 and commissioned Bramantino to design a splendid set of tapestries of the Twelve Months, parts of which were still being woven in December 1509.[10] Besides engaging Leonardo for a marble and bronze tomb project around 1507, Trivulzio also paid Bramantino for the construction of a large burial chapel from 1511 to 1518.

Still, Leonardo may have found Trivulzio a reluctant and parsimonious patron. The chronicler Prato described him as miserly in his old age,[11] and Ludovico Guicciardini reported that when Louis XII asked Trivulzio what was needed to succeed in seizing Milan he replied, "Money, money, and more money."[12] Such was the character of most Renaissance *condottieri*, who were infamously paid king's ransoms both to fight and not to fight.[13] As Robertson justly surmises, Leonardo's tomb project may not have moved ahead because Trivulzio eventually found it a bit too pricey,[14] though as we shall see, Leonardo's cost estimate was well within the bounds of normal expenditures and he had designed a monument that was especially sensitive to Trivulzio's social status and position in Milan.

Fig. 87 Reconstruction of the Trivulzio monument.

We learn of Trivulzio's intentions from two wills. In the first, dated 2 August 1504, he expressed his desire to be buried in a marble tomb some eight braccia (more than fifteen and one-half feet) above the ground on the interior of the Milanese Church of San Nazaro. He allotted the sizable sum of 4,000 ducats,[15] the same amount that his brother Roberto had set aside in 1498 for his own marble tomb monument,[16] so he was obviously keeping up family traditions as well as commemorating his own accomplishments. Still, while other family members chose to erect their tombs in San Francesco, Sant' Eustorgio, and San Stefanino Nosigia,[17] Gian Giacomo selected the politically charged site of San Nazaro, located on the Via Porta Romana. The road had been used since Roman times as a triumphal entry route into Milan—highly appropriate for Trivulzio, who viewed himself as the liberator of Milan from the oppression of the Sforza.[18]

## LEONARDO'S COST ESTIMATE FOR THE TRIVULZIO MONUMENT

By 22 February 1507, Trivulzio's plans had become much more ambitious and included the construction and decoration of a separate chapel containing a tomb monument in or near the Church of San Nazaro, as well as lodgings for a prepositus and ten chaplains assigned to the chapel.[19]

Leonardo's intentions for Trivulzio's monument, now freestanding, can be gathered with some specificity from a *preventivo*, or cost estimate (see Appendix A), which we date to late 1508 or early 1509.[20] Leonardo provided a very detailed accounting of nearly every individual component—something that would surely have appealed to or have been required by the penurious Trivulzio—but it is written in the artist's idiosyncratic mirror-writing and is slightly incomplete, so it is clearly Leonardo's own record, not the final proposal.

Leonardo divided his estimate into three sections. The first gives the costs of acquiring materials and creating a life-sized bronze horse and horseman. The second lists expenses for acquiring marble blocks for the funerary monument on which the horse and rider were to stand. The third section details the costs of carving the marble as well as certain items that Leonardo had left out of the first two sections. In each case Leonardo gives detailed cost estimates. They add up to the substantial sum of 3,046 ducats, 954 ducats short of the 4,000 ducats Trivulzio had allotted for the entire project, leaving some (though probably not sufficient) funds for chapel construction and other expenses.

Leonardo described the structure from top to bottom, corresponding to a drawing (now lost) that he says accompanied his list.[21] Our reconstruction (figs. 87 and 88) follows the order of the architectural elements as Leonardo presents them in the second section, supplemented by the carving instructions that are found in the third. Our results diverge from prior reconstructions by Beltrami and Castelfranco in that we adhere rigorously to the data provided by Leonardo and do not appeal to undocumented

Fig. 88  Reconstruction of the burial chamber of the Trivulzio
monument marked with numbers corresponding to items in
Leonardo's cost estimate. (See Appendix A.)

parallels with other monuments.[22] Adopting only the information contained in the estimate, several problems remain unresolved, confirming that the document represents a highly developed, but not final, stage of Leonardo's planning.

Leonardo indicated that his first block of marble (fig. 88, block 2.1), which he intended to place directly under the equestrian sculpture at the top of the monument, would measure four braccia long, two braccia and two ònze wide, and nine ònze thick (238 × 129 × 45 cm or 7 ft. 9½ in. × 4 ft. 2¾ in. × 17¾ in.). Leonardo calculated the cost of the material at fifty-eight ducats.[23] The high price indicates that he was probably stipulating Carrara marble, which, because it was rarer and was transported a much greater distance to Milan, cost four times as much as most local stone.[24]

We learn from the third section of the estimate (3.1) that Leonardo intended to place eight marble figures around the edges of the block. They were probably smaller than life-size, as indicated by their position and the fact that Leonardo estimated a cost of only twenty-five ducats each for both material and carving.[25] Since he did not include the material for the figures in his list in Section 2, they may have been an addition to his initial plans or, because they

were nonstructural, they simply slipped his mind as he was making the first part of the list.

In the third section of the estimate (3.2) Leonardo indicated that his first block, the base of the equestrian sculpture, was also to be carved with eight festoons and other accompanying ornaments (ribbons, fasteners, coats of arms?) for a cost of ninety-two ducats.[26] He divided the price into two categories: four festoons at fifteen ducats each and four at eight ducats each. Therefore, they likely varied in size, pairs of smaller and less-expensive ones probably on the ends, and larger, more expensive ones on the long sides. The cost of squaring these pieces of marble prior to carving was to be six ducats.[27]

Next Leonardo listed a block of stone for a cornice (2.2) thirteen braccia and six ònze long, seven ònze wide, and four ònze thick (8.03 m × 35 cm × 20 cm or 26 ft. 4⅛ in. × 13¹¹⁄₁₆ in. × 8 in.) costing twenty-four ducats.[28] Arranging this piece under the sculptural base (fig. 89) would have required dividing the block into four pieces: two of them four braccia and six ònze long and two half that length (two braccia and three ònze). Mitering the edges of all four pieces at forty-five-degree angles would have allowed the cornice to form a rectangle slightly exceeding the length and width of the upper block. A substantial empty space would have been left in the center of the cornice pieces, presumably later filled with brick or other material not specified in the estimate and masked by the blocks of marble above and below it. In the third section of the estimate (3.4) Leonardo gave the cost of carving the cornice at a modest two ducats per braccio (twenty-seven ducats),[29] so it was to be relatively simple. The total expenditure was to amount to fifty-one ducats—twenty-four for materials and twenty-seven for carving.

Leonardo then moved on to the block reserved for the frieze and architrave (2.3). He wrote that the material was to cost twenty ducats[30]—surprisingly low considering that he had estimated that the thinner cornice block above it was to cost twenty-four ducats and the upper block, which was only about

thirty percent larger than the frieze and architrave block, was to cost fifty-eight ducats. Calculating by volume and corresponding weight, one would have expected that the frieze and architrave block would have weighed at least forty hundredweight and thus would have cost at least forty ducats, double what Leonardo lists.[31] Either he miscalculated, or perhaps he had already located a block of stone of the necessary dimensions at a discount, or he was using cheaper local stone and mistook the weight based on the discounted cost. At four braccia and six ònze long, the length of the block described by Leonardo matched the long sides of the assembled cornice perfectly, but its two-braccia width was three ònze less than the short ends of the cornice; it was six ònze thick (268 × 119 × 30 cm or 8 ft. 9½ in. × 46⅞ in. × 11¾ in.). A further indication that the block for the frieze and architrave may have been preexisting comes from the fact that Leonardo's estimate for carving the sides of the block stipulates a total of only twelve braccia of carving (presumably two braccia on each end and four braccia on each long side), rather than the thirteen braccia available on the block as he described it.

In the end, Leonardo designated a total of sixty ducats, five ducats per braccio, for carving the frieze (3.5), which he must have intended to include ornamentation and/or architectural delineation, for it greatly exceeds the cost of one and one-half ducats per braccio (eighteen ducats total) that he allotted for the obviously simpler architrave (3.6)[32] and the two ducats per braccio that he had previously estimated for the cornice. This was to be one of the most heavily worked blocks in the monument. Leonardo indicated (3.7) that another sixty ducats would be needed to carve three flowered coffers (twenty ducats per flower) on the underside of the block, articulating a ceiling above the sepulcher.[33]

The preceding elements—the bronze equestrian statue and its festooned marble base, the eight marble figures surrounding it, and a marble entablature —were to be supported by eight marble columns (2.5). Leonardo began his list of the columnar

Fig. 89 Reconstruction of a mitered cornice for the Trivulzio monument.

supports with eight metal capitals (2.4)—he does not specify the material further—each five ònze square and two ònze thick (25 cm square × 10 cm or 9³⁄₁₆ in. square × 3⅞ in.), costing fifteen ducats each.[34] The metal capitals are the only nonmarble items listed in the *preventivo* except for the bronze horse and rider, which appears in its own separate section. The inclusion of the metal capitals in the *preventivo* obviously stems from architectural necessity and would seem to indicate that, while Leonardo intended this to be an exhaustive estimate, he had not considered every detail before listing the component parts in distinct categories. We have already seen, for example, that he neglected to include the marble blocks necessary for the figures he decided to set around the base of the equestrian monument in his list of marble blocks, and here he had not yet fully determined the material from which he was going to make the capitals, nor did he specify their architectural order.

The marble blocks for the eight columns were each to be two braccia and seven ònze high, with a thickness of four and one-half ònze (154 × 22 cm or 60⅝ × 8⅝ in.), costing a total of twenty ducats.[35] The weight and price that Leonardo gives for the column blocks indicate that the marble for this (and most of the remaining components of the monument as well) was slightly less heavy and hence slightly less expensive than the two blocks of stone at the top of the monument (on average .004 hundredweight per cubic ònze versus .005

hundredweight per cubic ònze).[36] Either Leonardo was sourcing his marble from a variety of dealers or finding slightly different qualities of stone, in which case, it is curious indeed that he chose to use the heavier stone on top of slightly lighter marble. Perhaps he preferred the denser stone nearer the large bronze equestrian at its apex. The difference may also indicate a coloristic distinction; however, Leonardo left no clues about the specific type or types of marble he intended to employ.

In the third section of the *preventivo* (3.8) Leonardo estimated that it would take sixty-four ducats (eight each) to flute the columns,[37] understandably more expensive than any of the previous architectural carving and more easily accomplished with a slightly less dense marble. Below the fluted columns Leonardo planned to place eight bases (2.6) made from slabs of similar marble five and one-half ònze square and two ònze thick (27 cm square × 10 cm or 10$^{11}/_{16}$ in. square × 3⅞ in.), costing a total of five ducats.[38] Since Leonardo estimated that carving the bases would cost just one additional ducat each (3.9),[39] he probably intended them to be simple, but the marble itself was to have been twice as expensive and therefore presumably twice as heavy as nearly all the other stone used on the monument.[40]

The bases of the columns would have rested upon a block of marble (2.7) that Leonardo says was also to have the tomb placed upon it.[41] He called for a substantial block measuring four braccia and ten ònze long and two braccia and four and one-half ònze wide (2.88 × 1.41 m or 9 ft. 6 in. × 4 ft. 6 in.), but he did not specify the thickness. Perhaps he was again reusing a preexisting piece? Based on the average weight and volume of the two principal types of marble blocks listed elsewhere in the estimate, we have arrived at an approximate height of five ònze (10 cm or 3³⁄₁₆ in.) for the block.[42] Its large surface dimensions would have allowed the bases of the columns to be evenly spaced nine and one-half ònze (47 cm or 18½ in.) between one another on the long side, forming a combined length of four braccia and four ònze (2.58 m or 8 ft. 6 in.)—that

is, two ònze (9 cm or 3½ in.) less than the length of the frieze and architrave block. The open space in the middle of the monument, measured from the interior faces of the bases of the columns on one long side to the inner faces of the other, would have been a little more than one braccio and two ònze (69 cm or 27⅛ in.).

Leonardo went on to describe other elements that he intended to place below the structure we have just described. Eight pedestals (2.8) were to be cut from a single block of marble measuring eight braccia in length and six and one-half ònze wide and thick (4.76 m × 32 cm × 32 cm or 15 ft. 6 in. × 12½ in. × 12½ in.), which would cost twenty ducats.[43] The pedestals, then, would have been one braccio (59 cm or 2 ft.) high and six and one-half ònze (32 cm or 12½ in.) square. On the long side of the monument, the pedestals could have been spaced evenly with nine ònze (45 cm or 18 in.) between each, forming a combined length of four braccia and five ònze (263 cm or 8 ft. 7 in.), leaving two and one-half ònze (12 cm or 4⅞ in.) on each end. As we shall see in our explication of item 2.12, Leonardo likely intended the distance between the pedestals on the short ends of the monument to be one braccio and two ònze (69 cm or 27⅛ in.), so a narrower strip of three-quarters of an ònze (4 cm or 1½ in.) would have appeared along both long sides.

In the third part of the *preventivo* (3.10) Leonardo indicated that carving the pedestals would cost a total of sixty-four ducats. Four of the pedestals, at the corners where two fronts would be revealed, required ten ducats of work each; four others, presumably for the sides and therefore carved on only one face, six ducats each.[44] Squaring and trimming the pedestals (3.11) was estimated at sixteen ducats, two ducats per pedestal.[45]

The next block of marble described by Leonardo (2.9) would have formed the lowest, broadest, and widest layer of the monument. Termed a cornice, it was to go underneath the entire monument and measure four braccia and ten ònze long, two braccia and five ònze wide, and four ònze thick (2.88 m ×

144 cm × 20 cm or 9 ft. 6 in. × 56¾ in. × 8 in.); the cost was to be thirty-two ducats.[46] The cornice would have protruded two and one-half ònze (12 cm or 4⅞ in.) on each end and one ònze (5 cm or 1⅞ in.) on each long side.

Having completed the exterior framing of the monument Leonardo then returned to the interior space of the monument between the columns. He specified that the stone intended for the effigy (2.10) would be placed there and measure three braccia and eight ònze long, one braccia and six ònze wide, and a somewhat hefty nine ònze thick (218 × 89 × 45 cm or 85⅞ × 35 × 17¾ in.), suggesting that the block was to contain not just the effigy but also a bier. The block was to cost thirty ducats.[47] The length of the block exactly matches the combined measurements of the two central columns on the long side of the monument and the empty spaces between and to either side of them. But Leonardo specified that the width of the effigy block was to be two ònze (9 cm or 3⅞ in.) larger than the space available. Either he assumed that the finished columns and bases would leave sufficient room or that carving the effigy would remove the excess marble. Leonardo evidently intended a good deal of carving, for he allotted one hundred ducats "for carving the figure well," the most for any single block.[48]

The artist then indicated that the effigy was not to rest directly on the block he previously described as having the tomb over it (2.7) but on yet another layer of marble (2.11). The marble slab, costing sixteen ducats, was to measure three braccia and four ònze long, one braccia and two ònze wide, and four and one-half ònze thick (198 × 69 × 22 cm or 78 × 27⅛ × 9 in.).[49] The marble slab would have elevated the effigy above the bases of the columns and served as its base. The length and width of the slab were each to be four ònze smaller than the effigy, allowing easy placement within the surrounding columns and providing a slight recess under the effigy. The stone was going to be articulated, judging from the sizable amount of forty ducats that he allotted for finishing it.[50]

Leonardo indicated that the final marble block (2.12) was to be used for eight slabs to be inserted between the pedestals. The full block was to measure nine braccia long, nine ònze wide, and three ònze thick (5.36 m × 45 cm × 15 cm or 17 ft. 7 in. × 18 in. × 6 in.) and cost just eight ducats (.00274 hundredweight per cubic ònze).[51] Like the block he had specified for the frieze and architrave (2.3), this was just a little more than half the price of most of the other materials. It, too, then may have been a preexisting block and/or was of local stone rather than Carrara marble.

Leonardo's intended disposition of the final marble block (2.12) is the most difficult part of the monument to reconstruct convincingly. In previous reconstructions scholars have positioned the slabs standing upright on their ends.[52] This disregards the fact that the block could not have been divided satisfactorily for such a disposition. For example, if the nine-braccia-long block were divided into eight equal sections, each slab would have been one braccio and one and one-half ònze long: too tall to rest upright in the one-braccio-high space between the pedestals. What is more, large gaps would have appeared to either side of the panels on the ends of the monument, where the pedestals were to be placed further apart than on the sides. The problem would not have been resolved had the slabs been cut exactly one braccio high like the openings, leaving one braccio to fill the gaps at the sides of the end panels. At nine ònze wide the leftover marble would have been insufficient to fill the ten ònze of gaps. More importantly, such a strategy would have created unsightly seams.

It makes even less sense to imagine that Leonardo intended to place the slabs upright on their sides. First, the nine-ònze-wide slabs would have been 3 ònze (15 cm or 6 in.) short of the twelve-ònze (one braccio) height, leaving a substantial gap that would not have been easy or logical to disguise with additional moldings. Second, even if the distance between the pedestals were increased to the absolute maximum, creating six ten-ònze (20 cm or 7¹¹⁄₁₆ in.) openings on the long sides and two

one-braccio-and-four-ònze (139 cm or 54¾ in.) openings at each end, Leonardo would have utilized only seven braccia and eight ònze (4.17 m or 13 ft. 8 in.) of marble. At the same time, the remaining one braccio and four ònze would have been woefully insufficient to fill the three-ònze gaps that would have run across all the openings.

We propose instead that Leonardo intended for the marble slabs to lie flat. Positioning the pedestals at intervals of nine ònze (45 cm or 17¾ in.) on the long sides of the monument and one braccio and two ònze (69 cm or 27⅛ in.) at the ends allows for complete utilization of the block of marble between the pedestals (figs. 90a and b). On the ends the marble slabs would have extended to the edges of the lower cornice.[53] They could have done the same on the long sides, though we prefer a more compact and secure alignment where the slabs are slightly recessed from the fronts of the pedestals and meet one another in the center of the monument. The slabs, then, would have created a grid that neatly secured the alignment of all the pedestals.

Fig. 90a Reconstruction of ground plan of item 2.12 in Leonardo's cost estimate of the Trivulzio monument.

Fig. 90b Ground plan of item 2.12 with Milanese dimensions.

On the long sides of the monument this grid could have been masked by six panels (3.12) that Leonardo describes in the third section of the *preventivo* as being decorated with figures and trophies, each costing twenty-five ducats.[54] Leonardo does not give their dimensions. We suggest that square trophy panels would have been placed along the sides of the monument to mask the ends of the flat grid of blocks we have just reconstructed, creating the illusion of a paneled sarcophagus under the effigy. That Leonardo specifies only six trophy panels, however, is curious, for there would have been a total of eight openings between the pedestals (two on each short end and three on each long side). He may, therefore, have intended to close the ends with panels in another material—perhaps inscriptions and/or coats of arms in bronze that he had not yet considered.

In the penultimate line of the estimate Leonardo also specified six harpies holding candelabra (3.15), again costing twenty-five ducats each.[55] He could have placed them between the columns and above the trophy panels on the long sides of the effigy, though he again provides no dimensions and does not specify their location. By this point in the *preventivo* Leonardo's itemizing was getting messy. On the last line of the third section he listed the twenty-ducat cost of squaring and trimming the stone where the effigy was to lay, which should have come earlier in the accounting if he had had every item in perfect order—and he repeated himself as he wrote the note.[56]

Leonardo did provide an accurate sum of all the costs for marble and labor as well as for modeling, casting, and finishing the equestrian monument (1.1–4). Still, it is clear that his *preventivo* offers us a somewhat incomplete view of his intentions for the Trivulzio monument. When Leonardo began to draft the document he seems to have had a good sense of the monument's general form and most of the materials that he needed for the architecture and effigy, but his list of marble did not take into account blocks for fourteen small figures—eight at the base of the horse and

six harpies serving as candelabra—nor did he give their dimensions. Furthermore, he did not specify the dimensions or the specific amount of marble needed for six trophy panels. He was also imprecise about the dimensions of the bronze equestrian statue, merely terming it life-size, and he did not mention any inscriptions, coats of arms, or mottoes —items which we have seen were on Trivulzio's brother's tomb and which were common on funerary monuments.

While it is somewhat difficult to judge the fiscal propriety of Leonardo's cost estimate, he seems to have been working within parameters that Trivulzio should have found reasonable. As we have noted, Leonardo projected a total cost of 3,046 ducats for the monument, leaving Trivulzio nearly 1,000 ducats to direct to other aspects of his funerary arrangements from the 4,000-ducat total that he had stipulated in his 1507 will. Leonardo's projected cost of the bronze horse and rider compares favorably with the cost his master Andrea del Verrocchio agreed to be paid for the bronze Colleoni equestrian monument in Venice. Leonardo estimated a cost of 1,582 ducats for modeling, casting, and finishing the bronze,[57] while Verrocchio's contract had stipulated a payment of 1,800 Venetian ducats for similar work.[58] By the time of his death in 1488, Verrocchio had received only 380 ducats, presumably for the clay model he had shipped to Venice on 16 July 1481.[59] Leonardo's estimate of 432 ducats for making his own clay model was somewhat higher, but also included creating the wax version necessary to cast it.[60]

## DRAWINGS FOR THE TRIVULZIO MONUMENT

We are left with the impression that Leonardo did everything in his power to propose a feasible project to Trivulzio. The process by which Leonardo came to his design, however, had started out much more ambitious and even fanciful, as can be reconstructed from five surviving sheets of drawings.[61] Other drawings that had been frequently associated with the project have now been convincingly reas-

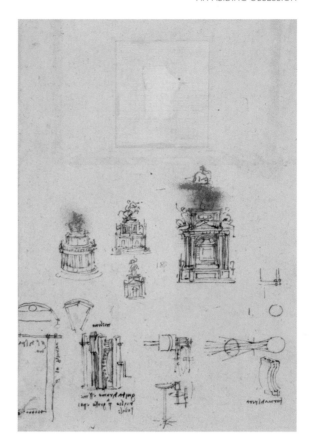

Fig. 91 Leonardo da Vinci, *Sketches of Equestrian Monuments, Architecture. and Machines*, after 1505?, pen and ink on coarse-grained paper, 11 × 7¾ inches, Royal Library, Windsor Castle, RL 12353r.

signed to Leonardo's late French period by Martin Clayton and will be discussed shortly.

What are probably Leonardo's earliest drawings for the project—and certainly the furthest from what he finally proposed to Trivulzio in the estimate—were his most ambitious and fanciful. Four sketches on RL 12353r (fig. 91)—a circular one resembling Bramante's Tempietto in Rome,[62] a buttressed version recalling the apse end of a Gothic cathedral, and two elaborate classical constructions—indicate that Leonardo initially toyed with the prospect of revisiting the enormous size of the Sforza monument. A tiny sketch of a tripartite triumphal arch at the far left of RL 12355r (plate 33) suggests the same. Each of these enormous structures was to be topped by a rearing horse and rider,[63] a motif that had dominated

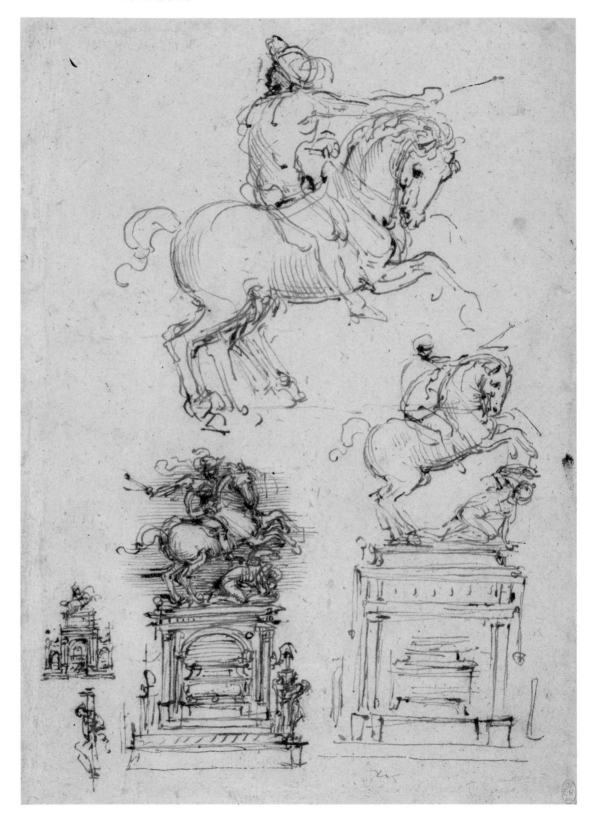

PLATE 33 **Leonardo da Vinci** (Italian, 1452–1519), *Studies for the Trivulzio Monument*, ca. 1508–1510, pen and ink on paper, 11½ × 7⅞ inches. Royal Library, Windsor Castle, RL 12355 recto.

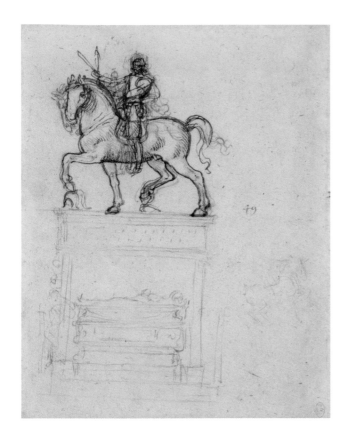

Fig. 92  Leonardo da Vinci, *A Horse Walking in Profile with Foreleg Raised and Resting on a Helmet*, ca. 1508–1511, pen, ink, and red chalk on white paper, 8½ × 6⅝ inches, Royal Library, Windsor Castle, RL 12356r.

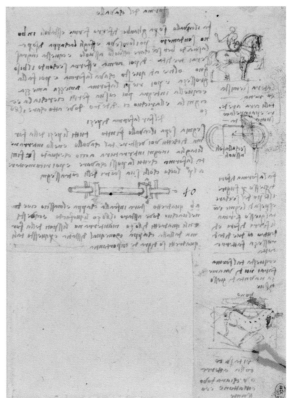

Fig. 93  Leonardo da Vinci, *A Sheet of Text with Instructions for Casting a Bronze Horse and Rider*, ca. 1508–1509, pen and ink on paper, 7¾ × 5⅜ inches, Royal Library, Windsor Castle, RL 12347r.

Leonardo's early thinking for the Sforza monument, too, and was especially dear to Trivulzio—it appears on a commemorative medal made for the general in 1508.[64]

At the same time, Leonardo began thinking about more reasonably scaled monuments, as can be seen in several designs for wall tombs that appear along with the triumphal arch on RL 12355r (plate 33). He may have begun the sheet with the large rearing horse and rider at the top. With his head and left shoulder turned back and right arm and baton extended forward as in a battle scene, the rider reappears on the lower right more normally facing forward. Leonardo probably then moved to the middle and left, as would have been logical for a left-handed artist. Leonardo drew on a smaller and smaller scale each time, but his thinking was hardly linear. By the time he got to the far left of the sheet, his mind jumped to the larger,

more impressive tripartite scheme we have already noted. Along the way Leonardo had enhanced the rather simple monument on the far right with figures bound to freestanding columns in the middle sketch, their forms perhaps first coming to his mind when he quickly drew two vertical lines to either side of the monument at the right. Leonardo always thought large, but his initially grand conception and the bound figures may also have been inspired in part by Michelangelo's 1505 plans for the tomb of Julius II.[65] The papal tomb was to have been three stories high, cover a footprint of some 23 × 36 feet (7.2 × 10.8 meters), and famously featured captives or slaves on its façade. Leonardo, however, saw his bound figures as less integral to the structure, enhancements that could be added or subtracted at will.

By the time Leonardo drew RL 12356r (fig. 92), he had come around to the more practical idea of

a striding horse stabilized with a helmet under the horse's left front hoof and what appears to be a rock under the right rear, perhaps overcompensating for the rather extravagant poses he had proposed earlier. As in the *preventivo*, the horse and rider stand on top of a tomb monument. But Leonardo sketches the funerary figure laid out on an elaborate bier and sarcophagus that recall Florentine prototypes such as the Marsuppini and Bruni monuments in Santa Croce, suggesting that at this stage he may have been imagining a wall tomb, not a freestanding monument.[66] Indeed, the open form of the burial chamber, supported by rather thin columns, indicates that Leonardo had not yet considered the full structural challenges of supporting a large equestrian sculpture, which he later addressed in his cost estimate with its eight columnar supports. Quick sketches at either side of the structure may refer to hanging lamps and figures attached to freestanding columns that appear more clearly on RL 12355r (see plate 33).

Probably the latest (and most securely dated) of the drawings for the Trivulzio monument is a page of casting notes (fig. 93). Pedretti estimated a date of 1508 or possibly 1507 for this folio,[67] convincingly comparing the handwriting to *Ms. F*, which Leonardo said he began on 12 September 1508.[68] We place the casting notes in late 1508 or early 1509. Trivulzio dictated his will in February 1507, so Leonardo may have begun thinking about the monument around that time. However, the artist spent the fall and winter of 1507–1508 in Florence, so the project is not likely to have been fully underway until after April 1508, when he settled back in Milan. The casting notes would logically have come toward the end of the design process—though Leonardo was infamous for considering detailed technical matters long before he needed to, so a precise chronology is impossible.

The notes on the casting page (see fig. 93) indicate that Leonardo's thinking was quite advanced.[69] He quickly sketched a figure of a horse and rider, his right arm flung backward, in the upper right margin, indicating that Leonardo was still consid-

ering the possibility of giving the rider an unusual pose, though not as radical as the one he sketched at the top of RL 12355r (plate 33). Leonardo's notes tell us that he intended to construct the model on iron legs.[70] Below the horse and rider is a sketch of the male and female parts of the sculptural mold, indicating that Leonardo was revisiting technical innovations he had proposed for the Sforza monument. His note indicates that the outer mold was to be made of clay and that specially designed spacers, which he illustrates in the middle of the page, were to keep the core, mold, and cover in a fixed position. At the bottom right corner of the sheet he quickly sketched the horse on its side, set diagonally across a casting pit and connected to a fan-shaped arrangement of casting runners, similar to schemes he had developed for the Sforza monument.

## FORM AND MEANING

The surviving drawings and the visual evidence we have been able to derive from Leonardo's cost estimate indicate that he approached the Trivulzio project enthusiastically and ambitiously. The scheme that we have reconstructed from the cost estimate (see fig. 87), probably Leonardo's nearly final solution, offered yet another variation on his theme. The eight figures that he proposed to place around the base of the equestrian monument (3.1) may harken back to figures that he had sketched seated at the corners of the attic zone on the rightmost of his grand early sketches (see fig. 91), and the effigy may have followed some of the forms he sketched in RL 12356r (see fig. 92), but the estimate indicates that for the most part his thinking developed far beyond what appears in the surviving drawings. As we shall see, he fused models from ducal tombs with forms and proportions associated with public equestrian cenotaphs.

Leonardo's decision to propose a rectangular burial chamber with several intercolumniations along the sides, not seen in any of the sketches, finds a prestigious Milanese precedent in the funerary monument of Duke Gian Galeazzo Visconti, commissioned from Gian Cristoforo Romano for

Fig. 94  Giovanni Cristoforo Romano (Italian, ca. 1470–1512), *Tomb of Gian Galeazzo Visconti*, Certosa di Pavia, Pavia, Italy.

Fig. 95  Bonino da Campione (Italian, active 1350–1390), *Monument to Bernabò Visconti*, 1363–1385, marble, 19 feet 8¼ inches high, Castello Sforzesco, Milan.

the Certosa of Pavia in 1492 (fig. 94).[71] A similar arrangement was later adopted for the tomb of the French King Louis XII (died 1515) at Saint Denis,[72] who probably knew the Visconti tomb and whose artists used the chamber as a platform for monumental sculptures of the kneeling king and queen, much as Leonardo proposed placing Trivulzio's equestrian statue above his sepulchral chamber. Leonardo's scheme, then, spoke of authority and rulership.

As he and Trivulzio thought about the monument, they also seem to have been particularly aware of the splendid fourteenth-century sepulcher of Bernabò Visconti (fig. 95), lord of Milan.[73] His tomb stood directly behind the high altar of San Giovanni in Conca—Milanese rulers could not be accused of undue modesty. Our reconstruction indicates that Leonardo was proposing a tomb

chamber six braccia and three ònze tall (3.71 m or 12 ft. 2 in.). A well-proportioned equestrian figure on top would have brought the overall height to about twenty feet (6.10 m), nearly identical to the Visconti monument.[74] The two monuments would have had approximately the same footprint as well. The columniated structure of Leonardo's proposal, then, should also be thought of as an updated response to the stocky set of columns under Bernabò's sarcophagus, and the eight figures that Leonardo proposed to situate around the base of the equestrian sculpture may be a concession to Lombard tradition and recall the small figures on the Visconti monument. Thus, the Trivulzio monument was to have been unabashedly Milanese and clearly the tomb of one of its civic rulers.

At the same time, by placing his equestrian sculpture on top of a much more vertically oriented and distinctly classical sepulchral chamber,

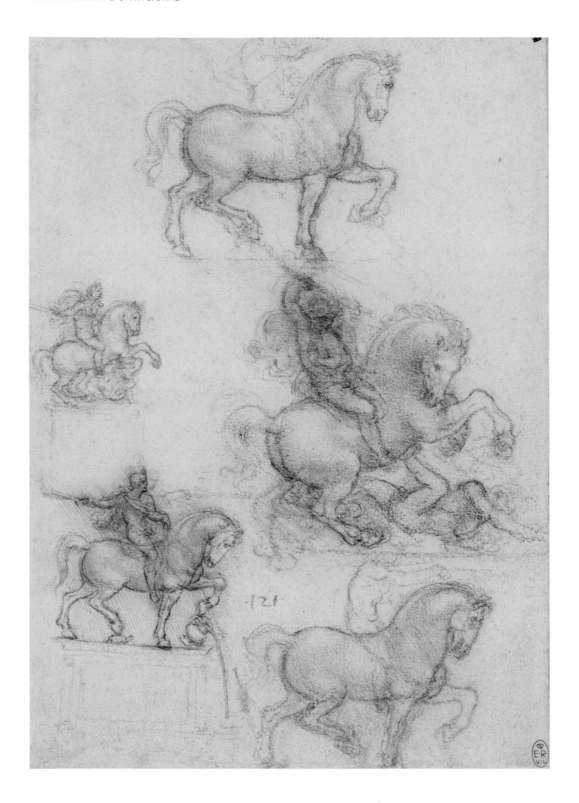

PLATE **34** **Leonardo da Vinci** (Italian, 1452–1519), *Studies for an Equestrian Monument*,
ca. 1517–1518, black chalk, pen, and ink on paper, 8⅞ × 6⅜ inches. Royal Library, Windsor
Castle, RL 12360 recto.

Leonardo also successfully recalled the most famous equestrian cenotaphs of the fifteenth century: the Gattamelata monument by Donatello in Padua (1447–1453)[75] and the Colleoni monument by his teacher Verrocchio in Venice (fig. 96, 1479–1495),[76] each raised high above the piazza in which it stands. Leonardo's monument would have been significantly shorter than either monument—the pedestal and base alone of the Gattamelata measure around 25 ft. 7 in. (7.8 m)—but inside the Trivulzio chapel the monument would have seemed larger than if it had been located outside.

Leonardo seems to have been particularly impressed by the pedestal under Verrocchio's sculpture, which, like his design, features columns set on pedestals, though it was actually designed and built by Verrocchio's Venetian successor Alessandro Leopardi.[77] Judging from the sketch Leonardo provided in his casting notes (see fig. 93), the horse probably stepped high and followed Verrocchio's direct example. Like Colleoni, the rider may also have been turning in his saddle. With his left arm swung back, he would have invited movement around the monument and into and out of the Trivulzio chapel, which served as a grand vestibule for the Church of San Nazaro.

The Trivulzio monument, then, would have provided a remarkable fusion of a burial monument type adopted by one of the most fearsome members of the Visconti family in the fourteenth century, with allusions to a ducal tomb of the late fifteenth century, and cenotaphs of two of the most renowned *condottieri* of the fifteenth century. Military man and civic ruler Trivulzio should have been delighted. The fact that the project got to the stage of Leonardo preparing a detailed estimate would seem to indicate that he was. Only a change of circumstances or intention could have led Leonardo and his patron to abandon the project. When Trivulzio's son died in 1512, a familial mausoleum rather than a personal commemorative and celebratory monument claimed Trivulzio's attention and may have led him to consider a more modest personal tomb.[78] But given the fact that Leonardo

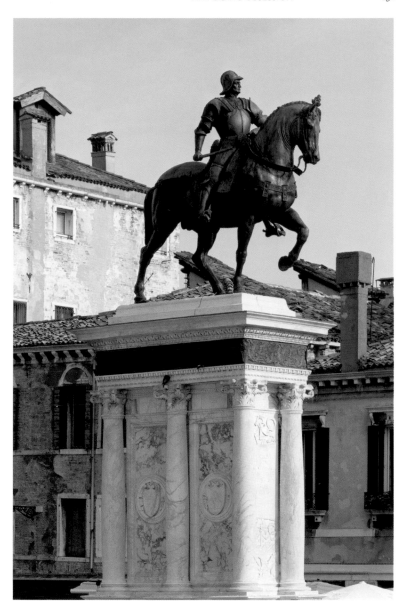

Fig. 96 Andrea del Verrocchio (Italian, 1435–1488) and Alessandro Leopardi (Italian, active 1482–1522), *Equestrian Monument of Bartolomeo Colleoni*, ca. 1483–1488, bronze, 13 feet high, Campo dei Santi Giovanni e Paolo, Venice.

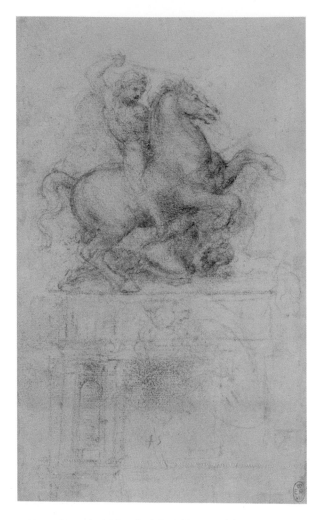

**Fig. 97** Leonardo da Vinci, *Study for an Equestrian Monument*, ca. 1517–1518, black chalk on paper, 7¹⁵⁄₁₆ × 4⅞ inches, Royal Library, Windsor Castle, RL 12354.

seems to have been poised to fully put his plans into action four years earlier, it may have been Trivulzio's renowned frugality, after all, that brought the project to an end.

## A FRENCH PROJECT

Until recently, scholars assumed that Leonardo stopped designing equestrian monuments once he left Milan for good on 24 September 1513. But in 1996 Martin Clayton convincingly argued that ten evocative black chalk drawings in Windsor—many of them on paper bearing French watermarks and some reinforced with ink—record Leonardo's thinking for an otherwise undocumented eques-

trian project, probably for the French king Francis I.[79] Sheet RL 12360r (plate 34) provides an anthology of Leonardo's abiding fascination with rearing and striding horses. While his horses became longer and huskier, probably reflecting the French steeds he now saw in front of him, Leonardo still refused to prefer one pose or stance over another. In fact, there is a fresh energy in these drawings, especially among the lightly sketched horsemen who twist, turn, and swing their arms and batons with new vigor.

The composition in the lower left quadrant of the page recalls Leonardo's composition for the Trivulzio monument (see fig. 92)—he seems to have brought the drawing with him to France and traced it on the verso for reference.[80] By lowering the horse's head and placing a tipped vase under his front leg, Leonardo simultaneously provides a support for his horse's high-stepping leg and sets it in motion. This is very sophisticated theatre, presumably made kinetically powerful by plumbing inside the vase that would have allowed water to flow forth perpetually to express bounty and munificence.[81] Leonardo had been experimenting with mechanized sculptures in this period, most famously a mechanical lion that was commissioned from him by the Florentine community in Lyon to welcome Francis I in July 1515.[82] It walked toward the king, stopped, and automatically opened its chest to reveal a display of lilies. In the case of the equestrian monument, the rider flings his arm back, as he did in the casting notes for the Trivulzio monument (see fig. 93), but he now extends his baton well beyond the tail of the horse at the back of the monument, while water from the vase would have rushed ahead of him. Neither time nor space can constrain this horse and rider. Similarly, the other striding horses on this page charge forward with a determined, proud gait.

Equally impressive is the rearing horse at the right of this page, among the most mobile and carefully choreographed Leonardo ever envisioned. A nude rider swings his arms and whip in furious motion, just about to slip off his mount to engage a

fallen enemy whose vulnerable buttocks and genitals are directly beneath the rider's right foot. The horse menaces as well, crouching low on its hind legs and rearing in response to the rolls and kicks of the man on the ground. Every limb of rider, horse, and fallen man echo one another through the entire composition. This would seem to be a composition imagined for a painting rather than a sculpture—it depicts such a transitory and dynamic moment—but other drawings, such as RL 12354r (fig. 97), with a similar group set upon a triumphal arch and the quick horizontal line under the group we have been describing on RL 12360r (plate 34), make it clear that Leonardo was imagining an unprecedented kind of equestrian sculpture. While it might stand on an arch or other pedestal, it would defy time and space. Leonardo's idea was literally too large to be contained or restrained by normal expectations.

A bronze horse and rider statuette in Budapest clearly reflects these ideas (see plate 43).[83] While it is difficult to imagine that the group, especially the rider, came directly from Leonardo's hand,[84] the horse may have been cast from or closely dependent upon a lost wax or clay model that Leonardo made in preparation for his French equestrian project.[85] Only in this late period does he come to thoroughly understand and appreciate how a broad, crouching stance would allow such a large-bellied horse to support itself convincingly in the air.[86] All four legs of the horse bend and move in slightly different directions. Here we encounter an object that is satisfying from multiple points of view, conquering space and sculptural form in ways that would inspire artists for countless generations. As we have already noted, Leonardo's most direct sculptural heir, Giovan Francesco Rustici, for example, composed complex terracotta battle groups according to these principles, the best of them offering delights and surprises as we walk around them (see plates 41 and 42).

Leonardo's abiding obsession with horses and horsemen proved nigh inexhaustible. He had been exploring the subject of rearing horses and horse-

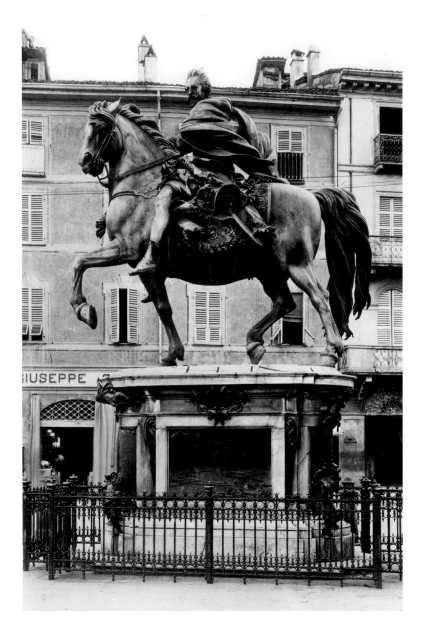

Fig. 98  Francesco Mochi (Italian, 1580–1654), *Equestrian Monument to Alessandro Farnese*, 1612–1625, bronze, Piazza dei Cavalli, Piacenza, Italy.

men since at least the early 1480s for the background of his altarpiece of the Uffizi *Adoration of the Magi* (see fig. 100), went on to develop his ideas further in preparation for the Sforza and Trivulzio monuments, and in France continued to entertain new possibilities, each more energized and dynamic than those before. Neither his horses and horsemen nor his imagination ever stood still. Had

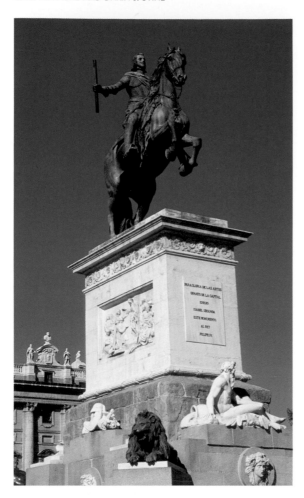

Fig. 99 Pietro Tacca (Italian, 1577–1640), *Monument to King Philip IV of Spain*, 1634–1640, bronze, Plaza de Oriente, Madrid.

any of the monuments associated with his studies been erected they surely would have altered the course of all subsequent equestrian sculpture, making the type more mobile, multidirectional, and narrative. As it was, Baroque artists did take up his challenge, especially Francesco Mochi in his marvelously kinetic monument to Alessandro Farnese in Piacenza (fig. 98) and Pietro Tacca in the rearing horse on his monument to Philip IV of Spain (fig. 99),[87] but works such as these might have come much sooner—and those featuring rearing horses would have surely been more naturalistic —had Leonardo's compositions been realized in his lifetime.

# Appendix A[88]

Cost estimate from the *Codex Atlanticus*, folio 179v-a

*Tomb of Messer Gian Giacomo Trivulzio*

### 1  Cost of the labor and materials for the horse

1.1  A lifesize charger, with a man above, requires for the cost of the metal . . . 500 ducats.

1.2  And for the cost of the ironwork that goes in the model, and the charcoal and wood and pit for casting it, and for locking the mold, and for the furnace where it needs to be cast . . . 200 ducats.

1.3  For making the model of clay and then of wax . . . 432 ducats.

1.4  And for the workers, who will chase it when it has been cast . . . 450 ducats.

In sum they are . . . 1,582 ducats.

### 2  Cost of the marbles for the Sepulcher. Cost of the marble according to the drawing

2.1  The piece of marble that goes underneath the horse, which is 4 braccia long, and 2 braccia and 2 ònze wide, and 9 ònze thick, 58 hundredweight, at 4 lire and 10 soldi per hundredweight . . . 58 ducats.

2.2  And for the cornice of 13 braccia and 6 ònze, 7 ònze wide, and 4 ònze thick, 24 hundredweight . . . 24 ducats.

2.3  And for the frieze and architrave, which is 4 braccia and 6 ònze long, 2 braccia wide, and 6 ònze thick, 20 hundredweight . . . 20 ducats.

2.4  And for the capitals made of metal, which are 8, going in 5 ònze squares, and 2 ònze thick, at a price of 15 ducats for each, amount to . . . 120 ducats.

2.5  And for the 8 columns of 2 braccia and 7 ònze, 4½ ònze thick, 20 hundredweight . . . 20 ducats.

2.6  And for 8 bases, which are in 5½ ònze slabs and a 2 ònze height, 5 hundredweight . . . 5 ducats.

2.7  And for the stone on which is the tomb, 4 braccia and 10 ònze long, 2 braccia and 4½ ònze wide, 36 hundredweight . . . 36 ducats.

2.8  And for 8 pedestal feet, which go 8 braccia long and 6½ ònze wide, 6½ ònze thick, 20 hundredweight, amount to . . . 20 ducats.

2.9  And for the cornice that is underneath, which is 4 braccia and 10 ònze long, 2 braccia and 5 ònze wide, and 4 ònze thick, 32 hundredweight . . . 32 ducats.

2.10  And for the stone from which is made the effigy, which is 3 braccia and 8 ònze long, 1 braccia and 6 ònze wide, 9 ònze thick, 30 hundredweight . . . 30 ducats.

2.11  And for the stone that goes under the effigy, which is 3 braccia and 4 ònze long,1 braccia and 2 ònze wide, 4½ ònze thick . . . 16 ducats.

2.12  And for the slabs of marble inserted between the pedestals, which are 8 and are 9 braccia long, 9 ònze wide, and 3 ònze thick, 8 hundredweight . . . 8 ducats.

In sum they are . . . 389 ducats.

### 3  Cost of the labor for the marble

3.1  Around the base of the horse go 8 figures, 25 ducats each . . . 200 ducats.

3.2  And on the same base go 8 festoons, with certain other ornaments; and of these there are 4 at the price of 15 ducats for each, and 4 at the price of 8 ducats for one . . . 92 ducats.

# Appendix B

3.3 And for squaring those stones . . . 6 ducats.

3.4 Again for the cornice, which goes under the base of the horse, which is 13 braccia and 6 ònze, at 2 ducats per braccio . . . 27 ducats.

3.5 And for 12 braccia of frieze at 5 ducats per braccio . . . 60 ducats.

3.6 And for 12 braccia of architrave at 1½ ducats per braccio . . . 18 ducats.

3.7 And for three flowered coffers, which make the ceiling of the tomb, at 20 ducats per large flower . . . 60 ducats.

3.8 And for 8 columns fluted at 8 ducats for one . . . 64 ducats.

3.9 And for 8 bases at 1 ducat for one . . . 8 ducats.

3.10 And for 8 pedestals, of which 4 of them are at 10 ducats for one, which go above the corners, and 4 at 6 ducats for one . . . 64 ducats.

3.11 And for squaring and trimming the pedestals, at 2 ducats for one, which are 8 . . . 16 ducats.

3.12 And for 6 slabs with figures and trophies at 25 ducats for one . . . 150 ducats.

3.13 And for the trimming of the stone that goes under the effigy . . . 40 ducats.

3.14 For the figure of the effigy, to make it well . . . 100 ducats.

3.15 For 6 harpies with candelabra at 25 ducats for one . . . 150 ducats.

3.16 For squaring the stone where the effigy lies, and for the trimming . . . 20 ducats.

In sum . . . 1,075 ducats.

In sum, all things added together are 3,046 ducats.

*Cubic ònze to hundredweight of marble required for Leonardo's Trivulzio monument*

2.1 Marble Base Block 11,232 ò.$^3$ = 58 hw
   1 ò.$^3$ = 0.005 (0.0052) hw

2.2 Upper Cornice 4,536 ò.$^3$ = 24 hw
   1 ò.$^3$ = 0.005 (0.0053) hw

2.3 Frieze and Architrave 7,776 ò.$^3$ = 20 hw
   1 ò.$^3$ = 0.003 (0.0026) hw

2.4 4 Metal Capitals

2.5 Eight Columns 5,022 ò.$^3$ = 20 hw
   1 ò.$^3$ = 0.004 (0.0039) hw

2.6 Bases 484 ò.$^3$ = 5 hw
   1 ò.$^3$ = 0.010 (0.0103) hw

2.7 Stone above the Sepulcher [missing the height]

2.8 Pedestal Block 4,056 ò.$^3$ = 20 hw
   1 ò.$^3$ = 0.005 (0.0049) hw

2.9 Lower Cornice 6,728 ò.$^3$ = 32 hw
   1 ò.$^3$ = 0.005 (0.0048) hw

2.10 Effigy Block 7,128 ò.$^3$ = 30 hw
   1 ò.$^3$ = 0.004 (0.0042) hw

2.11 Stone under the Effigy 2,520 ò.$^3$ = 16 hw
   1 ò.$^3$ = 0.006 (0.0063) hw

2.12 Slabs inserted between the pedestals 2,916 ò.$^3$ = 8 hw
   1 ò.$^3$ = 0.003 (0.0027) hw

## NOTES

Work on this essay began in a graduate seminar on Leonardo and the Art of Sculpture conducted by Gary Radke at Syracuse University in Fall 2007, where Darin J. Stine proposed a new reconstruction of Leonardo's Trivulzio monument. The two authors have since collaborated on refining Stine's proposal, translating Leonardo's cost estimate, and defining the historical context offered in this essay.

1. Martin Clayton was the first to recognize that a series of drawings usually associated with the Trivulzio monument are likely to have been produced in France. See Clayton 1996, esp. pp. 140–149.

2. Two famous Florentine military captains, Sir John Hawkwood and Niccolò da Tolentino, were commemorated in Florence Cathedral by frescoed monuments, not carved ones, painted respectively by Paolo Uccello and Andrea del Castagno.

3. For this and other biographical information, see Valsecchi 1968, pp. 27 and 53–59.

4. Margherita Colleoni (1455–1485).

5. Beatrice Inigo d'Avalos d'Aquino (married 1488; died 1547).

6. A more comprehensive discussion can be found in Rosmini 1815.

7. Valsecchi 1968, p. 54.

8. Robertson 2003, pp. 323–340.

9. Robertson 2002, pp. 67–81. Robertson, p. 71, reports that Bramante is documented as having received a short silver cloth and a fustian jerkin as a member of the Trivulzio household while he was working on the wooden and gilt Camera dell'Oro in the palace. He may also have been involved in the making of large medals that are recorded in an account book of 1485.

10. See Valsecchi 1968. The complete set survives in the Museum of the Castello Sforzesco in Milan.

11. Robertson 2003, p. 323, n. 1. Between 1499 and 1519, Prato wrote that Trivulzio "was liberal in youth but in old age he became mean although he was worth a million and a half in gold [Liberale in gioventù, ma in senectute scarso divento, ancora che ricco fussi di circa un milione e mezzo d'oro]."

12. Reported in Robertson 2003, p. 329.

13. Federico da Montefeltro owed much of his disposable income to this practice. See Gould 1973, pp. 129–144, and Gould 1978, pp. 718–734.

14. Roberston 2003, p. 336.

15. Baroni 1939, p. 204, "in arca marmorea elevata a terra saltem brachia 8 vel circa, laborata . . . ornamento ecclesie predicte santi Nazarii."

16. Baroni 1939, pp. 203–204, gives the text of his wishes for burial at San Stefanino: "in ipsa ecclesia et capella fiat unum sepulchrum, in quo ponatur cadaver meum, quod sit marmoreum, et desuper ipso sepulchro adsit effigies mei testatoris e pulchro marmore et sit armata, et in ipso sepulchro, computatis pecuniis expendendis in dicta ecclesia et capella, volo ut expenditure libri 4000 imperialium ad minus." He also stipulated the inclusion of his family's coat of arms and the motto *tempori melius*.

17. Baroni 1939, p. 203.

18. The original *decumanus* was lined by columns on either side. The basilica was situated between the city gate and a triumphal arch. See Lewis 1969, p. 91.

19. ". . . corpus vero suum, cum cadaver effectum fuerit, vult et ordinat tradi debere ecclesiastice sepulture ultime in capella per prefatum dominum testatorum costruenda et fondanda in ecclesia vel prope ecclesiam Sancti Nazarii in Brolio Mediolani, pro qua capella costruenda et dotanda ac ornanda et uno sepulcro in ea costituendo ac pro una domo habili pro habitatione unius prepositi et decem capellanorum deputandorum pro tempora ad dictam capellam, prelibatus dominus testator assegnavit et assignat redditus. . . ." Archivio Trivulzio (Arch. Mil. 154) Testament. G. Giac. Trivulzio 1507 febbraio 22, rog. G.B. Caccia da Castiglione, as recorded in Baroni 1939, p. 208, n 4.

20. The ink, handwriting, and format of the *preventivo* are similar to a sheet in the *Codex Atlanticus* (hereafter abbreviated *CA*), 199v-b, containing notes on painting and light and shade, which Pedretti has dated circa 1506–1507 (Pedretti 1962, p. 60). Similar handwriting is also found on *CA* 83r-b and 83v-b, datable to around 1508 from a connection to *Ms. F*, which has a commencement date of 1508 on the cover (Pedretti 1962, p. 60, from Codice F, f.1r, 12 September 1508: "Cominciato a Milano addì 12 di settembre 1508." Cited in Villata 1999, p. 227).

21. "Spesa del marmo secondo il disegno" (*CA* 179v-a, section 2).

22. Beltrami 1920 and Castelfranco 1955, pp. 262–269.

23. "Il pezzo del marmo che va sotto il cavallo, ch'è lungo braccia 4, e largo braccia 2 e ònze 2, e grosso ònze 9, centinara 58, a lire 4 e soldi 10 per centinara . . . ducati 58" (*CA* 179v-a, 2.1). We have not been able to determine the precise means by which he calculated the prices of each block. The prices vary slightly according to both volume and linear dimensions.

24. We are very grateful to Charles Morscheck of Drexel University, who has studied the building records of Milan Cathedral in great detail, for this information.

25. "Attorno allo imbasamento del cavallo va figure 8, di 25 ducati l'una . . . ducati 200." *CA* 179v-a, 3.1.

26. "E nel medesimo imbasamento li va festoni 8, con certi altri ornamenti; e di questi ve n'è 4 a prezzo di ducati 15 per ciascuno, e 4 a prezzo di 8 ducati l'uno . . . ducati 92." *CA* 179v-a, 3.2.

27. "E per isquadrare dette pietre . . . ducati 6." *CA* 179v-a, 3.3.

28. "E per 13 braccia di cornice e ònze 6, larga ònze 7, e grossa ònze 4, centinara 24 . . . ducati 24." *CA* 179v-a, 2.2.

29. "Ancora pel cornicione, che va sotto lo imbasamento del cavallo, ch'è braccia 13 e ònze 6, a ducati 2 per braccio . . . ducati 27." *CA* 179v-a, 3.4.

30. "E per lo fregio e architrave, ch'è lungo braccia 4 e ònze 6, largo braccia 2 e grosso ònze 6, centinara 20 . . . ducati 20." *CA* 179v-a, 2.3.

31. We have found the average weight of the two blocks Leonardo had already listed to be .005 hundredweight per cubic ònze.

32. "E per 12 braccia di fregio a ducati 5 per braccio . . . ducati 60. E per 12 braccia d'architrave a ducati 1 e ½ per braccio . . . ducati 18." *CA* 179v-a, 3.5–6.

33. "E per 3 fioroni, che fan soffitta alla sepoltura, a 20 ducati per fiorone . . . ducati 60." *CA* 179v-a, 3.7.

34. "E per li capitelli fatti di metallo, che sono 8, vanno in tavola ònze 5, e grossi ònze 2, a prezzo di ducati 15 per ciascuno, montano . . . ducati 120." *CA* 179v-a, 2.4.

35. "E per 8 colonne di braccia 2 e ònze 7, grosse ònze 4 e ½, centinara 20 . . . ducati 20." *CA* 179v-a, 2.5.

36. Modern calculations to four decimal points actually yield a slightly different weight per cubic ònze for every block, but it is unlikely that Leonardo's calculations were this precise. See Appendix B.

37. "E per 8 colonne accanalate a 8 ducati l'una . . . ducati 64." *CA* 179v-a, 3.8.

38. "E per 8 base, che sono in tavola ònze 5 e ½ e alte ònze 2, centinara 5 . . . ducati 5." *CA* 179v-a, 2.6.

39. "E per 8 base a 1 ducato l'una . . . ducati 8." *CA* 179v-a, 3.9.

40. See the data in Appendix B.

41. "E per la pietra dov'è su la sepoltura, lunga braccia 4 e ònze 10, larga braccia 2 e ònze 4 e ½, centinara 36 . . . ducati 36." *CA* 179v-a, 2.7. Admittedly, Leonardo's terminology "dov'è su la sepoltura" is open to interpretation, but later in the estimate he does clarify that Trivulzio's effigy was to rest above this block.

42. With a weight of .004 hundredweight per cubic ònze the missing section would have been 5.45 ònze thick, while with a weight of .005, the missing dimension would come to 4.35 ònze. The average of the two measurements amounts to 4.9 ònze.

43. "E per 8 piè di piedistalli, che van lunghi braccia 8 e larghi ònze 6 e ½, grossi ònze 6 e ½, centinara 20, montano . . . ducati 20." *CA* 179v-a, 2.8.

44. "E per 8 piedistalli, de' quali n'è 4 a 10 ducati l'uno, che van sopra li cantoni, e 4 a 6 ducati l'uno . . . ducati 64." *CA* 179v-a, 3.10.

45. "E per isquadrare e scorniciare li piedistalli, a due ducati l'uno, che sono 8 . . . ducati 16." *CA* 179v-a, 3.11.

46. "E per la cornice ch'è di sotto, ch'è lunga braccia (4) e ònze 10, larga braccia 2 e ònze 5 e grossa ònze 4, centinara 32 . . . ducati 32." *CA* 179v-a, 2.9.

47. "E per la pietra di che si fa il morto, ch'è lunga braccia 3 e ònze 8, larga braccia 1 e ònze 6, grossa ònze 9, centinara 30 . . . ducati 30." *CA* 179v-a, 2.10.

48. "Per la figura del morto, a farla bene . . . ducati 100." *CA* 179v-a, 3.14.

49. "E per la pietra che va sotto il morto, ch'è lunga braccia 3 e ònze 4, larga braccia 1 e ònze 2, grossa ònze 4 e ½ . . . ducati 16." *CA* 179v-a, 2.11.

50. "E per la scorniciatura della pietra che va sotto il morto . . . ducati 40." *CA* 179v-a, 3.13. The term *scorniciatura* would seem to imply a simple trimming of the block, but the price for this work is very high. When compared to the carving of the architrave, for example, almost one-third larger than the stone under the effigy and costing only eighteen ducats finish, we can assume that a more ornate carving was intended.

51. "E per le tavole del marmo interposte infra li piedistalli, che sono 8 e son lunghe braccia 9, larghe ònze 9 e grosse ònze 3, centinara 8 . . . ducati 8." *CA* 179v-a, 2.12.

52. Castelfranco 1955, p. 265.

53. The six-and-one-half-ònze width of the pedestal combined with the two-and-one-half-ònze space from the cornice mentioned earlier in the reconstruction total nine ònze, the exact width of the marble slabs.

54. "E per 6 tavole con figure e trufei a 25 ducati l'una . . . ducati 150." *CA* 179v-a, 3.12.

55. "Per 6 arpie colli candellieri a 25 ducati l'una . . . ducati 150." *CA* 179v-a.

56. "Per isquadrare la pietra dove si posa il morto, e sua scorniciatura . . . ducati 20." *CA* 179v-a, 3.16.

57. "In somma sono . . . ducati 1582."
*CA* 179v-a, section 1.

58. Adorno 1991, p. 216.

59. Covi 1966, p. 98.

60. "*Per fare il modello di terra e poi di
cera . . . ducati 432.*" CA 179v-a, 1.3.

61. RL 12347r, RL 12353r, RL 12353A,
RL 12355r, and RL 12356r.

62. Leonardo was in Tivoli on 10 March
1501, and would have been familiar with
the Temple of the Sybils, which served
as a source for Bramante's design for
the *Tempietto* of San Pietro in Mon-
torio, completed in 1502. See Marani
1995, pp. 207–225, esp. 207–208. Leo-
nardo returned to Rome again in 1505,
as witnessed by a customs notice of 30
April from the Archivio di Stato, Flor-
ence, *Operai di Palazzo*, Stanziamenti
10, 76v-80r, 30 April 1505: "A Lionardo
di Ser Piero da Vinci paghati per lui a
Mariotto Ghalilei camerlengo in gogana
per ghabella duno suo fardello di sue
veste fatto venire da Roma 1. 18 s. 9 d. 8
[ . . . ]." Cited in Villata 1999, p. 184.

63. See, too, the tiny sketch cut out of
a page from 83v-b of the *Codex Atlan-
ticus*, now catalogued as RL 12353A.
Leonardo jotted a few casting notes on
the recto of the same page. See Pedretti
1977, vol. 2, pp. 8–9.

64. See Hill 1910, pp. 20–21.

65. See De Tolnay 1957, pp. 5–19.

66. RL 12353A, the little fragment from
the *Codex Atlanticus*, looks as though it
could have been a wall monument, too.

67. Pedretti bases the possibility of 1507
on the similarity in the handwriting to
the notes describing the *Sito di Venere*,
found on RL 12591r and v, detailing the
garden of Venus and a proposed garden
for the palace of Charles d'Amboise.
Pedretti *I cavalli* 1984, pp. 66–68;
Pedretti 1962, p. 51.

68. Pedretti 1962, p. 60.

69. Richter 1883, vol. 2, section 711,
provides a transcription and English
translation of the notes, though he mis-
takenly associates them with the Sforza
monument. See also the brief discus-
sion in Pedretti 1977, vol. 2, pp. 12–13.

70. "Fa il cavallo sopra ghambe di ferro
ferme e stabili in bono fondamento poi
l'om se va e faghi la choppa de sopra
lasciando ben sughare a suolo a suolo e
questa ingrasserai tre dita." RL 12347r.

71. See Norris 1977.

72. Produced by the Italian sculptors
Antonio and Giovanni Giusti. See
Panofsky 1964, p. 75 and fig. 524.

73. Begun before 1363 and now in the
Castello Sforzesco, Milan. The monu-
ment and Bernabò's patronage deserve
a major modern reconsideration. See
Baroni 1944. For Bernabò's patronage of
manuscripts, see Sutton 1991, pp. 322–
326.

74. Precise dimensions are not available,
but museum officials list the height as
six meters (19 ft. 8 in.).

75. See Janson 1963, pp. 151–161.

76. See Butterfield 1997, pp. 158–183 and
232–236.

77. Butterfield 1997, p. 183.

78. Baroni 1939, p. 254, reports that
Prato said Trivulzio began the chapel
at San Nazaro in 1513. For documenta-
tion regarding the subsequent history
of the chapel, see Baroni 1939, 256f.,
and Valsecchi 1968, pp. 56–59.

79. RL 12313, RL 12341, RL 12342,
RL 12343, RL 12344, RL 12354, RL 12359,
RL 12360, and RL 13042, as well as
RL 12356v. See Clayton 1996, pp. 141–
149, cat. nos. 81–87. Clayton 1996, p. 142,
reminds the reader "that there is no doc-
ument to support this theory of a French
equestrian project, but this is only one

document less than the sum of our
knowledge of the Trivulzio project."

80. Clayton 1996, p. 142.

81. Clayton 1996, p. 148.

82. See Taddei 2007, esp. pp. 164–235,
and Garai 2007, esp. pp. 11–27, both of
which, however, present highly specula-
tive reconstructions.

83. Szépművészeti Múzeum, inv. no.
5362. See Agghấzy 1989 and Clayton
1996, p. 142. The more recent associa-
tion of the Budapest bronze with the
*Battle of Anghiari* is less convincing;
see Zoltán Kárpáti and Maria Sframeli
in *Splendour of the Medici* 2008, p. 175.

84. First proposed by Meller 1916,
pp. 213–250, and most vociferously
supported by Agghấzy 1989.

85. Recent technical studies overseen
by Shelley Sturman in the conservation
laboratories of the National Gallery of
Art, Washington, D.C., indicate that the
horse and rider were cast with the same
alloy and technique, apparently in the
mid-sixteenth century.

86. Closely explored in such sketches
as RL 12331.

87. See the very useful survey in Covi
1995, pp. 40–56.

88. The most recent transcription of
the *preventivo*, found in Villata 1999,
pp. 197–198, has several shortcomings.
In section 2.9 he provides an additional
width for the stone that goes above
the sepulcher matching the length and
neglects to include the braccia length of
four. He also combines 2.10–2.11, using
the length of 2.10 and the width, thick-
ness, and cost weight of 2.11. Our trans-
lation attempts to stay as close to the
original text as possible, even when it
results in certain awkward formulations.
For earlier, less rigorous translations,
see Richter 1883, vol. 2, 725, pp. 15–17,
and MacCurdy 2003, pp. 1010–1012.

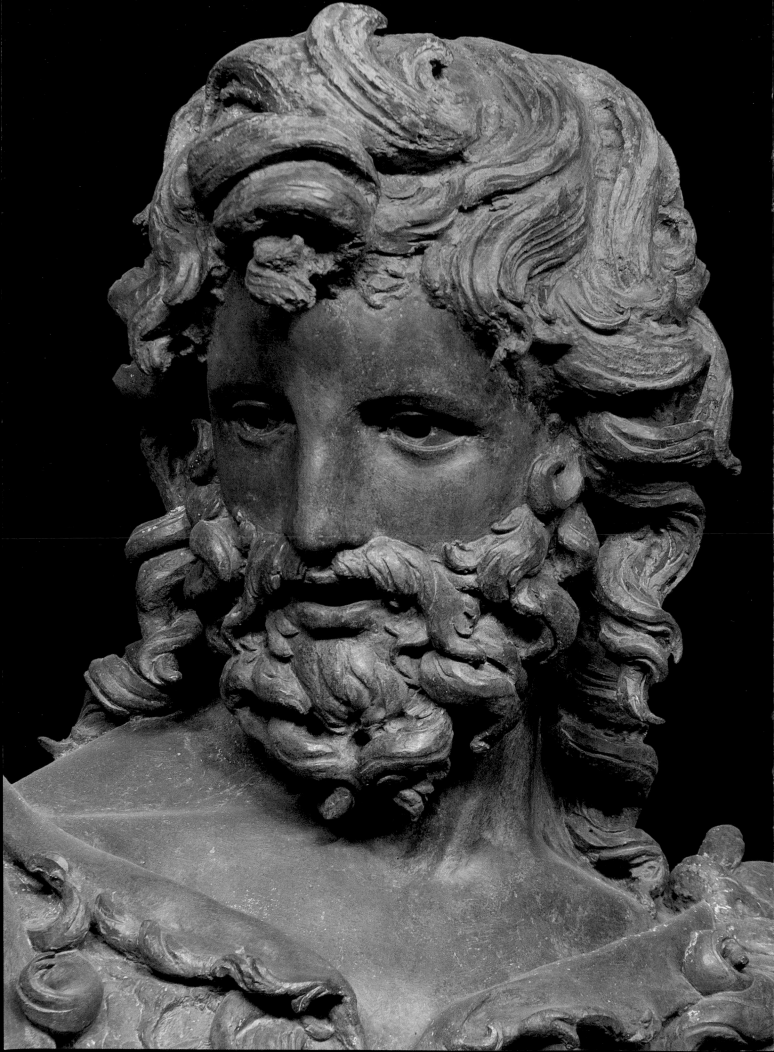

PHILIPPE SÉNÉCHAL

# *Giovan Francesco Rustici,*
# *With and Without Leonardo*

The cruel loss of almost all of Leonardo da Vinci's sculpture has led many scholars to consider that much of the work of Giovan Francesco Rustici (Florence, 1475–Tours, 1554) was derived directly from the ideas of Leonardo, who was a friend of Rustici's and his senior by twenty-three years. Following a long period during which Rustici's work remained largely forgotten and misjudged, numerous scholars working in parallel have now provided us with a clearer and more nuanced assessment of the artist's work.[1] To begin with, we now know that most of his activity was devoted to sculpture. With the exception of a few rare pictures mentioned by Vasari but now lost, and a panel at the Victoria and Albert Museum in London depicting *The Conversion of Saint Paul*—which, moreover, might have been painted by two different artists[2]—Rustici produced very few paintings. Although he undoubtedly drew a great deal, only one red chalk and three ink drawings by him have been conserved, and the hatching in the ink works betrays similarities with that of Michelangelo in his first period.[3] It is true that for a man who lived to be nearly eighty, the list of his sculpted works is short, yet we should not forget that this born sculptor probably had more opportunities than Leonardo did to make audacious sculptural experiments in a variety of media and genres. He tried his hand at enameled and nonenameled terracotta, marble, wax, bronze, and *cartapesta* (papier-mâché), and produced a bust, two medals, and several large-scale statues, as well as isolated statuettes, sculpted groups, funerary monuments, reliefs for private devotion, a fountain, and an altarpiece.

Although both Rustici and Leonardo entered the service of King Francis I and died in France, Giovan Francesco arrived in Paris nine years after the death of Leonardo and outlived him by thirty-five years. The direct contact between the two artists should therefore probably be dated to Rustici's Italian period, a time when the interaction between the two men was at its most stimulating—even if faint Leonardesque echoes can be detected in certain of Rustici's works during his later Parisian period, as well as in those of one of his followers,

Lorenzo Naldini (Laurent Regnauldin in French), who like Rustici went to live and work in France.

The first meeting between Leonardo and Rustici could hardly have taken place in Andrea del Verrocchio's workshop, where, according to Vasari, Giovan Francesco worked as an apprentice. We know that Leonardo had become independent by 1478, and it is most unlikely that Rustici began working as a *garzone* in the workshop before 1482, the date when Leonardo left for Milan. Verrocchio went to Venice in 1486, and the young Giovan Francesco would probably have spent the major part of his apprenticeship under Lorenzo di Credi. He was, however, exposed to the same Verrocchian influences as Leonardo, and tried to go beyond them in a similar way. The distorted, shrieking faces and the centrifugal movements of the soldiers in the Careggi *Resurrection* (see fig. 13, now in the Museo Nazionale del Bargello),[4] the studies of swirling and cascading drapery, the robust bald-headed figures, and the ever-mobile putti are all motifs used by Rustici that had previously been employed by Leonardo in a multitude of forms. The manner in which Leonardo used certain dynamic and psychological inflections on selected aspects of works by Verrocchio probably constituted a kind of filter and served as an indicator of the modern way Rustici should follow. It has been established that the da Vinci and Rustici families were in contact by 1489 at the latest, and this may have encouraged the two men to reestablish contact when Leonardo returned to Florence from Milan, at first occasionally from 1501 onward, and then more regularly from the autumn of 1503.[5]

However, as the marble plaque fixed to a wall in the Via Martelli in Florence proclaims, it was only in 1508 that these artists of two different generations really began to collaborate. During Leonardo's long absence, Giovan Francesco had become acquainted with bronze and with the works of antiquity while working under Bertoldo; he had also met Michelangelo, with whom he would remain close all his life, and had begun to carve in marble, possibly under the supervision of Benedetto da Maiano,

whose workshop in the Via de' Servi he took over in 1500. His first works were in marble, namely a *Bust of Boccaccio*, produced for the poet's cenotaph in Certaldo, and the *Virgin and Child with the Infant St. John the Baptist* for the convent of the Annunziata. Whereas these works, with their full, enveloping forms emphasized by deep incisions, reveal the still-present influence of Benedetto da Maiano and Francesco di Simone Ferrucci,[6] they betray no sign of Leonardo's influence. It was probably between 1503 and 1506, when Leonardo was working on the *Battle of Anghiari*, that the two men met again, a renewed contact that would mature into a deep and lasting friendship and mark a turning point in Rustici's art. Leonardo subsequently returned to Milan, but between March and September 1508 he was once again in Florence, staying in the house of Piero di Braccio Martelli. Giovan Francesco was living very close by, possibly in the adjoining house, which he rented from Giovanfrancesco Martelli,[7] in the street named after that distinguished family, situated between the Baptistery and the Medici Palace in the Via Larga.

In December 1506, thanks most likely to the mediation of the Neo-Platonic philosopher Francesco Cattani da Diacceto, the Arte di Calimala commissioned three bronze figures from Rustici. They were to surmount the north door of the Baptistery, in replacement of the previous statues by Tino da Camaino, which had become out of date and were considered *goffe*—i.e., so ridiculously clumsy that they brought shame on the town of Florence.[8] We are indebted to Vasari for a firm indication regarding the genesis of *John the Baptist Preaching to a Levite and a Pharisee* (plate 35), a sculptural group in which the Baptist is depicted replying to the questions of the Pharisee and Levite standing beside him, while announcing the coming of the Savior to bystanders below. Vasari relates an opinion, held by certain of his contemporaries—though unsubstantiated by any definite proof—that "Leonardo worked at the group with his own hand, or that he at the least assisted Rustici with counsel and good judgment."[9] While noting the "infinite majesty and

force" and the "heroic gravity"—more in the vein of a Michelangelo—Vasari emphasizes the graceful and lively attitudes of the figures, the singular ease and flow as well as the stupefying variety of the draperies, the anatomic perfection of the limbs and the irreproachable way in which they are "conjoined to the trunks"—all of which correspond to the recognized talents of Leonardo.[10] Admittedly, during the long dispute between the Arte di Calimala and Rustici over payment for the group, no mention was made of any direct intervention by Leonardo on the work itself.[11]

However, we should beware of taking the rumor related by Vasari too lightly. In view of the numerous similarities between the Baptistery statues on the one hand and certain precise works and the general aesthetic of Leonardo on the other, it is almost

certain that Rustici studied drawings by Leonardo, and it is even tempting to postulate that da Vinci possibly intervened directly on the models before they were cast in 1509 by Bernardino d'Antonio da Milano. One of the directions indicated by Leonardo would have been that of Donatello.[12] In 1480, after studying Donatello's *Bearded Prophet* for the Campanile of Florence (see plate 2), Leonardo had started considering the possibility of creating asymmetrical figures and meditative attitudes. This can be seen clearly both in the central figure of Leonardo's pen-and-ink study on paper dating to 1480–1481, now in the British Museum (see plate 11) —where the drapery clings more to the leg than does the drapery of Donatello's prophet—and in the Philosopher, the figure standing to the left in the Uffizi's *Adoration of the Magi* (fig. 100), which

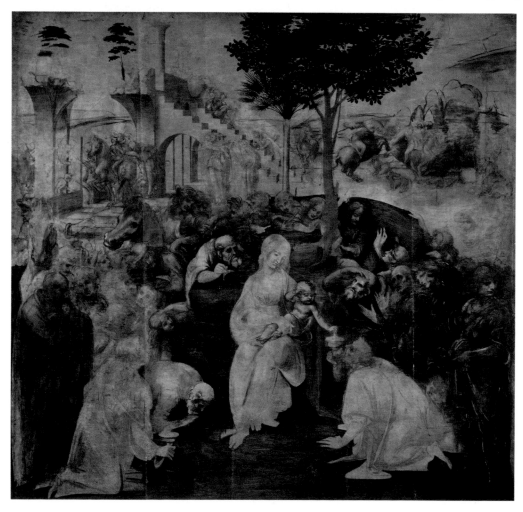

**Fig. 100**  Leonardo da Vinci, *Adoration of the Magi*, 1481–1482, underpainting on panel, 97 × 96 inches, Galleria degli Uffizi, Florence, inv. 1594.

Unrestored statues above the North Doors of the
Baptistery of St. John, Florence.

PLATE 35 **Giovan Francesco Rustici** (Italian, 1475–1554), *John the Baptist Preaching to a Levite
and a Pharisee*, 1506–1511, bronze, Pharisee: 105¼ × 35½ inches; John the Baptist: 107½ × 35½ inches;
Levite: 103¼ × 35½ inches. Museo dell'Opera del Duomo, Florence.

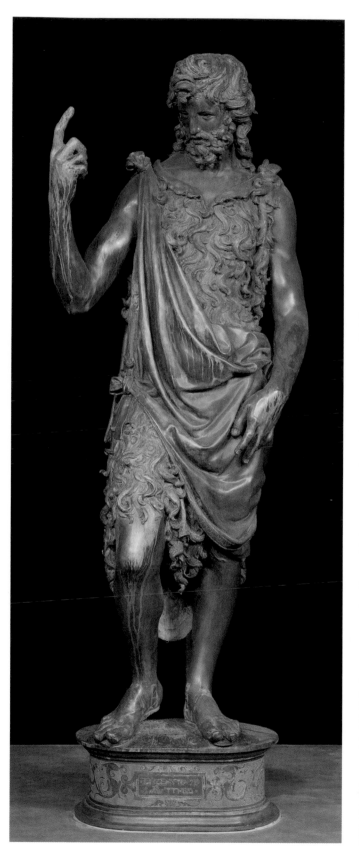
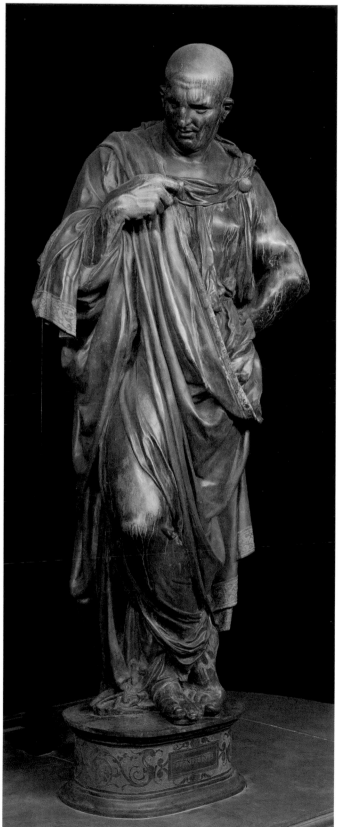

Leonardo was commissioned to paint in March 1481. Following this logic, Rustici's *Pharisee* becomes a modern *Pensieroso*, a figure that owes much to Donatello yet offers a new roundness to the limbs, showing them separate and luminous in the surrounding space. The knees and calves of the figures in the *John the Baptist Preaching* project outward, catching the light. The separation of the three figures by columns could have led to a reduction in the narrative unity of the group, but the visual rhythm created by the projecting knees acts as a unifying factor. The same frank movement of the legs, the same roundness, and the same suffused light are to be found in Michelangelo's unfinished *St. Matthew* (1505, Florence, Accademia), as well as in Leonardo's *St. Jerome* (plate 36).

The *Levite*, on the other hand, clearly recalls the *Zuccone* (fig. 101), another figure in marble created by Donatello for the Campanile, if only on account of the bald head and the contrast between the heavy tunic falling in a straight diagonal and the delicately fine shirt tied at the waist and fastened on the shoulder with a circular pin, leaving the arm bare. However, when it comes to the body and the facial expressions, the two figures are very different. Rustici's *Levite* is no haggard, visionary prophet. This giantlike figure seems more like a Leonardo *Hercules* carved by another in his stead. We have numerous studies by Leonardo of male nudes with muscled bodies, standing with their legs wide apart, drawn by him between 1503 and 1508 (plate 37 and fig. 102), and in particular from 1506 onward—the exact period during which *John the Baptist Preaching* was produced.[13] These *Hercules* were intended to be perfect examples of heroic nudes, more powerful and more thickset than Michelangelo's *David*. Between 1493 and 1494, Leonardo also made a number of anatomical studies of the sullen, bald heads of middle-aged men (see plate 28), followed in 1503–1504 by studies of their geometric proportions (fig. 103). A drawing now in the Metropolitan Museum of Art (plate 40) announces the sullen face of the *Levite*, as well as the furious curls of the *Pharisee* and the *Baptist*. However, when he heard that Piero Soderini was thinking of commissioning Michelangelo to create a Herculean figure as a pendant to his *David*, Leonardo dreamed up a series of colossi which—with the exception of a sanguine drawing now in Her Majesty's collections at Windsor (fig. 104)—have much knottier muscles and less smooth limbs than those of the *Levite*.

Fig. 101  Donatello (Italian, 1386–1466), *The Prophet Habakuk*, called *Zuccone*, ca. 1424–1426, marble, 76¾ inches high, Museo dell'Opera del Duomo, Florence.

PLATE 36 **Leonardo da Vinci** (Italian, 1452–1519), *St. Jerome*, ca. 1480, mixed oil and tempera on walnut, 40½ × 28¹⁵⁄₁₆ inches. Vatican Museums, Vatican City.

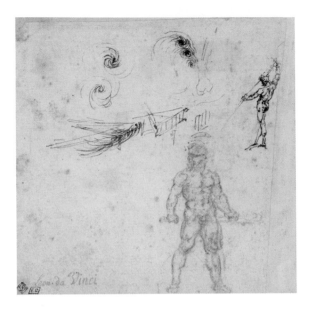

**Fig. 102** Leonardo da Vinci, *Study for Hercules Holding a Club Seen in Frontal View, Male Nude Unsheathing Sword, and Movements of Water* (recto), *Study for Hercules Holding a Club, Seen in Rear View* (verso), ca. 1506–1508, pen and brown ink with charcoal or soft black chalk on off-white laid paper, 5⅜ × 5½ inches, The Metropolitan Museum of Art, New York, purchase, Florence B. Selden Bequest and Rogers Fund, and promised gift of Leon D. and Debra R. Black, 2000 (2000.328 recto and verso).

As for the *Baptist*, he stretches out his right arm and forefinger up toward the heavens, just like the *Angel of the Annunciation*, drawn by a student of Leonardo in the center of a study on paper (see plate 27), and even more like the one in a painting by the master himself, today known only through copies, the best of which is in the Kunstmuseum of Basel (fig. 105). In some versions, the Angel changes into a St. John the Baptist who negligently holds a reed cross in the fingers of his left hand; interestingly, a thin cross—this time in metal—once rose diagonally from a small slit in the base of Rustici's *Baptist*, ending delicately between the Messenger's left thumb and forefinger.[14]

One of the most striking aspects of this group is the fact that the utterances made by the three figures are carved in Hebrew on the oval bases of the statues. The words, displayed in cartouches, were originally gilded and would therefore have stood out more clearly than they do today. To the question of the Pharisee, on the left—*me tomar mimmeni?* (What do you say [of yourself?])—and to that of the Levite, on the right—*mi attà Eliahu?* (Are you Elijah?)—St. John the Baptist replies, *kal kore bahid-bar pamì derech* (I am the voice of one crying in the wilderness. Make straight the way [of the Lord]). We know that the Medici circle was especially interested in Jewish culture, and that Girolamo Savonarola had favored the teaching of Hebrew, a field in which Sante Pagnini (1470–1536) and Girolamo Benivieni (1453–1542) excelled. However, in central Italy, Hebrew texts were very rarely depicted in works of art. In 1480 Domenico Ghirlandaio had shown a phylactery hanging on a shelf in his fresco of *St. Jerome* in the Church of Ognissanti, Florence, and just shortly after Rustici produced his Baptistery group, Raphael portrayed *Isaiah* unrolling a phylactery in his fresco painted between 1511 and 1512 in the Church of Sant'Agostino in Rome. We also have the example of the inscriptions carved in marble by Francesco da Sangallo on the pedestal of his *Virgin and Child with St. Anne* (1522–1526) at Orsanmichele.[15]

We know, then, that Rustici revealed the content of the dialogue between the three figures to spectators of his Baptistery group, but what is less clear is exactly whom he had in mind as spectators. Was he thinking solely of those rare scholars capable of reading the cartouches? Or of the Jews whom the Florentine clergy wished to convert? Or was he addressing God? In fact, Rustici went even further,

PLATE 37 **Leonardo da Vinci** (Italian, 1452–1519), *Studies for a Fortress-type Palazzo, and for a Figure of Neptune, with Notes*, ca. 1508, pen, ink, and black chalk on paper, 10⅝ × 8 inches. Royal Library, Windsor Castle, RL 12591 recto.

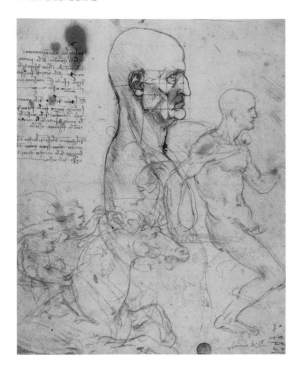

**Fig. 103**  Leonardo da Vinci, *The Facial Proportions of a Man in Profile; Study of Soldiers and Horses*, ca. 1490–1504 (man in black chalk, 1490–1495; figures in red chalk, ca. 1503–1504), red and black chalk with pen and brown ink on paper, 11 × 8¹³⁄₁₆ inches, Gallerie dell'Accademia, Venice, inv. 236r.

**Fig. 104**  Leonardo da Vinci, *A Nude Man from the Front, and a Partial Study of the Left Leg*, ca. 1504–1506, red chalk on red prepared paper, 8⅞ × 6⁹⁄₁₆ inches, Royal Library, Windsor Castle, RL 12593.

for he also carved a number of words on the edge of St. John the Baptist's tunic, words that are invisible from the ground and can be seen only by a spectator perched high up in a crane opposite the statue or by the Almighty himself.

Thanks to the recent restoration we can now see these letters correctly. They were carved by a non-Jewish craftsman, and although well formed, they display a number of irregularities and oddities, such as the frequent appearance of vowels. On the left part of the tunic we can read: *hagadol: Zekharya* (the great: Zacharias). Just above the left knee, we see: *yom bo merahets bo kapav* (the day he washed his palms). And finally, on the right side we can see the word *qadosh* (saint).[16] It is extremely difficult to attribute an overall sense to these few inscriptions. The emphasis on the name of Zacharias, John

the Baptist's father, who, bereft of speech, had to write the name of his son on a tablet, is particularly strange. Should we conclude that these cryptic Hebrew inscriptions point to the influence of Rustici's protector, Francesco Cattani da Diacceto? The latter did not know Hebrew but had studied Jewish mysticism from Latin translations and summaries in controversial works, and was fascinated by the similarities between certain aspects of the Kabbalah and Neo-Platonism.

So far we have limited ourselves to a consideration of stylistic motifs. We now need to reflect on the deeper aesthetic affinities between Rustici and Leonardo. The composition of the Baptistery *John the Baptist Preaching* has a psychological complexity that is unequaled in other groups of the same kind. Rustici sought to do two things: first, he wished to convey the different reactions of the Levite and the Pharisee to the stunning declarations of the Baptist, and in order to do this he needed to create an interaction between the three figures surmounting the door; second, he wanted to associate the passers-by below with the message of the Baptist, something he achieved by the expression he gave to the Messenger's face and the turn of his head.

The visual strategy of the artist thus encompassed all the surrounding space. It seems likely that Rustici reached his final solution only after devoting considerable thought to how he could convey narration, reflections that were stimulated both by his study of the *Adoration of the Magi* (see fig. 100), which Leonardo left behind with Amerigo Benci when he went to Milan, and by his discussions with Leonardo himself.

It is interesting to see how Rustici radically differentiates the faces, for we know how passionately fascinated Leonardo was by the portrayal of facial expressions (plates 28, 38, 40). The leonine features and the animated exuberance of the hair and beards of the *Levite* and the *Pharisee* are Leonardesque motifs that had never before been expressed in three dimensions. Finally, Rustici was as aware as Leonardo of optical effects, and managed to exploit the effects of light and the upward view of the spectators by refraining from modeling the eyes of his figures; on the contrary, he left the eyesockets completely empty beneath the thick, frowning eyebrows, thus creating deep shadows and, para-

Fig. 105 Anonymous Artist (after Leonardo), *Angel of the Annunciation*, ca. 1505–1507, tempera on wood, 28 × 20½ inches, Kunstmuseum, Basel, inv. 1879.

doxically, succeeding in using emptiness to convey profound expression.

We thus have evidence of the complicity between the two artists during the creation of the group for the Florentine Baptistery. But Rustici also used the work of his older friend as a catalyst on several other occasions. Rustici's brilliant mastery of space bursts forth in his two terracottas dating to about 1510: *Battle Group* (plate 41), now conserved in the Louvre, and the *Equestrian Battle Group* (plate 42) in the Bargello.[17] The departure point for the two terracottas was a fresco that Leonardo began for the Sala del Gran Consiglio of the Palazzo della Signoria in 1504 but never finished. Works by Vasari now mask the remaining fragments of this *Battle of Anghiari*, today known to us only through numerous spirited studies of skirmishes (plate 45) and partial copies of the work, such as Rubens's admirable *Fight for the Standard of the Battle of Anghiari* (plate 47), derived from the central motif of the fresco. In Rubens's grisaille of ca. 1615, we clearly see that Leonardo wanted to revolutionize the battle genre by depicting a furious entanglement, an outpouring of the intertwined forces of men and animals, all conveyed with the greatest plasticity—especially apparent in the rounded hindquarters of the steeds and their stout legs and joints. The violence is conveyed through the hateful expressions and the ground melee, and is embodied with particular force in the wound inflicted by one of the horses on another horse placed in the center of the composition.

Rustici took his inspiration from Leonardo's fresco to create groups that bring together five men and a horse on a narrow, uneven terrain, and he thrusts them into an explosion of fury and pain. Rustici employed numerous key elements from the *Battle of Anghiari*, including the morphology of the horses—the true actors in the drama—as well as the gaping mouths of the soldiers and the tangle of violent gestures, but they cannot be considered as literal transpositions. In his terracottas, which he originally painted to resemble bronze, Rustici did not evoke any precise historical event; he used simplified battle accessories and left his soldiers

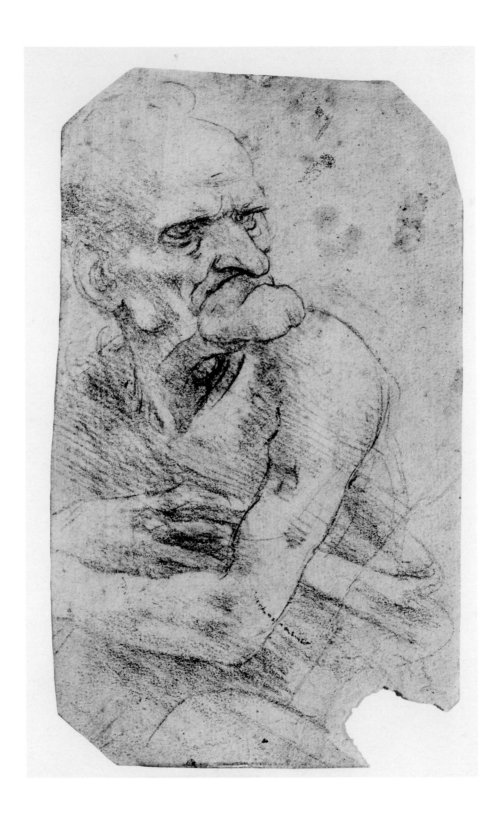

PLATE 38  **Leonardo da Vinci** (Italian, 1452–1519), *Old Man*, ca. 1490, red chalk on ivory-colored treated paper, 7⅛ × 4⅛ inches. Istituto Nazionale per la Grafica, Rome, F.N. 4 (31645).

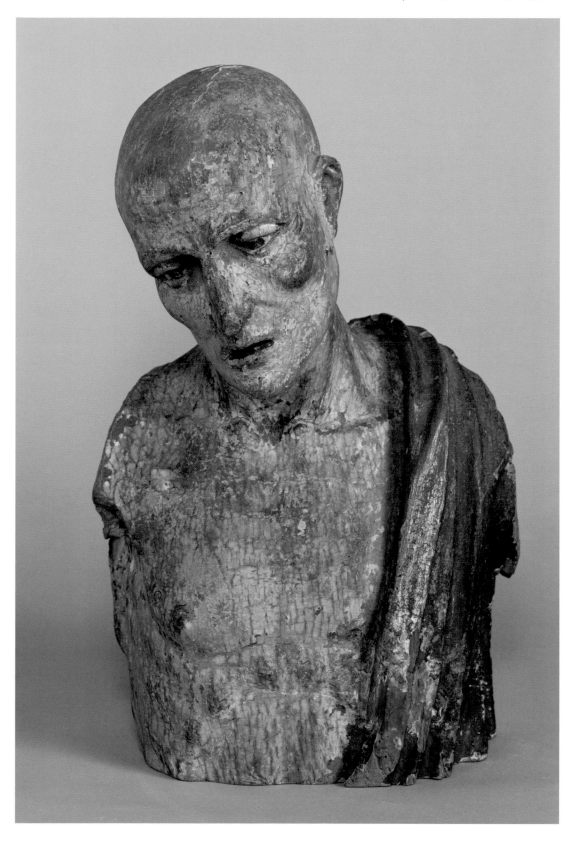

PLATE **39** **Unknown Artist**, *Bust of a Man* (possibly St. Jerome), ca. 1525, polychromed wood, 17 × 10 × 8 inches. High Museum of Art, Atlanta, gift of Mrs. Irma N. Straus in memory of her husband, Jesse Isidor Straus, 64.21.

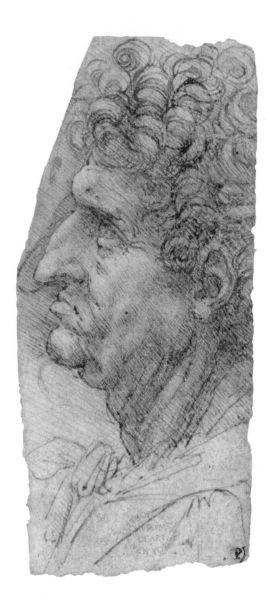

PLATE 40 **Leonardo da Vinci** (Italian, 1452–1519), *Head of a Man in Profile Facing to the Left*, ca. 1490–1494, pen and brown ink over soft black chalk on paper, 4⅝ × 2⅟₁₆ inches. The Metropolitan Museum of Art, New York, Rogers Fund, 1909 (10.45.1).

either nude or protected by breastplates or close-fitting, almost skin-tight tunics. Leonardo, on the other hand, clothed his soldiers in vaguely contemporary costumes and decked them out in fantastic helmets reminiscent of Quattrocento tournaments and parades. In the Rustici terracottas, the warriors wear relatively simple helmets bereft of plumes, or have no helmets at all, leaving their curly hair bare *all'antica*. Only the Bargello group (plate 42) introduces a strange turban ending in a volute that conjures up a conventional Orient. Rustici based his work on the fresco but did not create a narrative relief. His aim was to render battles in the form of statuettes in the round, which can be looked at from all sides and which offer the spectator surprises and sudden, unexpected views according to the angle from which they are observing. Rustici succeeded in linking all the figures together as well as diffusing the competitive antagonism between them. The figures are so intertwined that we have some difficulty counting and distinguishing them. The spectator should certainly not be satisfied with the front view. A quick walk around the Louvre group (plate 41), for example, and it becomes immediately clear that the number of figures changes according to the viewpoint. When looking at the group from the front we see five figures, with the horse playing a major role. From the left we still see five figures, but what we notice in particular are the four shrieking heads caught in a centrifugal movement, whereas our attention is much less drawn to the mouth of the horse. When viewing the group from behind, apart from the horse we only see two figures clearly—including the one draped figure—and parts of two others. Finally, the view from the right offers only three figures—the horseman, his adversary, and one soldier on the ground. The figures do not stand out against the background, but seem to emerge from the earth. As in Leonardo's fundamentally Neo-Aristotelian philosophy, the clay seems to come to life beneath the hands of the artist, who thus perfects what Nature is powerless to accomplish. Existence is presented as a clash between forces, and everything comes alive—including the horses' tails, which seem to become

a threatening vortex (plate 41) and even appear to be strangling the soldier on the ground (plate 42).

In the first third of the sixteenth century, these two masterpieces by Rustici were imitated in a confused and insipid way in the form of hollowed-out high reliefs depicting a spread of warriors.[18] No other sculptor succeeded in creating a work in the round where the figures emerge so splendidly from such a small base. In the Florentine context, Rustici also showed that Bertoldo di Giovanni's bronze *Battle Relief* (plate 48) belonged to an erudite and analytic phase of the revival of the antique that was now outmoded. The Bargello relief is indeed a triumphant adaptation or recreation of a Roman sarcophagus, a tour de force, a repertoire of complex poses and foreshortenings—but there remains something pedantic and artificial about it that prevents us from experiencing the horror of the combat. In his admirable *Battle Relief* (plate 49), Lorenzo Naldini—a follower of Rustici who moved to Paris in the late 1520s—produced a work that referred back to antiquity and also to Bertoldo's version of the antique. He succeeded in combining a contrapuntal succession of planes that dramatically and elegantly convey the pathos of the dead and wounded bodies and the fallen horses, along with the vigor of Leonardesque torsions and the picturesque effects of skirmishes seen from a distance.[19]

We have already discussed the anatomic similarities between the horses in Rustici's groups and those depicted in the *Battle of Anghiari*. Vasari attests to Giovan Francesco's love of representing horses and mentions a number of such works fashioned in different materials;[20] numerous small bronzes have in consequence been attributed to Rustici, but in the absence of an undisputed reference work in the round, it is not easy to decide which bronze horses are authentic.[21] It should be noted, however, that Rustici always favored a fairly stocky canon for his horses, with a wide neck and a very round rump ending in a restless, agitated tail—features which are all present in the Budapest equestrian group (plate 43). The horse ridden by the Budapest *St. George and the Dragon* (fig. 106)[22] and the one destined for the equestrian statue of King Francis I of

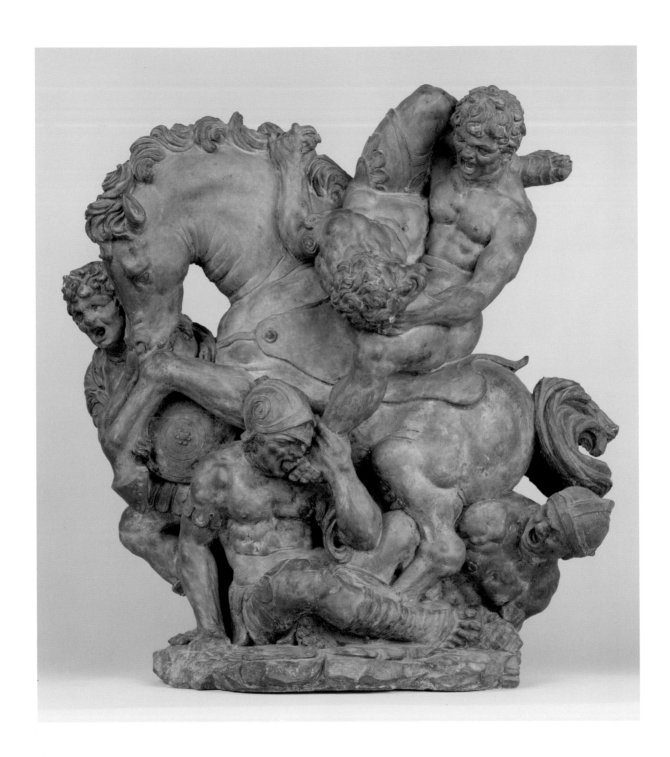

PLATE **41  Giovan Francesco Rustici** (Italian, 1475–1554), *Battle Group*, ca. 1510, terracotta,
18⅜ × 17¾ × 9½ inches. Musée du Louvre, Paris, Department of Sculptures, RF 1535.

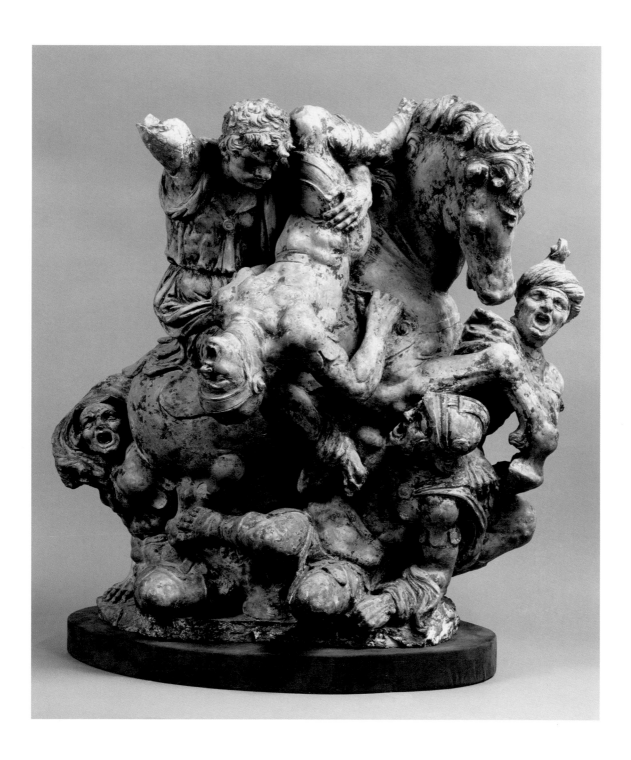

PLATE 42 **Giovan Francesco Rustici** (Italian, 1475–1554), *Equestrian Battle Group*, ca. 1510, terracotta, 17⅜ × 18½ × 9 1/16 inches. Istituti museali della Soprintendenza Speciale per il Polo Museale Fiorentino, Museo Nazionale del Bargello, Florence, inv. 469 S.

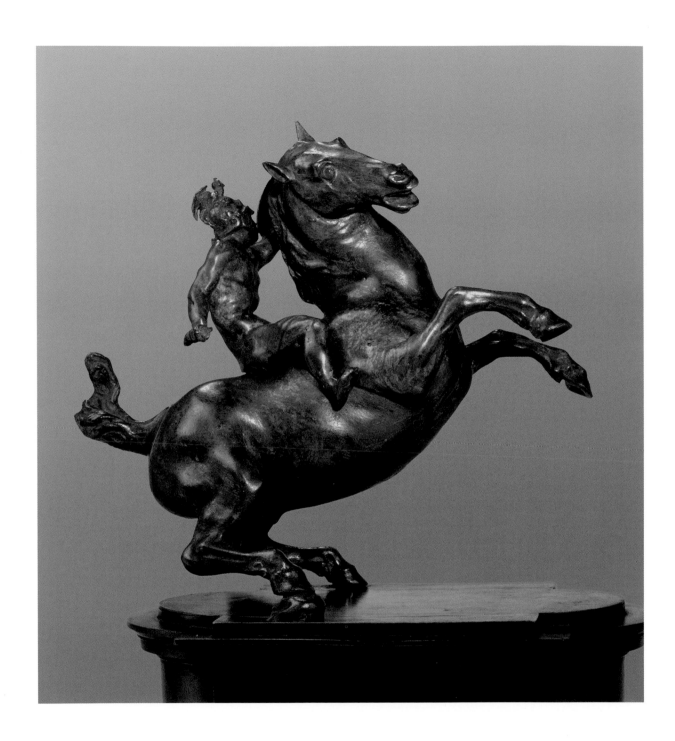

PLATE **43** **Leonardo da Vinci?** (Italian, 1452–1519), *Equestrian Statue*, sixteenth century, bronze, 24½ × 20⅞ × 20⅞ inches. Szépművészeti Múzeum, Budapest, Collection of Old Sculptures, 1914, inv. 5362.

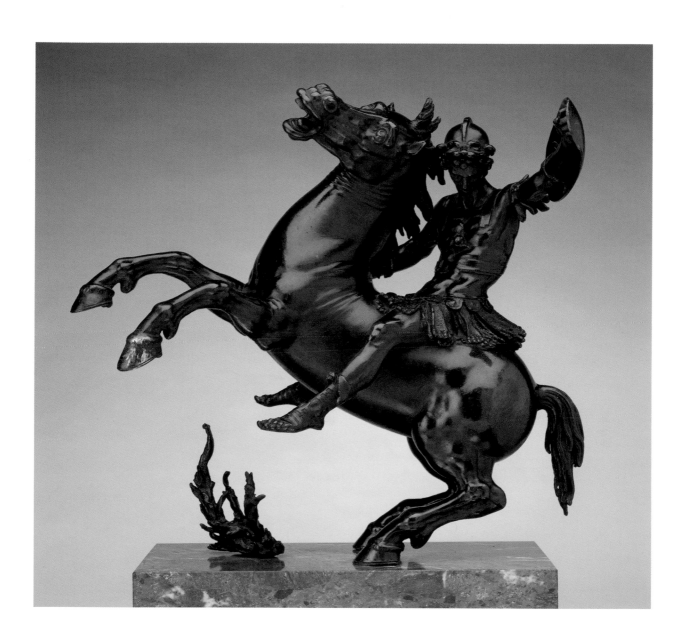

PLATE 44 **Attributed to Willem Danielsz. van Tetrode** (Netherlandish, ca. 1525–after 1575),
*Warrior on Horseback*, ca. 1562–1565, bronze, 16 × 17⅜ × 11¹/₁₆ inches. The J. B. Speed Art
Museum, Louisville, Kentucky, Bequest from the Preston Pope Satterwhite Collection, 1949.30.2.

France (fig. 107)[23] can also be considered variations on Leonardo prototypes.

When fashioning his marble relief, Rustici was emulating not only Donatello but also Leonardo, as shown in his conception of the confrontation between a horseman and a dragon, a theme which Leonardo treated in several exceptionally vigorous drawings (plate 46).[24] The wounded monster turns around, vexed, furious, its spiral tail and jagged, ocellated wings rendered with convincing naturalism. All Leonardo's dragons display the same disturbing combination of a plausible physique with an aggressive psyche. However, the tightly juxtaposed frieze of soldiers, the incisions emphasizing the shapes, the foreshortenings taken from Paolo Uccello's *Deluge*, and the compression of space (resulting from the strange insertion of the Pantheon) all give the impression of an archaistic collage aesthetic for erudite Florentine art lovers, very different from the rendering of atmosphere and from the ample vibration in space characteristic of Leonardo. Nevertheless, one feature of the Budapest *St. George* (fig. 106) would have met with Leonardo's approval—the complex hairstyle of the princess. Coils of twisting plaits abound in Leonardo's works, to mention only the *Benois Madonna* (fig. 108), and his various versions of *Leda*.[25] Rustici remembered this when he adorned his *Fontainebleau Madonna* (fig. 109) with a plait that winds around like a ziggurat,[26] reminiscent of Leonardo's drawing *Head of a Young Woman* (fig. 110),

a study associated with the small *Annunciation* in the Louvre.

Giovan Francesco, then, was not only influenced by the heroic in Leonardo's work. When he emulated Michelangelo's marble *tondi* by sculpting a marble medallion for the Arte della Seta (fig. 111), Rustici took his inspiration as much from Filippino Lippi's paintings of devotion, with their diaphanous veils flowing over tortuous drapery, as he did from Donatello's reliefs of the *Madonna*.[27] But the fluid, undulating surfaces of varying depth gently caressed by light, the slight smile of the Virgin, the proportions of the Child Jesus and the infant St. John the Baptist leaning forward with his hands joined—much as he does in the *Virgin of the Rocks* (see fig. 39)—are all Leonardesque features. Rustici also strove to achieve a subtle psychological diversity among the three personages, something that would also have earned his older friend's approval. He placed the three heads close together

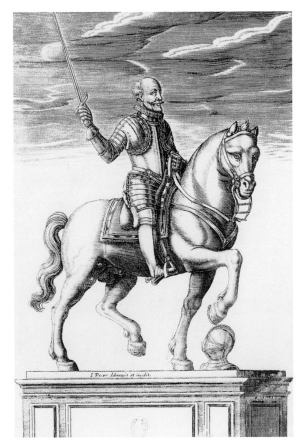

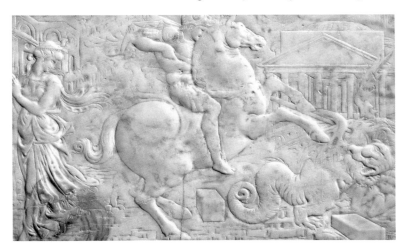

Fig. 106  Giovan Francesco Rustici (Italian, 1475–1554), *St. George and the Dragon*, ca. 1520–1528, marble, 11⅜ × 18⅞ inches, Szépművészeti Múzeum, Budapest, inv. 1138.

Fig. 107  Jean Picart (French, active 1620–1670), *Equestrian Statue of Duke Henry the First of Montmorency*, engraving in André Du Chesne, *Histoire généalogique de la maison de Montmorency et de Laval. A la suite: Preuves de l'histoire de la maison de Montmorency* (Paris: Sébastien Cramoisy, 1626), p. 454.

PLATE 45 **Leonardo da Vinci** (Italian, 1452–1519), *Two Skirmishes between Horsemen and Foot Soldiers*, ca. 1503–1504, pen and brown ink with brush and brown wash over traces of stylus on paper, 5¾ × 6¹⁄₁₆ inches. Gallerie dell'Accademia, Venice, 215A.

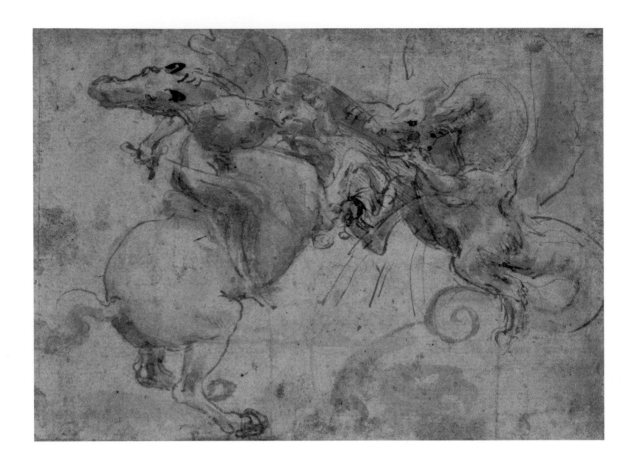

PLATE 46 **Leonardo da Vinci** (Italian, 1452–1519), *A Horseman Fighting a Dragon*,
ca. 1480, pen and brown ink with brown wash on paper, 5½ × 7½ inches. The British
Museum, London, 1952,1011.2.

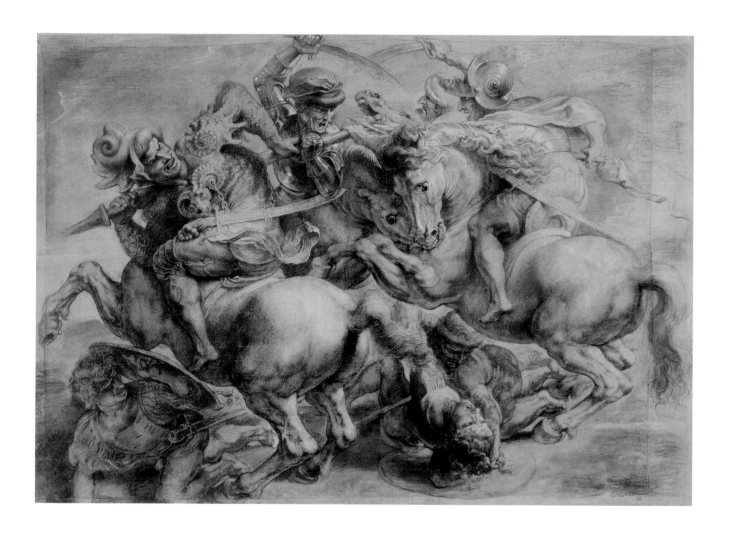

PLATE 47 **Italian copy after Leonardo, restored and reworked by Peter Paul Rubens** (Flemish, 1577–1640), *The Fight for the Standard of the Battle of Anghiari*, sixteenth century and ca. 1615, black chalk, pen, ink, and watercolor on paper, 17⅞ × 25⅟₁₆ inches. Musée du Louvre, Paris, Department of Graphic Arts, INV 20271.

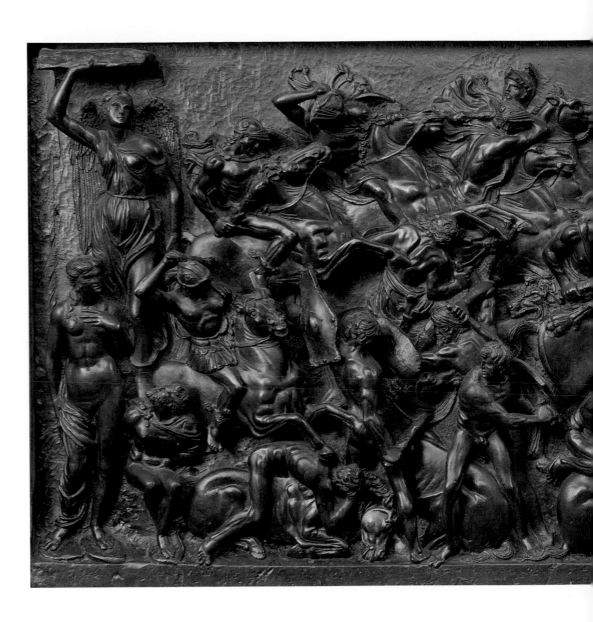

PLATE 48 **Bertoldo di Giovanni** (Italian, ca. 1420–1491), *Battle Relief*, ca. 1479, bronze, 17 × 39 inches. Istituti museali della Soprintendenza Speciale per il Polo Museale Fiorentino, Museo Nazionale del Bargello, Florence, inv. 258 B.

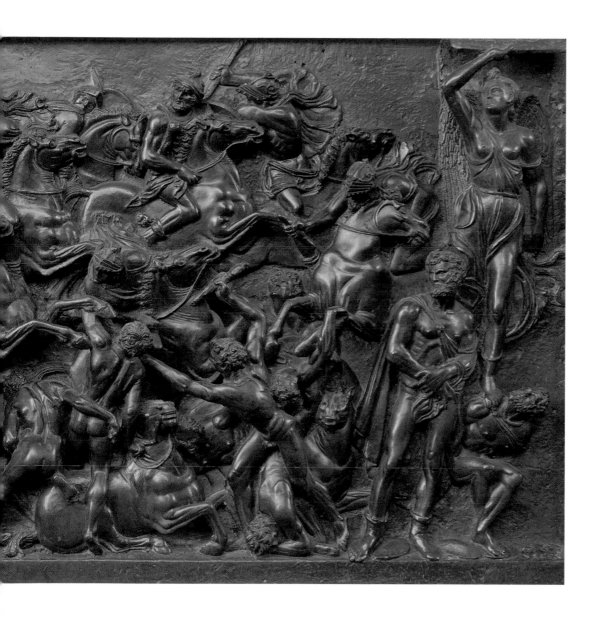

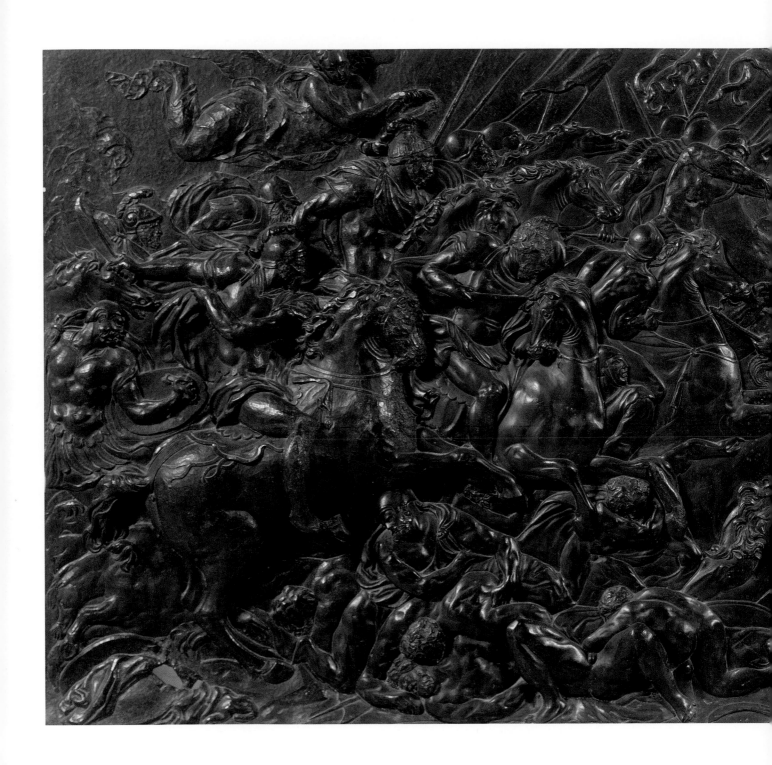

PLATE **49** **Lorenzo Naldini?** (Italian, died 1567), *Battle Scene* (Battle of the Granicus?), mid-1500s, bronze relief, 32⅛ × 71¼ × 2⅜ inches. Musée du Louvre, Paris, Department of Sculptures, RF 668.

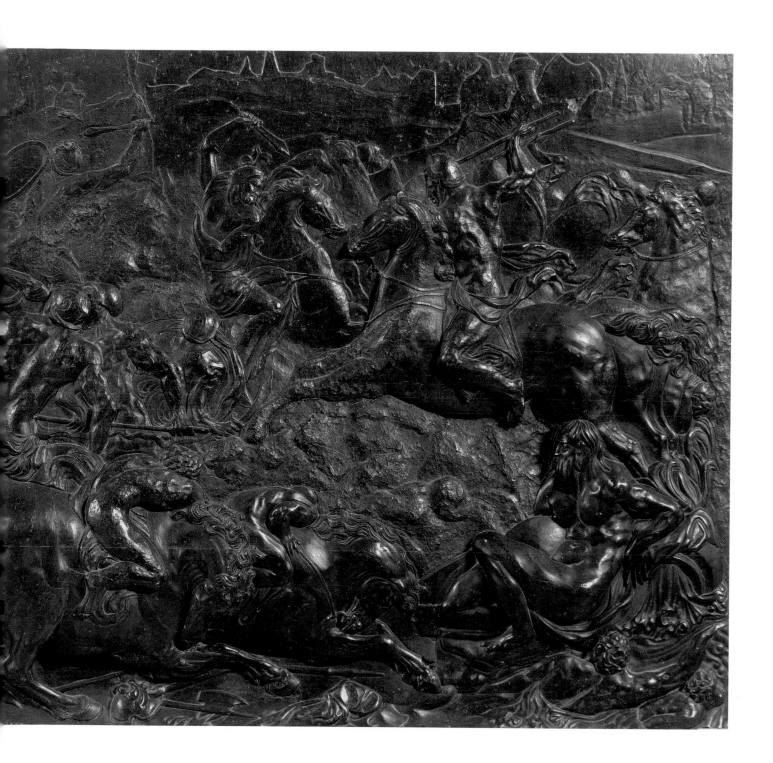

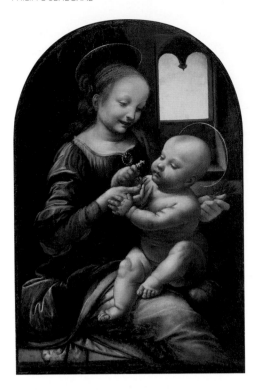

**Fig. 108** Leonardo da Vinci, *The Benois Madonna*, 1478, oil on canvas, 19½ × 13 inches, Hermitage Museum, St. Petersburg.

**Fig. 109** Giovan Francesco Rustici (Italian, 1475–1554), *Virgin and Child*, called *Fontainebleau Madonna*, ca. 1515, cast after 1528, bronze, 33¹³⁄₁₆ inches high, Musée du Louvre, Paris, Department of Sculptures, ENT 1876.01.

in a small space, and by varying the degree with which they open their mouths, succeeded in conveying three different sentiments: emotive adoration on the part of St. John, carefree cheerfulness for Jesus—whose smile is reminiscent of the work of Desiderio da Settignano—and silent tenderness for the Mother of God. However, the specific strategies Rustici used for dealing with the format and the medium seem to be his own. He was, it is true, using a Michelangelo technique when he reserved half of the space for the Mother of God, but he placed her firmly on the ground and let her ample cloak follow the curve of the medallion, allowing no interruption, but sweeping up the braided hem so that it remains contained within the field.

With this *Madonna dell'Umiltà*, Rustici was trying to achieve one of the great feats of sculpture—placing three figures in a medallion in such a way that they take up maximum space without losing their individual integrity. There is no allusion here to any exterior reality, no cutting off, no outside field. This explains both the imperious closure of the circle by the right foot of the Virgin carved in high relief, and the tentative, slightly unstable pose of the infant St. John the Baptist, who leans forward on tiptoe, full of emotion, his knees bent in readiness for prayer—an effective way of keeping the whole figure within the field and at the same time delicately increasing the pathos.

This demonstration of interior emotion, this dramatization of tenderness, and this conversion of souls through disturbing gentleness are also essential aspects of Leonardo's modernity and of the *Terza Età*, a "third" age when the technical conquests made by the great artists of the fifteenth century were surpassed. The same modernity is particularly evident in the *St. John the Baptist* which was recently discovered by Marietta Cambareri in the reserves of the Museum of Fine Arts, Boston (fig. 112),[28] a terracotta covered with an off-white enamel much creamier than the one habitually used on *robbiane*,[29] and with the eyes and eye-

brows soberly emphasized in dark manganese purple. Rustici created here a monochrome sculpture that reflects the light in delicate modulations, reminiscent of his friend Andrea del Sarto's monochrome frescoes in the Chiostro dello Scalzo—a successful fusion of understatement and effective narration.[30] Taking as his starting point the pose of Donatello's partially gilded bronze *St. John the Baptist* in Siena Cathedral, Rustici created a weakened (though far from haggard) anchorite, suffused with the poignant melancholy he feels at the daunting prospect of converting those estranged from God. Debilitated by his self-inflicted mortifications, the Forerunner of Christ nevertheless finds the strength to preach, and his lips open slightly, revealing his teeth. As in the Baptistery statue (plate 35), the animal skin is partially covered by a cloak, thus mitigating the wildness of the preacher from the desert. The statue is animated by a superb combination of different textures, all magnificently rendered: the unkempt hair, the skin modeled tightly over the high cheekbones, the hairy skin and leg of the goat, the smooth woolen cloak, and the rough base. By bringing the legs of the young man closer together and giving them a less athletic appearance,

Rustici achieved a more graceful and slender—if less heroic—silhouette than that of the Florentine Baptistery statue. The sculptor retained a number of details, however: the right arm remains completely detached and the left arm falls down alongside the body, with the hand coming forward over the hip. Although the side views are interesting and provide additional psychological insight, the large shadow between the legs and the visual rhymes created by the right arm folded upward, and the folds of the cloak falling over the hip at the level of the thigh, all render the view from the front the most appealing, gratifying, and energetic.[31]

The sober intensity of the Baptist's facial expression and pose recall Leonardo's experimentation for the *Adoration of the Magi* (see fig. 100), while the actual fashioning of the statue reflects Rustici's knowledge of the techniques practiced in the workshops of Verrocchio and Leonardo. The tapering hands that curve over from the upper knuckles evoke drawings by Verrocchio and Leonardo, as well as the three-dimensional plaster models they worked from. The hands were modeled separately, probably so that their final position could be decided at the last moment and thus

Fig. 110  Leonardo da Vinci, *Head of a Young Woman*, ca. 1478–1480, metalpoint, pen and brown ink, brush and brown wash, highlighted with white gouache on paper, 11 × 7⅞ inches, Gabinetto Disegni e Stampe, Galleria degli Uffizi, Florence, inv. 428 E.

Fig. 111  Giovan Francesco Rustici (Italian, 1475–1554), *Virgin and Child with the Infant St. John the Baptist*, 1508–1509, marble, 35¹³⁄₁₆ inches in diameter, Museo Nazionale del Bargello, Florence, inv. 102/S.

the most effective angle chosen. The same love of experimentation, the same desire to reflect on the exact positioning of every part of the statue, and the same refusal to remain trapped within a preconceived shape are evident in Rustici's arrangement of the clothes. The empty space between the Baptist's cloak and his animal skin seems to be proof that the drapery was added after the body had been shaped, as though Rustici only clothed his saint once he had achieved the most eloquent pose possible.[32] The decision to convey a particular rhythmic intensity and expression to the virtuoso drapery, the importance attached to the manner in which the clothing falls, and the emphasis on the weight and arrangements of the fabrics under the light all reveal Rustici's debt to Verrocchio and Leonardo.

On the other hand, certain creations by Rustici show a radical departure from the innovative momentum set in motion by Leonardo. Instead,

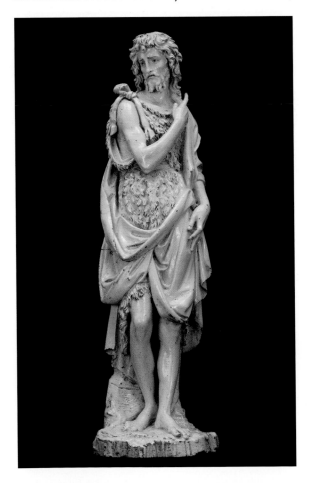

Fig. 112  Attributed to Giovan Francesco Rustici (Italian, 1475–1554), *St. John the Baptist*, ca. 1510–1520, glazed terracotta, 39½ × 13 × 10½ inches, Museum of Fine Arts, Boston, gift of Mrs. Solomon R. Guggenheim, 50.2624.

they mark a return to the compositions of the Quattrocento and display a deliberately archaistic style, which was probably insisted on by the patrons who commissioned them. When Cardinal Giulio de' Medici (the future Pope Clement VII) regained possession of his family palace on the Via Larga, he asked Giovan Francesco to create a fountain depicting the god Mercury for the palace courtyard. The fountain has since been dismantled, and only the main part, the bronze statue of the god, is now conserved at the Fitzwilliam Museum in Cambridge (fig. 113).[33] The god originally stood on a bronze bowl and blew on a pinwheel to turn the blades; the whole monument was installed above three bronze tortoises. This unattractive heavyweight took its inspiration from a *Spiritello* in gilded bronze (Metropolitan Museum of Art) created by an artist in Donatello's circle,[34] as well as from several putti in the style of Verrocchio. But the compact hair, the knotted muscles, and the ferocious tension all make it a cousin of Pollaiuolo's *Hercules and Antaeus* (ca. 1478, Museo Nazionale del Bargello, Florence).[35] We can be in no doubt that Leonardo would have disapproved of both the Cambridge *Mercury* and the *Dancing Satyr* (now in the National Gallery of Art in Washington, D.C.), recently attributed by Tommaso Mozzati to Rustici.[36] Leonardo always expressed the most caustic contempt for the dry, analytic rendering of musculature by his contemporaries, from Luca Signorelli to Michelangelo—he called them *sacchi di noci* (sacks of walnuts).[37] Fortunately the artist's homage to Pollaiuolo was more happily expressed in the *Funeral Monument of Alberto III Pio da Carpi* (1535, Musée du Louvre) produced twenty years later, a monument that takes its inspiration from such works as the *Allegory of Philosophy* from the *Tomb of Sixtus IV* (1484–1493, Tesoro della Basilica di San Pietro, Vatican). The figure—a celebration of a humanist prince—is dressed in a breastplate after the antique and portrayed lying down and absorbed in reading, with books scattered at his feet.[38]

Whereas reference to the Classical world was not one of the distinguishing features of Leonardo's

art, it constitutes a relatively important aspect of Rustici's works, especially from the 1510s on. The reference is either direct, as in the terracotta medallions adorning the Villa Salviati in the hills around Florence (ca. 1515–1524), which are enlargements of the composition of antique engraved gems and thus follow the precedent created by the medallions of the Palazzo Medici on the Via Larga. This direct reference is also evident in the bronze chandelier of the Bargello, a copy of Roman torchères, which can now be seen in the Vatican Museums, but which in Rustici's time were in the Basilica di Sant'Agnese fuori le Mura in Rome.[39] On the other hand, the reference could be an allusion to recognizable monuments of antiquity, such as the Agrippa Pantheon in the Budapest *St. George* (see fig. 106) or, quite simply, plausible *all'antica* references, such as the triumphal arch that closes the perspective in the marble *Annunciation* (ca. 1515–1516) adorning the altar in the Chapel of the Villa Salviati.[40] Finally, the influence of antiquity is evident in the proportions he gives to his figures and the manner in which he positions the hips, as in the Louvre's bronze *Apollo Defeating Python* (ca. 1535–1545), a late production by Rustici, fashioned while he was living in Paris.[41]

By placing Leonardo at the threshold of the *Terza Età*—that third stage of art which succeeded the heroic period of the Quattrocento inventors of the Renaissance, during which artists had continually striven to innovate on both a technical and an aesthetic level—Vasari introduced a historiographical cut-off that is difficult to contest. However, in his analysis of the new art—which he defines as culminating with Michelangelo—Vasari did not sufficiently emphasize the degree to which artists from central Italy, particularly those active in the last years of the fifteenth century and afterward, were obsessed by the masterpieces of their predecessors, how they continually had such works in mind, and how they tried to surpass or challenge them by producing works that displayed a new ease and breadth of vision or, alternatively, troubling dissonances. Even the most jarring protests of the Tuscan avant-garde in the 1520s constituted a kind of homage to the awe-inspiring tradition of the founding fathers of modernity. And so, when we point out the hybrid nature of Rustici's works, we in no way diminish his genius. In Rustici's art, Donatello maintains the basso continuo while Leonardo plays the melody. It is true that these two fundamental strains are occasionally supplemented and consequently enriched or confused by deliberately harsh archaisms, strange embellishments, and eccentricities typical of a Filippino Lippi or a Piero di Cosimo, or, on the contrary, by classicizing echoes of Rome and Greece. If Leonardo had not prepared the way before him, Rustici might not have deployed his figures in space with such vital intensity or endowed them with the same subtle psychological interaction. The personal power of his carving and the strange eclecticism of his works distinguish him as an autonomous master who, though admittedly versatile, was one of the most inventive artists of the first half of the sixteenth century and one of the fathers of Florentine anticlassicism.

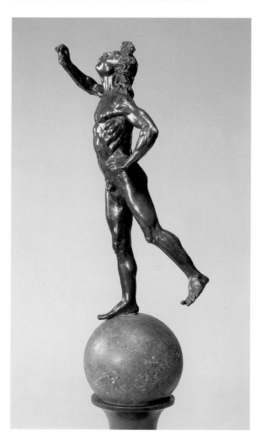

**Fig. 113** Giovan Francesco Rustici (Italian, 1475–1554), *Mercury*, ca. 1515, bronze, 18³⁄₁₆ inches high, Fitzwilliam Museum, University of Cambridge, M.2-1997.

## NOTES

1. See in particular Gentilini 1992, pp. 452–485; Davis 1995; Caglioti "Il perduto" 1996; Mozzati 2003; Minning 2005; Mozzati "Fece una Nostra Donna" 2005; Mozzati 2007; Sénéchal 2007 (with a chapter on the changing fortunes of the sculptor's reputation), pp. 11–25; Mozzati 2008; and Minning 2009.

2. See the entry by David Franklin in *Leonardo da Vinci* 2005, pp. 90–91, no. 14; and Sénéchal 2007, pp. 143–148 and 210, no. P.1.

3. Sénéchal 2007, pp. 52, 147–148, and 211, nos. D.1 and D.2; and Mozzati 2008, pp. 123–123.

4. Butterfield 1997, pp. 2–86 and 213–215, no. 11; and the entry by Michael Rohlmann in *Firenze e gli antichi* 2008, pp. 94–97, no. 4.

5. The suggestion concerning family links was made by Mozzati 2007, pp. 167–168, n. 16, who writes that ser Piero da Vinci drew up the document concerning the purchase by Bartolomeo di Marco di Bartolomeo Rustici, the father of Giovan Francesco, of land at Corte Vecchia, in the parish of San Piero a Grigniano, in the suburbs of Prato, as attested by Bartolomeo's tax declaration of 1498 (A.S.F., Decima repubblicana, 22, f. 187 r; the document is transcribed in Sénéchal 2007, pp. 269–270, doc. 3).

6. Sénéchal 2007, pp. 34–43 and 185–187, nos. S.4 and S.5; and, for the *Boccaccio*, Mozzati 2008, pp. 37–44, and figs. 30–31, 34–36, and 39–40.

7. Giovan Francesco sublet this house to the painter Carlo Segni in November 1507. See Waldman 1997; Mozzati 2007, p. 168, n. 16; Sénéchal 2007, p. 273, doc. 13; and Mozzati 2008, pp. 71–72.

8. Sénéchal 2007, p. 271, doc. 7.

9. "... che Lionardo vi lavorasse di sua mano, o almeno aiutasse Giovanfrancesco col consiglio e buon giudizio suo" (Vasari 1966–1987, vol. 5, p. 478).

10. Vasari 1966–1987, vol. 5, pp. 477–478.

11. The bronze was installed for the feast of St. John in 1511, but Rustici only received the last payment in January 1524. See Sénéchal 2007, pp. 45–68 and 187–189, no. S.6; and Mozzati 2008, pp. 77–85.

12. According to Vasari, Leonardo encouraged the young Baccio Bandinelli, who frequented Rustici's workshop between 1508 and 1514–1515, to take his inspiration from Donatello (Vasari 1966–1987, vol. 5, p. 240).

13. Laurenza 2006, pp. 124–131. Works derived from this pose and style of anatomy include *Hercules and Cacus* by Bandinelli (ca. 1534) in the Piazza della Signoria, Florence; *Hercules Pomarius* (1562–1567) by Willem Danielsz. van Tetrode (ca. 1525–1580), who lived in Florence from ca. 1548 to 1552 and in June 1562 (*Willem van Tetrode* 2003, pp. 13–16 and 27–29); and the *Great Hercules* burin engraving of 1589 by Hendrick Goltzius, For the different versions of *Hercules Pomarius*, see *Willem van Tetrode* 2003, pp. 34–38 and 121–123, nn. 21–25.

14. Nicola Salvioli was responsible for the excellent restoration recently carried out on the *St. John the Baptist*. My warm thanks go to him for this observation concerning the bronze and for the helpful photographs he provided.

15. For Hebrew inscriptions in fifteenth-century Italian art, see Ronen 1992. For Hebrew culture in Florence, see Sénéchal 2007, pp. 60–65, with previous bibliography.

16. My profound gratitude goes to Judith Olszowy-Schlanger, Director of Studies of the École Pratique des Hautes Etudes, for her transcriptions, translations, and comments on the written forms of inscriptions. Before the group was restored, Mme. Olszowy-Schlanger had read *ha-rosh* as "the head" (that is, "the leader"), and not *qadosh* ("saint"). The hypotheses resulting from the previous reading have now in consequence been partially called into question. See Sénéchal 2007, pp. 63–65.

17. Sénéchal 2007, pp. 84–93 and 191–192, nos. S.10 and S.11; and Mozzati 2008, pp. 44, 45, 47, and 49–51, and figs. 50–60.

18. Even very recently, these groups—now in the Palazzo Vecchio in Florence, the Pushkin Museum of Fine Arts in Moscow, and on the British art market—have been unwarrantedly attributed to Rustici (see the entry by Simona Cremante on the *Battle* groups of the Palazzo Vecchio and the Pushkin Museum in *La mente* 2006, pp. 110–113, nos. VII.1.t–VII.1.v). I have withdrawn them from the catalogue of Giovan Francesco and returned them to the workshop. See Sénéchal 2007, pp. 89–90 and 235–238, nos. SR.32 to SR.35. Tommaso Mozzati has done the same thing. See Mozzati 2008, pp. 44–47, 50, and 51, and figs. 61–75 and 78. On the other hand, a work from Rustici's French period, an *Archer* in terracotta (Paris, Musée Carnavalet, inv. S.1806), still displays a completely Leonardesque violence bordering on the grimacing. See Sénéchal 2007, pp. 162–164 and 205–206, no. S.25.

19. This relief was the subject of two papers I gave in 2008, one at the Scuola Normale Superiore in Pisa, the other at

Rhodes College in Memphis, Tennessee. The study will be published shortly.

20. Vasari 1966–1987, vol. 5, p. 476.

21. The most convincing suggestions so far have been made by Pietro C. Marani. See Marani 2001 and Marani 2003.

22. For this relief, see the entry by Michela Maccherini in *Il giardino* 1991, pp. 145–146, no. 35; Sénéchal 2007, pp. 142–143 and 204–205, no. S.22; and Mozzati 2008, pp. 112–116 and fig. 191.

23. The equestrian statue of the French king was not executed in full. The horse, which had probably been damaged during casting and had problems of equilibrium, was the only part of the statue that was actually delivered. It was given by King Henry II to Anne of Montmorency, and only found a rider in 1612. This time the figure represented was modeled by Hubert Le Sueur and represented Duke Henry I of Montmorency. This group, which was installed in front of the Château de Chantilly until it was destroyed during the French Revolution, is now known only through an engraving by Jean Picart in André Du Chesne's treatise on the history of the Montmorency family. See Du Chesne 1624, pp. 454–455; Bresc-Bautier 1985; Sénéchal 2007, pp. 158–160 and 213–214, no. * S. 10; Minning 2007; Mozzati 2008, pp. 182–185; and Minning 2009.

24. See also *Studies of Horses and for a St. George and the Dragon* in the Royal Library at Windsor (inv. no. 12331; Clark 1968, vol. 1, pp. 29–30).

25. For the *Leda* and the different preparatory drawings, see *Leonardo da Vinci* 2001; and Dalli Regoli 2006.

26. This Virgin and Child is an awkward working model, probably produced in France after a relief made by Rustici in ca. 1515 and brought by him to Paris in 1528. It displays numerous references to Donatello and is decorated with extravagant ornamentations such as the hydrocephalic cherubims on the Virgin's aureole and breasts, features which are inconceivable in the work of Leonardo. See Sénéchal 2007, pp. 82, 157–158, and 193–195, no. S. 14; and Mozzati 2008, pp. 73–74 and fig. 106.

27. Davis 1995, pp. 100, 111–112, and 126–128; Mozzati 2005, pp. 120 126, 134, 136–137; Sénéchal 2007, pp. 77–81 and 190–191, no. S. 7; and Mozzati 2008, pp. 75–77, and figs. 115–119.

28. See the entry by Marietta Cambareri in Franklin 2005, pp. 76–77, no. 8; Sénéchal 2007, pp. 72–75 and 197, no. S. 16; and Mozzati 2008, pp. 75–77 and figs. 115–119.

29. This nuance in the enamel comes from the quite exceptional inclusion of copper, as well as an unusual addition of iron. See Abigail Hykin's outstanding 2007 report on the restoration of the statue in Hykin 2007.

30. The comparison comes from Marietta Cambareri in Franklin 2005, p. 76. The cycle of frescoes, which moreover narrate the life of St. John the Baptist, was executed by Andrea between 1509 and 1526 and by Franciabigio in 1518–1519.

31. During the recent restoration the broken right forefinger was correctly completed and replaced.

32. For all these points, see the entry by Marietta Cambareri in Franklin 2005, pp. 76–77, and Hykin 2007.

33. See the entry by Anthony Radcliffe in *Renaissance and Baroque Bronzes* 2002, pp. 59–69, no. 2; also the notice by Victoria Avery in Franklin 2005, pp. 72–73, no. 6; Mozzati 2007, pp. 147–148; Sénéchal 2007, pp. 98–102 and 196–197, no. S. 17; and Mozzati 2008, pp. 116–119 and figs. 194–199.

34. See the entry by James David Draper in *Giovinezza* 1999, pp. 254–255, no. 24 (which dates the work to about 1432); and Caglioti 2000, vol. 1, pp. 376–377 and figs. 341–344 (with a date of about 1460).

35. The figure is 18⅛ inches high (with the base), inv. no. Bronzi 280. Moreover, the small group in bronze by Pollaiuolo also rests on tortoises. See the entry by Beatrice Paolozzi Strozzi in *Eredità* 1992, pp. 12–14, no. 3.

36. The figure is dated ca. 1515, bronze, 6 inches high, inv. 1957. 14.1.15. See Mozzati 2007, pp. 152–157 and figs. 237 and 239; and Mozzati 2008, 117, n. 605 and figs. 200–204.

37. *Codex Madrid II*, 128; and *Codex Urbinas* 1270, 117r and 118v = *Libro di pittura* § 334, 340 (*Libro di pittura* 1995, vol. 2, pp. 275–276 and 278). See Laurenza 2006, p. 128 and n. 27.

38. The gilding on the tomb, executed in 1542, is still partially visible. See Sénéchal 2004; Minning 2005; Sénéchal 2007, pp. 164–174 and 206–207, no. 26; Mozzati 2008, pp. 166–172 and figs. 300–304; and Sénéchal 2008.

39. Inv. 2482 and 2487. This illuminating parallel was made by Tommaso Mozzati in Mozzati 2007, pp. 149–150.

40. Sénéchal 2007, pp. 106–112, 114, and 198–199, no. S. 19.A.1; and Mozzati 2008, pp. 133–134, 137 and 139 and figs. 230 and 234–239.

41. Sénéchal 2007, pp. 174–178 and 208–209, no. S. 27; and Mozzati 2008, pp. 174–177 and figs. 310–314.

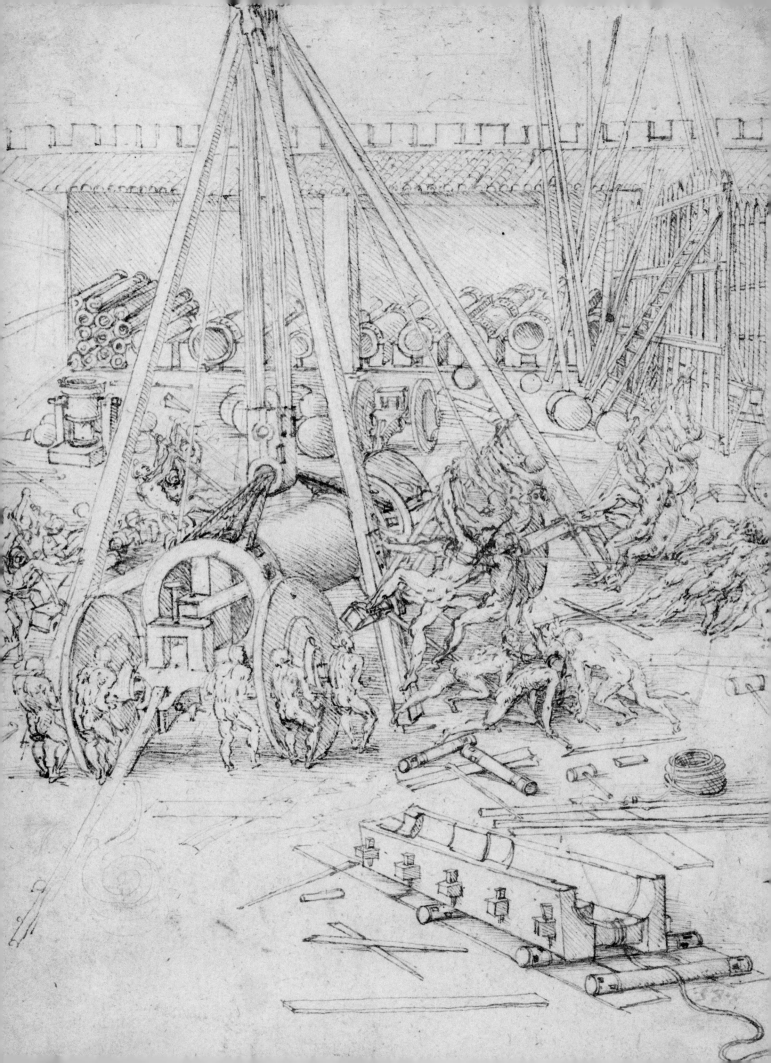

TOMMASO MOZZATI

# Florence and the Bronze Age

## Leonardo and Casting, the War of Pisa, and the Dieci di Balìa

In the year of Leonardo's return to Florence the city was helplessly involved in the eleventh year of an endless war. The city of Pisa had refused to be subjugated to Florence when Charles VIII of France entered Italy, taking the opportunity to reclaim its independence. From that point on, the Signoria of the Republic had been unable to reconquer the rebellious Pisa.[1] In the words of chronicler Piero di Marco Parenti, recorded in his *Storia fiorentina* of May 1500: "At present our land is exhausted and exploited because of this continuous six-year war."[2]

It is no surprise that this period was marked by Leonardo's constant collaboration with the Dieci di Balìa, the war magistrature that oversaw the military campaign. Leonardo actually came back to Florence from Milan in courtly dress, as an expert in military engineering and as the brave creator of the project for the huge Sforza horse. Thus he was uniquely well-positioned to participate in Florence's new "Bronze Age," a zeitgeist that, from a civic and propagandistic perspective, was fueled by the arsenal's powerful and very costly expansion with furnaces necessary for military operations and applauded by unexpected voices and out-of-the-ordinary demonstrations within the city's walls.

A symbolically important event took place in spring 1505 and must be considered in this light: when the Republic had once again decided to intervene against Pisa, Bartolomeo Cerretani reports that *gonfaloniere* Pier Soderini ordered "the exhibition of 30 large artillery wagons, creating an imperial air [la monstra di 30 charri d'artiglieria groxa che fano aspetto imperiale]." The war emergency was sensationally represented in the splendor of bronze and the marvelous sight of triumphant artillery in the city streets, making it possible (in Cerretani's words) to awaken the ancient echoes of a monocratic and victorious Rome.[3] Exaltation of the city's arsenal offers an interesting key for interpreting the new fortune of bronze and makes it clear why, after Verrocchio's 1483 bronze *Christ and St. Thomas* for Orsanmichele (see fig. 1) and through the first years of the sixteenth century, there had

been no important bronze castings in Florence. The intimate relationship between artistic and military practices prompted me to investigate Leonardo's relationships with military institutions and with the war economy in those years, an investigation that clarifies how the production of bronze sculpture was inextricably linked to the arms industry and to the provisioning of copper and tin alloy for producing cannons. This was a system that, through the mutual and distinct use of the same material, caused a radical redefinition of bronze.

In fact, only between 1504 and 1511 did Florentines return to creating large-scale bronze sculptures, first with a bronze *David* (fig. 114), commissioned from Michelangelo by the Signoria for the Marshal of Giè, and then the *John the Baptist Preaching to a Levite and a Pharisee* modeled by Giovan Francesco Rustici and Leonardo da Vinci for above the North Door of Florence's Baptistery (see plate 35).

Leonardo's involvement in Rustici's work—witnessed by Vasari's words and the superb quality of the three figures—is certainly an eloquent indi-

cation that upon his return to Florence Leonardo played a key role in reviving the Florentine practice of casting, also in the cultural sphere. As we have emphasized, Leonardo was even tightly linked to the war magistrature of the city government and was actively at its service. According to a letter by the commissioner Pierfrancesco Tosinghi, Leonardo visited the Pisan camp in June 1503. In the following July he made some sketches of the Arno River, contributing to ill-fated futuristic and fantastic endeavors such as the diversion of the river, which the exhausted Florentines dreamed up as a final solution to the ongoing conflict.[4]

Moreover, Leonardo's residence at Santissima Annunziata (fig. 115), like the spaces he used as an atelier at the Santa Maria Novella convent, were located near spaces managed by the Dieci for creating and storing the imposing Florentine arsenal. The "Sala del Papa [Pope's Hall]," where the artist created the great cartoon for the *Battle of Anghiari*, was close to the "Pope's Stables," a place that served until 1511 as the depot for the municipality's artillery before the Loggia de' Lanzi was designated for this purpose.[5] Even more significantly, the rooms that Vasari says Leonardo occupied in the Annunziata were but a step away from the Sapienza foundry,[6] used for making most of the cannons for the army involved in the Pisa conflict and of capital importance for the production of great bronze monuments during the first half of the 1500s.

The foundry was situated in the extended, incomplete complex (fig. 116) established by Niccolò

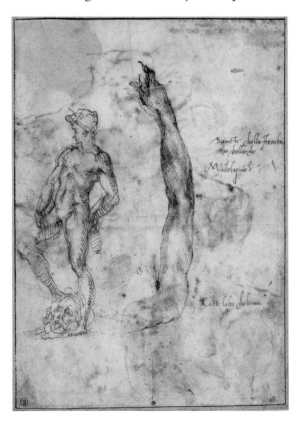

Fig. 114 Michelangelo Buonarroti (Italian, 1475–1564), *Studies for the Colossal Statue of David, and Study of Arm*, pen and ink on paper, 10⅜ × 7¼ inches, Musée du Louvre, Paris, Department of Graphic Arts, INV 714.

Fig. 115 Fra Bartolommeo (Italian, 1472–1517), *View of Santissima Annunziata*, Gabinetto Disegni e Stampe, Galleria degli Uffizi, Florence, inv. 45 P.

da Uzzano in 1429 as a college associated with the Studio Fiorentino, erected between San Marco and Santissima Annunziata. This building, originally designed to house poor and needy students, never served this function: its centuries-long history witnessed many alterations to the original plan. At the dawn of the 1500s, less than a century after its establishment, the complex had already been a textile factory and private housing. According to Emanuela Ferretti's research, the publicly owned structure was managed by the Arte di Calimala (the guild of the cloth merchants) through four directors elected to lifetime appointments.[7]

The earliest record of a place dedicated to casting artillery at the Sapienza was believed to go back to 1498. We have been led to believe that this date marked the inauguration of the foundry;[8] however, a note by Angelo Angelucci written in 1896 has gone unnoticed in the literature dedicated to the factory: the scholar pointed out that in the Ammunition Registry of the Republic of Florence reference was already made to artillery activity in the Sapienza foundry at the beginning of 1495.[9]

Following this trail I have been able to retrace a series of documents related to the foundry and its management (see Documentary Appendix), singling out the date of its construction. The documents show that the foundry was constructed in February 1495 at the expense of the Dieci di Balìa as a direct consequence of the beginnings of hostilities with Pisa. Among the workers involved we find very qualified people, such as "Chimenti di Domenicho," identifiable as Chimenti del Tasso. Construction was completed on 23 February and detailed payments in the books of the Munizioni dei Dieci show a more complex administration of the Sapienza than had been thought. The foundry was not supervised by Calimala authorities (who were supposed to manage the Sapienza), but by the Balìa, who financed the foundry's construction (see Documents 1–4).

The magistrates entrusted administration of the facility to salaried founders who enjoyed long terms of employment. A similar attitude is suggested by

Fig. 116  Stefano Bonsignori (Italian, died 1589), *Sapienza Complex*, from *Nova Pulcherrimae Civitatis Florentiae topographia accuratissimae delineata*, Florence, 1584.

the regularity with which some *bombardieri* were certified at the Sapienza in the Munizioni registers. This is the case for Simone de' Bronzi and Francesco Telli for 1494–1495,[10] Giovannandrea da Novara and Giovanni Piffero—Cellini's father—between 1502 and 1503,[11] and Bernardino d'Antonio da Milano from 1503 to 1512.[12] Identifying the casting masters who were delegated to manage the foundry serves to sharpen our understanding of Leonardo's relationships with the Sapienza foundry. The artist's acquaintance with Giovanni Piffero is well documented in the years they served the Dieci magistrature. On 26 July 1503, the musician appears as the moneyholder of fifty-six lire and thirteen cents for food and transportation the artist paid during his trip to the Pisan camp;[13] and in February 1505 Giovanni was paid, along with the painter Nunziato, for the cost of the movable wooden scaffolding designed by Leonardo for painting the *Battle of Anghiari* on the walls of the Great Council Hall.[14]

Leonardo, who was no stranger to the production of bombs and firearms (fig. 117),[15] likely frequented the Sapienza, perhaps in the guise of unofficial counsellor and expert for the Signoria. Knowledge of a facility like the Sapienza could have suggested to Leonardo the possibility of

**Fig. 117** Leonardo da Vinci, *A Scene in an Arsenal*, ca. 1485–1490, pen and ink over traces of black chalk, 9¾ × 7³⁄₁₆ inches, Royal Library, Windsor Castle, RL 12647.

reviving the practice of creating bronze sculptures to decorate the Florentine Baptistery. We have already stressed in other contexts how the Arte di Calimala council's decision in December 1506 to entrust the execution of three large bronze statues to Giovan Francesco Rustici—sculptures that would replace works by Tino di Camaino—must have been directly related to Leonardo's previous stay in Florence. Just four years earlier, in 1502, the corporation, engaged in modernizing the decorative sculptures of San Giovanni, had called upon Andrea Sansovino to make a *Baptism of Christ* in marble to place above Lorenzo Ghiberti's Gates of

Paradise. Commissioning a colleague of Leonardo's to create a bronze group of *John the Baptist Preaching to a Levite and a Pharisee* very soon thereafter suggests Leonardo's influence.[16]

Florence's establishment of a public foundry equipped for handling large castings must have had a truly dramatic effect on the bronze market. It was an innovation that disrupted well-established routines, and the foundry was set in competition with other traditionally important centers of bronze production in fifteenth-century Florence. An example is "le Porte," the large courtyard (fig. 118) surrounded by loggias where Ghiberti had carried out all of his most important casting for the Baptistery.[17] The courtyard remained in operation until the beginning of the 1500s, hosting the activity of Ghiberti's son Vittore and then his nephew Bonaccorso; therefore the most illustrious dynasty of casters in the city operated one of the best-equipped sites in Florence for figure and large-scale casting. Their private management had been stipulated by a formal act: between 1452 and 1453 Ghiberti received the courtyard from the Arte di Calimala as partial payment for work on the Gates of Paradise.[18] This very famous site reflects the artists' desire to have direct control over the casting areas for all kinds of practical reasons, including the supervision of suppliers and workers. Benvenuto Cellini later expressed a similar desire to cast his *Perseus* with his own furnace,[19] and in 1587–1588 Giambologna sought the installation of a house-studio, including the purchase of a permanent furnace for figure casting, to crown his career in the service of the Grand Duke Francesco.[20]

The construction of a public foundry in 1495 would have assisted in meeting pressing needs for armaments and would have countered a tendency toward the privatization of bronze casting. The use of the Santissima Annunziata site guaranteed patrons more direct control of the different stages of production, such as supplies and the quantities of materials used by the artists. The metal alloy was normally an expense charged to those who ordered the work, creating an incentive for closely super-

Fig. 118 Stefano Bonsignori (Italian, died 1589), *Le Porte*, from *Nova Pulcherrimae Civitatis Florentiae topographia accuratissimae delineata*, Florence, 1584.

vising sculptors. It is no coincidence that during the 1500s Rustici, Vincenzo Danti, Giambologna, and Bartolomeo Ammannati were urged to work at the Sapienza.[21] The presence of a facility directly overseen by the Signoria could also ensure greater competition for winning public or semipublic commissions for bronze statues (for the guilds and the government), and permitted artists who did not have suitable tools and facilities to participate in competitions. Rustici, for example, lacked experience in casting, but he was able to win the commission for the Baptistery statues because he could count on the Sapienza foundry, where the figures were later created.

It is important to stress that the materials for the *John the Baptist Preaching* group were partly furnished by the Dieci di Balìa. In 1510 the Munizioni books noted the delivery to the merchants guild of 1,400 pounds of bronze over the previous months, a quantity of metal alloy likely used for casting the statues, since, according to Bartolomeo Cerretani, they must have been cast in December 1509 (see Documents 5–6).[22]

The Balìa also played an active role in commissioning another monumental casting performed in Florence at the beginning of the 1500s. Detailed studies by Luca Gatti and Francesco Caglioti have made clear that the bronze *David* by Michelangelo Buonarroti commissioned by the Signoria in 1502 (see fig. 114), first offered to Pierre de Rohan and then to Florimond Robertet, was an artistic "gift" implicated in the Pisan War and consequently "naturally taken care of by the magistrature for foreign affairs and military," meaning the Dieci di Balìa financed by the Signoria.[23] It is significant that the history of Michelangelo's sculpture can be reconstructed through the war institute's accounting books that usually contained expenditures for army maintenance. In respect to what we consider typical bookkeeping, the Munizioni registers of the Dieci recorded deliveries of the materials needed for the casting.[24] We know that in spring 1504 Michelangelo obtained 114 pounds of tin, "avuto sino addi 5 di marzo p(er) gittare il Davitte" (Documents 7–8). The casting would have been done at that time, when the sculptor had just finished the marble *David* and was therefore freer to dedicate his time to this other project.[25]

Determining 1504 as the statue's casting date helps clarify how bronze production took shape in Florence at the beginning of the sixteenth century in a continuous relationship with the Pisan War. Casting *David* in 1504, after a commission contracted in 1502, did not indicate Michelangelo's *lungaggini* (slowness), so much as it suggests a strategic second thought by the Signoria about its need for available metal alloy. At this point—precisely in 1504—military operations seemed to shift from a tactic of attack to one of siege, involving engineering and even the aforementioned diversion of the Arno River.

To understand how bronze and iron supplies created a problem for the Florentines in the never-ending years of conflict, we can read Bonaccorso Ghiberti's *Zibaldone*. Lorenzo's nephew, who was personally involved in the production of cannons and light artillery for the Republic, noted on 16 July 1499 that the Dieci, lacking iron for making bullets during a major attack on Pisa, had delivered a large quantity of poor-quality bronze to reuse for

ammunition.[26] Even 17 September 1509, the day Rustici signed a contract with the master *bombardiere* Bernardino d'Antonio da Milano for casting the figures of the *John the Baptist Preaching* group, is significant.[27] Pisa's surrender was made official on 8 June, and Florentine officials began to think about completing the statues once bronze supplies were no longer monopolized by cannon production.

Studying Bernardino d'Antonio's professional career helps illustrate how the realization of a bronze work in Florence in the early 1500s was closely related to the war economy that had dominated the political and financial life of the city for more than a decade. We are dealing with activities that used materials closely linked to a special and costly technology, anchored to a multiphased and restrictive production system. In 2007 I noted how Bernardino d'Antonio, who enrolled in the guild of the stonemasons and woodworkers in 1502, is documented as being in constant service to the Republic of Florence as an artillery master from 1503 to 1512.[28] New documents to which I have previously made reference place his activity as manager of the Sapienza foundry in the same time period. Similar participation in governmental activity suggests the possibility of re-reading Leonardo's relation to the *bombardiere*. Instead of thinking of Leonardo as instrumental in bringing Bernardino to Florence,[29] I am inclined to place their acquaintance during the time that they both gravitated around the Dieci magistrature and the Uzzano foundry complex.

Before being called to participate in casting *John the Baptist Preaching* in 1509, Bernardino was already involved in another important project, the realization of a bronze statue of Pope Julius II for Bologna. The model's author, Michelangelo, received the commission in 1506. Buonarroti had initially turned to two other helpers to accomplish the casting, Lapo d'Antonio and Ludovico Lotti.[30] Following misunderstandings with these two Florentine collaborators, the artist came in contact with the master from Milan in 1507 through the Signoria's herald, Angelo Manfidi.[31] The casting process was quite troubled, causing Michelangelo to feel disdained and discouraged. He wrote to his brother Buonarroto on 6 July of that year: "Arei creduto che maest[r]o Bernardino avessi fonduto sanza foco, tanta fede avevo in lui [I had so much faith in master Bernardino that I would have believed that he could cast without fire]."[32]

Today it is obvious that Michelangelo's faith was fed by the support Bernardino enjoyed from the government of Pier Soderini. This makes two pieces of previously unnoticed information very important: the first comes from the *Libro di Ricordanze* by Bonaccorso Ghiberti and the second from a register of deliberations managed and financed by the Dieci beginning in 1511. On 5 December 1508, Lorenzo di Cione's nephew mentioned Bernardino in a delivery invoice of 2,260 net pounds of alloyed bronze as "maestro Bernardino che lavora nela Sapienza per chommesione del gonfaloniere [master Bernardino who works at the Sapienza by commission of the *gonfaloniere*]."[33] On 7 December 1512, the caster, known as "uno de' donzelli de n(ost)ri ex(cel)si S(igno)ri [one of the members of the entourage of our excellent Signori]," asked to be reimbursed for a satin vest, a velvet and silver belt, new shirts, and knives lost during the armed occupation of Palazzo Vecchio following the Medicis' return to the city. This is proof of the social status Bernardino had reached—besides the founder's flourishing economic situation—and demonstrates that he was part of the Signoria family, both in terms of employment and residence (Document 9).

This circumstance clarifies another result of state control of a casting site. Beyond responding to the city's constant war emergency, founders could increase their status through their involvement with the Republic's geriarchy. Florence's public foundry also favored a clearer separation between the roles of the person creating the model of large bronze sculptures and those casting it. Even though the two skills enjoyed different professional identities in the 1400s, the hybrid world of the Quattrocento *bottega* (artist's shop) allowed more complex familiarity

and less exclusive specialization. The recognition of spaces managed directly by the casters—and used for more than just artistic works—indicates how the new times tended toward a clearer separation of modeling and casting, a distinction that was even more sensitive in creating highly technical works like bronze statues.

The innovations in Florence were already common practices in Milan while Leonardo was there. More than once the artist defended the superiority of his own "invention" compared to the casting methods of the masters. A page in the *Codex Atlanticus* regarding the Piacenza project for the new bronze doors for the city's Cathedral is exemplary. Leonardo launched his candidacy for the job by warning the *Fabbricieri* (church building superintendents) about jug makers, armorers, bell makers, and *bombardieri*.[34] Nevertheless, Leonardo lived in a courtly atmosphere governed by a military dynasty and had observed the great fame the casters of Il Moro's entourage experienced. He must have known Bernardo Bellincioni's sonnet celebrating the glory of the Sforza regime and praising Giannino Alberghetti, who at that time was well known as a *bombardiere* (honored as the Lombard "Volcano")[35] and who went down in history for taking the bronze intended for casting the Sforza monument to Ferrara for making artillery during wartime, as requested by Duke Ercole.[36]

Predictably, it was the Sienese *bombardiere* Vannoccio Biringuccio, active at the Sapienza in 1539, who wrote the most extensive Italian essay on casting, the *De la pirotechnia* (published in 1540), full of memories of Leonardo's works and souvenirs of the artist's activity in bronze.[37] The text sanctioned the definitive separation of the sculptor's and founder's roles in paradoxical yet eloquent terms. Recognizing and praising the considerable physical challenges facing the founder, Biringuccio emphasized that this work was too sweaty and dirty for a nobleman and was best left to "the strong, the young, and the vigorous."[38] This proud understatement calls to mind—by analogy—a beautiful drawing by Leonardo traditionally dated to the 1490s (see fig. 117).

The sheet, today at Windsor, contrasts miniature human figures with colossal artillery, indicating the Herculean dimensions of work around the furnace. Furthermore, the nudity of the *bombardiers* ensures that they take on the heroic dignity of ancient athletes in this new Bronze Age.

# Documentary Appendix

## DOCUMENT 1

Dieci di Balìa, Munizioni, 5, 10 dicembre 1494–1496

c. 20r

1494

A questi maestri di murare e manovali ellegniaiuoli cho-
minciorono adi iii di febraio a tt.o di vii detto <febbraio>
che sono 5 opere per uno alla muraglia alla Sapienza dove
sanno a fare le bombarde in questo

Bartolomeo di Marco legniaulo per 5 opere di m[ur]o £ 5

m.o Ghuasparre di Salvestro muratore per 5 opere di m[ur]o a
s 18 el di £ 4.10

m.o Domenicho . . . muratore per 5 opere di m[ur]o a s 18 el di
£ 4.10

m.o Piero . . . muratore per 5 opere di m[ur]o a s 18 el di £ 4.10

a piu manovali

Betto di Lorenzo per opere 5 di manovali a s 8 el di queste
opere £ 2

Giovanni di Pagholo manovale per 5 opere a s 8 il di £ 2

Andrea di Piero per 5 opere di manovali a s 8 el di £ 2

Andrea di Francesco per 5 opere di manovali a s 8 el di £ 2

Alesandro lonbardo per 5 opere di manovali a s 8 el di £ 2

Beltrame lombardo per 5 opere di manovali a s 8 el di £ 2

Lotto . . . manovale per 5 opere a s 8 el di £ 2

Francesco di Filippo legniaiulo per 5 opere a s 8 el di £ 2

Chimenti di Domenicho legniaiulo per 5 opere a s 8 el di £ 2

Giovanni d'Alesso per 5 opere di manovali a s 8 el di £ 2

£ 40.10

Sommali sopradicti maestri e manovali chome si vede a . . .
e paghasi e sopradicti da Franc.o Scharfi chamarlingo al
g.e a 46 £ 40.10

Marcho d'Andrea renaiuolo fuori della Porta al Prato per 72
some di rena a d viii la soma monta £ 2 s 8

Bartolomeo di Chanbio renaiuolo per some 130 di rena dare
alla muraglia della Sapienza a d viii la soma

Paghare adi viiii detto al g.e di Franc.o Scharfi e comp[agn]i a
46 in due parti

## DOCUMENT 2

Dieci di Balìa, Munizioni, 5, 10 dicembre 1494–1496

c. 24r

Qui da pie faro richodo di queste opere ogi questo di xiiii.o di
febraio chominciando adi viiii di detto mese e per e tutto di
xiiii di detto in questo

Maestro Domenicho di Filippo murattore per 6 opere s 18 luna
per resto £ 5.8

Maestro Piero di Francesco Rudi per 6 opere per resto a s 18
luna £ 5.8

Maestro Ghuasparri di Salvestro muratore per resto a s 18 el di
per 6 opere £ 5.8

Andrea di Francesco manovale per 6 opere a s viii el di £ 2.8

Giovanni di Girolamo da novale per 6 opere a s viii el di £ 2.8

Andrea di Piero Rulli per 6 opere a s viii el di £ 2.8

Betto di Pagholo per 6 opere a s viii el di £ 2.8

Giovanni di Pagholo per 6 opere a s viii el di £ 2.8

Beltrame lonbrado per 6 opere a s viii el di £ 2.8

Lotto di Matteo di Vanni per 6 opere a s viii el di £ 2.8

Lazero da Potremoli per 6 opere a s viii el di £ 2.8

Giovanni d'Alesso manovale per 6 opere a s 8 el di £ 2.8

Bacio Grosso scharpellino per 3 opere a fare 4 buchi per
metere le chatene al fornello a s 10 el di £ 1.10

Bacio di Chanbio renaiuolo per some 90 di rena a'd' 8 la soma
£ 3

Lucha di Paradiso per i.a barelle e i.o paio di case per portare
terre £ 1.2

202

Simone d'Antonio detto Moscha charettaio per xii some di terre per mure el fornello recho dalla Giustizia fuori e 9 charettoni di pietre dalla Portta alla Giustizia de denttro dachordo £ 3.15 £ 3.15

Andrea lonbardo m.o de chiavi e toppe per i.a chiavé è i.a toppa alluscio dove se fatto el tetto e i.a toppa grande fratescha e iiii chiavi dachordo £ 3 s 14 £ 3.14

£ 50.17

Paghasi al g.e di Franc.o Scharfi a 62

## DOCUMENT 3
Dieci di Balìa, Munizioni, 5, 10 dicembre 1494–1496

c. 30v

1494

Qui da pie faro richordo di questo resto dellopere a rienpere inttorno al pozzo e dove el fornello chomiciati adi 16 di febraio a tt.o di 21 detto questi nomi qui da pie

Betto di Pagholo manovale per 6 opere a s 8 el di per riepere dove si gita le bonbarde per resto £ 2.8

Giovanni di Pagholo per 2 opere a s 8 el di e per resto £ – 16

Domenicho di Maso manovale per 6 opere a s 8 el di chome di sopra £ 2.8

Giovanni di Girolamo manovale per 6 opere a s 8 el di chome di sopra e per resto

Paghati al g.e di Franc.o Scharfi a 62 montano £ 8.0

## DOCUMENT 4
Dieci di Balìa, Munizioni, 5, 10 dicembre 1494–1496

c. 31r

1494

Qui da pie faro richordo di queste opere lavorono alla Sapienza a vagliare la terra e porttarle dentro per operare a rempire el pozo dove si gita le bombarde cominciati adi 23 detto

Domenicho detto Bigio manovale chomicio adi 23 detto a tt.o di 27 detto a s viii el di per resto coe 4 opere £ 1.12

Giovanni di Pagholo per 4 opere cominciato come di sopra £ 1.12

Giovanni di Girolamo per 4 opere chome di sopra e per resto £ 1.12

£ 4.16

Paghatto al g.e di Franc.o Scharfi a 62

## DOCUMENT 5
Dieci di Balìa, Munizioni, 10, 1506–1513

c. 23v

MDX

M(aestr)o Bernardino d'Ant(oni)o da Milano m(aestr)o di getti de dare levato di questo a 23 lib. 3448 di bronzo

E de dare adi 17 daghosto lib. 988 di bronzo tratto della Parte Guelfa come si vede nella partita de 13 detto in credito lib. 9g8

E de dare addi 25 gennaio lib. 196 di bronzo auto da maestri di doghana che venne da Pistoia lib. 196

E de dare lib. 1400 di bronzo aute per noi da chonsoli dell'Arte de Merchatanti posto avere in q[uest]o 27 lib. 1400

E de dare lib. 2691 di bronzo consegnatoli per noi da capitani di Parte avere in questo a 7 lib. 2691

E adi 19 di febraio lib. 490 di bronzo in uno falchonetto rotto lib. 490

E adi 12 di luglio 1512 lib. 1906 di bronzo che tanto ci fa buono per Signori capitani di Parte avere in questo a 7 lib. 1906

Lib. 11119

## DOCUMENT 6

Dieci di Balìa, Munizioni, 10, 1506–1513

c. 26v

MDX

E chonsoli dell'Arte de Merchatanti deono dare lib. 1400 di
  bronzo per noi da maestro Bernardino da Milano avere in
  questo a 24 a Ghaleazo Alamani Priore dell'Arte lib. 1400

Anone dato e per noi a maestro Bernardino d'Antonio da
  Milano posto dare in questo a 74 lib. 1400

## DOCUMENT 7

Dieci di Balìa, Munizioni, 8, 1502–1504

c. 4 dare

MDIII

Michelagnolo scultore de dare addi . . . di marzo libb.e 114 di
  stagno

c. 4 avere

Porto Michelangelo scultore di contro de avere posto dare al
  libro di munitione a 38 segnato a libb.e 114 di stagno

## DOCUMENT 8

Dieci di Balìa, Munizioni, 8, 1502–1504

c. 38 dare

MDIII

Porto Michelagnolo scultore de dare posto resto da quel conto
  al quaderno d'Antonio Venturi libb.e 114 di stagno avuto
  sino addi 5 di marzo p[er] gittare il Davitte per mandare in
  Francia allo scaccia foglio di Lorenzo Moregli a 1

## DOCUMENT 9

Dieci di Balìa, Deliberazioni, condotte e stanziamenti, 58,
  1511–1513

c. 142v

Adi vii di dicemb. MDXII

Bernardino di . . . da Milano uno de donzelli de nostri excelsi
  Signori £ septantasei s dieci piccioli: sono per satisfactione
  di uno farsetto di raso alexandrino nuovo uno cinto di
  velluto chermisi fornito di argento quattro camice nuove
  xxii br.a di panno lino et uno paio di coltelli nuovi da
  tagliare : quali robe li furno tolte el di del parlamento da
  soldati che entrorono in palazo: quali ruppono luscio d[e]
  lla camera di dicto Bernardino: et la cassa dove erano dette
  sue cose et perche pare visto d[ic]to Bernardino debba
  sopportare tale danno max. ancora perche fu ca. cercando
  di dicte sue robe et cercando uno soldato alla catena si
  ritrovassi in uno vaso grande della argenteria di palazzo
  di valuta di fl LXXX lar. in oro incirca se li fa il presente
  stantiamento fl – £ 76 s 10.

## NOTES

1. For the Pisan War it is still useful to consult classic texts like Pieri 1952, pp. 368–377 and 435–436. Cf. Luzzati 2000.

2. Cf. Parenti 2005, p. 350.

3. Cf. Cerretani 1994, p. 336.

4. For an incisive synthesis, see Vecce 1998, pp. 227–229.

5. News of the arsenal's transfer is reported by Luca Landucci, as it happened on 16 July 1511. See Landucci 1883. An exhaustive study on the convent complex of Santa Maria Novella has yet to be written. See Paatz 1940–1954, vol. 3, 1952, pp. 692–731; see also Nobili 1994, pp. 31–46.

6. For a study on this aspect of Leonardo's life, see Bambach 2005, pp. 34–43, which reviews the most recent debates related to the arrangement of Leonardo's rooms at Santissima Annunziata.

7. The most recent study dedicated to the construction of the Sapienza is Ferretti 2009. For the use of the areas in the great complex, see Cardini and Tarchiani 1986, pp. 1099–1128; and Mozzati 2008, pp. 223–227.

8. Cardini and Tarchiani 1986, p. 1110.

9. Angelucci 1896, p. 95.

10. ASF, Dieci di Balìa, Munizioni, 5, 15v, 21r, 31r, 37r, 47r, 103r. The payment on 17 March 1495 (s.f.) declares the patronymics of the two bronze workers "Dom(enic)o Franc(esc)o di Bart(olome)o Telli e m(aestr)o Simone di Giovanni B(er)toldi" (37r). Francesco di Bartolomeo Telli was registered at the Arte dei Maestri di pietra e legname on 14 November 1511;. ASF, Arte dei Maestri di pietra e legname, 4, 440 dare avere.

11. ASF, Dieci di Balìa, Munizioni, 8, 1502–1504, [the volume's pages have double numering] 78 dare, 30 dare, 32 avere; Dieci di Balìa, Munizioni, 9, ca. 1502–1505, 18v, 19v, 24r, 25r.

12. ASF, Dieci di Balìa, Munizioni, 8, 1502–1504, 33 dare; Munizioni, 9, 1502–1505 ca., 19v, 24r, 31r, 52v, 80v; Munizioni, 10, 1506–1513 [the volume's pages have double numbering], 19v, 21 r e v, 23v, 31v, 50r, 60r, 81r, 119r, 114r, 23 avere, 23 dare, 30 avere, 75 avere, 77 dare. We limit ourselves here in pointing out the documents not mentioned in our biography file of Bernardino; see Mozzati "Notizia" 2005, pp. 159–163.

13. ASF, Camera dei Comuni, Depositario dei Signori, Depositario di Entrata e Uscita, 15, 52v. For a modern transcript of the document, see Villata 1999, p. 161, no. 181.

14. ASF, Operai di Palazzo, Stanziamenti, 10, 74r–75v. For a modern transcript of the document, see Villata 1999, p. 179, no. 211. On 25 January 1504 Giovanni Piffero sat together with Leonardo on the commission called to decide on the placement of Michelangelo's *David*; see *ivi*, p. 163, no. 186. For an inventory of Giovanni Piffero's activity under the direction of the Republic's magistrature, see Polk 1986, pp. 67–68; Mozzati "L'educazione" 2005, pp. 201–203.

15. Vecce 1998, p. 97.

16. Mozzati 2007, pp. 142–145.

17. On the site of "le Porte," see Krautheimer-Hess 1964, pp. 309–314. See also Coonin 1991, pp. 100–104. We have already pointed out how a correct reading of the documentation about the foundry managed by the Ghiberti family makes it possible to place the occupied area at the current Sant'Egidio, Oriuolo, and Portinari Streets, facing the Ospedale di Santa Maria Nuova; see Mozzati 2008, pp. 237–238, n. 292. A careful study of the book *Libro di Ricordanze* by Bonaccorso Ghiberti, kept at the Archivio dell'Ospedale degli Innocenti, makes it possible to clarify how the furnaces of the foundry remained in the hands of the family even when part of the building was rented by

Pietro Perugino (AOI, CXLIV, 546, 146r–v); they continued to work on castings, led by the nephew of Lorenzo. On 1 March 1497, Bonaccorso begins to "stare adberghjare ale mie sttanze di Santta Maria Nuova cioe ala bottegha mia dove fecie mio padre e mio avolo Lorenzo di Cione Ghiberti altrimenti detto Lorenzo di Barttolucho le portte di bronzo di San Giovanni di Firenze" (AOI, CXLIV, 546, 14v). On 22 October 1499, the caster records: "Ricordo come adi 22 dottobre 1499 io mi usci di chasa e ttornai a bottegha cioe ale stanze mie di Santa Maria Nuova per istarvi e piu rizai u(n)o letto e cominciavi a dormire e mangiare e stare da me chon nuno gharzone io ttolsi che mi governassi" (AOI, CXLIV, 546, 37v). This makes it clear that every time Bonaccorso mentions his studio in *Libro di Ricordanze*, he is referring to the rooms at the Ospedale. Trude Krautheimer-Hess stressed how the great collections of Lorenzo remained in this environment after his death until the 1540s. Today it seems important to add this unedited note from *Libro di Ricordanze* by Bonaccorso: on 12 May 1503, the *Libro* mentions the delivery to the Signoria of "u(n)a testa di chavalo di bronzo grande al natturale," the same antique sculpture "che nelorto de medicci ogi q(uest)o di d'aghosto 1513 perche ffuloro" as noted in an addition after the note (AOI, CXLIV, 546, 98r). This was one of the most celebrated ancient bronzes in Florence (now at Museo Archeologico di Firenze); see file no. II.5, in *In the Light* 2004, vol. 1, p. 198. In the first year of the Soderinian government the Signoria was worried about collating the other treasures of the Medici collections, after having already obtained possession of the *David* and the *Giuditta* by Donatello.

18. Krautheimer 1982, pp. 420–421, doc. 289.

19. Ferretti 2006, p. 317.

20. Zikos 2002, pp. 357–408.

21. On the continuous use of the Sapienza foundry in the 1500s, see Summers 1979, p. 406, doc. 2; Ferretti 2006, pp. 317 and 320, n. 70.

22. Cerretani 1993, p. 217.

23. Caglioti "Il *David*" 1996, pp. 87–132, particularly p. 98; see also Gatti 1994, pp. 433–472.

24. The same registers denounce the monopoly by the magistrature on the management of the publicly commissioned large castings: new archival attainments clarify that on 2 July 1512, the Balìa furnished the materials necessary for creating two other important works, this time intended for Palazzo Vecchio, the "gratichola p(er) lla capella" de' Priori and the "balaustro fatto alla base del davitte" by Donatello; ASF, Dieci di Balìa, Munizioni, 10, 1506–1513, 77v.

25. Hirst 2000, pp. 489–490.

26. AOI, CXLIV, 547, 51 avere.

27. Vasari 1878–1885, vol. 6, 1881, p. 626. The text of the Arte's decision is published in Milanesi 1873, pp. 253–255, doc. II. The passage on p. 254 is particularly interesting for our study: "et quando dette figure si facessino di bronzo e belle sarebbono corrispondenti alle porte di bronzo di detta chiesa che sono cose belle e degne, sanza dubbio sarebbe cosa laudabile."

28. Mozzati "Notizia" 2005, pp. 159–163.

29. Agosti 1990, p. 126, n. 21.

30. In Mozzati 2007, p. 168, n. 27, I announced a biographical file for Lotti. Ludovico di Guglielmo is in fact among the most important Florentine *bombardieri* of the early 1500s. Born in 1460, according to Milanesi, "Lodovico di Guglielmo, campanaio e maestro di getti . . . nel 1504 fu a consigliare sopra la collocazione del David di Michelagnolo; . . . nel 1516 ebbe a gettare dagli Operai di Santa Maria del Fiore una campana di 5000 libbre, ed un'altra dello stesso peso nel 1518; . . . nel 1519 doveva gettare i candelieri di bronzo per la medesima chiesa"; Vasari 1878–1885, vol. 4, 1879, p. 577, n. 1, and p. 587; see also Lotti 1929, p. 410, a text that essentially repeats the same information. Ludovico's family was *addecimata* in the Santa Maria Novella Quartiere, Gonfalone Lion Bianco. In 1469 Guglielmo's father declares: "Ghuglielmo del Buono fornaio in detto G(onfalon) e disse nel p(rim)o chatasto nel Buono mio padre e fu detto miserabile" (ASF, Catasto, 921, 329 r.). Ludovico is recorded between the "bocche," as "danni 10." In 1480, Guglielmo's widow, "M(adonn)a Lena veduva figliuola di [. . .] [manca] di s(er) Lorenzo di Sandro da Carmignano" presents his declaration, and between the bocche dependents on her was named "Lodovicho suo figliuolo danni 22 Sta all'orafo con Ant(oni)o del Pollaiolo": the indication of Ludovico's age, along with the land register of 1469, would invite us to move the date of birth proposed by Milanesi up one or two years. Ludovico presents his own Decima repubblicana (ASF, Decima repubblicana, 25, 52 r). La Decima granducale is entitled to "*m(adonn)a Lesandra donna fu di L(udovi)co di Ghuglielmo del Buono horafo*" (ASF, Decima granducale, 3623, 1r). Ludovico's matriculation at Arte della Seta goes back to 23 March 1484 (ASF, Arte della Seta, 10, 75r): Bemporad 1992–1993 noted the matriculation number, committing an error in transcribing the name of the goldsmith (see Bemporad 1992–1993, vol. 1, 1993, p. 446). Ludovico worked for the Opera del Duomo; see Poggi 1909, vol. 2, p. 160, no. 2232; p. 161, no. 2235; p. 191, nos. 2357–2359; and p. 192, nos. 2360–2361. He also lent his services to some Republican magistratures: he was employed by Parte Guelfa (ASF, Capitani di Parte Guelfa, 11, 202 r.), but he mostly operated as a master of artillery for the Dieci di Balìa, at least between 1502 and 1510 (see ASF, Dieci di Balìa, Debitori e creditori, 54, big red book marked S from June 1505 to June 1506, 142 dare avere; Deliberazioni, condotte, e stanziamenti, 52, 1504–1505, 100r, 162v; Ricordanze, 10, 1505, 7r; Munizioni, 8, 1502–1504, 16 dare; 36 avere; Munizioni, 10, 1506–1513, 22 dare). Ludovico, besides his son Lorenzo (the sculptor Lorenzetto), had an heir named Guglielmo, who continued as a caster; see, for example, AOD, II. 2. 12, 29 dare; VII.1.52, 31 dare; ASF, Capitani di Parte Guelfa, 13, 5r, 212r.

31. Poggi, Barocchi, and Ristori 1965–1983, vol. 1, 1965, pp. 18–19, 22–23, 26–28, 38, 42, and 44.

32. See ibid., p. 45.

33. AOI, CXLIV, 546, 144r.

34. Cf. note 18.

35. *Rime del arguto* 1493, fols. e Ir–e 2v. For a modern transcription, see Villata 1999, p. 77, note 72d.

36. See Herzfeld 1926–1929, pp. 80–86; Grierson 1959, pp. 40–48. For a modern transcript of this document, see Villata 1999, p. 85, no. 90.

37. Vannoccio's father probably met Leonardo in Siena at the beginning of the sixteenth century; cf. Cianchi 1964, pp. 277–297; Pedretti, "La campana di Siena," in Galluzzi 1991, pp. 121–134.

38. "Per il che considerando molte volte di questo esercitio, oltre a l'impedimenti straordinari, le corporali e facchinesche fadighe ho voglia di dir iscambio desaltarlo con laude, esser tale che un huomo nato nobile . . . non dovere ne poterla esercitare, si non per essere assuefatti a li sudori e alli molti disagi . . . & appresso a questo chi tal esercitio vuol fare è di bisognio che . . . sia . . . forte, giovene e vigoroso" (Biringuccio 1977, p. 75).

# References

## MANUSCRIPTS BY LEONARDO

*Codex Arundel*
  *Codex Arundel 263*, ca. 1478–1518, British Library, London.

*Codex Atlanticus*
  *Codex Atlanticus*, 12 vols., ca. 1478–1518, Biblioteca Ambrosiana, Milan. Citations correspond with Richter 1883.

*Codex Forster I, Codex Forster II, Codex Forster III*
  *The Forster Codices*, Victoria and Albert Museum, London. The first part of *Forster I* (fols. 1–40) is dated 1505, and the second part (fols. 41–55) is from ca. 1487–1490. The first part of *Forster II* (fols. 1–63) dates from ca. 1495–1497, while the second part (fols. 64–159) dates from ca. 1494–1497. *Forster III* appears to date from ca. 1490–1497.

*Codex Leicester*
  *Codex Leicester* (formerly *Leicester 699*, Holkham Hall; formerly called the *Codex Hammer* when it was owned by Armand Hammer), ca. 1508–1512, Collection of Bill and Melinda Gates, Medina, Washington.

*Codex Madrid I, Codex Madrid II*
  *The Madrid Codices*, Biblioteca Nacional, Madrid. *Codex Madrid I* (8937) dates from ca. 1493–1499. *Codex Madrid II* (8936) bears the dates 1491 and 1493, and other material in this volume seems to date ca. 1503–1505. English language citations largely follow *Madrid Codices 1974*, though with some amendments and corrections.

*Codex Trivulzianus*
  *Codex Trivulzianus N 2162*, ca. 1487–1490, Castello Sforzesco, Milan.

*Codex Urbinas*
  *Codex Urbinas Latinus 1270*, 1515–1570, Biblioteca Apostolica Vaticana. This is also known as the *Libro di pittura*, posthumously compiled by Francesco Melzi, based on Leonardo's notes. Citations refer to the 1995 version of the codex compiled and edited by Carlo Pedretti (see *Libro di pittura 1995*).

*Ms. A*
  Paris Manuscript A (2172; 2185), Institut de France, Paris. The first part of Paris *Ms. A* is dated 1492, but was begun earlier, ca. 1490–1491. Some-time between ca. 1840 and 1847, the second part of this manuscript (fols. 81–114) was stolen by Count Guglielmo Libri, from whom it was purchased by Lord Ashburnham in 1875 (designated as Ms. Ashburnham 1875/2). This part was acquired by the Bibliothèque Nationale as Ms. B.N.It.2038 around 1888, and was then restituted to the Institut de France. Fols. 54 and 65–80 were probably lost at the time of Libri's theft. In early Leonardo literature the second part of *Ms. A* is referred to as Ms. Ashburnham II. Later, this second part is also designated as Ms. B.N.2038, while recent literature presents the foliation of the fully reconstituted manuscript.

*Ms. B*
  Paris Manuscript B (2173; 2184), Institut de France, Paris. The second part of this manuscript (fols. 91–100) was also stolen by Count Guglielmo Libri in ca. 1840–1847, and has the same history as the second part of *Ms. A*, until it was acquired by the Bibliothèque nationale as Ms. B.N.It.2037, and then restituted to the Institut de France. While in Lord Ashburnham's collections, this part of Paris *Ms. B* was known as Ms. Ashburnham 1875/1. Fols. 3 and 84–87 were probably lost at the time of Libri's theft. In the early Leonardo literature, the second part of *Ms. B* is known as Ashburnham I. In the later literature this second part is also designated Ms. B.N.2037, while recent Leonardo literature presents the foliation of the fully reconstituted manuscript. *Ms. B* dates from ca. 1486–1490.

*Ms. C*
  Paris Manuscript C (2174), 1490 and 1491, Institut de France, Paris.

*Ms. F*
  Paris Manuscript F (2177), 1508, Institut de France, Paris.

*Ms. H*
  Paris Manuscript H (2179), Institut de France, Paris. The first part (fols. 1–48) is dated March 1494; the second part (fols. 49–94) is dated January and February 1494; and the third part (fols. 95–142) is dated 1493 and 1494.

*Ms. L*
  Paris Manuscript L (2182), ca. 1497–1502, and possibly 1504, Institut de France, Paris.

All of Leonardo's manuscripts are now available in facsimile reproductions published by Giunti Barbèra–Giunti Gruppo Editoriale (the Giunti Publishing Group), Florence. The editions of the *Codex Atlanticus*, the French Manuscripts, the *Madrid Codices*, and the *Forster Codices* are under the direction of Augusto Marinoni. The *Codex Trivulzianus* is under the direction of Anna Maria Brizio. The *Codex Arundel*, *Codex Urbinas*, and *Codex Leicester* are under the direction of Carlo Pedretti.

## BIBLIOGRAPHY

Acidini 2006
  Acidini, Cristina. "Alberti, il Della pittura, i pittori: appunti fiorentini." In *L'uomo del Rinascimento. Leon Battista Alberti e le arti a Firenze tra ragione e bellezza*, edited by Cristina Acidini and Gabriele Morolli. Florence: Palazzo Strozzi, in association with Mandragora/Maschietto Editore, 2006. An exhibition catalogue.

Adorno 1991
  Adorno, Piero. *Il Verrocchio: nuove proposte nella civiltà artistica del tempo di Lorenzo Il Magnifico*. Florence: Casa Editrice Edam, 1991.

Agghàzy 1989
  Agghàzy, Mária G. *Leonardo's Equestrian Statuette*. Budapest: Akadémiai Kiadó, 1989.

Agosti 1990
  Agosti, Giovanni. *Bambaia e il classicismo lombardo*. Turin: Einaudi, 1990.

Agosti and Isella 2004
  Agosti, Giovanni, and Dante Isella. *Antiquarie prospettiche romane*. Parma: Fondazione Pietro Bembo-Ugo Guanda, 2004.

Ahl 1995
  Ahl, Diane Cole, ed. *Leonardo da Vinci's Sforza Monument Horse*. Bethlehem, Pennsylvania, and London: Lehigh University Press, 1995.

Alberti 1991
  Alberti, Leon Battista. *De pictura—Leon Battista Alberti: On Painting*. Translated by Cecil Grayson. Introduction by Martin Kemp. London: Penguin, 1991.

**Alberti *De statua* 1998**
*Leon Battista Alberti: De statua.* Edited by Marco Collareta. Livorno: Sillabe Editore, 1998.

**Allison 1974**
Allison, Ann H. "Antique Sources of Leonardo's *Leda.*" *The Art Bulletin* 56 (1974).

**Angelucci 1896**
Angelucci, Angelo. *Documenti inediti per la storia delle armi da fuoco italiane.* Turin: Einaudi, 1896.

**Augustine 1973**
Augustine. *La città di Dio.* Edited by C. Borgogno. Alba: Edizioni Paoline, 1973.

**Bambach 2005**
Bambach, Carmen C. "In the footsteps of Leonardo." *Apollo* (July 2005).

**Baroni 1939**
Baroni, Constantino. *Leonardo, Bramantino e il mausoleo di G. Giacomo Trivulzio.* Milan: *Raccolta Vinciana,* fasc. XV–XVI (1935–1939), 1939.

**Baroni 1944**
Baroni, Constantino. *Scultura gotica lombarda.* Milan: E. Bestetti, 1944.

**Barocchi 1971**
Barocchi, Paola. "La letteratura italiana. Storia e testi." In *Scritti d'arte del Cinquecento.* Vol. 32, Book 1. Milan and Naples: Ricciardi Editore, 1971.

**Bearzi 1950**
Bearzi, Bruno. "Considerazioni di tecnica sul San Ludovico e la Giuditta di Donatello." *Bollettino d'arte* 16 (1950).

**Bearzi 1968**
Bearzi, Bruno. "La tecnica fusoria di Donatello." *Donatello e il suo tempo: Atti dell'VIII Convegno Internazionale di Studi sul Rinascimento* 8 (1968).

**Beltrami 1919**
Beltrami, Luca, ed. *Documenti e memorie riguardanti la vita e le opere de Leonardo da Vinci in ordine cronologico.* Milan: Fratelli Treves, 1919.

**Beltrami 1920**
Beltrami, Luca. *La ricostituzione del monumento sepolcrale per il Maresciallo Trivulzio in Milano di Leonardo da Vinci.* Milan: Corriere della Sera, 1920.

**Bemporad 1992–1993**
Bemporad, Dora Liscia. *Argenti fiorentini dal XV al XIX secolo: tipologie e marchi.* 3 vols. Florence: Studio per Edizioni Scelte (S.P.E.S.), 1992–1993.

**Berra 1993**
Berra, Giacomo. "La storia dei canoni proporzionali del corpo umano e gli sviluppi in area lombarda alla fine del Cinquecento." *Raccolta Vinciana,* fasc. XXV (1993).

**Biringuccio 1959**
Biringuccio, Vannoccio. *De la pirotechnia (1540).* Translated by Cyril Stanley Smith and Martha Teach Gnudi. New York: Basic Books, 1959.

**Biringuccio 1977**
Biringuccio, Vannoccio. *De la pirotechnia.* Venice, 1540. Anastatic reprint, Adriano Carugo. Milan: Il Polifilo, 1977.

**Bober and Rubinstein 1986**
Bober, Phyllis Pray, and Ruth Rubinstein. *Renaissance Artists and Antique Sculpture: A Handbook of Sources.* London and New York: Harvey Miller Publishers, 1986.

**Boffrand 1743**
Boffrand, Germain. *Description de ce qui a été pratiqué pour fondre en bronze d'un seul jet la figure équestre de Louis XIV en 1699.* Paris: Guillaume Cavelier, 1743.

**Borrelli 1992**
Borrelli, Licia Vlad. "Considerazioni su tre problematiche teste di cavallo." *Bollettino d'arte* 71 (1992).

**Boucher 2001**
Boucher, Bruce, ed. *Earth and Fire, Italian Terracotta Sculpture from Donatello to Canova.* New Haven and London: Yale University Press, 2001.

**Bovi 1959**
Bovi, Arturo. *L'opera di Leonardo per il monumento Sforza a Milano.* Florence: Leo S. Olschki, 1959.

**Brambilla Barcilon and Marani 2000**
Brambilla Barcilon, Pinin, and Pietro C. Marani. *Leonardo: L'Ultima Cena.* Milan: Electa, 1999. Translated by Harlow Tighe as *Leonardo: The Last Supper* (Chicago: University of Chicago Press, 2000).

**Bresc 2006**
Bresc, Geneviève, ed. *Les sculptures européennes du musée du Louvre.* Paris: Somogy, Editions d'Art, Musée du Louvre éditions, 2006.

**Bresc-Bautier 1985**
Bresc-Bautier, Geneviève. "L'activité parisienne d'Hubert Le Sueur sculpteur du Roi (connu de 1596 à 1658)." *Bulletin de la Société de l'Histoire de l'Art français* (1985).

**Brizio 1952**
Brizio, Anna Maria, ed. *Leonardo da Vinci. Scritti scelti.* Turin: Unione Tipografico-Editrice Torinese (U.T.E.T.), 1952.

**Brown 1998**
Brown, David Alan. *Leonardo da Vinci, Origins of a Genius.* New Haven and London: Yale University Press, 1998.

**Brown 2003**
Brown, David Alan. "The Presence of the Young Leonardo in Verrocchio's Workshop." In *Verrocchio's David* 2003.

**Brugnoli 1954**
Brugnoli, Maria Vittoria. "Documenti, notizie e ipotesi sulla scultura di Leonardo." In *Leonardo, Saggi e ricerche,* edited by A. Marezza. Rome: Istituto Poligrafico dello Stato, Libreria dello Stato, 1954.

**Brugnoli 1974**
Brugnoli, Maria Vittoria. "Il Monumento Sforza." In *Reti* 1974.

**Bush 1978**
Bush, Virginia. "Leonardo's Sforza Monument and Cinquecento Sculpture." *Arte lombarda* 50 (1978).

**Bush 1995**
Bush, Virginia. "The Political Contexts of the Sforza Horse." In Ahl 1995.

**Bussagli 2003**
Bussagli, Marco. "Geometria del sorriso." *Art e Dossier* 17, no. 189 (2003).

**Butterfield 1997**
Butterfield, Andrew. *The Sculptures of Andrea del Verrocchio.* New Haven and London: Yale University Press, 1997.

**Cadogan 1983**
Cadogan, Jean K. "Linen Drapery Studies by Verrocchio, Leonardo and Ghirlandaio." *Zeitschrift für Kunstegeschichte* 46 (1983).

**Caglioti "Il David" 1996**
Caglioti, Francesco. "Il *David* bronzeo di Michelangelo (e Benedetto da Rovezzano): il problema dei pagamenti." *Quaderni del Seminario di Storia della critica d'arte* 6 (1996).

**Caglioti "Il perduto" 1996**
Caglioti, Francesco. "Il perduto 'David medíceo' di Giovanfrancesco Rustici e il 'David' Pulszky del Louvre." *Prospettiva* 83–84 (1996).

**Caglioti 2000**
Caglioti, Francesco. *Donatello e i Medici. Storia del "David" e della "Giuditta."* 2 vols. Florence: Leo S. Olschki, 2000.

**Caglioti 2003**
Caglioti, Francesco. "Naples Horse Head." In *In the Light* 2004.

**Calcani 1983–1984**
Calcani, Giuliana. "Un modello antico in Andrea del Castagno e in Leonardo." *Prospettiva* 33–36 (1983–1984).

**Cardini and Tarchiani 1986**
Cardini, Domenico, and Giuseppe Tarchiani. "Il 'Quadrilatero' Universitario di S. Marco." In *Storia dell'Ateneo Fiorentino,* edited by Luigi Lotti, Claudio Leonardi, and Cosimo Ceccuti. Vol. 1. Florence: F. & F. Paretti Grafiche, 1986.

**Castelfranco 1955**
Castelfranco, Giorgio. "In margine alla mostra didattica Leonardesca, Il preventivo di Leonardo per il monumento sepolcrale di Giangiacomo Trivulzio." *Bollettino d'arte* 3 (1955).

**Castiglione 1560**
Castiglione, Sabba da. *Ricordi di Monsignor Sabba da Castiglione Cavalier Gierosolimitano, di nuovo corretti, et ristampati.* 1546. Venice: Paolo Gherardo, 1560.

**Cavallaro 2005**
Cavallaro, Anna. "Gli artisti intorno all'Alberti e il disegno di figura dall'antico." In *La Roma di Leon Battista Alberti. Umanisti, architetti e artisti alla scoperta dell'antico nella città del Quattrocento,* edited by Francesco Paolo Fiore, in cooperation with Arnold Nesselrath. Rome: Musei Capitolini, in association con Electa, 2005. An exhibition catalogue.

Cellini 1967
Cellini, Benvenuto. *The Treatises of Benvenuto Cellini on Goldsmithing and Sculpture.* Translated by C. R. Ashbee. New York: Dover, 1967.

Cellini 1987
Cellini, Benvenuto. *Della architettura.* In *La vita, i trattati, i discorsi,* by Benvenuto Cellini, with an introduction and notes by Pietro Scarpellini. Rome: G. Casini, 1987.

Cennini 1933
Cennini, Cennino. *The Craftsman's Handbook, The Italian "Il libro del'arte."* Edited by Daniel V. Thompson, Jr. New York: Dover, 1933.

Cerretani 1993
Cerretani, Bartolomeo. *Ricordi.* Edited by Giuliana Berti. Florence: Leo S. Olschki, 1993.

Cerretani 1994
Cerretani, Bartolomeo. *Storia fiorentina.* Edited by Giuliana Berti. Florence: Leo S. Olschki, 1994.

Christiansen 1990
Christiansen, Keith. "Letters: Leonardo's Drapery Studies." *The Burlington Magazine* 132 (1990).

Cianchi 1964
Cianchi, Renzo. "Figure nuove del mondo vinciano: Paolo e Vannoccio Biringuccio da Siena." *Raccolta Vinciana,* fasc. XX (1964).

Clark 1968
Clark, Kenneth. *The Drawings of Leonardo da Vinci in the Collection of Her Majesty the Queen at Windsor Castle.* 2nd ed., revised by Carlo Pedretti. London: Phaidon, 1968.

Clark 1969
Clark, Kenneth. "Leonardo and the Antique." In *Leonardo's Legacy, An International Symposium,* edited by C. D. O'Malley. Berkeley and Los Angeles: University of California Press, 1969.

Clayton 1996
Clayton, Martin. *Leonardo da Vinci, A Singular Vision.* New York, London, and Paris: Abbeville Press, 1996.

Coonin 1991
Coonin, Victor. "New Documents Concerning Perugino's Workshop in Florence." *The Burlington Magazine* 141 (1991).

Covi 1966
Covi, Dario A. "New Documents Concerning Andrea del Verrocchio." *The Art Bulletin* 48 (1966).

Covi 1995
Covi, Dario. "The Italian Renaissance and the Equestrian Monument." In Ahl 1995.

Cunnally 1993
Cunnally, John. "Numismatic Sources for Leonardo's Equestrian Monuments." *Achademia Leonardi Vinci, Journal of Leonardo Studies & Bibliography of Vinciana* 6 (1993).

Dalli Regoli 2006
Dalli Regoli, Gigetta. "Eros e natura: Leda e il cigno." In *La mente* 2006.

Davis 1995
Davis, Charles. "I bassorilievi fiorentini di Giovanfrancesco Rustici. Esercizi di lettura." *Mitteilungen des Kunsthistorischen Institutes in Florenz* 35 (1995).

Del Piazzo 1956
Del Piazzo, Marcello. *Protocolli del carteggio di Lorenzo il Magnifico per gli anni 1473–1474.* Florence: Leo S. Olschki, 1956.

De Marchi 1599
De Marchi, Francesco. *Della architettura.* Brescia: Comino Presegni ad instanza di Gasparo dall'Oglio, 1599.

De Tolnay 1957
De Tolnay, Charles. *Michelangelo: The Tomb of Julius II.* Princeton, New Jersey: Princeton University Press, 1957.

Dizionario 1960–2006
*Dizionario biografico degli Italiani.* 66 vols. Rome: Instituto della Enciclopedia Italiana, 1960–2006.

Dolcini 1988
Dolcini, Loretta. *Donatello e il restauro della Giuditta.* Florence: Centro Di, 1988.

Dragstra 1997
Dragstra, Rolf. "The Vitruvian Proportions for Leonardo's Construction of the *Last Supper.*" *Raccolta Vinciana,* fasc. XXVII (1997).

Draper 1992
Draper, James David. *Bertoldo di Giovanni, Sculptor of the Medici Household, Critical Reappraisal and Catalogue Raisonné.* Columbia, Missouri, and London: University of Missouri Press, 1992.

Du Chesne 1624
Du Chesne, André. *Histoire généalogique de la maison de Montmorency et de Laval. Iustifiée par chartes, tiltres, arrests et autres bonnes & certaines preuves. Enrichie de plusieurs figures, & divisée en XII livres.* Paris: Sébastien Cramoisy, 1624.

Elam "Il Giardino" 1992
Elam, Caroline. "Il Giardino delle sculture di Lorenzo de' Medici." In *Il giardino* 1991.

Elam "Lorenzo" 1992
Elam, Caroline. "Lorenzo de' Medici's Sculpture Garden." *Mitteilungen des Kunsthistorischen Institutes in Florenz* 36 (1992).

Eredità 1992
*Eredità del Magnifico 1492–1992.* Edited by Giovanna Gaeta Bertelà, Beatrice Paolozzi Strozzi, and Marco Spallanzani. Florence: Museo Nazionale del Bargello, in association with Studio per Edizioni Scelte (S.P.E.S.), 1992. An exhibition catalogue.

Farago 1992
Farago, Claire. *Leonardo da Vinci's Paragone.* Leiden, The Netherlands: Brill, 1992.

Favaro 1918
Favaro, Antonio. *Plinio e Leonardo.* Bergamo: Istituto Italiano Arti Grafiche, 1918.

Ferretti 2006
Ferretti, Emanuela. "Giambologna architetto." In *Giambologna* 2006.

Ferretti 2009
Ferretti, Emanuela. "La Sapienza di Niccolò da Uzzano: l'istituzione e le sue tracce architettoniche nella Firenze rinascimentale." Preprint, *Annali di Storia di Firenze* 4 (2009). http://www.eprints.unifi.it/archive/00001660/01/FerrettiPreprint.pdf.

Field 1988
Field, J. V. *Kepler's Geometrical Cosmology.* Chicago: University of Chicago Press, 1988.

Filarete 1972
Filarete, [Antonio Averlino]. *Trattato di architettura.* Edited and introduced by Lilian Grassi and Anna Maria Finoli. 2 vols. Milan: Edizioni il Polifilo, 1972.

Firenze e gli antichi 2008
*Firenze e gli antichi paesi Bassi 1430–1530 dialoghi tra artisti: da Jan van Eyck a Ghirlandaio, da Memling a Raffaello.* Edited by Bert W. Meijer. Florence: Palazzo Pitti, Galleria Palatina, in association with Sillabe, 2008. An exhibition catalogue.

Formigli 1992
Formigli, Edilberto. "La grande testa di cavallo in bronzo detta *Carafa*: Un'indagine tecnologica." *Bollettino d'arte* 71 (1992).

Formigli *I grandi Bronzi* 1999
Formigli, Edilberto. *I grandi Bronzi antichi. Le fonderie e le tecniche di lavorazione dall'età arcaica al Rinascimento. Atti dei seminari di studi ed esperimenti, 24 March–30 July 1993, and 1–7 July 1995.* Siena: Nuova Immagine Editrice, 1999.

Formigli "Le antiche terre" 1999
Formigli, Edilberto. "Le antiche terre di fusione, i problemi di formatura dei grandi bronzi e la tecnica di fusione dei Bronzi di Riace." In Formigli *I grandi Bronzi* 1999.

Franklin 2005
Franklin, David, ed. *Leonardo da Vinci, Michelangelo, and the Renaissance in Florence.* Ottawa: National Gallery of Canada, in association with Yale University Press, 2005. An exhibition catalogue.

Fusco 1982
Fusco, Laurie. "The Use of Sculptural Models by Painters in Fifteenth-Century Italy." *The Art Bulletin* 64 (1982).

Fusco and Corti 1992
Fusco, Laurie, and Gino Corti. "Lorenzo de' Medici on the Sforza Monument." *Achademia Leonardi Vinci: Journal of Leonardo Studies and Bibliography of Vinciana* 5 (1992).

Fusco and Corti 2006
Fusco, Laurie, and Gino Corti. *Lorenzo de' Medici: Collector and Antiquarian.* New York: Cambridge University Press, 2006.

Galluzzi 1991
Galluzzi, Paolo, ed. *Prima di Leonardo: Cultura delle macchine a Siena nel Rinascimento.* Siena: University of Siena, in association with Electa, 1991.

Garai 2007
Garai, Luca. *Gli automi di Leonardo / Leonardo's Automata*. Bologna: Bononia University Press, 2007.

Gatti 1994
Gatti, Luca. "'Delle cose de' pictori et sculptori si può mal promettere cosa certa': la diplomazia fiorentina presso la corte del re di Francia e il 'Davide' bronzeo di Michelangelo Buonarroti." *Mélanges de l'École Française de Rome: Italie et Méditerranée* 105, no. 2 (1994).

Gaurico 1504
Gaurico, Pomponio. *De sculptura*. Florence: Filippo Giunta?, 1504.

Gaurico 1999
Gaurico, Pomponio. *De sculptura*. Edited and translated by Paolo Cutolo. Naples: Edizioni Scientifiche Italiane, 1999.

Gentilini 1992
Gentilini, Giancarlo. *I Della Robbia: La scultura invetriata nel Rinascimento*. 2 vols. Florence: Cantini, 1992.

Giambologna 2006
*Giambologna: Gli Dei, Gli Eroi*. Edited by Beatrice Paolozzi Strozzi and Dimitrios Zikos. Florence: Museo Nazionale del Bargello, in association with Giunti Editore, 2006. An exhibition catalogue.

Giovinezza 1999
*Giovinezza di Michelangelo*. Edited by Kathleen Weil-Garris Brandt, Cristina Acidini Luchinat, David James Draper, and Nicholas Penny. Florence: Casa Buonarroti, in association with ArtificioSkira, 1999. An exhibition catalogue.

Gould 1973
Gould, Cecil. "Federigo da Montefeltro's Patronage of the Arts." *Journal of the Warburg and Courtauld Institutes* 36 (1973).

Gould 1978
Gould, Cecil. "Federigo da Montefeltro's Artistic Patronage." *Journal of the Royal Society of Arts* 126 (1978).

Grierson 1959
Grierson, Philip. "Ercole d'Este and Leonardo da Vinci Equestrian Statue of Francesco Sforza." *Italian Studies* 14 (1959).

Heilmeyer 1999
Heilmeyer, W. D. "Osservazioni tecniche su grandi bronzi romani." In Formigli *I grandi Bronzi* 1999.

Herzfeld 1926–1929
Herzfeld, Marie. "Zur Geschichte des Sforzadenkmals." *Raccolta Vinciana*, fasc. XII (1926–1929).

Heydenreich 1929
Heydenreich, Ludwig H. *Die Sakralbau-Studien Leonardo da Vinci's*. Engelsdorf and Leipzig: Vogel, 1929.

Heydenreich 1949
Heydenreich, Ludwig H., ed. *I disegni di Leonardo da Vinci e della sua scuola, conservati nella Galleria dell'Accademia di Venezia*. Florence: Lange, Domsch and Co., 1949.

Hill 1910
Hill, G. F. "Notes on Italian Medals-X." *The Burlington Magazine* 18 (1910).

Hirst 2000
Hirst, Michael. "Michelangelo in Florence: *David* in 1503 and *Hercules* in 1506." *The Burlington Magazine* 142 (2000).

Hykin 2007
Hykin, Abigail. "The Conservation and Analysis of a Glazed Terracotta Figure of St. John the Baptist Attributed to Giovanni Francesco Rustici." In *Riconoscere un patrimonio, 2. La statua e la sua pelle: artifici tecnici nella scultura dipinta tra Rinascimento e Barocco*, edited by Raffaele Casciaro. Galatina: Congedo, 2007.

Il giardino 1991
*Il giardino di San Marco: Maestri e compagni del giovane Michelangelo*. Edited by Paola Barocchi. Florence: Casa Buonarroti, in association with Silvana Editoriale, 1991. An exhibition catalogue.

In the Light 2004
*In the Light of Apollo: Italian Renaissance and Greece*. Edited by Mina Gregori. Vol. 1. Athens: National Gallery of Art and Alexandros Souzos Museum, in association with Silvana Editoriale, 2004. An exhibition catalogue.

Janson 1963
Janson, H. W. *The Sculpture of Donatello*. Princeton, New Jersey: Princeton University Press, 1963.

Keele and Pedretti 1978–1980
Keele, Kenneth, and Carlo Pedretti. *Corpus of Anatomical Studies in the Collection of Her Majesty the Queen at Windsor Castle*. 3 vols. London and New York: Johnson Reprint Corporation, 1978–1980.

Kemp "Geometrical Bodies" 1989
Kemp, Martin. "Geometrical Bodies as Exemplary Forms in Renaissance Space." In *World Art: Themes of Unity in Diversity*, edited by Irving Lavin. 3 vols. Acts of the 26th International Congress for the History of Art, held in Washington, D.C., 1986. University Park, Pennsylvania, and London: Pennsylvania State University Press, 1989.

Kemp *Leonardo on Painting* 1989
Kemp, Martin, ed. *Leonardo on Painting. An Anthology of Writings by Leonardo da Vinci with a Selection of Documents Relating to His Career as an Artist*. Translated by Martin Kemp and Margaret Walker. New Haven: Yale University Press, 1989.

Kemp 1991
Kemp, Martin. "Cristo fanciullo." *Achademia Leonardi Vinci: Journal of Leonardo Studies and Bibliography of Vinciana* 4 (1991).

Kemp 1992
Kemp, Martin. *The Science of Art: Optical Themes in Western Art from Brunelleschi to Seurat*. London and New Haven: Yale University Press, 1992.

Kemp 1999
Kemp, Martin. "Leonardo e lo spazio dello scultore." *Lettura Vinciana XXVII* (Vinci, 1987). Florence: Giunti Barbèra, 1988. Translated as "Leonardo and the Space of the Sculptor." In *An Overview of Leonardo's Career and Projects until c. 1500*, edited by Claire Farago. New York and London: Garland, 1999.

Kemp *Leonardo* 2006
Kemp, Martin. *Leonardo, nella mente del genio*. Turin: Einaudi, 2006.

Kemp *The Marvellous Works* 2006
Kemp, Martin. *Leonardo da Vinci: The Marvellous Works of Nature and Man*. Revised ed. New York: Oxford University Press, 2006.

Kemp and Smart 1980
Kemp, Martin, and Alastair Smart. "Leonardo's *Leda* and the Belvedere *River-Gods*, Roman Sources and a New Chronology." *Art History* 3 (1980).

Kepler 1596–1597
Kepler, Johannes. *Mysterium Cosmographicum*. Tübingen: Georg Gruppenbach, 1596–1597.

Kirwin and Rush 1995
Kirwin, W. Chandler, and Peter G. Rush. "The Bubble Reputation: In the Cannon's and the Horse's Mouth (or The Tale of Three Horses)." In Ahl 1995.

Krautheimer 1982
Krautheimer, Richard. *Lorenzo Ghiberti*. Princeton, New Jersey: Princeton University Press, 1982.

Krautheimer-Hess 1964
Krautheimer-Hess, Trude. "More Ghibertiana." *The Art Bulletin* 46 (1964).

Kwakkelstein 1994
Kwakkelstein, Michael W. *Leonardo da Vinci as a Physiognomist, Theory and Drawing Practice*. Leiden, The Netherlands: Primavera Press, 1994.

Kwakkelstein 1999
Kwakkelstein, Michael W., trans. "The Use of Sculptural Models by Italian Renaissance Painters: Leonardo da Vinci's *Madonna of the Rocks* Reconsidered in Light of His Working Procedures." *Gazette des Beaux-Arts* 6, 133 (1999).

La mente 2006
*La mente di Leonardo, Al tempo della "Battaglia di Anghiari."* Edited by Carlo Pedretti. 2 vols. Florence: Gabinetto Disegno e Stampe degli Uffizi, in association with Giunti, 2006. An exhibition catalogue.

Landucci 1883
Landucci, Luca. *Diario Fiorentino dal 1450 al 1516*. Edited by Iodoco Del Badia. Florence: Sansoni, 1883.

Laurenza 1997
Laurenza, Domenico. "*Corpus mobile*: Tracce di patognomica in Leonardo." *Raccolta Vinciana*, fasc. XXVII (1997).

Laurenza 2001
Laurenza, Domenico. *De figura umana: Fisiogno-
mica, anatomia e arte in Leonardo*. Florence: Leo S.
Olschki, 2001.

Laurenza 2006
Laurenza, Domenico. "La figura erculea tra anato-
mia e fisiognomica." In *La mente 2006*.

Lein 1999
Lein, Edgar. "Il problema della fusione in un getto
o in parti separate dei bronzi del Rinascimento
italiano." In Formigli *I grandi Bronzi 1999*.

*Leonardo da Vinci 2001*
*Leonardo da Vinci e il modello di Leda: Modelli,
memorie e metamorfosi di un'invenzione*. Edited by
Gigetta Dalli Regoli, Romano Nanni, and Antonio
Natali. Vinci: Palazzina Uziella del Museo Leo-
nardiano, in association with Silvana Editoriale,
2001. An exhibition catalogue.

*Leonardo da Vinci 2003*
*Leonardo da Vinci: Master Draftsman*. Edited by
Carmen C. Bambach. New York: The Metro-
politan Museum of Art, in association with Yale
University Press, 2003. An exhibition catalogue.

*Leonardo da Vinci 2005*
*Leonardo da Vinci, Michelangelo, and the Renais-
sance in Florence*. Edited by David Franklin.
Ottawa: National Gallery of Canada, in associa-
tion with Yale University Press, 2005. An exhibi-
tion catalogue.

*Leonardo da Vinci 2006*
*Leonardo da Vinci: Experience, Experiment and
Design*. Edited by Martin Kemp. London: Victoria
and Albert Museum, in association with Princeton
University Press, 2006. An exhibition catalogue.

*Leonardo e il leonardismo 1983*
*Leonardo e il leonardismo a Napoli e a Roma*. Edited
by Alessandro Vezzosi. Naples and Rome: Museo
Nazionale di Capodimonte and Palazzo Venezia,
in association with Giunti Barbèra, 1983. An
exhibition catalogue.

Leoni 1992
Leoni, Massimo. "La tecnica di fonderia ai tempi
del Verrocchio." In *Verrocchio and Late Quattro-
cento Italian Sculpture*, edited by Steven Bule,
Alan Phipps Darr, and Fiorella Superbi Gioffredi.
Florence: Casa Editrice, 1992.

Lewis 1969
Lewis, Suzanne. "Function and Symbolic Form in
the Basilica Apostolorum at Milan." *The Journal of
the Society of Architectural Historians* 28 (1969).

*Libro di pittura 1995*
*Leonardo da Vinci: Libro di pittura. Codice Urbinate
lat. 1270 nella Biblioteca Apostolica Vaticana*. Edited
by Carlo Pedretti. Critical transcription by Carlo
Vecce. 2 vols. Florence: Giunti, 1995.

Lomazzo 1584
Lomazzo, Gian Paolo. *Trattato dell'arte della
pittura, scultura et architettura*. 7 vols. Milan: Paolo
Gottardo Pontio, 1584.

Lomazzo 1957
Lomazzo, Gian Paolo. *Trattato dell'arte de la pit-
tura*. In Pedretti 1957.

Lopez 1982
Lopez, Guido. *Leonardo e Ludovico il Moro: la roba
e la libertà*. Milan: Mursia, 1982.

Lotti 1929
Lotti, Antonio?. "Ludovico di Gulielmo del
Buono." In *Allgemeines Lexikon der Bildenden
Künstler von der Antike bis zur Gegenwart*, edited
by Ulrich Thieme and Felix Becker. Vol. 23.
Leipzig: Seemann?, 1929.

Luchs 2007
Luchs, Alison. "The *Bambini*." In *Desiderio da
Settignano, Sculptor of Renaissance Florence*, edited
by Marc Bormond, Beatrice Paolozzi Strozzi,
and Nicholas Penny. Washington, D.C.: National
Gallery of Art, in association with 5 Continents
Editions, 2007. An exhibition catalogue.

Luzzati 2000
Luzzati, Michele. *Una guerra di popolo: La seconda
libertà di Pisa (1494–1509)*. Pisa: Pacini, 2000.

MacCurdy 2003
MacCurdy, Edward, ed. *The Notebooks of Leonardo
da Vinci (Definitive Edition in One Volume)*. 1938.
Reprint. Old Saybrook, Connecticut: Konecky
and Konecky, 2003.

*Madrid Codices 1974*
*Leonardo da Vinci: The Madrid Codices*. Edited
and translated with commentary by Ladislao Reti.
New York: McGraw Hill, 1974.

Maffei 1999
Maffei, Sonia, ed. *Paolo Giovio: Scritti d'arte:
Lessico ed ecfrasi*. Pisa: Scuola Normale Superiore,
1999.

Marani 1984
Marani, Pietro C. *L'Architettura fortificata negli
studi di Leonardo da Vinci: con il catalogo completo
dei disegni*. Florence: Leo S. Olschki, 1984.

Marani 1994
Marani, Pietro C. "Leonardo e Leon Battista
Alberti." In *Leon Battista Alberti*, edited by Joseph
Rykwert and Anne Engel. Mantua: Palazzo Tè,
in association with Electa, 1994. An exhibition
catalogue.

Marani 1995
Marani, Pietro C. "The 'Hammer Lecture' (1994):
Tivoli, Hadrian and Antinoüs, New Evidence of
Leonardo's Relation to the Antique." *Achademia
Leonardi Vinci, Journal of Leonardo Studies &
Bibliogrpahy of Vinciana* 8 (1995).

Marani 1999
Marani, Pietro C. *Leonardo: Una carriera di pittore*.
Milan: Motta Editore, 1999. Translated as *Leo-
nardo da Vinci: The Complete Paintings* (New York:
Harry N. Abrams, 2000).

Marani 2001
Marani, Pietro C. "Leonardo e gli scultori. Un
altro esempio di collaborazione col Rustici?"
*Raccolta Vinciana*, fasc. XXIX (2001).

Marani 2003
Marani, Pietro C. "Per Leonardo scultore: nuove
ipotesi sul bronzo di Budapest, il Monumento
Trivulzio e il Rustici." *Arte lombarda* 139 (2003).

Marani 2004
Marani, Pietro C. "'*Imita quanto puoi li Greci e
Latini*': Leonardo da Vinci and the Antique."
In *In the Light 2004*.

Marani "Leonardo, l'Antico" 2007
Marani, Pietro C. "Leonardo, l'Antico, il rilievo e
le proporzioni del'Uomo e del Cavallo." In Marani
and Fiorio 2007.

Marani *I disegni di Leonardo* 2008
Marani, Pietro C. *I disegni di Leonardo da Vinci e
della sua cerchia nelle collezioni pubbliche in Francia*.
Florence: Giunti Editore, 2008.

Marani and Fiorio 2007
Marani, Pietro C., and Maria Teresa Fiorio. *Leo-
nardo: Dagli studi di proporzioni al Trattato della
pittura*. Milan: Electa, 2007.

Marinoni 1961
Marinoni, Augusto. "L'essere del nulla." *I Lettura
Vinciana* (Vinci, 1960). Florence: Giunti Edito-
riale, 1961. Reprinted in *Leonardo da Vinci letto
e commentato*. In *Lettura Vinciana I–XII*, edited
by Paolo Galluzzi (1960–1972). Florence: Giunti
Barbèra, 1974.

Meller 1916
Meller, Simon. "Die Reiterdarstellungen Leo-
nardos und die Budapesten Bronzestatuette."
*Jahrbuch der Königlich Preuszischen Kunstsamm-
lungen* 37 (1916).

Meller 1934
Meller, Simon. "I Progetti di Antonio Pollaiuolo
per la Statua Equestre di Francesco Sforza." In
*Hommage à Alexis Petrovics*. Budapest: Kiadják az
Országos Magyar Szépművészeti Múzeum, 1934.

Meller 1983
Meller, Peter. "Quello che Leonardo non ha scritto
sulla figura umana: Dall'uomo di Vitruvio alla
Leda." *Arte Lombarda* 67 (1983).

Milanesi 1873
Milanesi, Gaetano. *Scritti vari sulla Storia dell'arte
toscana*. Siena: Lazzeri, 1873.

*The Mind of Leonardo 2006*
*The Mind of Leonardo, The Universal Genius
at Work*. Edited by Paolo Galluzzi. Florence:
Museum of History and Science, in association
with Giunti, 2006. An exhibition catalogue.

Minning 2005
Minning, Martina. "Zu Begräbniszeremoniell und
Grabmal des Fürsten Alberto III. Pio da Carpi."
In *Praemium Virtutis II: Grabmäler und Begräbnis-
zeremoniell in der italienischen Hoch- und Spät-
renaissance*, edited by Joachim Poeschke, Britta
Kusch-Arnold, and Thomas Weigel. Münster:
Rhema, 2005.

Minning 2007
Minning, Martina. "Le projet de monument équestre en l'honneur de François Ier du sculpteur florentin Giovan Francesco Rustici." *Cahiers du château et des musées de Blois* 37 (2007).

Minning 2009
Minning, Martina. *Forschungen zu Leben und Werk des Florentiner Bildhauers Giovan Francesco Rustici (1475–1554).* Münster: Rhema, 2009.

Morscheck 1978
Morscheck, Charles R. *Relief Sculpture for the Façade of the Certosa di Pavia, 1473–1499.* New York and London: Garland, 1978.

Mozzati 2003
Mozzati, Tommaso. "'Fece . . . una Nostra Donna col Figlio in collo': tradizione e maniera moderna nelle Vergini con Bambino di Giovanfrancesco Rustici. I." *Nuovi Studi* 10 (2003).

Mozzati "Fece una Nostra Donna" 2005
Mozzati, Tommaso. "'Fece . . . una Nostra Donna col Figlio in collo': tradizione e maniera moderna nelle Vergini con Bambino di Giovanfrancesco Rustici. II." *Nuovi Studi* 11 (2005).

Mozzati "L'educazione" 2005
Mozzati, Tommaso. "L'educazione musicale di Benvenuto Cellini." *Mitteilungen des Kunsthistorisches Institutes* 50 (2005).

Mozzati "Notizia" 2005
Mozzati, Tommaso. "Notizia biografica." In Mozzati "Il fuoco" 2005.

Mozzati 2007
Mozzati, Tommaso. "Il fuoco e l'alchimista: Giovanfrancesco Rustici e la pratica del bronzo." *Proporzioni,* n.s., 6, 2005 (2007).

Mozzati 2008
Mozzati, Tommaso. *Giovanfrancesco Rustici, le Compagnie del Paiuolo e della Cazzuola.* Florence: Leo S. Olschki, 2008.

Negri Arnoldi 1999
Negri Arnoldi, Francesco. *Pomponio Gaurico e gli scultori illustri.* In Gaurico 1999.

Nepi Scirè and Torrini 2003
Nepi Scirè, Giovanna, and Annalisa Perissa Torrini, eds. *I disegni di Leonardo da Vinci e della sua cerchia nelle Gallerie dell'Accademia di Venezia.* Ordered and presented by Carlo Pedretti. Florence: Giunti Editore, 2003.

Nobili 1994
Nobili, Luigi. *Il convento di Santa Maria Novella in Firenze, sede della Scuola Sottufficiali Carabinei.* Milan: Electa, 1994.

Norris 1977
Norris, Andrea S. *The Tomb of Gian Galeazzo Visconti at the Certosa di Pavia.* PhD diss., New York University, 1977.

Paatz 1940–1954
Paatz, Walter and Elizabeth. *Die Kirchen von Florenz: Ein Kunstgeschichtliches Handbuch.* 4 vols. Frankfurt am Main: Klostermann, 1940–1954.

Pacioli 1509
Pacioli [da Borgo San Sepoloro], Fra Luca. *De divina proportione. Opera a tutti glingegni perspi caci e curiosi necessaria One cia scun studioso di Philosophia: Prospectiua Pittura Sculptura: Architectura: Musica: e altre Mathematice: sua uissima: sottile: e admirabile doctrina consequira: e de lectarassi co varie questione de secretissima scienta.* Venice: Paganino di Paganini, 1509.

Panofsky 1940
Panofsky, Erwin. *The Codex Huygens and Leonardo da Vinci's Art Theory: The Pierpont Morgan Library Codex M. A. 1139.* London: Warburg Institute, 1940.

Panofsky 1964
Panofsky, Erwin. *Tomb Sculpture: Four Lectures on Its Changing Aspects from Ancient Egypt to Bernini.* New York: Harry N. Abrams, 1964.

Panofsky 1996
Panofsky, Erwin. *Codex Huygens et Théorie de l'Art de Léonard da Vinci.* Paris: Flammarion, 1996.

Parenti 2005
Parenti, Piero. *Storia fiorentina.* Edited by Andrea Matucci. Florence: Leo S. Olschki, 2005.

Parronchi 1989
Parronchi, Alessandro. "Nuove proposte per Leonardo scultore." *Achademia Leonardi Vinci, Journal of Leonardo Studies & Bibliography of Vinciana* 2 (1989).

Parronchi 2005
Parronchi, Alessandro. *Proposte per Leonardo scultore.* Milan: Medusa, 2005.

Passavant 1966
Passavant, Günter. "Beobachtungen am Silberaltar des Florentiner Baptisteriums." *Pantheon* 24 (1966).

Passavant 1969
Passavant, Günter. *Verrocchio Sculptures, Paintings and Drawings.* London: Phaidon, 1969.

Passerini 1861
Passerini, Luigi, ed. *Genealogia e storia della famiglia Rucellai, descritta da Luigi Passerini.* Florence: Coi tipi di M. Cellini, 1861.

Pedretti 1954
Pedretti, Carlo. "La macchina idraulica di Leonardo per conto di Bernardo Rucellai e i primi contatori d'acqua." *Raccolta Vinciana,* fasc. XVII (1954).

Pedretti 1957
Pedretti, Carlo. *Studi Vinciani: Documenti, analisi e inediti leonardeschi.* Geneva: E. Droz, 1957.

Pedretti 1962
Pedretti, Carlo. *A Chronology of Leonardo da Vinci's Architectural Studies after 1500.* Geneva: E. Droz, 1962.

Pedretti 1977
Pedretti, Carlo. *The Literary Works of Leonardo da Vinci, Compiled and Edited from the Original Manuscripts by Jean Paul Richter: Commentary.* 2 vols. Berkeley and Los Angeles: University of California Press, 1977.

Pedretti 1978
Pedretti, Carlo. "Leonardo a Venezia." In *Giorgione 1478. 1978. Guida alla mostre: I tempi di Giorgione,* edited by Paolo Carpeggiani. Florence: Alinari, 1978.

Pedretti "Studi di proporzioni" 1983
Pedretti, Carlo. "Studi di proporzioni." In *Leonardo da Vinci. Corpus degli studi anatomici nella Collezione di Sua Maestà la Regina d'Inghilterra nel Castello di Windsor,* edited by Kenneth D. Keele and Carlo Pedretti. Vol. 2. Florence: Giunti Editore, 1983.

Pedretti *I cavalli* 1984
Pedretti, Carlo. *I cavalli di Leonardo, Studi sul cavallo e altri animali di Leonardo da Vinci dalla Biblioteca Reale nel Castello di Windsor.* Florence: Giunti Barbèra, 1984.

Pedretti "Il linguaggio delle mani" 1984
Pedretti, Carlo. "Il linguaggio delle mani." In *La Madonna Benois di Leonardo da Vinci a Firenze: Il capolavoro dell'Ermitage in mostra agli Uffizi,* edited by Luciano Berti. Florence: Galleria degli Uffizi, in association with Giunti Barbèra, 1984. An exhibition catalogue.

Pedretti 1988
Pedretti, Carlo. "Leonardo da Vinci architetto militare prima di Gradisca." In *L'architettura militare veneta del Cinquecento.* Milan: Electa, 1988.

Pedretti "A Proem" 1989
Pedretti, Carlo. "A Proem to Sculpture." *Achademia Leonardi Vinci. Journal of Leonardo Studies and Bibliography of Vinciana* 2 (1989).

Pedretti "Leonardo as a Sculptor" 1989
Pedretti, Carlo. "Leonardo as a Sculptor: A Bibliography." *Achademia Leonardi Vinci: Journal of Leonardo Studies and Bibliography of Vinciana* 2 (1989).

Pedretti 1991
Pedretti, Carlo. "Leonardo and the Antique: A Bibliography." *Achademia Leonardi Vinci: Journal of Leonardo Studies and Bibliography of Vinciana* 4 (1991).

Pedretti 1992
Pedretti, Carlo. "Il disegno strumento di conoscenza." *Art e Dossier* 7, no. 67 (1992).

Pedretti 1995
Pedretti, Carlo. "The Sforza Horse in Context." In Ahl 1995.

Pedretti 2003
Pedretti, Carlo. *L'Anatomia di Leonardo da Vinci fra Mondino e Berengario.* Florence: Cartei & Becagli Editori, 2003.

Pedretti and Keele 1980–1984
Pedretti, Carlo, and Kenneth D. Keele, eds. *Leonardo da Vinci. Corpus degli studi anatomici nella Collezione di Sua Maestà la Regina d'Inghilterra nel Castello di Windsor.* 3 vols. Florence: Giunti Editore, 1980–1984. First published 1978–1980 by Johnson Reprint Company, Ltd., with a different order of the three volumes. In the original edition, the facsimile volume is third; in the Italian edition, it is first.

Pedretti and Roberts 1977
Pedretti, Carlo, and Jane Roberts. "Drawings by Leonardo da Vinci at Windsor Newly Revealed by Ultra-Violet Light." *The Burlington Magazine* 119 (1977).

Pieri 1952
Pieri, Piero. *Il rinascimento e la crisi militare italiana.* Turin: Einaudi, 1952.

Pliny 1534
Pliny. *Historia naturale di C. Plinio Secondo di latino in volgare tradotta per Christophoro Landino.* Venice: Thomaso de Ternengo ditto Balarino, 1534.

Pliny 1982–1988
Pliny. *Storia naturale.* Edited by Gian Biago Conte, in collaboration with Alessandro Barchiesi and Giuliano Ranucci. 5 vols. Turin: Einaudi, 1982–1988.

Poggi 1909
Poggi, Giovanni. *Il Duomo di Firenze: documenti sulla decorazione della chiesa e del campanile, tratti dall'archivio dell'opera.* 2 vols. Berlin: Cassirer, 1909. Reprint edited by Margaret Haines. Florence: Edizioni Medicea, 1988. Page references are to the 1909 edition.

Poggi, Barocchi, and Ristori 1965–1983
Poggi, Giovanni, Paola Barocchi, and Renzo Ristori, eds. *Il carteggio di Michelangelo.* 5 vols. Florence: Sansoni, 1965–1983.

Polich 1995
Polich, Richard. "Engineering and Casting an Eighty-Ton Horse to Stand on Two Legs." In Ahl 1995.

Polk 1986
Polk, Keith. "Civic Patronage and Instrumental Ensembles in Renaissance Florence." *Augsburger Jahrbuch für Musikwissenschaft* 3 (1986).

Radcliffe 1992
Radcliffe, Anthony. "New Light on Verrocchio's *Beheading of the Baptist.*" In *Verrocchio and Late Quattrocento Italian Sculpture*, edited by Steven Bule. Florence: Le Lettere, 1992.

Radke 2003
Radke, Gary M. "Verrocchio and the Image of the Youthful David in Florentine Art." In *Verrocchio's David* 2003.

Reti 1974
Reti, Ladislao, ed. *The Unknown Leonardo.* New York: McGraw-Hill, 1974.

*Renaissance and Baroque Bronzes* 2002
*Renaissance and Baroque Bronzes from the Fitzwilliam Museum Cambridge.* Edited by Victoria Avery and Jo Dillon. London: Daniel Katz Ltd., in association with Gli Ori, 2002. An exhibition catalogue.

Richter 1883
Richter, Jean Paul. *The Literary Works of Leonardo da Vinci Compiled and Edited from the Original Manuscripts.* 2 vols. London: Low, 1883.

*Rime del arguto* 1493
*Rime del arguto et faceto poeta Bernardo Belinzone fiorentino.* Florence: 1493.

Robertson 2002
Robertson, Charles. "Bramante and Gian Giacomo Trivulzio." In *Bramante Milanese*, edited by Christoph L. Frommel, Luisa Giardino, and Richard Schofield. Venice: Marsilio, 2002.

Robertson 2003
Robertson, Charles. "The Patronage of Gian Giacomo Trivulzio during the French Domination of Milan." In *Louis XII en Milanais*, edited by Philippe Contamine and Jean Guillaume. Paris: Honoré Champion, 2003.

Rohlmann 2008
Rohlmann, Michael. "Andrea del Verrocchio, *Resurrezione di Cristo.*" In *Firenze e gli antichi* 2008.

Ronen 1992
Ronen, Avraham. "Iscrizioni ebraiche nell'arte italiana del Quattrocento." In *Studi di storia dell'arte sul Medioevo e il Rinascimento nel centenario della nascita di Mario Salmi*, Atti del Convegno Internazionale, vol. 2., Arezzo-Florence 1989. Florence: Edizioni Polistampa, 1992.

Rosmini 1815
Rosmini, Carlo. *Dell'istoria intorno alle militari imprese e alla vita di Gian-Jacopo Trivulzio, detto il Magno.* Vol. 2. Milan: Gio. Giuseppe Destefanis, 1815.

Sanudo 1883
Sanudo, Marin. *La spedizione di Carlo VIII in Italia/raccontata da Marin Sanudo.* Edited by Rinaldo Fulin. Venice: Tip. del Commercio di M. Visentini, 1883.

Schofield 1991
Schofield, Richard. "Leonardo's Milanese Architecture: Career, Sources, and Graphic Techniques." *Achademia Leonardo Vinci: Journal of Leonardo Studies and Bibliography of Vinciana* 4 (1990).

Schofield 1992
Schofield, Richard. "Avoiding Rome: An Introduction to Lombard Sculptors and the Antique." *Arte lombarda* 100, no. 1 (1992).

Schofield and Burnett 1997
Schofield, Richard, and Andrew Burnett. "The Medallions of the Basamento of the Certosa di Pavia. Sources and Influence." *Arte Lombarda* 120, no. 2 (1997).

Sciolla 1996
Sciolla, Gianni Carlo. "Leonardo e Pavia." *Lettura Vinciana XXXV* (Vinci, 1996). Florence: Giunti Barbèra, 1996.

Sénéchal 2004
Sénéchal, Philippe. "Il monumento funebre di Alberto Pio al Louvre." In *Alberto III e Rodolfo Pio collezionisti e mecenati. Atti del seminario internazionale di Studi (Carpi, Palazzo Pio, 22–23 novembre 2002)*, edited by Manuela Rossi. Carpi: Comune di Carpi—Museo Civico, 2004.

Sénéchal 2007
Sénéchal, Philippe. *Giovan Francesco Rustici 1475–1554: Un sculpteur de la Renaissance entre Florence et Paris.* Paris: Arthena, 2007.

Sénéchal 2008
Sénéchal, Philippe. "Il monumento funebre del Louvre." In *L'immagine del principe. I ritratti di Alberto III nel Palazzo dei Pio a Carpi*, edited by Manuela Rossi. Carpi: Città di Carpi / Fondazione Cassa di Risparmio di Carpi, 2008.

Settis, Farinella, and Agosti 1987
Settis, Salvatore, Vincenzo Farinella, and Giovanni Agosti. "Passione e gusto per l'Antico nei pittori italiani del Quattrocento." In *La pittura in Italia: Il Quattrocento*, edited by Federico Zeri. Book 2. Milan: Electa, 1987.

Sinisgalli 2003
Sinisgalli, Rocco. "La sezione aurea nell'Uomo Vitruviano di Leonardo." In Nepi Scirè and Torrini 2003.

Spencer 1973
Spencer, John. "Il progetto per il cavallo di bronzo per Francesco Sforza." *Arte lombarda* 38–39 (1973).

*Splendour of the Medici* 2008
*The Splendour of the Medici, Art and Life in Renaissance Florence.* Edited by Monica Bietti, Annamaria Giusti, and Maria Sframeli. Budapest: Szépművészeti Múzeum, 2008. An exhibition catalogue.

Stahl 2000
Stahl, Alan M. "Mint and Medal in the Renaissance." In *Perspectives on the Renaissance Medal*, edited by Stephan K. Scher. New York: American Numismatic Society, 2000.

Summers 1979
Summers, John David. *The Sculpture of Vincenzo Danti: A Study in the Influence of Michelangelo and the Ideals of the Maniera.* PhD diss., Yale University, 1969. New York: Garland, 1979.

Sutton 1991
Sutton, Kay. "Milanese Luxury Books, The Patronage of Bernabò Visconti." *Apollo* 134 (1991).

Taccone 1493
Taccone, Baldassare. *Coronatione e Sponsalitio de la Serenessima Regina M.Bianca Maria Sforza Augusta.* Milan: 1493.

Taddei 2007
Taddei, Mario. *I Robot di Leonardo / da Vinci's Robot.* Milan: Leonardo3, 2007.

Tanaka 1995
Tanaka, Hidemichi. "The Process of the Nagoya City Sforza Reconstruction." In Ahl 1995.

*Trattato della pittura* 1995
Leonardo da Vinci. *Trattato della pittura.* In *Libro di pittura* 1995.

*Treatise on Painting* 1956
*Leonardo da Vinci: Treatise on Painting (Codex Urbinas Latinus 1270).* Edited and annotated by A. Philip McMahon. Introduction by Ludwig Heydenreich. 2 vols. Princeton, New Jersey: Princeton University Press, 1956.

Tucci 1968
Tucci, U. "Biringucci Vannoccio." *Dizinario Biografico degli Italiani (DBI)* 10 (1968).

Valentiner 1932
Valentiner, W. R. "Leonardo and Desiderio." *The Burlington Magazine* 61 (1932).

Valeri 1922
Valeri, Francesco Malaguzzi. *Leonardo da Vinci e la scultura.* Bologna: Nicola Zanichelli, 1922.

Valsecchi 1968
Valsecchi, Marco. *Gli arazzi dei Mesi del Bramantino.* Milan: Cassa di Risparmio delle Province Lombarde, 1968.

Vasari 1878–1885
Vasari, Giorgio. *Le opere.* Edited by Gaetano Milanesi. 9 vols. Florence: Sansoni, 1878–1885.

Vasari 1906
Vasari, Giorgio. *Le vite de' più eccellenti pittori, scultori e architettori scritte da Giorgio Vasari pittore Aretino.* Edited by Gaetano Milanesi. Vol. 4. Florence: Sansoni, 1906.

Vasari 1966–1987
Vasari, Giorgio. *Le vite de' più eccellenti pittori scultori e architectori nelle redazioni del 1550 e del 1568.* Edited by Rosanna Bettarini and Paola Barocchi. 6 vols. Florence: Studio per Edizioni Scelte (S.P.E.S.), 1966–1987.

Vasari 1973–1981
Vasari, Giorgio. *Le opere di Giorgio Vasari con nuove annotazioni e commenti di Gaetano Milanesi.* 9 vols. Florence: Sansoni, 1973–1981.

Vasari 1991
Vasari, Giorgio. *The Lives of the Artists.* Translated by Julia Conway Bondadella and Peter Bondadella. Oxford and New York: Oxford University Press, 1991.

Vecce 1998
Vecce, Carlo. *Leonardo.* Rome: Salerno, 1998.

Verrocchio's David 2003
*Verrocchio's David Restored: A Renaissance Bronze from the National Museum of the Bargello, Florence.* Edited by Gary M. Radke, guest curator. Atlanta: High Museum of Art, in association with Giunti, 2003. An exhibition catalogue.

Viatte 2003
Viatte, Françoise. "The Early Drapery Studies." In *Leonardo da Vinci 2003.*

Villata 1999
Villata, Edoardo, ed. *Leonardo da Vinci. I documenti e le testimonianze contemporanee.* Milan: Ente Raccolta Vinciana, 1999.

Waldman 1997
Waldman, Louis A. "The Date of Rustici's *Madonna* Relief for the Florentine Silk Guild." *The Burlington Magazine* 139 (1997).

Weil-Garris Brandt 1989
Weil-Garris Brandt, Kathleen. "Leonardo e la scultura." *Lettura Vinciana* 28 (April 18, 1988). Florence: Giunti Barbèra, 1989.

Willem van Tetrode 2003
*Willem van Tetrode, sculptor (c. 1525–1580): Guglielmo Fiammingo scultore.* Edited by Frits Scholten. Amsterdam: Rijksmuseum, and New York: The Frick Collection, in association with Waanders, 2003. An exhibition catalogue.

Windt 2003
Windt, Franziska. *Andrea del Verrocchio und Leonardo da Vinci, Zusammenarbeit in Skulptur und Malerei.* Münster: Rhema, 2003.

Zeffi 1892
Zeffi, Francesco. *Di Lorenzo Strozzi, autore di queste Vite.* In *Vite degli Uomini illustri di Casa Strozzi,* by Lorenzo di Filippo Strozzi. Florence: Sansoni?, 1892.

Zikos 2002
Zikos, Dimitrios. "Giambologna's Land, House and Workshops in Florence." *Mitteilungen des Kunsthistorisches Institutes in Florenz* 46 (2002).

Zimmer 1999
Zimmer, Gerhard. "Tecnologia delle fonderie del bronzo nel V secolo a. C." In Formigli *I grandi Bronzi* 1999.

Zöllner 1995
Zöllner, Frank. "L'Uomo Vitruviano di Leonardo da Vinci, Rudolf Wittkower and l'Angelus Novus by Walter Benjamin." *Raccolta Vinciana,* fasc. XXIV (1995).

Zöllner 2003
Zöllner, Frank. *Leonardo da Vinci 1452–1519.* Cologne and Los Angeles: Taschen, 2003.

# Contributors

**Andrea Bernardoni** is a researcher at the University of Bergamo and at the Istituto e Museo di Storia della Scienza, Florence.

**Martin Kemp** is Emeritus Professor of the History of Art, Trinity College, Oxford University.

**Pietro C. Marani** is professor straordinario di Storia dell'Arte Moderna at the Politecnico di Milano and director of the Raccolta Vinciana, Milan.

**Tommaso Mozzati** teaches art history at the University of Perugia.

**Gary M. Radke** is Dean's Professor of the Humanities at Syracuse University and guest curator for exhibitions of Italian art at the High Museum of Art, Atlanta.

**Philippe Sénéchal** is professeur d'histoire de l'art moderne, université de Picardie Jules Verne, Amiens.

**Darin J. Stine** completed his master's degree in art history at Syracuse University.

# Photography Credits

Royal Collection © 2009 Her Majesty Queen Elizabeth II: pp. 2, 62, 94, 136, 194; pls. 10, 13, 15, 20, 22, 27–31, 33, 34, 37; figs. 3, 36, 44–47, 49, 52, 53, 64–68, 77, 79, 82, 91–93, 97, 104, 117

© Scala / Art Resource, NY: pp. 19, 164; pls. 36, 42, 45, 48; figs. 2, 6, 8, 13, 15, 40, 57, 59, 80, 95, 96, 99, 108, 110, 115

© The British Museum / Art Resource, NY: p. 14; fig. 17

© Jean-Gilles Berizzi / Réunion des Musées Nationaux / Art Resource, NY: pl. 3

© The Trustees of the British Museum: pls. 9, 11, 18, 46; fig. 63

© 2009 Board of Trustees, National Gallery of Art, Washington: pls. 12, 19; fig. 16

© Ojéda / Hubert / Réunion des Musées Nationaux / Art Resource, NY: pls. 16, 17

© Alinari / Art Resource, NY: pl. 38; figs. 94, 98

© The Metropolitan Museum of Art, New York: pl. 40; figs. 60, 62, 102

© Réunion des Musées Nationaux / Art Resource, NY: pl. 41

© Michèle Bellot / Réunion des Musées Nationaux / Art Resource, NY: pl. 47

© Christian Jean / Réunion des Musées Nationaux / Art Resource, NY: pl. 49

© Franck Raux / Réunion des Musées Nationaux / Art Resource, NY: fig. 39

© V&A Images / Victoria and Albert Museum, London: figs. 42, 43, 73

© Pierre Philibert / Musée du Louvre: fig. 109

© Thierry Le Mage, Réunion des Musées Nationaux / Art Resource, NY: fig. 114

Image © 2009 Museum of Fine Arts, Boston: fig. 112

Soprintendenza Speciale per il Patrimonio Storico, Artistico, ed Etnoantropologico e per il Polo Museale della città di Firenze: pl. 1

Opera di Santa Maria del Fiore, Florence / photograph by Antonio Quattrone: pp. 4, 160; pls. 2, 21, 35; figs. 19–32

Soprintendenza Archeologica per la Toscana: pls. 4, 5

Soprintendenza Speciale per i Beni Archeologici di Napoli e Pompei: pl. 8

Scala / Ministero per I Beni e le Attività culturali / Art Resource, NY: figs. 1, 38, 54

Alinari / Art Resource, NY / photograph George Tatge, 2000: fig. 4

Cameraphoto Arte, Venice / Art Resource, NY: p. 82; figs. 5, 51, 103

Photographs Antonio Quattrone: figs. 9, 10, 34, 35

Finsiel / Alinari / Art Resource, NY: fig. 11

Bildarchiv Preussischer Kulturbesitz / Art Resource, NY: fig. 18

Eric Lessing / Art Resource, NY: figs. 33, 48, 72, 100, 101

National Gallery, London / Art Resource, NY: fig. 37

Image Select / Art Resource, NY: fig. 41

Vanni / Art Resource, NY: figs. 55, 70

The Bridgeman Art Library: fig. 84

Kunstmuseum Basel, photograph Martin P. Bühler: fig. 105

Fitzwilliam Museum, University of Cambridge, UK / The Bridgeman Art Library: fig. 113

Istituto e Museo di Storia della Scienza: pp. 114–116